Great Private Collections
of Imperial Russia

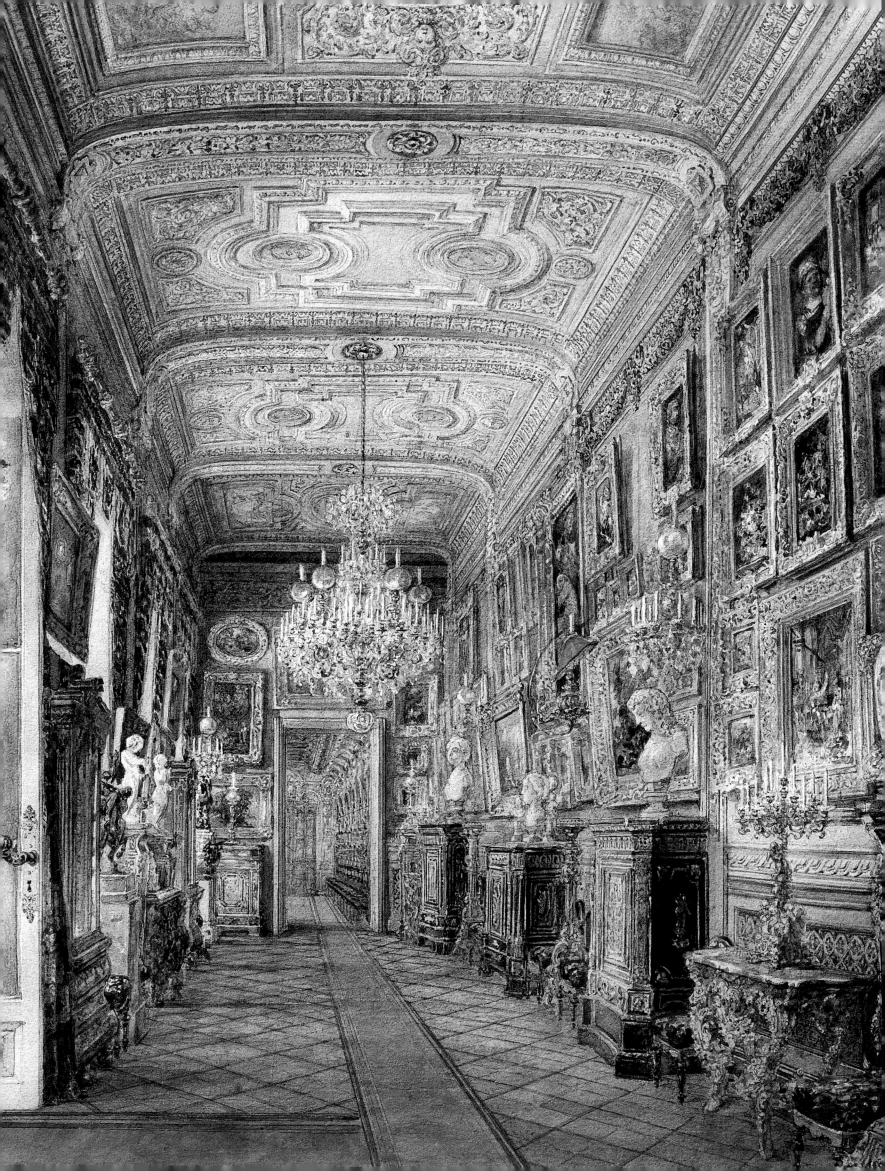

OLEG YAKOVLEVICH NEVEROV

Great Private Collections of Imperial Russia

Introductions by

MIKHAIL BORISOVICH PIOTROVSKY *and*

H.H. NICHOLAS ROMANOV, PRINCE OF RUSSIA

General Editor: Emmanuel Ducamp

 Thames & Hudson

Note on proper names

Russian proper names consist of a first name, a patronymic (the father's first name with the suffix "vich" for men and "vna" for women), and a family name. In some cases the name is also preceded by a title. Count Alexander Sergeievich Stroganov, for example, the son of Sergei Grigorievich Stroganov, for the sake of variety, is referred to by his full name, or as Count Alexander Sergeievich, Count Alexander, or simply Alexander Sergeievich. Outside Russia, women are customarily referred to by their hsuband's name, without using the feminine suffix that would normally be used in Russia (Countess Sofia Vladimirovna Stroganova).

First published in the United Kingdom in 2004 by
Thames & Hudson Ltd, 181A High Holborn, London WC1V 7QX

www.thamesandhudson.com

British Library Cataloguing-in-Publication Data
A catalogue record for this book is available from the British Library

ISBN 0-500-51182-9

Printed and bound in China

TABLE OF CONTENTS

PRIVATE COLLECTIONS: THE ORIGIN OF MUSEUMS

That any museum or gallery should take a special interest in the nature of the cooperation and mutual support that exists between museums and private collectors is only natural, and all the more so if the museum in question happens to owe its own history—and its treasures—to a hundred or more private collectors whose contributions, whether voluntary or otherwise, have helped to enrich its prestigious collections. At the Hermitage it is thus customary to speak with reverence not only of Empress Catherine the Great, who founded the museum, and of the sovereigns who continued her work, but also of all the other collectors whose love of art, exceptional discernment, and impeccable taste have made the museum one of the finest in the world.

Too numerous to list and highly individual in their approach, each and every one of these collectors represents both an extraordinary life history and a legend. They include the explorer Piotr Semionov-Tian-Shansky, the diplomat Alexander Basilevsky, the inspired archeologist Count Bobrinsky; sophisticated connoisseurs such as Prince Nikolai Borisovich Yussupov and passionate enthusiasts such as Nikolai Nikitich and Anatoly Nikolaievich Demidov; great noblemen such as Count Ivan Shuvalov and Count Piotr Borisovich and Count Nikolai Petrovich Sheremetev; men who displayed as much clear-eyed judgement in business matters as in art, such as Sergei Shchukin and Ivan Morozov; those dedicated to the education of their students, such as the collector Alexander Stieglitz, and intellectuals in the Soviet mold such as Varshavsky, Dushin, and Schuster. However many they may be, we remember their names and honor their memories with gratitude. Nor do we forget those collectors who inspired Catherine in her purchases, including Pierre Crozat, Sir Robert Walpole, Count Brühl, Count Cobenzl, and numerous others.

But what does "remembrance" signify? It is not a matter merely of citing the names of these individuals on labels and in catalogues, but also of researching the history of their collections. Among the many works devoted to the Hermitage, indeed, is one entitled simply *Collections and Collectors*. Every year books and articles appear that trace the history of the lives and works of these remarkable men, who picked the opportune moment to put together collections of the works of great artists and then handed them down to their descendants. In so doing they shaped the tastes of successive eras, including our own; in their way, they were responsible for writing the history of art. At the Hermitage we are faithful in our remembrance of them, and perhaps most especially in the exhibitions we have staged (with growing frequency over recent years) as tributes to those who played a part in making the museum what it is today: the Yussupovs and Stroganovs, Prince Bezborodko, Shchukin, Morozov, Prince Gorchakov, Baron Stieglitz, Alexander Basilevsky, Walpole, the Duc d'Orléans, and many more are to come.

Private collections have a role of fundamental importance to play in the art world. Without the support of private collectors, numerous artists would have been unable to continue their work and the majority of today's museums and galleries would never have come into existence. The rightful place of great works of art is certainly within public museums and galleries, but in general these products of artistic genius can only find their way into public collections by first conquering the hearts of private collectors.

One of the most hotly debated topics among today's collectors is the question of where paintings or other works of art are best displayed: in a collector's house or in a museum? Should future generations view works of art within the collections of which they originally formed part or in the halls of a great museum? Opinions differ widely, as do the proposed solutions to this problem. Some museums and galleries have been created around a collection, others are devoted to private collections, and some large institutions set out to preserve a number of different collections in their entirety. There are also museums whose collections include groups of works lovingly collected by an individual with a view to creating a visual history of art. The possible solutions are numerous, and all are legitimate. The crucial point is never to forget that the time when any work has found itself in the hands of a collector forms part of the work's history, and of the history of art in general. This time is of just as much significance, moreover, as the time when it was still in the artist's studio, or when it made its first appearance in the hallowed halls of a great museum.

It is my personal view that the works making up a private collection should be integrated within the larger collections of public museums and galleries. But it then becomes incumbent on these institutions every now and again to bring together all the works amassed by a particular collector, and to remind us of his or her contribution by means of exhibitions, catalogues and articles. This is the approach that we adopt at the Hermitage, and I am tempted to believe that the official name of one of the museum's most important paintings, the *Benois Madonna,* does quite as much—if not more—to preserve the reputation of this illustrious family as the entire museum devoted to them in Peterhof.

When they first start collecting, all collectors are clearly motivated by the personal pleasure they take in their works. But nearly all of them also have an eye to the future, and museums and galleries, in their different ways, form part of this future. They are the culmination of the artistic process and the final outcome of the choices made by connoisseurs and collectors. They bring together works collected by a wide range of individuals, with a corresponding diversity of means, interests and tastes. Together these collections bear witness to the inexhaustible appeal of these many different approaches and of their ability to respond to the exigencies of their times; taken as a whole, they form an immense, distinguished, and privileged asset, unique to the world's great museums.

The development of the collections of national museums is a fascinating aspect of any country's cultural history. We are accustomed to paying due homage to Catherine II, founder of the Hermitage and a collector in a class of her own, who combined a fanatical zeal for collecting with shrewd judgement—so displaying the qualities that are essential in a true collector, and that also earned her the epithet "the Great." Yet in fact she was only continuing, and refining to perfection, an activity started by Peter the Great. Not only the tsar but also his companions in arms, and notably Prince Alexander Menshikov, closest of all to him, collected curiosities with passionate enthusiasm. Catherine II's companions in arms followed suit, but instead of collecting "wonders" they amassed artistic masterpieces. Like Catherine, they were perspicacious enough not only to choose their works shrewdly, but also to surround themselves with skilled advisors. And also like Catherine, they viewed their collections not merely as a source of pleasure, but also as a means of increasing both their personal prestige and that of their country.

Following the example of their sovereigns, members of the mighty Russian aristocratic families amassed collections which also invariably bore the imperial stamp. Their tastes went hand in hand with their political instincts, and it was a combination that was to give rise to remarkable and astonishing collections. And although these great connoisseurs often had their residences in Moscow and kept their artistic trophies there, the spirit of their collections remained imbued with the culture of St. Petersburg, and of the imperial court. Many of these collections maintained close links with the imperial museum, even if they did not enter the Hermitage collections until after the Revolution; from the outset, indeed, a number of them had been conceived with the intention of being exhibited at the Hermitage, or of being bequeathed to it.

But Moscow also inspired a different type of collector, drawn from the ranks of businessmen who matched their passion for art with an equally strong commitment to the spreading of knowledge, and a desire to promote the development of Russian culture. The names of the most outstanding collectors of Western European art—Shchukin and Morozov—are known throughout the world, but there were many others. Whole families now became patrons and collectors, and many of them developed a passion for Russian as well as Western art, frequently displaying the two together. The names of the Tretyakov brothers, Savva Mamontov, the Riabushinskys, Tsvetaiev, and many others, all of whom created private galleries open to the public, or museums of art intended for public instruction, became the symbols of a certain type of Russian capitalism, aware of both their national culture and of its international context.

During the Revolution and the civil war that followed it, many collections were destroyed and others went abroad. The Soviet government, finally, auctioned some works in its attempts to solve the financial problems of the new Russian state. Yet many of these collections formed by nobles, diplomats, soldiers, and entrepreneurs remained in Russia, and still enrich the country's museums. Were it not for these works of art these museums and galleries would not exist, and so they are committed to preserving the names and memories of their original owners. This book stands as a mark of the respectful homage we owe these exceptional figures, and of the affection in which we hold their memories.

Dr. Mikhail Piotrovsky
Director, The State Hermitage Museum
St. Petersburg

FAMILY COLLECTING

When I was asked to write a foreword to *Great Private Collections of Imperial Russia*, the ambition and scale of this project made an overwhelming impression on me. The careful selection of illustrations—many of them unknown to me, and all chosen to bring an interesting text to life—made me wonder how anyone could have had the daring and ambition to confront such a vast and problematic subject as the art collections of the great Russian families in their palaces before the fall of the empire.

The greatest collector in our family was of course Catherine the Great, who provided the backbone of the art collections in the galleries of the imperial palaces. But no comparable collection, in terms of both quality and quantity, was acquired during successive reigns. After Catherine, the first collector who comes to my mind is Grigory Potemkin (pp.64–71), a man of discrimination in many fields, thanks to whom great art collections and whole libraries were purchased during the reign of the empress. This "splendid Prince of Taurida" was indeed a great man, a genius of staggering drive and energy, who opened up the Black Sea for Russia and even thought of sending a Russian grand duke to reign as emperor in Constantinople. He was, of course, also my great-great-great-great-grandmother's lover, and generation after generation of Romanovs has felt an inherent dislike for Potemkin's depiction in this role. After all, the Lanskois, whose handsome son eventually followed Potemkin into Catherine's bed, found this a cause of deep embarrassment, as do we still.

After this period, I have a distinct feeling that, besides Nicholas I's creation of the New Hermitage, a random purchase here or there, and the occasional large payment for an important collection to enter the Hermitage on the suggestion of statesmen or directors of the gallery, the Romanovs did not show any particular inclination to become patrons of art.

Instead, paintings representing parades, cavalry, maneuvres, and battle scenes were commissioned, works that were precise in every detail of uniforms, colors, and standards. As for the grand dukes, the sons and grandsons of Emperor Nicolas I, their palaces were conspicuously devoid of any real works of art at all, except for Grand Duke Konstantin Nikolaievich's palace at Pavlovsk, which was indeed an art gallery—albeit on a more minor scale than the imperial galleries. Details were often taken for art among ruling royalty. Emperor Napoleon III, when visiting an exhibition of contemporary painters (according to Maxime Du Camp in his memoirs), stopped in front of a painting of Mont Blanc and, after admiring the work, commented that it was a pity that the painter had not completed the work by indicating the height of each peak. Surely I didn't expect the last Romanovs to be collectors of modern art to rival the enlightened Muscovite merchant princes Shchukin or Morozov; yet after leafing through this book, I was left with the depressing feeling that my Romanov ancestors had never really managed to become true collectors at all.

On the other hand, and to my great relief, I found out that—after all—I had art collectors in my Sheremetev, Vorontsov-Dashkov and Shuvalov ancestors. I am gratified that my great-grandfather, Count Sergei Dmitrievich Sheremetev, is described here as a great intellectual who served his country through scientific progress, while pursuing the conservation of Russian folklore and traditions.

Looking through the reproductions of the art collections in the palaces of my non-Romanov ancestors pulled me out of my previous gloom. At least on one side of my ancestry there were men and women who enjoyed art and made a major contribution to the beauty of their palaces.

But to be fair, on the Romanov side I cannot forget that in Grand Duke Nikolai Mikhailovich, known to us as Uncle Bimbo, we had a man of infinite culture whose monumental work *Russian Portraits*, published in the early 1900s, contributed greatly to the preservation and knowledge of Russian portraiture.

In many ways, it is a predecessor to this book.

H.H. Nicholas Romanov, Prince of Russia

Private Galleries as a Public Service

So many and varied are the passions and motivations that fire the desire to collect that the story of any group of outstanding collectors cannot help but read like a novel based in remarkable historical truth. And nowhere more so than in the history of the private collections amassed in Russia from the early 18th century to the start of the 20th. In many respects the history of Russia is bound up with that of its rulers, so closely did their will shape its destiny and character, and the history of the imperial collections—originally the tsars' private collections—would merit a volume in its own right. This work, however, touches upon them only tangentially, to the extent that they influenced the development of private collections, were influenced by them in turn, or were enriched by them.

Peter the Great's favorite maxims—"For I am one who learns, and I crave those who teach," and "I desire that the people look and learn"—highlight the unquenchable thirst for knowledge that he longed to pass on to the peoples under his sway. His collections accordingly were first and foremost a window onto the world. The tsar's *Kunstkamera*—Russia's first museum, opening its doors to the public in 1719—was an accumulation of curiosities from the natural world, of didactic rather than aesthetic interest. Coming as it did from the greatest of all the Russian emperors, this imperative to inform appears in some way to have acquired the force of an ukase, focusing and driving the energies of Russian collectors for two hundred years to come.

The art of collecting initially took hold among members of the Russian rulers' inner circle, as highly ranked diplomats and grandees were particularly well placed to bring back works of art from their tours of duty in foreign capitals or their travels abroad. In 1757, Count Ivan Ivanovich Shuvalov (1727–97, ill.57) was one of those who set up the St. Petersburg Academy of Fine Arts. The following year he endowed the institution with over a hundred paintings from his own remarkable collection, his aim being to allow young Russian artists to study and copy them and so advance in their own work. A few years later another president of the academy, Count Alexander Sergeievich Stroganov (1733–1811, ill.26), was also to throw his collection open to his students.

Nonetheless, we should not be so beguiled by the generous approach of some Russian collectors that we overlook the social prestige attached to the cultivation of the arts at this time. Yet it is impossible not to be astonished at how early this desire to share the fruits of their passions with their fellow countryman came into evidence. On his death, Prince Dmitri Mikhailovich Galitzin (1721–93, ill.39) founded a gallery of some 400 paintings attached to a charitable hospital in Moscow, an institution which was to open in 1802 through the good offices of his cousin, Prince Alexander Mikhailovich (1723–1807, ill.40). This was not a private gallery open to individuals by appointment—as was the case with many private collections—but rather a true museum, open to the public. Sadly this first Galitzin museum was to remain open only until 1816, and its successor, created by Prince Mikhail Petrovich, was likewise to close its doors in 1825.

Similar establishments were to spring up throughout the nineteenth century. In 1846, Count Alexander Kushelev-Bezborodko (1800–55) created a picture gallery in St. Petersburg while his youngest son, Nikolai Alexandrovich (1834–62), was to achieve immortality by bequeathing his entire collection of paintings and sculpture to the Academy of Fine Arts in 1862, stipulating that they should be displayed in their own gallery, open to artists and members of the public alike, with no requirement to buy tickets or observe any dress code. Members of the Galitzin family were once more to prove pioneers in this field. Honoring the wishes of his father, Prince Mikhail Alexandrovich (1804–60), in 1865 Sergei Mikhailovich opened a gallery of western European painting in Moscow, where visitors could admire the Perugino triptych known as the "Galitzin Triptych" (ill.41). In 1886 the collection was acquired en masse for the imperial Hermitage, so epitomizing the influence brought to bear on Russia's national collections by private connoisseurs.

Examples such as this did not go unheeded in the inner circles of power. Despite its visiting restrictions—seeking permission in advance from the imperial administration was de rigueur, as was the wearing of formal dress or uniform—the New Hermitage was a formidable temple to the arts, conceived with all the method and order that were typical of Nicholas I. In 1856, a year after his accession to the throne, Nicholas's son Alexander II took a decision that was to prove of far-reaching significance. He ordered separate inventories to be drawn up of the imperial family's private collections on the one hand, and on the other of those of the Hermitage, sanctioning in so doing the handover of a generous number of works to the state.

In Moscow, meanwhile, the first signs were emerging of a development that was to have all the appearance of a genuine cultural revolution. The imperial librarian E.I. Makovsky (1802–86) opened his collection of Dutch masters and prints to connoisseurs of art, while the architect Evgraf Dmitrievich Tiurin (d.1870), who already threw his own gallery open every Sunday, attempted in 1851 to persuade the local authorities to set up a public gallery showing works drawn exclusively from private collections. In 1862 the state authorities finally despatched the entire collection of Count Nikolai P. Rumiantsev to Moscow, where it was to be put on public exhibition at the Pashkov palace. It was in the same premises and virtually at the same time, moreover, that the city fathers decided to open the "Moscow Public Museum." This bore witness to a mood that was to continue to grow in strength into the early years of the twentieth century: Moscow's severance from the capital was now complete, and its cultural destiny lay in its own hands.

The first manifestations of this schism were in the economic sphere. From the 1840s, industry and business had flourished in Moscow, encouraging the emergence of a new social class of wealthy merchants and entrepreneurs, known as "merchant-princes." For these men, forming art collections was, again, a means of confirming their social standing. Yet for some, naked social ambition was tempered by a degree of disinterestedness and altruistic zeal. Perhaps the most colorful of these characters, the very epitome of the *samodorok,* or Russian self-made man, was Vasily Alexandrovich Kokorev (ill.205). In 1862 he threw his collection of paintings open to the public, to immediate acclaim. Freed from the yoke of Petersburg and of court prejudice, Kokorev—like many other Moscow collectors—chose to concentrate on Russian painting, both contemporary and historical. A major turning point in this revival of Russian painting was the public opening, in 1893, of the Pavel and Sergei Tretyakov Municipal Gallery, dedicated specifically to the national school.

By allowing public access to their private galleries—or handing them over wholesale to the community, like the Tretyakovs—private collectors thus played a role of crucial importance in the artistic development not only of the Russian people but also of the country's artists. It was a phenomenon that was to spread yet further, with more galleries opening to the public, including the collections of icons amassed by Ilya Ostroukhov (1858–1929, ill.248), and the collections of Piotr Shchukin (1853–1912, ill.286), opened initially to research students in 1895 and from 1905 to the public at large, and those of his brother Sergei (1854–1936, ill.297), also open to the public from 1909. This remarkable impulse to share their works with the public also had a number of related phenomena, including a huge increase in the number of commissions offered to contemporary Russian artists, the staging of exhibitions of their work, and the setting up of artistic communities on estates such as Abramtsevo (p.179) and Talashkino (p.191), which became crucibles of new ideas, techniques and styles. Communities such as these were also the latest manifestation of a uniquely Russian tradition, whereby workshops were set up on the great estates where serfs with artistic abilities could hone their skills. Abramtsevo and Talashkino were to be the ultimate expressions of this ideal, in which artists and patrons shared a mutual passion and exchanged ideas freely and on equal terms. The Russian maxim *bogatstvo objazyvaet,* or *richesse oblige,* could well have stood as the motto of these merchant-princes: this was the motivation that prompted Russian collectors gradually to leave bourgeois benevolence behind them, aspiring instead to what might be termed civic patronage.

The story of these private collectors ends with an augury for the future. In a sublime paradox of art history, in the closing years of the 19th century, it fell to Russia to show the way forward to the countries of western Europe and especially to France, which at that time dismissed its avant-garde artists with scornful disdain. In 1894, the French state refused to accept some sixty works by Degas, Manet, Monet, Renoir, Pissarro, and Cézanne, bequeathed to it by the painter Caillebotte, on the grounds that the artists in question were "charlatans who had led a generation of young artists astray." In Moscow, on the other hand, the talents of the Impressionists, of Gauguin, van Gogh, Matisse, and Picasso were fully recognized by a handful of collectors of prescient genius.

The final chapter in this tale of adventures and dreams is provided by Sergei Shchukin: the enthusiasm that he displayed in front of visitors when he took them through his collection (p.227), acting as an inspired guide, has now spread throughout the world. In the early 1930s, after being forced into exile by the Revolution of 1917, he was asked if he intended to take legal action against the Soviet government for the return of his confiscated paintings. "It was not merely for myself that I amassed my collections," he replied, "even less for myself than for my country, for my people. Whatever may happen on Russian soil, there my collections must remain." No one could challenge Shchukin's right to the title of merchant-prince. Merchants by profession, he and his peers were princes in their flamboyance, their courage, and their passion: three qualities shared in abundance by these outstanding figures in the history of private collections in Russia.

Emmanuel Ducamp

THE EMERGENCE OF PRIVATE COLLECTIONS IN RUSSIA: PETER THE GREAT AND HIS INNER CIRCLE

The early 18ᵗʰ century

eter the Great (1672–1725) (ill.2), youngest son of Tsar Alexei Mikhailovich Romanov (1629–1676) by his second wife Natalia Naryshkina, became co-tsar of Russia in 1682 at the age of ten, together with his half-brother, the mentally deficient Ivan V. Following their accession to the throne, Peter's first concern was to free himself from the control of their older sister, the regent Sophia, whom he banished to a convent in 1689. A few years later, after the death of Ivan in 1697, he assumed sole rule of Russia, and set about the gradual but fundamental modernization of the empire. In 1697–98 he embarked on an extensive tour of Europe, during which he took every opportunity to learn, even going so far as to work as a carpenter in the naval shipyards of Holland and Britain and study industrial practices in Europe. When he returned to Moscow in 1699, he was resolved to drag Russia—then still wedded to medieval traditions—into the modern world, summoning Western experts to teach his compatriots the latest industrial and management techniques then current in Europe.

Having muzzled his constantly mutinous nobles by such measures as forcing them to shave their distinctive beards and forsake their traditional Russian costumes for Western clothes, Peter the Great introduced far-reaching constitutional reforms, and made the Orthodox church subordinate to the state. With ferocious determination, from 1703 he also pursued his goal of "opening a window on to Europe" by building a magnificent new capital—St. Petersburg—on marshy land on the Gulf of Finland.

By this means he assured himself free access to the sea (though frozen for half the year) other than via the Bosphorus and the Black Sea, and shook off once and for all the yoke of the more conservative Moscow, insisting that his courtiers embraced a new, European life style and built palaces that broke completely with the traditions of the old capital.

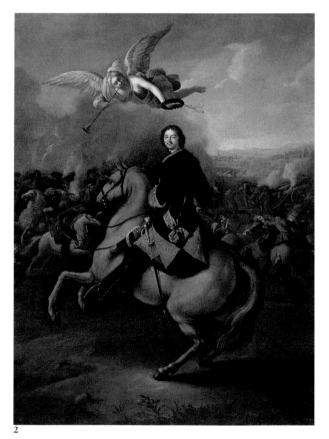

2

Art collections as such did not exist in Russia before the reign of Peter the Great. Here and there, especially in sixteenth-century texts, we find references to rare objects the Russian monarchs had managed to acquire in the course of events. There was Ivan the Terrible's collection, which, according to legend, included gold earrings from ancient Greece and a Gothic silver reliquary. Among the natural curiosities in the collection of Tsar Alexei Mikhailovich, special mention was made of the tusk from a "sea unicorn," the narwhal.

The Armory Palace, within the Moscow Kremlin, all but overflowed with exotic trophy arms and *objets d'art* that were unique of their kind, all diplomatic gifts

1. Johann Christoph Dorsch
Portraits of Russian Sovereigns
Nuremberg, early 18ᵗʰ century
Jasper intaglio, 3 x 2.5 cm
Hermitage, St. Petersburg

2. Johann Gottfried Tannauer
Peter the Great at the Battle of Poltava, 1724–25
Oil on canvas, 76 x 63.5 cm
Russian Museum, St. Petersburg

Peter the Great's *Kunstkamera*—the first museum collection open to the public in St. Petersburg—was more a cabinet of curiosities than a collection of objects united by their intrinsic aesthetic value. But it was during his reign, nevertheless, that the 'art' of collecting made its first appearance in Russia. It was to grow continuously in popularity until the Revolution in 1917. Like Catherine the Great in a later era, Peter was well aware of the important political role that art could play, and he took precautions accordingly. When he acquired the celebrated Taurida Venus—a Roman copy of a Greek statue of Aphrodite—for the imperial collections in 1718, he took the highly unusual step of having it transported to Russia by land in order to avoid the risk of any mishap *en route*.

3. Siberia,
3ᵈ to 4ᵗʰ century B.C.
Heroe's Repose
Width: 15.5 cm
Hermitage, St. Petersburg

Akinfy Demidov—a pioneer in exploiting the mineral reserves of Siberia—is said to have made a gift to Peter the Great of a collection of mysterious gold objects (ill.3) removed from ancient graves. The tsar immediately issued orders to the governor of Siberia, Matvei Gagarin, that the spoils of all future excavations of burial tumuli should be brought to the new capital.
In this unlikely fashion, and well before the era of scientific excavations, the sovereign ensured the safety of this priceless heritage of the Scythians—proof of the sophistication and refinement of the people who lived on the central steppes of Asia in the fifth century B.C.

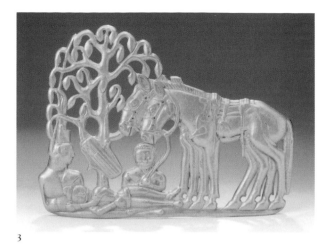

3

presented to the Russian crown. Nonetheless, although sources also mention portraits and paintings, engravings, tapestries, and valuable utensils, these items represented little more than constituent parts of the general décor, rather than manifestations of a desire to form a collection for its own sake. Adam Olearius (1599–1671), mathematician and diplomat from Holstein, was scathing in his remarks about the Russians: "They know nothing of the sciences, show only the slightest interest in the events of the history of their fathers and forebears, and display equally scant concern for the lives of other peoples."

Describing Russia before the reign of Peter the Great, meanwhile, the Dutch traveler Nicolaas Witsen (1641–1717), who acted as the guardian to the young Peter during his stay in Amsterdam, observed: "There study is forbidden, and those who would nevertheless

venture into the sciences are accused of heresy." This attitude prevailed even with regard to Peter I and his circle, the young tsar himself being on occasion denounced as the Antichrist, and Jacob Bruce, his Scots-born companion, as a necromancer.

The young Witsen visited Russia at the head of a diplomatic mission in 1664–65. Throughout his stay he kept a secret travel journal, in which he noted his puzzled reaction to the response of the Russians to the sumptuous and exotic gifts he had brought them from his country: "Nothing pleases these people more than pure silver and unrefined gold, devoid of any artistic touch. ... In our country, we generally accord more importance to the artistic value of a piece than to its weight. The light weight of many objects incurred only criticism from the Russians. They understand nothing of art. ... As for faïence dishes, they declared them merely earthenware, and earthenware was of no interest to them. Concerning a richly inlaid table, they merely said it was made of wood."

Prince Vasily Galitzin (1643–1714), the favorite of the regent Sophia, displayed a degree of interest in antiquities and works of art, but in his European-style residence no clear distinction was made between everyday items and his art collections. The walls of the dining room were hung with portraits of Russian sovereigns, from Vladimir to Peter the Great and Ivan V, alongside portraits of Patriarchs Nikon and Yakim, and "three royal personages painted on canvas and framed in black." In the reception hall stood two immense armoires crammed with German artifacts in precious metal; the collective weight of the Galitzin hoard of silver objects amounted to as much as four hundred *pouds* (more than 6 tons), a good part of which passed into the collection of young Tsar Peter after the disgrace of Prince Galitzin in 1689 (following the fall from power of the regent Sophia, his mistress). These treasures included a gold cup embellished with enamel and semi-precious stones (now in the Moscow Kremlin, Armory Palace), a gift to the prince from Peter and Ivan, the co-regnant tsars, following the peace concluded with Poland in 1686. Galitzin's collection of coins and medals, meanwhile, went to the museum in Feodossia, while his icons went to the museum in Rostov.

Peter the Great was the first Russian ruler to offer his subjects the example of a genuine, dedicated collector. Peter's interest in the "rarities of nature and art" emerged clearly during his first journey abroad in 1697 and 1698, when he recorded his impressions in letters to Andrei Vinius, head of the Prikaz Apothecary in Moscow (the equivalent today of a ministry of health). From Libava he sent a description of a salamander preserved in alcohol that he had seen in a local pharmacy; in Deptford he was enthusiastic about a group of Chinese objects; and in Amsterdam he bought a stuffed crocodile. One by one the traveling monarch had all

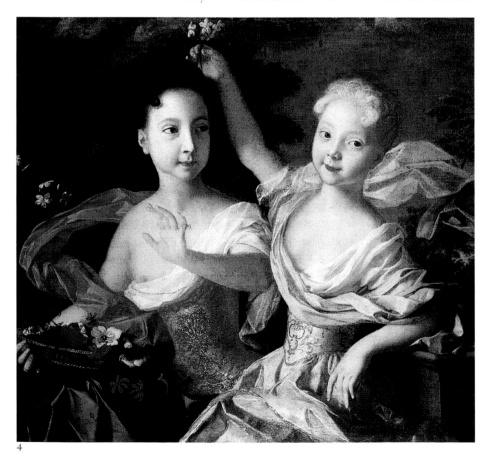

4

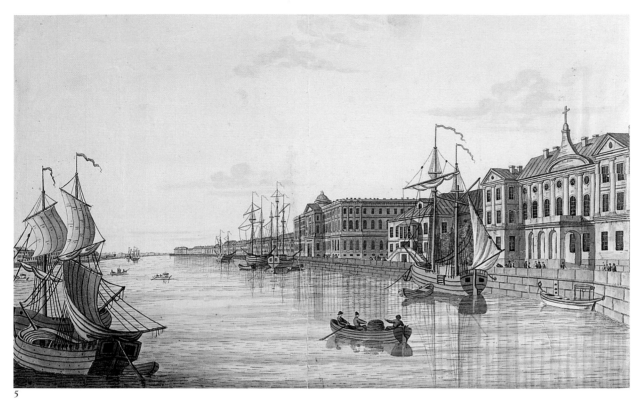

5

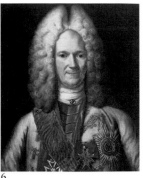

6

4. Louis Caravaque
*Portrait of the Grand Duchesses
Anna Petrovna and Elizaveta
Petrovna, Daughters of Peter
the Great,* 1717
Oil on canvas, 76 x 97 cm
Russian Museum,
St. Petersburg

5. I. Ivanov
*The Menchikov Palace and the
Academy of Fine Arts on the
banks of the Neva,* second half
of the 18th century
Engraving with watercolor
Hermitage, St. Petersburg

6. Unknown artist
*Portrait of Prince Alexander
Danilovich Menchikov
(1672–1729),*
early 18th century
Oil on canvas, 62 x 51 cm
Menchikov Palace,
St. Petersburg

these treasures dispatched to Moscow, where they formed the first imperial collection of natural and historical objects, under the supervision of Peter's personal physician, Robert Areskine. Initially the "Tsar's Cabinet"—then consisting essentially of exotic creatures, "monsters," anatomical specimens, weapons, ethnographic curiosities, and diplomatic gifts—retained a private character. In this, Peter was following the example of other royal and aristocratic families of the time, whose cabinets of curiosities or *Wunderkammer* (this being originally a German proclivity) were indeed replete with natural curiosities (narwhal tusks, ostrich eggs, rhinoceros horns, and other exotica), sometimes mounted in gold or silver set with precious stones. Thus these displays of the weird and wonderful rapidly became treasures, to which their owners, who generally were sovereigns, added other valuable collectibles. As collections of *naturaliae* became joined by *artificiliae*, the *Wunderkammer* became a *Schatzkammer* (cabinet of treasures) or *Kunstkammer* (cabinet of art), known in Russia as a *Kunstkamera.*

After Peter moved the Russian capital from Moscow to St. Petersburg he had his collections installed in the Summer Palace, declaring, according to Andrei Nartov (who made a collection of the "anecdotes and memorable remarks of Peter the Great"): "Now that the country no longer has to fear its enemies, it is time to consider how we should master the arts and the sciences." These rich collections, and particularly those of the *Kunstkamera*, could only enhance the glory of the tsar.

Peter made no secret of his view that the parks and gardens newly laid out in St. Petersburg were compara-

ble to those at Versailles. The Summer Garden, embellished with statues and "waterworks," was indeed described as being like paradise. Peter made no bones about his pragmatic intentions, because, as he observed, "it behoved the first among monarchs" to embellish nature. At the same time the tsar also intended to offer his subjects an instructive example, constantly repeating his earnest wish: "I desire that the people should look and learn!" Few of his contemporaries could have been aware that in building up these collections of rare and exotic objects, the tsar was also paving the way for the advancement of the arts and sciences in Russia. As early as 1708, in a memorandum addressed to Peter the Great, the German scholar Gottfried Wilhelm Leibniz impressed upon him the following advice: "As for the museum, as well as the cabinets and the *Kunstkamera* attached to it … it would be best to arrange them in such a way that they are not merely objects of general curiosity but also a means of perfecting our knowledge of the arts and the sciences."

Numerous accounts survive to bear witness to the reaction of Peter's Russian contemporaries to the appearance of the Western arts in their daily lives. The clergy proved to be the most intransigent, as attested by Dmitry of Rostov's admonishments in his *Sermon,* "Certain of these gentlemen are currently ashamed to keep icons of Christ and the Mother of God in their homes, and some of the more impudent have even gone so far as to display images of Venus or Diana or other idols from antiquity."

The *Anecdotes of Peter the Great* collected by Ivan Golikov recount the following episode, which took place during a visit by the tsar to Voronej: "His Majesty

In order to impose his will more effectively and carry through his program of radical reforms, Peter the Great surrounded himself with a small inner circle, composed exclusively either of advisers of foreign origins who were thus less likely to engage in plotting and treachery, or of Russians of exceptional qualities and unimpeachable loyalty. The most flamboyant among these was Alexander Menshikov (ill.6), a childhood friend of the tsar: a military strategist during the war against Sweden, he was later appointed governor-general of St. Petersburg, with responsibility for creating the new capital *ex nihilo* in the most inhospitable of sites. He was subsequently made president of the Military College (minister of war).

7. The "Walnut Cabinet" in the Menchikov Palace in St. Petersburg; the décor dates back to 1714

Not merely a favorite of Peter the Great, Alexander Menshikov also outdid the tsar in the extravagance of his tastes, a fact that doubtless contributed to his downfall in 1727. His palace (ill.5) and its interiors (ill.7) displayed a Dutch influence, and were highly influential in encouraging the Russian nobility's passion for building, and for doing so on a grand scale. Recently restored to its original appearance, the palace is now one of the few buildings in St. Petersburg where we can picture the daily life of the Russian aristocracy in the early eighteenth century.

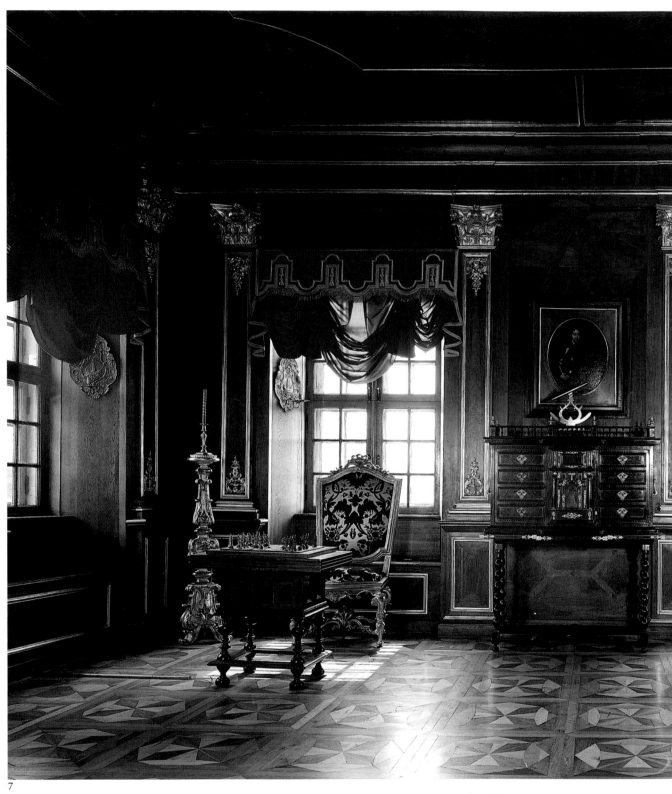

7

owned a small palace on an islet in the river at Voronej, where the entrance was embellished with statues of pagan gods such as Jupiter, Neptune, Minerva, Hercules, Venus, and others. While there, Peter extended an invitation to Bishop Mitrophan of Voronej to visit him: 'The old man came immediately, but hardly had he arrived in the forecourt and glimpsed the aforementioned statues, including a naked Venus, than he turned on his heels and left.' Unaware of the reason for his precipitate departure, the tsar sent for his guest once more. The priest refused to obey, protesting to the messengers: 'Until such time as the monarch orders idols that lead the people into temptation to be overthrown, I may not enter the palace.' Informed by the imperial messengers that he would be liable to execution if he refused to comply, the bishop ordered the church bells to be rung throughout the city before making confession in public, so determined was he to endure the most extreme torments, in the tradition of the Christian martyrs persecuted by the pagan emperors.

Peter, on the other hand, gave in and ordered the statues of the antique gods to be removed."

The year 1719 saw the inauguration of the first public museum in Russia, the *Kunstkamera* in the Kikin Palace in St. Petersburg. Peter decreed that "curiosities should be sought" throughout the land, a sum of money drawn from the treasury being set aside as a reward, and now even the enlightened clergy contributed to the enrichment of the museum. On July 23, 1723, for instance, Theophanos Prokopovich, a councillor to the

tsar, sent the museum librarian, Schumacher, a model of the temple at Jerusalem, and in the same year Archbishop Theodosius of Novgorod sent the *Kunstkamera* five cases "containing objects … that would seem to be curiosities … found near the Solovky Islands." On the express orders of the tsar, a whole team of painters set to work to make watercolor sketches of the objects exhibited in the *Kunstkamera*, which already numbered over a thousand. Their numbers were further swelled by the addition of Peter's private collections after his death in 1725, and in 1741 the publication of the first catalogue (in Latin) of the first Russian museum began.

Peter I's activities as a collector, and his private cabinet full of artistic, archeological, and natural curiosities, could not fail to influence his inner circle. Thus a number of his companions also began to form collections, particularly of coins and medals. Among these new collectors were Dmitry Galitzin, Count Andrei Ostermann, and Superintendent Piotr Krekshin, as well as foreigners in Russian service such as the scholars Joseph Delisle, Johann Christian Buchsbaum, and Gottfried Bayer.

Alexander Menshikov (ill.6), the tsar's favorite who served as governor-general of St. Petersburg and president of the Military College, quite naturally fell in with the new trend. We know the contents not only of his coin collection but also of his painting gallery, in which portraits predominated. Among the rare items in his cabinet of curiosities was a silver monstrance over three feet tall, the work of the fifteenth-century Revel artisan Hans Rissenberg (ill.8), brought back to Russia by Menshikov in 1711, after his time in Courland during the war with Sweden. Although it was a gift from the councillor in chief of Revel, it was not until 1725 that Menshikov passed this treasure on to the tsar.

The Menshikov residence in St. Petersburg (ill.5) boasted numerous sculptures, many of them commissioned in Venice and intended to symbolize the "virtues" possessed by the governor-general of the Russian capital: *Justice* (today in the Hermitage Museum, St. Petersburg), *Mercy* (Summer Garden, St. Petersburg), *Love of Country*, and *Valor Striking Down Vice* (Tsarskoie Selo). After Menshikov's fall from grace in 1727, many of these sculptures continued to adorn his palace and park in St. Petersburg. In 1732, however, some of them were removed to the Summer Garden and the park at Peterhof and then, in 1743, to Tsarskoie Selo.

In 1731 the Menshikov palace was refitted to become an officer-training establishment (later the First Corps of Cadets), and at the end of the nineteenth century the building underwent a second conversion, this time to become a museum dedicated to the prestigious school. Only in the twentieth century, from 1975 to 1981, was the palace restored to its original appearance.

From 1711 to 1726, the Scotsman Jacob Bruce (ill.9), having become the tsar's trusted subject, commanded the Russian artillery while also serving

8. Hans Rissenberg
Monstrance, Revel, 1474
Silver, silvergilt and glass
Height: 112 cm
Hermitage, St. Petersburg

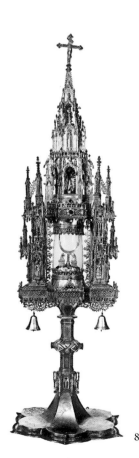

8

9.

9. A. Afanassiev
Portrait of Jacob Bruce
Engraving
Hermitage, St. Petersburg

10. *Koran case*, 1593–94
Silver, bronze, lapis lazuli
Hermitage, St. Petersburg

Jacob Bruce was another of Peter the Great's inner circle driven by a restless curiosity to amass a collection of unusual and eclectic objects and items of scientific interest, all of which served to increase contemporary understanding of foreign peoples and civilizations (ill.10). His commission to the engraver Dorsch for Siberian jasper intaglio portraits of all the Russian sovereigns (ill.1) was of highly symbolic significance. This was the first time, indeed, that anyone had ever set out to create a uniform and comprehensive set of such portraits, which hitherto had simply not existed. The resulting series of portraits lent the Russian succession an appearance of logic and simplicity that was very far from the reality.

During her reign, anxious as she was to appear as the next natural link in this unbroken chain, Catherine the Great had silver copies made of these portraits, as well as very large marble medallions by the sculptor Fedot Shubin, intended as adornments for the Chesme Palace in St. Petersburg (now at the Armory Palace in Moscow).

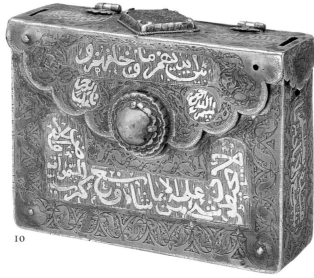

10.

Peter the Great in important diplomatic missions abroad, notably as chief negotiator at the congresses of Aland and Nystadt. In 1717 Bruce became president of the ministry of Industry as well as director of the state mint.

A man of cultivated tastes with a tremendous thirst for knowledge, Bruce devoted a great deal of time to the sciences of astronomy, ballistics, and mathematics. The "Bruce calendar," the first of its kind to be published in Russia, was a sort of astronomical and astrological compendium highly prized by his contemporaries. Among less educated Russians, however, Bruce gained a reputation as a sorcerer and was dubbed the "Russian Faust."

The important collections and library assembled by Bruce are relatively well known, thanks largely to a detailed inventory drawn up after his death, when Bruce transferred his collections to the Russian Academy of Sciences. They contained over 1500 books, 111 maps, 4 globes, a host of astronomical and optical instruments, 122 samples of minerals and ores, 44 portraits, and 300 other objects, of which a good half were curiosities of Chinese origin. His numismatic collection, meanwhile, went to join the coins in the *Kunstkamera*. So rare were these coins from antiquity—six gold and sixty-two silver—that Bayer gave a paper on them to the Academy of Sciences, singling out for particular attention a large silver tetradrachm from the reign of King Eucratides of Bactria (second century B.C.). Three years after Bruce's death, this report was published in Bayer's work entitled *A History of the Greek Empire in Bactria*. Equally worthy of note in the Bruce collection was a remarkable set of thirty-two jasper intaglios portraying Russian monarchs from Rurik to Ivan V, the half-brother of Peter the Great (ill.1), executed in the early eighteenth century by the engraver Johann Dorsch of Nuremberg. In the 1830s, the Petersburg engraver Andrei Spiridonov was to complete the set with the missing portraits, from Peter the Great to his niece Empress Anna Iannovna.

In addition to its Chinese pieces, over one hundred fifty in all, the Bruce collection also included Islamic antiquities, such as a sixteenth-century Koran casket encrusted with colored stones (ill.10) and a seventeenth-century Turkish cassolette for perfume in steatite embellished with turquoise and silver (both in the Hermitage). And among its curiosities, finally, were two pieces of German manufacture: a twelfth- or thirteenth-century watering can in the form of a centaur, and a seventeenth-century knife with an amber handle and a Hebrew inscription on the blade (now in the Hermitage).

From the catalogue of the treasures in Peter the Great's *Kunstkamera* we learn that General Bruce endowed the public museum as well with curiosities including a Sarmatian clay vessel, deformed during firing and discovered in the Stroganov salt mines, and a "Kalmuk funerary urn" (in fact a Kirghiz pot).

When we compare these two collectors, Menshikov and Bruce, it becomes clear that Menshikov adopted a more pragmatic approach, both in his painting collection—consisting primarily of family and dynastic portraits—and in his sculpture collection, notably with its series of statues intended to personify the "virtues" of the highly placed patron who commissioned these works—in other words, Menshikov himself. Bruce, meanwhile, was undoubtedly closer in spirit to the collectors of Europe, and quite the equal of Peter I in the universality of his approach. His collection of portraits, for instance, included a likeness of every Russian sovereign (unlike Menshikov's, which featured only rulers of his own era). His collection of coins and medals was likewise far more comprehensive than Menshikov's, which included only contemporary medals. And, following the example of Peter, Bruce also seems to have felt a special fascination for Eastern art.

Finally, two other members of Peter's inner circle deserve mention: Andrei Vinius and Robert Areskine. Andrei Vinius, or Vinius the Younger (ill.12), was born in Moscow into a family of merchants from Amsterdam. From 1664 he was employed as a translator at the foreign ministry, before being appointed head of the state apothecary services from 1677 to 1689, and director of the Siberian ministry from 1703. At the same time, he also ran the Russian postal service, and in 1695 was appointed first secretary of state.

A gifted administrator, Vinius played a major part in transforming the organizations for which he was responsible into efficiently run bureaucracies. Among his other achievements he taught Peter the Great Dutch, served him assiduously, carried out diplomatic missions, and set up the naval college. The correspondence the tsar maintained with Vinius during his own travels offers valuable insights into the genesis and development of the collections amassed by the latter. These included a library of some four hundred

books, not counting maps and atlases, and a collection of graphic art, kept in a binding inscribed "Andrei Vinius's Book" (now in the library of the Academy of Sciences), comprising 138 engravings and 171 drawings (ill.11), 24 of them by the Dutch artist Jan Lievens. It was Vinius, moreover, who kindled Peter I's discovery of graphic works and his desire to start collecting them. In 1941 the Academy of Sciences presented the Hermitage with another volume from Vinius's library attesting to this interest: an album of Antonio Tempesta's engravings of battle scenes.

The physician Robert Areskine was another Scot (originally named Erskine) who entered the service of Peter the Great. His collection and library, known to us because he bequeathed them to "His Majesty's Cabinet," were notable chiefly for the journal of the artist Maria Sybilla Merian (1647–1717), containing no fewer than 1560 watercolor vignettes (ill.13) on nearly 300 sheets of vellum (library and archives of the Russian Academy of Sciences, St. Petersburg).

Areskine also owned a collection of rare objects which, at his death, were incorporated into the *Kunstkamera* and appeared in the *Inventory of Gold and Silver Items*, drawn up in 1745 by the Academy of Sciences librarian, Taubert. Among them were a large seventeenth-century cup, or *bratina*, that had belonged to Prince Tiomkin, a silver mounted coconut inscribed

11

12

"Cup of Prince Mikhail Mikhailovich Tiomkin of Rostov. Drink deep: it brings health"; a scepter carved from a narwhal tusk; two agate cups; two chaplets fashioned from colored stones; a silver necklace; and a silver dish. Today, all these items can be identified in the Hermitage collections from watercolors executed during the time they were in the *Kunstkamera*.

Like Bruce and Vinius, Areskine formed part of Peter the Great's inner circle, and like the botanist Buchsbaum, the astronomer Delisle, and the historian Bayer, all of whom built up collections of coins and medals in St. Petersburg, he was of foreign origin—one of the distinguished côterie of cultivated foreigners who by their example nurtured the nascent Russian passion for collecting.

11. *Siberian Mammoth* Drawing from the *Book of Andrei Vinius*, c. 1690 Library of the Academy of Sciences of Russia, St. Petersburg

12. *Self-portrait of Andrei Vinius* Drawing, late 17th century Library of the Academy of Sciences of Russia, St. Petersburg

13. Maria Sybilla Merian *Caterpillar and Butterfly*, second half of the 17th century Watercolor on vellum, 32 x 22.5 cm Archives of the Academy of Sciences of Russia, St. Petersburg

The purpose of the book published by Andrei Vinius (ill.11) was to add to the general sum of knowledge about the world. The text was embellished with picturesque commentaries on recent discoveries: the excavation of the remains of a mammoth, for instance, prompted the explanation that this was an animal that lived underground and used its tusks to dig its way up to the surface.

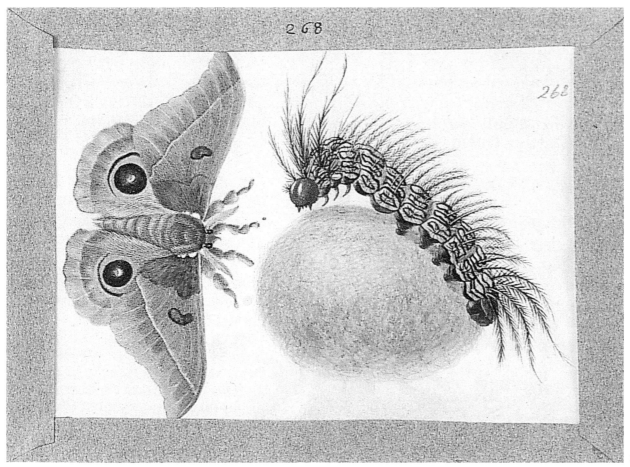

13

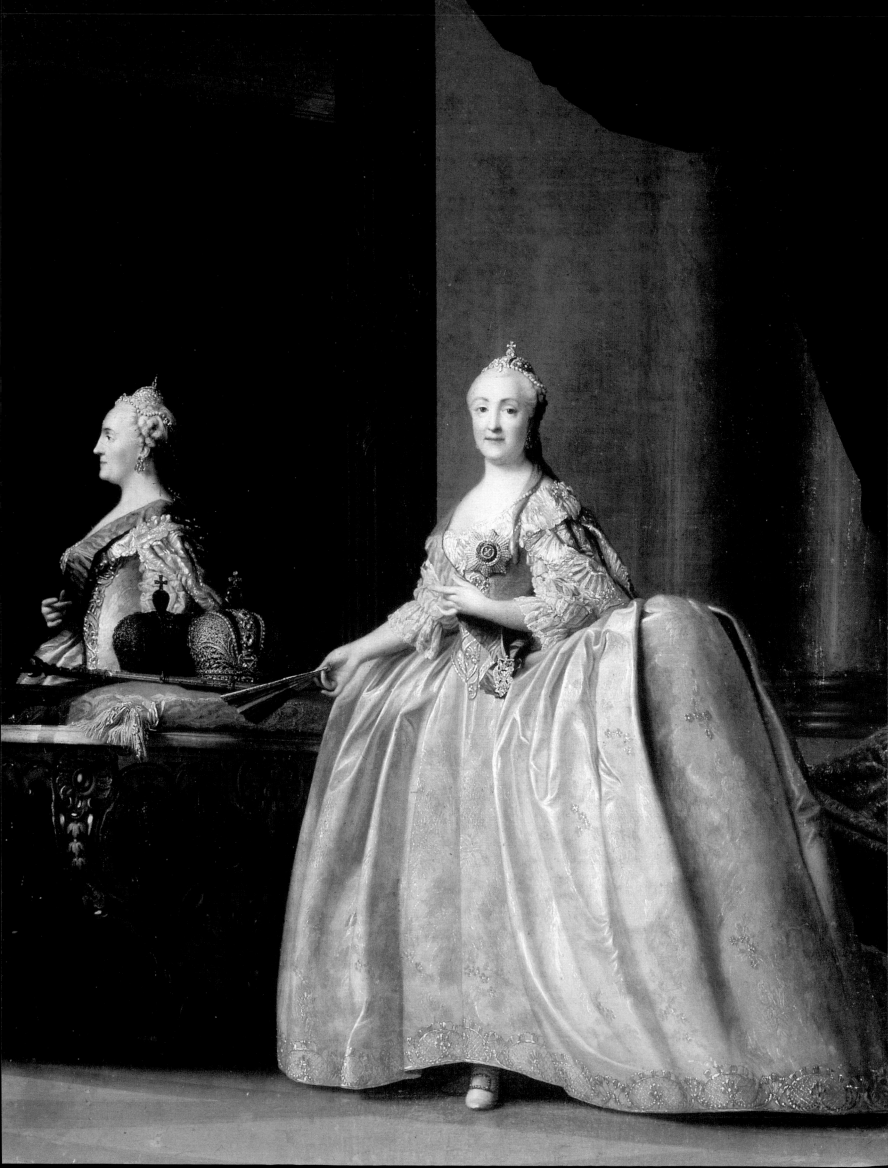

COLLECTORS FROM THE ARISTOCRACY, OLD AND NEW

The second half of the 18ᵗʰ century

The question of the succession of Peter the Great, following his death in 1725, was a particularly vexing one. In 1719 he had accused Grand Duke Alexei, his older son by his first wife Evdokia Lopukhin, of plotting against him, and had him flung into prison, where the brutal treatment meted out ensured his speedy death. In 1721 the Emperor of All the Russias, as Peter styled himself after his victories over Sweden and the Treaty of Nystadt, signed a decree that he alone would name his successor, who would thus no longer be chosen by the boyars of the Senate. Then in 1724 he crowned his second wife, Martha Skavronskaia, originally a Lithuanian servant who he had married in 1712, and it was she who eventually succeeded him as Empress Catherine I. On her death two years later, the crown reverted to Grand Duke Piotr, son of the dead Alexei, who acceded the throne in 1727 at the age of twelve and reigned for a mere three years as Peter II before his premature death in 1730. The crown was then offered to Peter the Great's niece, the daughter of his brother Ivan V, Anna Iannovna, duchess of Courland. Before her death in 1740, she in turn appointed as her successor her nine-month-old great nephew Ivan VI, under the regency of his mother, Anna Leopoldovna, princess of Brunswick. It was at this point, in 1741, that Grand Duchess Elizaveta Petrovna, Peter the Great's second daughter, seized the throne to become Empress Elizabeth I (ill.15).

It was during the period of relative calm that now ensued that the reforms instigated by Peter the Great in both the political and the cultural arenas began to bear fruit. The empress combined a taste for opulence with a love of architecture, and the sumptuous Baroque palaces she commissioned from the Italian architect Bartolomeo Francesco Rastrelli (1700–1771)—the Winter Palace and the Summer Palace, both in the heart of the city, and Tsarskoie Selo on the outskirts—were to change the face of St. Petersburg.

With a view to decorating these magnificent buildings, the court painter Georg Grooth acquired a collection of old masters in Prague in 1745, including a number intended specifically for the vast new palace at Tsarskoie Selo. At Oranienbaum, meanwhile, in the residence of the empress's heirs, Grand Duke Peter (son of her elder sister Anne of Holstein-Gottorp) and his young wife Grand Duchess Ekaterina Alexeievna, *née* Princess of Anhalt-Zerbst, two collections came into being, one at the "House of paintings" and the other at the Peterstadt fortress.

Gradually, and notably through the influence of Count Ivan Shuvalov (ill.57), the empress's favorite and president of the Academy of Arts, founded in 1757, an interest in the arts—and hence in collecting—started to take root among the imperial family and the new Russian elite. By the end of Elizabeth's reign in 1762, St. Petersburg and its environs could already boast eight imperial painting galleries and cabinets; two national galleries—one at the Academy of Sciences and the other at the Academy of Fine Arts; four grand-ducal galleries; and approximately a dozen important private collections, chief among them those of Piotr Sheremetev (ill.99), Mikhail Vorontsov (ill.51), Ivan Shuvalov, Kyrill Razumovsky, Nikita (ill.163) and Grigory Demidov, Karl Svers, Jacob Stehlin, and "private councillor" Pekhmen. Many court painters themselves amassed collections, moreover, including Johann Grimmel, Georg Grooth, Lucas Pfandzelt, Kaspar Georg von Prenner, Jean-Baptiste Le Prince, and Louis-Jean Lagrenée.

The political climate in which this artistic awakening took place was nonetheless one of growing instability once more. Although Elizabeth's chosen heir was the grandson of Peter the Great, he was also inseparable from his German roots and more concerned with military parades than with the production of an heir—or the governance of the empire. In 1754 the grand duchess finally gave birth to an heir, Pavel Petrovich (widely rumored to be the son of her lover, Sergei Saltykov).

When Elizabeth died in 1762, it was thus a ruler who was more German than Russian who acceded to the throne as Peter III, Tsar of All the Russias, and who forthwith concluded a separate peace treaty with

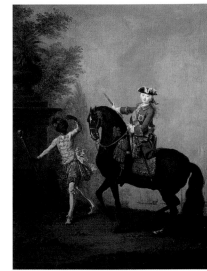

15

14. Vigilius Eriksen
Portrait of Catherine II before her Mirror, 1762
Oil on canvas,
265 x 203 cm
Hermitage, St. Petersburg

15.Georg Cristoph Grooth
Portrait of Empress Elizabeth I on Horseback with a Black Servant, 1743
Oil on canvas,
85 x 58.5 cm
Tretyakov Gallery, Moscow

Friedrich II of Prussia (to the indignation of the Russian army), tried to put his soldiers into Prussian uniforms, and declared war on Denmark. Nothing could be more calculated to alienate both his subjects and his court. Alerted to her husband's plans to cast her off and replace her with his mistress, in July of that same year Ekaterina Alexeievna, supported by a group of officers including the Orlov brothers, succeeded in ousting him and declaring herself empress under the name of Catherine II (ill.14). Under her reign, Russia was to enjoy a period of unprecedented political stability.

Catherine II (later to become known to history as Catherine the Great) was a ruler of enlightened views who was also now more Russian than German in her sympathies. She embarked on a program of reform encompassing the legislative system, state finances, and the practice of medicine (allowing herself to be vaccinated against smallpox in order to encourage her subjects to follow suit); entered into correspondence with the French encyclopedists Diderot and Voltaire; and sought to present herself to the countries of Europe as a monarch of the Enlightenment and a patron of artists and the arts.

In 1779 she wrote in French to her correspondent in Paris, Baron Grimm: "The passion for building still rages here and is stronger than ever, and scarcely can an earthquake ever have brought down as many buildings as we are presently putting up." She added, to Voltaire: "I am presently quite infatuated with Master Cameron . . . who is inspired by his study of the Ancients. With him we are making at Tsarskoie Selo a terraced garden, with baths below and a gallery above." This architectural ensemble was to become a veritable sculpture gallery : "Along my colonnade are bronze busts of the greatest men of Antiquity, such as Homer, Demosthenes and Plato and the like. You cannot imagine what fine ideas such company inspires . . . In time they will number 82."

In 1784 the whimsical grotto built by Rastrelli on the banks of the lake at Tsarskoie Selo received a statue of Voltaire by Jean-Antoine Houdon (ill. 17), as described by Catherine: "The statue of Voltaire sculpted by Houdon has been unpacked and placed in the Morning Salon; there it is surrounded by Antinous, the Belvedere Apollo, and quantities of other statues, for which the molds came from Rome to be cast in bronze here. To enter this salon is literally to have one's breath taken away, and—marvelous to report!—Houdon's statue of Voltaire is in no way diminished by all that surrounds it . . . He gazes upon everything that is most beautiful in statues both antique and modern."

In their sheer scope Catherine the Great's collections were stunning. Watched by the whole of Europe, the empress launched a peaceful offensive, waging battle after battle in the auction houses of Paris, Berlin, and Amsterdam, and carrying off the most outstanding of the works on sale under the very noses of her European competitors. Using the same tactics as her armies on the battlefields, her agents assured her victory by means of long sieges and surprise attacks. In adopting this strategy, the empress aimed not only to fulfill the cultural and artistic requirements of Enlightenment rulers, but also to achieve her own political ends. It gave her particular satisfaction, for instance, to know that in buying 225 paintings from Johann Gotzkowsky in Berlin in 1764, she had ensured that they escaped the clutches of Friedrich II of Prussia, then facing defeat and ruin in the wake of the Seven Years' War. This was also the year, moreover, that was considered to mark the official debut of the art gallery of the Hermitage, as Catherine liked to call her private museum in the Winter Palace.

Four years later, the Berlin acquisition was supplemented by some hundred canvases from the collection of the Count Cobenzl in Brussels; in 1769 these were followed by 350 pictures from Count Heinrich von Brühl in Dresden. In 1772 they were joined by the paintings collected by the Duc de Choiseul, French Minister of Foreign Affairs, as well as by five hundred or so paintings from the collection of the French banker Pierre Crozat. By no means unaware that his comments would certainly be passed on to the empress, Denis Diderot described this victory in a letter to the sculptor Etienne Falconet: "I have become the most detested enemy of the public, and do you know the reason why? It is because I am sending you some paintings. Connoisseurs will protest, painters will protest, wealthy collectors will protest . . . But despite all these cries and protests I shall carry on and the devil take them all . . . The empress is to acquire the collection of [Crozat] de Thiers this is what humiliates and confounds them."

In 1777 Catherine told Baron Grimm: "This winter I have the most admirable lodgings: I have a whole labyrinth of apartments, even though I am alone; in all this there is a kind of delirious luxury. . . . We have baptized it the Imperial Museum, and when in the midst of it one finds so many things to see that it is impossible to tear oneself away."

By 1785 Catherine's collection already boasted no fewer than 2,685 paintings, and as she wrote again to Baron Grimm in 1786: "In my old age I have become an antiquarian in the true sense of the word." Even the elements themselves seemed to conspire to favor her acquisitions—her only loss being the paintings of the Bramkamp collection which, having been acquired for the imperial collection, were shipwrecked in a storm off the Danish coast in 1771. In 1779, by contrast, when pirates in French waters made off with Mengs's *Perseus and Adromeda*, the French authorities not only seized the painting but went as far as offering it to Catherine.

It was not only in her collecting, of course, that Catherine was bold and forward-thinking: some of the buildings erected during her reign are impressive in

16

16. Konstantin Ukhtomsky
*The Raphael Loggia in the
Winter Palace*, 1860
Watercolor on paper,
42 x 25 cm
Hermitage, St. Petersburg

In commissioning
Quarenghi to build a
replica of Raphael's famous
Vatican Loggia at the
Winter Palace (ill.16),
Catherine the Great was
in some respects following
in the footsteps of the
emperor Hadrian, who had
not hesitated in copying
the temple of Aphrodite
of Knidos, shrine of the
Praxiteles masterpiece,
at his villa at Tivoli.
In similar fashion,
Catherine transposed
a masterpiece of Western
art and architecture to
the banks of the Neva.

17

17. Konstantin Ukhtomsky
*The Voltaire Library in the New
Hermitage*, 1859
Watercolor on paper,
42.2 x 26.4 cm
Hermitage, St. Petersburg

the endless knowledge to be gleaned from it." Anxious to forestall the sale at auction by his great-grandson of the extraordinary collection of gems amassed by the Duc d'Orléans, Catherine wrote to Baron Grimm that the duke would turn in his grave if he knew that his collection was about to be dispersed. She acquired it in 1787. More than once, Catherine jokingly referred to her gem collection as a "bottomless pit," describing to Baron Grimm how she and her attendants lugged the stones about in log baskets, like wood for the fireplace. In 1795 she declared to him that "all the cabinets in Europe are mere child's play compared to ours.... It is all arranged systematically, beginning with the Egyptians and passing via every aspect of history, up to the present day! Only images of the present war are lacking; perhaps in time we shall have a depiction of the capture of Prague, and the heroes Souvoroff, Fersen and Derfelden. Valerian [Zubov] is already there." The Braun brothers were commissioned to engrave cameos celebrating Potemkin's victories, Hackert to paint the Russian fleet's victories over the Turks, and Francesco Casanova the capture of Ochakov and Ismail (now in the Hermitage). By the end of her reign, the contents of Catherine's collections numbered no fewer than 3,996 paintings; 10,000 drawings; 10,000 cameos and intaglios; 38,000 books; and 79,784 engravings.

This passion for collecting could not help but influence Catherine's entourage. Grand Duke Pavel Petrovich, her son and heir apparent, embarked on his own collection in order to embellish the palace at Pavlovsk and subsequently, the Gatchina palace. The empress's infatuation with cameos and intaglios was meanwhile to communicate itself to those who were closest to her, inspiring both her daughter-in-law, Grand Duchess Maria Feodorovna, and her favorite, Alexander Dmitriev-Mamonov, to become highly competent engravers in their own right. And others close to Catherine, including Princess Dashkova, Alexander Lanskoi (ill.95) and Prince Yussupov (ill.111), among other connoisseurs, were to form their own collections of engraved gemstones.

By this time, collecting paintings had become an almost commonplace activity in St. Petersburg, among both foreigners and Russians alike. Already in 1748 an auction announcement in the St. Petersburg *News* addressed itself to "lovers of fine paintings." Thanks to the inventories of private collections drawn up by Jacob Stehlin, we know that by around 1760 Count Sheremetev had amassed some thirty canvases in his residence on the Fontanka. In 1756, Count Kyrill Razumovsky purchased a batch of paintings from Italy through the intermediary of the court violinist Domenico Daloglio, and also commissioned a set of engravings of views of St. Petersburg. This collection was then displayed in his residence on the road to Peterhof, on the outskirts of the capital.

the sheer audacity of their conception, which was unprecedented in Russia at the time. Even bolder in conception than the Gallery of Great Men at Tsarskoie Selo, discussed above, was the re-creation in St. Petersburg of Raphael's Vatican Loggia, reproduced by the architect Giacomo Quarenghi on the banks of the Neva (ill. 16).

The empress also had a passion for cameos and intaglios, collecting them with a special fervor and describing herself as afflicted with "gem disease" and a "species of gluttony that spreads like scabies." To Baron Grimm she confessed: "God knows the pleasure to be had from handling all these stones every day, and

Another important collection was assembled by Prince Alexander Beloselsky-Belozersky in his palace near the Anichkov Bridge. Rather than hanging his pictures edge to edge, or "tapestry fashion," as was then customary, the prince took the innovative step of displaying them following a systematic classification according to genres and schools.

Writing in 1772, Stehlin noted that the palace of Count Ivan Chernyshev contained eighty-nine pictures, and that in the course of a single year, 1771, the Russian capital saw the creation of four new painting galleries and collections, owned by Andrei Shuvalov, Zakhar Chernyshev, Adam Olsufiev, and Grigory Teplov, secretary of state under Catherine the Great. Contemporary accounts also evinced great admiration for the collection of General Alexei Korsakov, director of the Mining Corps, the essential nucleus of which (some one hundred canvases) was aquired in 1794 (these works were put up for sale in the early 1820s).

In the same year, the traveler Heinrich Storch reflected: "Perhaps in no other country are there such passionate collectors as those here. But it is this very excessive zeal . . . that often undermines the longevity of the collections, since the high prices they command make it too tempting to sacrifice them."

Thus, during the second half of the eighteenth century, St. Petersburg boasted over fifty major collections of paintings. Some belonged to the old nobility, such as the Beloselsky-Belozerskys, the Galitzins, the Yussupovs, and the Stroganovs. Others were created by connoisseurs who had "arrived" more recently, having worked their way up by means of palace revolutions, personal qualities, or charm. Into this category came the Vorontsovs, the Razumovskys, the Shuvalovs, Potemkin, Lanskoi, and the Bezborodkos. A few of them were favorites of the empresses Elizabeth and Catherine, who were able to build up their collections through gifts from their imperial mistresses.

Although most of the great eighteenth-century collections were clustered in and around St. Petersburg, Moscow and the estates in the surrounding region proved equally susceptible to this new passion. Indeed, at one time or another the Galitzins, Sheremetevs, and Yussupovs built up or transferred part of their collections from St. Petersburg to the former capital and its environs.

On Catherine's death in 1796, she was succeeded by her only son the tsarevich Pavel Petrovich (ill.18), who reigned as Paul I. Russia by this period had changed almost beyond recognition since the reign of Peter the Great: now one of the great powers of Europe, both politically and culturally, the empire had also undergone changes in two specific areas in the wake of the French Revolution of 1789. On the one hand, despite her close contacts with the great liberal thinkers of the age such as Diderot and Voltaire, Catherine had curbed her enthusiasm for the Enlightenment in the face of the upheavals of the French Revolution, reasserting her autocratic privileges in no uncertain terms; at the same time, St. Petersburg benefited from the arrival of wave of French émigrés eager to become loyal servants of the empire, such as the Duc de Richelieu, later to become governor of the Crimea, and Admiral de Traversay, who became minister for the navy. On the other hand, many artists made the same journey and owed their livelihoods to Russian commissions, including Madame Vigée-Lebrun, while the art markets of Europe were flooded to the huge delight of collectors in St. Petersburg and Moscow.

As a consequence of these events, Paul I, for example, amassed one of the finest collections of French furniture and *objets d'art* outside France, with a view to providing embellishments for his town residence, the Mikhailovsky Castle, built by the architect Vincenzo Brenna between 1797 and 1800. Collecting was by no means a new interest for the tsar, however. The prolonged grand tour of Europe that he and his wife Grand Duchess Maria Feodorovna, *née* princess of Würtemberg Montbéliard (traveling as the Comte and Comtesse du Nord), had undertaken in 1781–2 had strengthened their artistic aspirations and enabled them to lay the foundations of an outstanding collection (part of which may still be seen at the palace of Pavlovsk). Throughout Europe—in Austria and Germany, Venice, Rome and Naples, Lyon and Paris—the grand duke and grand duchess (sent by Catherine with the specific exhortation that they were to spare no expense) acted as traveling ambassadors, demonstrating to the courts of Europe that Russia was now their proud equal, meeting artists, receiving gifts, and placing extravagant commissions for paintings, Sèvres porcelain, and Lyon silks, and all the while inextricably mixing art with politics once more.

Sadly, however, Paul I's political acumen lagged far behind his aesthetic judgement. Impulsive, quick to anger, and nursing a deep resentment at his exclusion from affairs of state by his mother—who in any case would have preferred the succession to go to her eldest grandson, Grand Duke Alexander Pavlovich—Paul I was as infatuated with all things military as his father Peter III had been and shared the same obsessive nature, with a constant fear of being assassinated like so many of his forebears. His fear proved not to be unfounded, moreover. The changes that he introduced, whether to increase his own power or in other more trivial matters, found little favor at any level of society, and most particularly among members of the nobility who had felt the winds of change fanned by the French Enlightenment. In 1801 a small group of aristocrats, with the passive connivance if not the active support of the tsarevich, murdered the tsar and placed all their hopes in his son (educated in liberal principles by his tutor La Harpe), trusting him to usher in not only a new century, but also a new Russia.

18. Benedetta Batoni, after her father Pompeo Batoni *Portrait of Emperor Paul I* Watercolor and gouache on ivory, 15.8 x 12.5 cm Pavlovsk Palace Museum

Catherine the Great's passion for sculpture—and philosophy—made her order from the French sculptor Houdon the lifesize marble portrait of Voltaire. Having stood initially in the Grotto at Tsarskoie Selo, it was moved in the nineteenth century to the library of the New Hermitage (ill.17) where works by Voltaire, bought on his death by the Empress, were kept. They were not available for consultation at this period, however, as Nicholas I saw in them an incitement to dangerous and subversive liberalism.
In order to gain access to them the great poet Pushkin was obliged to apply for a special pass, which only the poet Jukovsky, a member of the tsar's inner circle, was able to obtain for him. Pushkin's notebook includes a sketch of the great marble bust with its wry smile which prompted Nicholas I to exclaim, at his first sight of it, "Smash that grinning monkey!"

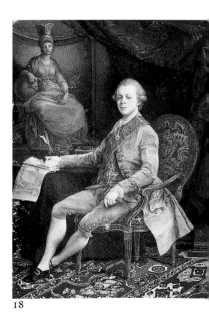

18

The Stroganovs

The Stroganov family originated in Novgorod, a city of merchants. Their immense wealth, however, stemmed from salt-mining, pursued first in Perm and then in Solvychegodsk, in Siberia, where they drained the great underground saline lakes; at one point they controlled seventy-five percent of the Russian salt market and then branched out into grain, money lending, pearl cultivation, fur trading, and much else.

By 1446 they had become rich enough to pay two hundred thousand rubles to ransom the prince of Moscow, Vasily II the Blind, held prisoner by the Tatars, and in the sixteenth century the Stroganovs even "undertook to conquer Siberia so as to place it under the high hand of the sovereign," according to one chronicler.

In Solvychegodsk, the Stroganovs built the important Cathedral of the Annunciation (1560), the first such stone church in northern Russia, which gave birth, before the time of Peter the Great, to the important Stroganov school of icon painting as well as a large religious embroidery workshop in which, as was the custom, the ladies of the family worked (in addition to the assistants they employed).

As a result, the Stroganov collection included many fine icons and embroideries. The family prospered mightily and it was Grigory Dmitrievich Stroganov (1656–1715) who merged all the salt works, land holdings and other industries and became the richest man in Russia.

There is a remarkable portrait of Baron Sergei Grigorievich Stroganov (1707–1756), the son of Grigory Dmitrievich, by Ivan Nikitin in the Russian Museum in St. Petersburg (ill. 25). Sergei married the aristocratic Princess Sophia Kyrillovna Naryshkina, who was close to the Romanov circle. The Stroganovs were ennobled as barons in 1772 and became counts of the Holy Roman Empire in 1761; by this time they had gained a major position in Russia's political and artistic history.

Baron Sergei may be considered the first family patron of the arts. Most important, he recruited Bartolomeo Francesco Rastrelli to design the splendid Baroque palace in the center of the city, on the Moika canal and Nevsky Prospekt (ill.20).

This was part of the movement initiated by Peter the Great to make St. Petersburg into a beautiful European city. Rastrelli, as mentioned above, was the favorite court architect of his daughter Empress Elizabeth I and had been responsible for building the Winter Palace as well as the Catherine Palace in Tsarskoie Selo.

Sergei's son Alexander (1733–1811; ill.26) also became one of the foremost collectors and patrons in Russia. After military training in Russia, his father sent Alexander to Europe in 1752. He started his grand tour in Berlin, where he visited the palaces of Potsdam and Sans Souci, before going to Geneva to learn languages. He eventually made his way to Italy, where he visited Venice, Florence, and Herculaneum (where he acquired a taste for antiquities), and, most importantly, he went to Paris. He returned to St. Petersburg in 1756, when his father died, and moved into the Rastrelli palace as the new head of the family. In 1758 he married Anna Vorontsova, daughter of the very powerful chancellor of the Russian empire, himself a brilliant collector (ill.54). Thereafter, Count Alexander Stroganov frequently traveled abroad, even settling in Paris from 1771 to 1778 and establishing contacts with the major

19. Rembrandt van Rijn *Jeremiah lamenting the Destruction of Jerusalem,* 1630 Oil on canvas, 58.3 x 46.6 cm Rijksmuseum, Amsterdam

20. The Stroganov Palace, St. Petersburg (facade overlooking the Moika), built by Bartolomeo Francesco Rastrelli, 1752–56

20

21

22

For their various residences the Stroganovs invariably engaged the services of the most renowned architects of the period. It was Andrei Nikiforovich Voronikhin, for example, who built a dacha for Count Alexander Sergeievich on the "Black River" in St. Petersburg (ill.21) and who refurbished the neo-classical interiors of the Stroganov palace, built by Rastrelli at the corner of Nevsky Prospekt and the Moika embankment (ill.20). A view of the picture gallery there (ill.22) shows Poussin's masterpiece *The Rest on the Flight to Egypt* (ill.37) alongside French decorative bronzes and elaborately mounted Russian hardstone pieces—including the large malachite coupe in the center of the room, now in the Hermitage. All this testifies to Alexander Sergeievich's interest in mineralogy and to his role as president of the Academy of Fine Arts. In the nineteenth century, instead of remaining in a gallery devoted exclusively to paintings, a number of the works in the collection were included in the decorative scheme of each of the rooms (ill.23) in the residence built for Count Pavel Sergeievich Stroganov by the architect Hyppolite Monighetti on Sergeievskaia Street in St. Petersburg.

21. Andrei Voronikhin
*View of the Stroganov Dacha,
St. Petersburg,* 1797
Oil on canvas,
67.5 x 100.5 cm
Russian Museum,
St. Petersburg

22. Nikolai Nikitin
*The Painting Gallery in the
Stroganov Palace,* 1832
Oil on canvas, 54 x 45 cm
Russian Museum,
St. Petersburg

23. Jules Mayblum
*The Salon of Count Pavel
Sergeievich Stroganov in his
Residence on Sergeievskaia Street
in St. Petersburg*
Watercolor, 55.3 x 40,5 cm
Hermitage, St. Petersburg

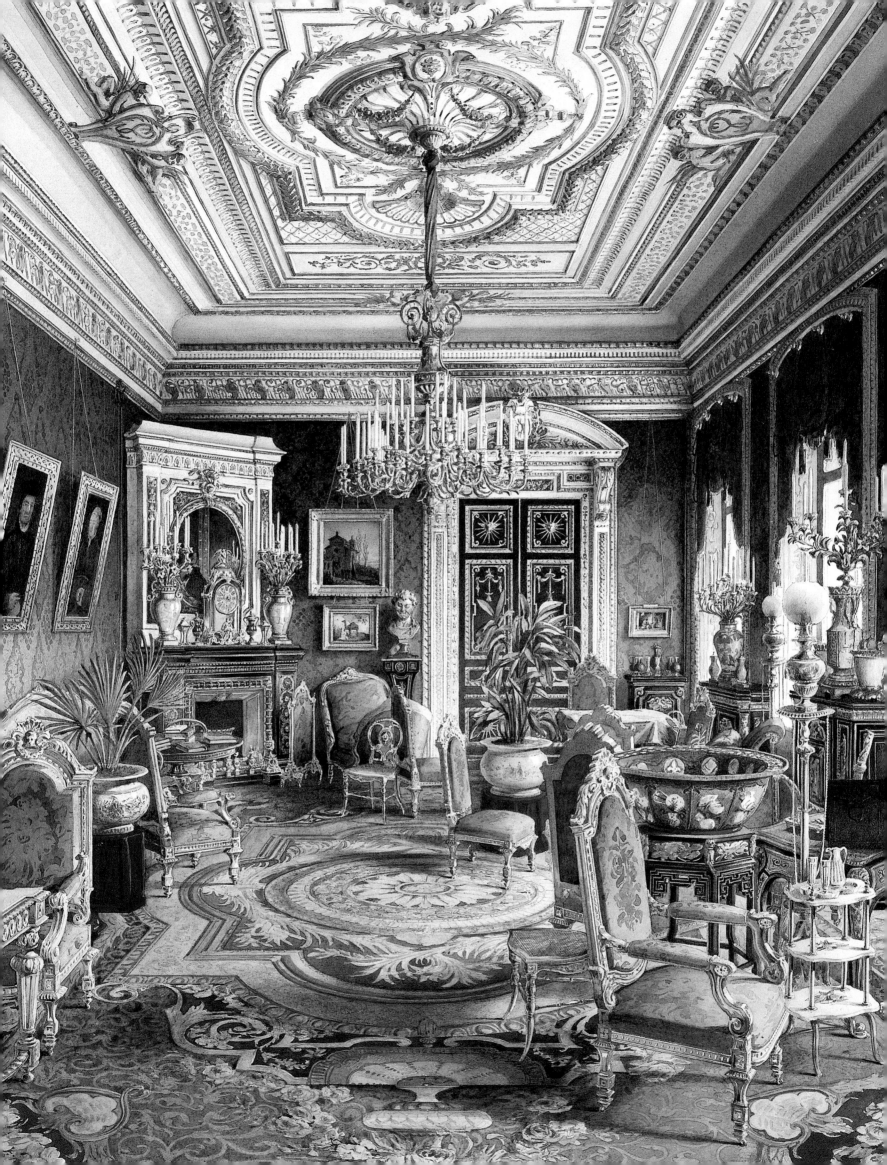

24

artists of the time and commissioning paintings and sculptures from them—Jean-Baptiste Greuze, Hubert Robert, Madame Vigée-Lebrun, Jean Antoine Houdon— or buying at auction works of past masters.

As a skilled courtier, he also commissioned Houdon and Jean Tassaert to make portraits of Catherine II, advising Tassaert to endow an image of Minerva, patroness of the arts, with the empress's features. And when Count Alexander acquired Francesco Solimena's *Allegory of Rule* (Hermitage, ill.36), he had the central medallion retouched in order to insert a portrait of Catherine II, precisely where the Sun King had been portrayed, a fact he confirmed in the 1793 catalogue of his collection : "The owner, M. Bouret, had curried favor by having the face of Louis XV painted there; in turn, I had this image replaced with that of Catherine II."

The catalogue of the works in the Stroganov gallery (of which there exists both a watercolor and engraving by the architect Andrei Voronikhin, who also designed the Mineralogical Cabinet and dining room) was the first of its kind in Russia, since it was customary to publish a catalogue only upon the owner's death or if his collection was sold at public auction. There were two volumes: the first was devoted to Italian and Spanish paintings, the second to the northern schools. In the introduction to his catalogue, Alexander Stroganov wrote, "Deliver us, Great God! from art lovers without love and great connoisseurs without connoisseurship." In 1800 Count Alexander published a second edition of his catalogue, by which time the collection had grown from 87 paintings to 115. The count also undertook to catalogue Catherine II's collection in the Hermitage, but the texts (now in the museum's archives), assembled by Count Ernst Minich (1773–83) and Franz Labensky (1797), were never published.

The personal tastes of Alexander Stroganov, a devotee of classicism, could not but be reflected in the very composition of his gallery, where virtually nothing *vil*, or "low,"—meaning genre and still-life painting—was to be found. The French school ended with the seventeenth century, so that the collection contained no Watteaus, Chardins, or Bouchers. The exceptions were Joseph Vernet and Stroganov's friends from Paris, Hubert Robert and Jean-Baptiste Greuze. The pride of his collection was *The Rest on the Flight to Egypt* by Nicolas Poussin (ill. 37), and Poussin was regarded by the collector as the paragon among painters. "The genius of Poussin," he wrote, "lay in his knowledge of the arts of the ancients from which he drew the profundity and nobility of his own paintings."

In 1800, the year of his second catalogue, Alexander was made president of the Academy of Fine Arts, an institution that controlled all new building projects, gave classes in art and architecture (in which antiquity was studied through the aid of casts), and had a small museum which contained such important works of art

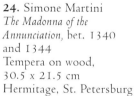

24. Simone Martini
The Madonna of the Annunciation, bet. 1340 and 1344
Tempera on wood,
30.5 x 21.5 cm
Hermitage, St. Petersburg

25. Ivan Nikitin
Portrait of Baron Sergei Grigorievich Stroganov, 1726
Oil on canvas, 87 x 65 cm
Russian Museum,
St. Petersburg

26. Alexander Varnek
Portrait of Count Alexander Sergeievich Stroganov, 1814
Oil on canvas,
251 x 185 cm
Russian Museum,
St. Petersburg

27. Jean Laurent Mosnier
Portrait of Count Pavel Alexandrovich Stroganov, 1808
Oil on canvas,
69 x 56.5 cm
Russian Museum,
St. Petersburg

28. Adolphe Ladurner
Portrait of Count Sergei Grigorievich Stroganov, 1830
Oil on canvas,
Hermitage, St. Petersburg

Statesmen, soldiers or enlightened connoisseurs of art, the Stroganov family sought constantly to enlarge their collection, not only for the purposes of study and teaching but also for the sake of enriching Russia's national heritage.

An inscription in the background of the portrait of Count Alexander Sergeievich (ill.26), engraved on a granite copy of the Otricoli Zeus, the marble original of which is in the Vatican, reads: *Ars aegiptica Petropoli renata* (Egyptian art is reborn in Petersburg). For the collector, the symbolism of this was clear: like the Egyptians, the Russians had translated the plastic arts into indestructible materials that would survive in perpetuity.

29

29. Giovanni Antonio Boltraffio
St. Sebastian,
Oil on canvas (transposed from wood), 48 x 36 cm
Pushkin Museum of Fine Arts, Moscow

30. Agnolo Bronzino
The Holy Family,
Oil on canvas (transposed from wood), 117 x 99 cm
Pushkin Museum of Fine Arts, Moscow

As was customary for collectors of his time, Alexander Stroganov's first purchases were old masters (ill.29 & 30), bought either personally or through agents. He was moreover fortunate enough to be resident in Paris during a period that saw the sale of major collections such as that of the Duc de Choiseul in 1772, of the Duc de Saint-Aignan in 1776, of the Prince de Conti in 1777, and of the farmers general Randon de Boisset and Blondel de Gagny.
But Alexander Sergeievich was also passionately interested in contemporary painting, and particularly in the work of Claude Joseph Vernet and Hubert Robert. He also set out to raise the standard of Russian artists by apprenticing them to distinguished Western European painters—on one occasion offering to pay Pompeo Batoni with fur-lined cloaks for lessons for one of his serfs.

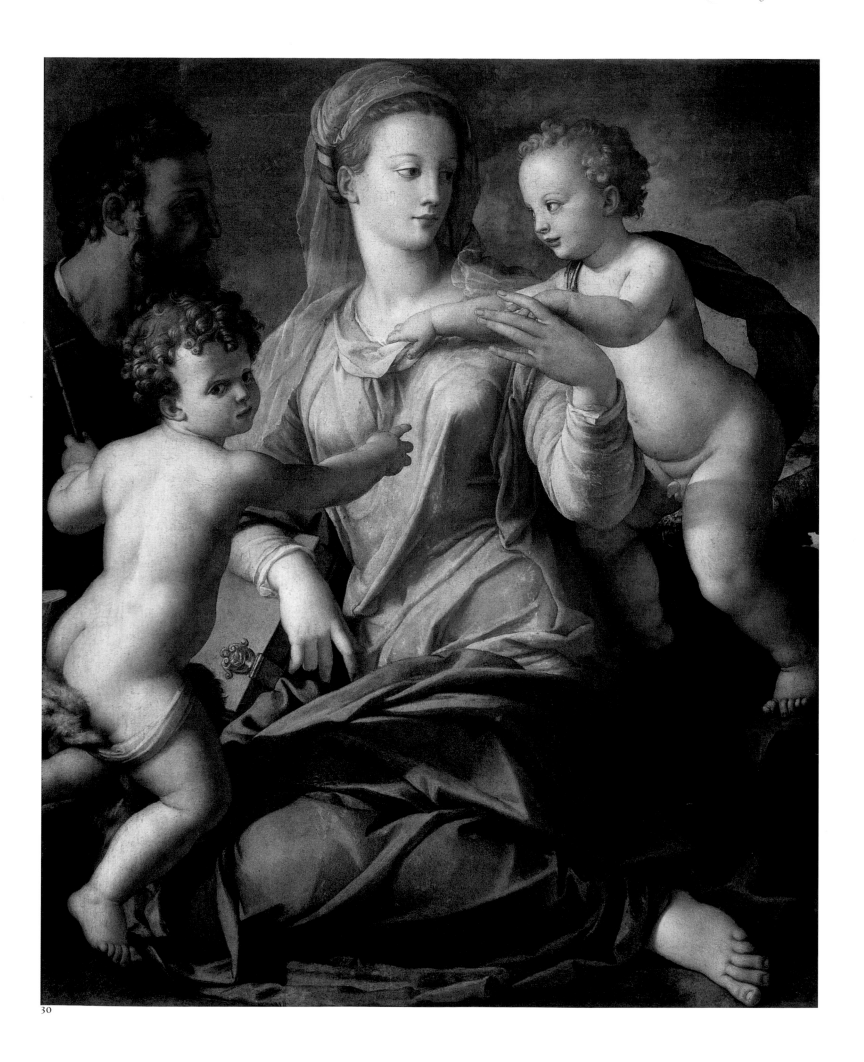

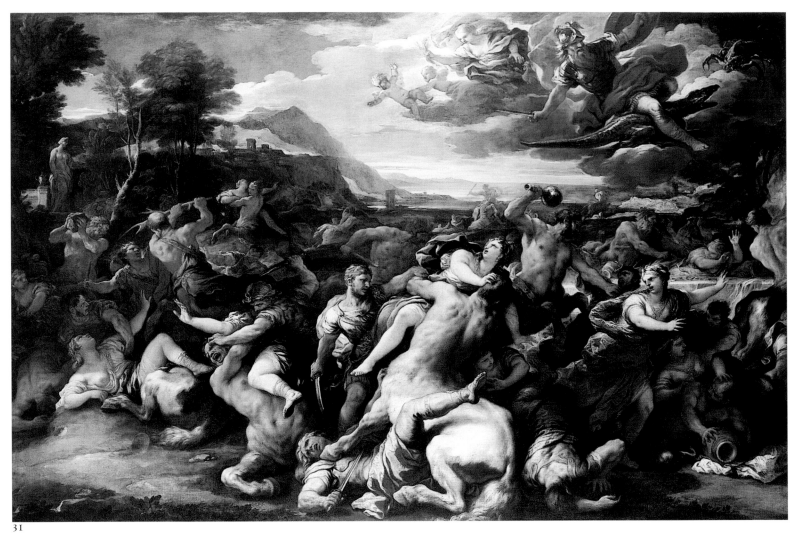

31

31. Luca Giordano
*The Battle of Lapiths and
Centaurs*, c. 1688
Oil on canvas,
255 x 390 cm
Hermitage, St. Petersburg

32. Anthony van Dyck
*Portrait of a Young Woman with
her Child*, 1618
Oil on canvas,
131 x 102 cm
Hermitage, St. Petersburg

Brought to St. Petersburg
in 1777 by the flamboyant
Duchess of Kingston, *The
Battle of Lapiths and Centaurs*
by Luca Giordano (ill.31)
was bought first by
General Count Ivan
Grigorievich Chernyshev
and then by Senator
Soimonov before being
acquired by Alexander
Sergeievich in around
1800.

as Michelangelo's *Crouching Boy* (Hermitage). The academy also controlled the Imperial Lapidary works, where renowned works in Russian semi-precious stone were made. Alexander was in charge of surveying the building of the Cathedral of Our Lady of Kazan (1801–11) on the Nevsky Prospekt whose design, according to the wish of Emperor Paul I, was inspired by that of St. Peter's in Rome. Stroganov chose his former serf Andrei Voronikhin (who was also believed to be his son) as the architect of the church, together with a team of Russian artists whose work he thus supported. These included the painters Orest Kiprensky, Alexander Varnek and Vasily Shebuyev, the sculptors Ivan Martos and Vasily Demut-Malinovsky and Ivan Prokofiev.

Alexander not only collected paintings. He commissioned busts of Voltaire and Diderot from Houdon and actively collected antiquities. One of the most interesting was a second-century marble sarcophagus decorated with bas-reliefs narrating the life of Achilles (ill. 33). It had been found in 1772 on the Aegean Isle of Chios during the Russo-Turkish War. Alexander described it as follows in 1807: "Upon seeing this monument, I could not keep myself from exclaiming: 'Is this not the very monument of Homer?' The phrase

passed from mouth to mouth, until everyone concluded, without the slightest foundation, that I owned Homer's tomb." Alexander had the sarcophagus placed in the park at his villa near St. Petersburg (ill.21). A watercolor by Voronikhin provides a view of this romantic corner of the park, where the antique tomb rests in the shade of pines with a solemn flight of steps leading up to it as if toward an altar.

After the death of Count Alexander Sergeievich in 1811, and then the premature death of his son Pavel Alexandrovich (ill.27) in 1817, the flame passed brilliantly first into the hands of his nephew, Sergei Grigorievich (1794–1882; ill. 28), who was appointed curator of Moscow University, and president of the Society of Russian History and Antiquities. He collected Byzantine coins and pre-Columbian works from Mexico and passed on the collecting tradition to his sons Grigory and Pavel. Count Grigory lived in the Stroganov Palace and Count Pavel in a mansion on Georgievskaia Street. The former spent many years in Rome, collecting European paintings and medieval ivories, and died in Paris in 1910. His brother, who collected paintings, sculpture, and Chinese vases, perished the following year in St. Petersburg. It was thanks to a legacy from counts Grigory and Pavel that the Hermitage

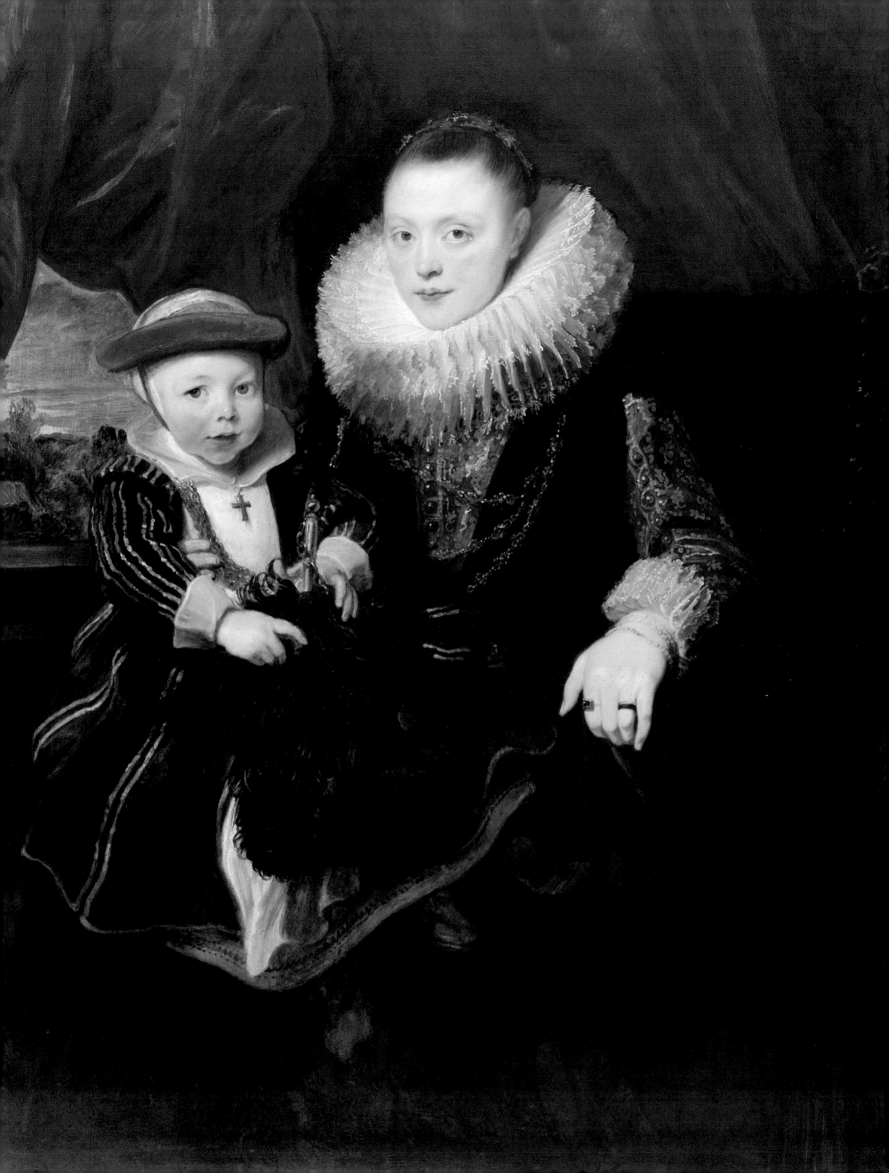

33. Greece, third quarter of the 2nd century A.D.
Sarcophagus
Marble; length: 243 cm
Hermitage, St. Petersburg

34. Etruria, 4th century B.C.
Hercules
Bronze; height: 20.3 cm
Hermitage, St. Petersburg

35. Rome, second half of the 1st century B.C.
Bas-relief with Head of Dionysos
Marble; 34 x 24 cm
Hermitage, St. Petersburg

36. Francesco Solimena
Allegory of Rule, 1690
Oil on canvas, 72 x 63 cm
Hermitage, St. Petersburg

Because it was decorated with bas-reliefs on a theme taken from the *Iliad* ("Achilles, disguised as a woman, is unmasked by Ulysses in the palace of Lycomedes"), a sarcophagus (ill.33) in the collection of Alexander Sergeievich was believed by some to be the sarcophagus of Homer himself, installed on the grounds of the collector's dacha.

33

received two superb panels by Italian Old Masters—Simone Martini's *The Virgin of the Annunciation* (ill.24) and an *Adoration of the Child Jesus* by Filippino Lippi—among other paintings.

Immediately following the Revolution of October 1917, the Stroganov Palace was transformed into a museum, only to be closed in the 1920s, along with the mansion on Georgievskaia Street. The collections that could have formed a separate family museum were

instead transferred to the Hermitage and the Russian Museum in Leningrad or the Pushkin Museum of Fine Arts in Moscow, while a number of works were sold off by the Soviet government at the Lepke auction house in Berlin in 1931.

The Byzantine and Sassanian silver pieces that are still the pride of the Hermitage today, as well as the museum's coin collection, come from the Stroganov holdings back in the eighteenth century while some of the Greek vases, Etruscan bronzes and terra-cottas, Roman sculptures, Limoges enamels, objects carved from bone, stone vases, antique and European gems, Chinese and Mexican antiquities were added to them in the nineteenth century.

34

35

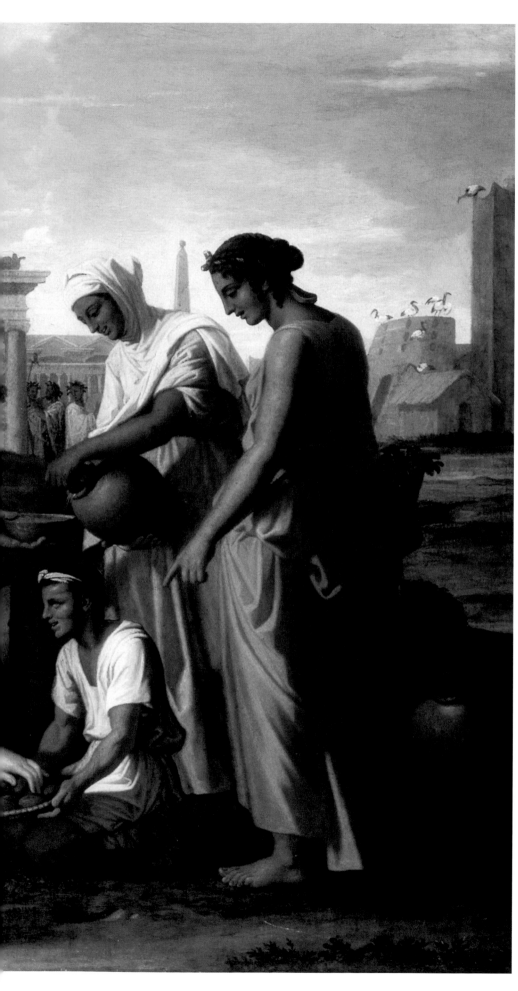

37

37. Nicolas Poussin
The Rest on the Flight to Egypt,
1658
Oil on canvas,
105 x 142 cm
Hermitage, St. Petersburg

Count Alexander Sergeievich Stroganov's voracious appetite for the work of Poussin (ill.37) and other great Western European artists came close to causing disaster. So numerous were the debts he left on his death in 1811 that the sale of his collections appeared inevitable. But, aware of their importance and determined to save them for the nation, his son Pavel Alexandrovich (ill.27) contrived to arrange a loan from Dutch bankers, with Tsar Alexander himself standing as guarantor.

On Pavel's death in 1817, the tsar took the unusual step of declaring the Stroganov bequest inviolable and inalienable, regardless of the loan, thus safeguarding it a second time for Russia and posterity.

The running of all the family estates now fell to Pavel's widow Sophia Vladimirovna, *née* Galitzina. This task she accomplished with such efficiency and intelligence that she succeeded not only in paying off the family debts but also in increasing their capital, while at the same time continuing to offer patronage to young Russian artists such as the highly talented Karl Briullov.

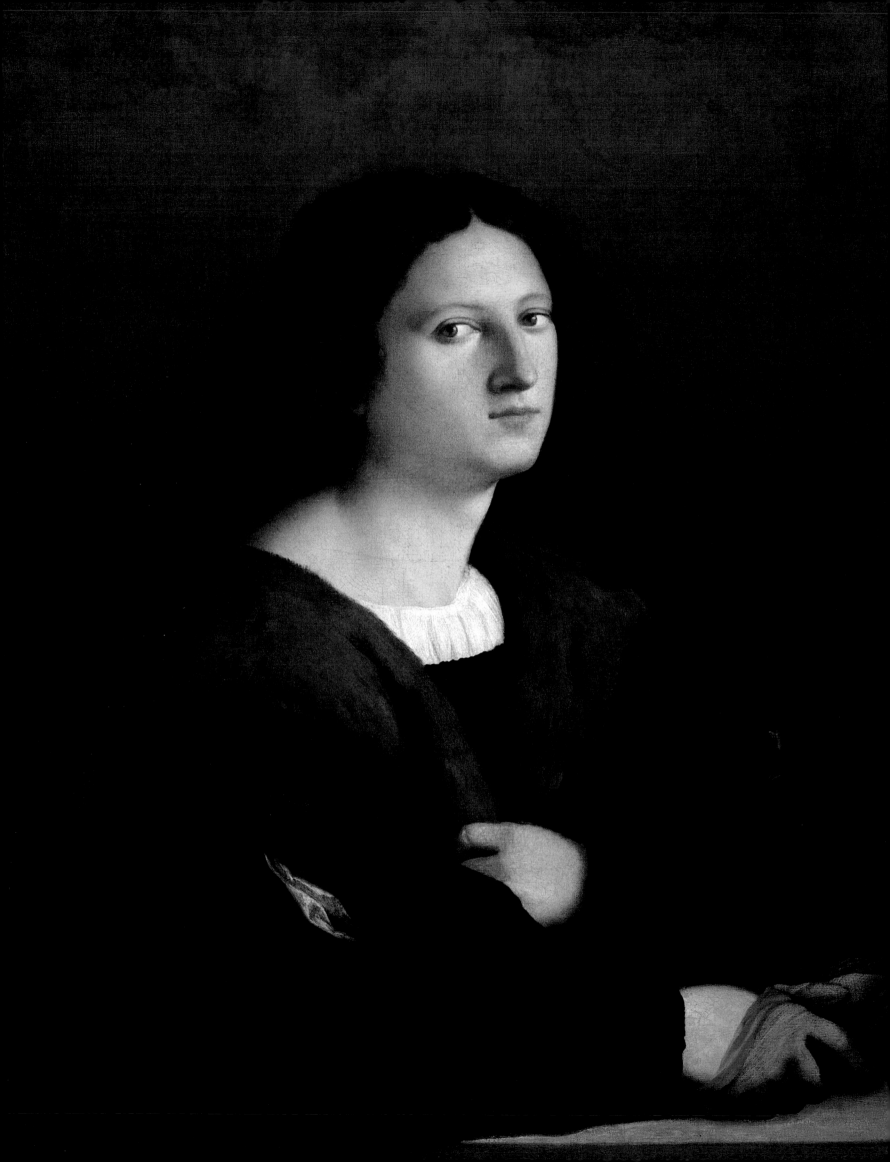

The Galitzins

By the end of the nineteenth century the renowned Galitzin family consisted of 13 branches with a total of 177 members. Already in the early seventeenth century there were Galitzins in high places within the Russian state. Prince Vasily (1643–1714) served as chancellor to the Regent Sophia, while prince Boris (1641–1713) became the tutor and favorite of Peter I. Many of the Galitzins opted for military careers, notably Field-Marshal Mikhail I (1675–1730) and Mikhail II (1681–1754). Even more of them went into the diplomatic service, with Prince Dmitry (1665–1738) serving as ambassador in Constantinople and Prince Alexander Mikhailovich (1723–1807; ill.40) as ambassador in both Paris and London. Prince Dmitry Alexeievich (1734–1803) represented Russia in Paris, Turin, and The Hague, while prince Dmitry Mikhailovich (1721–1793; ill. 40) did the same in Paris and Vienna.

A number of them were discerning collectors, taking advantage of being posted in the great European capitals to acquire works of art and sometimes even adding to the imperial collections. It was in 1766, for example, that Prince Alexander Mikhailovich bought for the Hermitage Rembrandt's *Return of the Prodigal Son*. The Galitzins proved so active as collectors that they soon converted their holdings into private museums capable of rivaling that of the crown. The first of the museums came into being in 1802 at the initiative of Prince Dmitry Mikhailovich who had entrusted his first cousin, Alexander Mikhailovich, to establish with his inheritance both a hospital and a picture gallery displaying his collection. Installed next to the Galitzin Hospital in Moscow, it was meant from the start to be accessible to the public at large. In 1817-18, however, the works in the museum had to be sold at auction. It fell to Prince Mikhail Petrovich (1764–1836) to found a second Galitzin museum, which the publisher and collector Pavel Svinin described as the "Moscow Hermitage." Several of its holdings had been acquired at the 1817-18 auction of works from the gallery at the Galitzin Hospital and were then preserved in Prince Mikhail's residence on Staro-Basmannaia Street in Moscow. Prince Mikhail published a catalogue in 1816, but in 1825 financial ruin forced him to sell his collection. Then came a third Galitzin Museum, inaugurated in 1865 in the mansion on Volkhonka Street in Moscow, and similarly open to the public. Founded

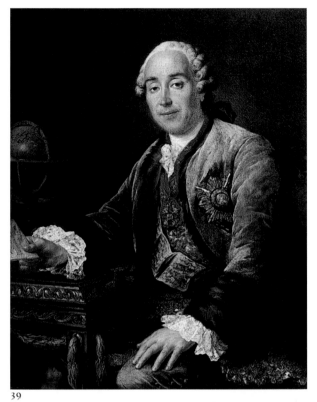

39

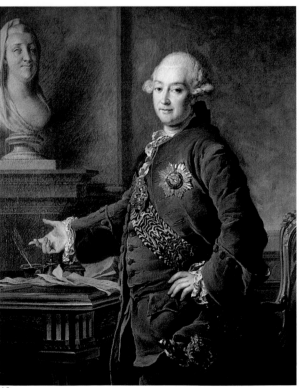

40

38. Jacopo Palma
Portrait of a Man, 1512–15
Oil on canvas,
93.5 x 72 cm
Hermitage, St. Petersburg

39. François Drouais
Portrait of Prince Dmitry Mikhailovich Galitzin, 1772
Oil on canvas, 97 x 78 cm
Pushkin Museum of Fine Arts, Moscow

40. Dmitry Levitsky
Portrait of Deputy Chancellor Prince Alexander Mikhailovich Galitzin, 1772
Oil on canvas,
126.6 x 102.5 cm
Tretyakov Gallery, Moscow

When Russia's first public picture gallery opened its doors, it owed its existence to the joint efforts of Prince Dmitry Mikhailovich Galitzin (ill.39) and Prince Alexander Mikhailovich Galitzin (ill.40). At his death in 1793, the former made his first cousin responsible for providing Moscow not only with a hospital, but also with a gallery housing the four hundred paintings that he had amassed during his diplomatic career, most notably in Paris and Vienna.
Sadly the gallery was to be short-lived, as in 1817-18 its contents were auctioned off, together with Alexander Mikhailovich's collection, in order to raise funds for the hospital.

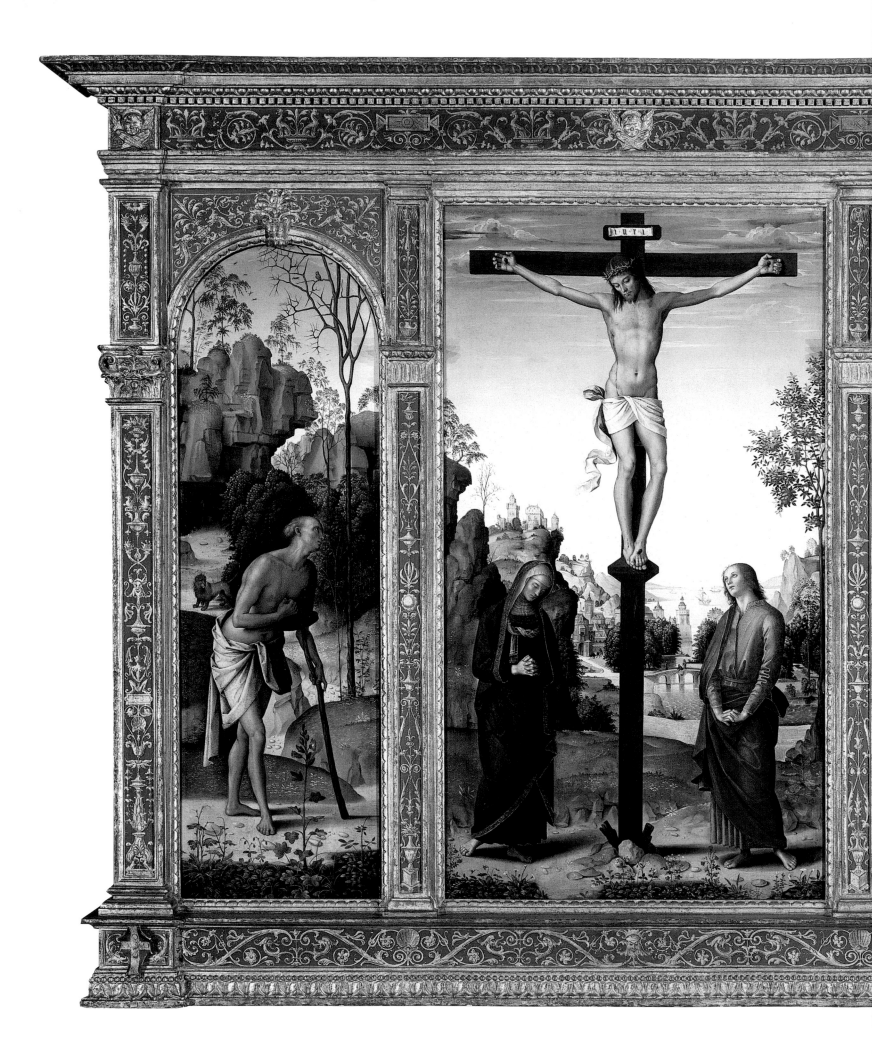

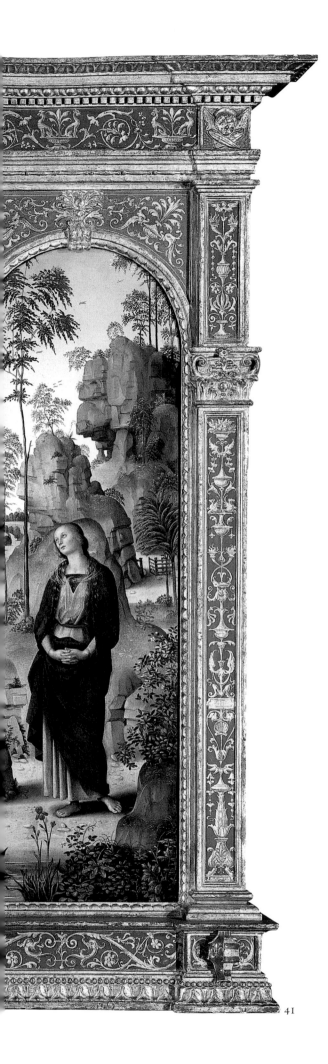

42

41. Pietro Perugino
The Crucifixion, 1485
Triptych, oil on canvas,
101.5 x 56.5 cm
National Gallery,
Washington, D.C., Andrew
W. Mellon Collection

42. Cima da Conegliano
The Annunciation, 1495
Oil and tempera on canvas
(transposed from wood),
136.5 x 107 cm
Hermitage, St. Petersburg

Perugino's *Crucifixion* triptych (ill.41), purchased by Alexander Mikhailovich and one of the pearls of the Galitzin collections, was sold during the sales organized by the Soviet government in the late 1920s and early '30s. In order to fund its program of reforms at this period, the Russian state sold off huge numbers of works from former private and imperial collections alike, offering them at specialist dealerships in Moscow and Leningrad, sending them to auction houses in Berlin or Amsterdam, or selling them direct to great collectors such as Calouste Gulbenkian and Andrew Mellon. It was Mellon who acquired this work, now one of the masterpieces of the collections of the National Gallery of Art in Washington, D.C.

41

43. Alexandria,
3rd century B.C.
Head of Zeus
Cameo, sardonyx; diameter:
6.1 cm
Hermitage, St. Petersburg

44. Rome, 1st century A.D.
Bull
Bronze; height: 9.8 cm
Hermitage, St. Petersburg

45. Rome,
1st century A.D.
Dioscurus
Bronze; height: 12.8 cm
Hermitage, St. Petersburg

46. Roman copy of a
4th century B.C. statue
Hercules and the Nemean Lion
Marble; height: 65 cm
Hermitage, St. Petersburg

43

Through the vagaries of history, the collections of the various members of the Galitzin family have been dispersed not once but several times. A large proportion of items from the collections entered the Imperial Hermitage as early as 1886, when the museum purchased the entire collection of Prince Sergei Mikhailovich for the sum of 800,000 rubles in order to keep it for Russia. Following his father's last wishes, and family tradition, Sergei Mikhailovich had opened a third Galitzin Museum in Moscow in 1865 for the edification of the population. One of its exhibits, *Hercules and the Nemean Lion* (ill.46), is reputed to be a copy of one of a series of bronzes on the subject of the twelve labors of Hercules by the great Greek sculptor Lysippus.

44

45

by Prince Mikhail Alexandrovich (1804–1860), this gallery would also be compared to the Hermitage. Yet once again, the founder's son, prince Sergei Mikhailovich, was obliged to place the lot on the auction block, as early as 1886. Luckily, the best works were acquired by the Hermitage (in 1994, ironically, one of the wings in the former Galitzin residence on Volkhonka Street was to house the Museum of Private Collections, the sole institution of its kind in Russia, which serves as a tribute to Russia's illustrious collectors).

One of the Galitzins' acquisitions, *The Annunciation* by Cima da Conegliano (ill.42), was the central panel of a triptych that once stood in the Church of Santa Maria dei Croci Chieri in Venice (the lateral panels now form part of the Eastlake Collection in London). Another Galitzin find, a portrait by Jacopo Palma the Elder, joined the Hermitage in 1886 (ill.38). A third fifteenth-century Italian masterpiece from the Galitzin collections is Perugino's *Crucifixion* triptych, purchased by Alexander Mikhailovich Galitzin (1772-1821), during his tenure as Russia's ambassador in Rome. It

entered the Hermitage in 1886, only to depart in 1931 for the National Gallery in Washington, D.C. where the painting hangs today (ill.41). Ambassador Galitzin frequently had missions to carry out for Catherine II. Very likely it was the empress, as well as the prince's European circle, who imparted to Prince Alexander a taste for the masters of the Italian Renaissance. But the Galitzins ranged very broadly in their love of collecting.

Prince Mikhail Pavlovitch, for example, owned François Boucher's *Hercules and Omphale* (ill.49). Later Prince Nikolai Borisovich Yussupov, of another great art-collecting family (see p.89-103), bought it and included it in his 1827 catalogue.

The Galitzins also owned numerous masterpieces of seventeenth- and eighteenth-century art in other media. Today, for example, the Hermitage owns the terra-cotta model for François Girardon's monument to Louis XIV as well as two ivory vases by Pierre Gouthière, works that bear the monograms of Louis XVI and Marie-Antoinette (ill.48). All three items came from the Galitzin Hospital. Falconet's *Winter* (Hermitage), thought to have been

47. Louis-Michel Van Loo
*Portrait of Princess Ekaterina
Galitzin,* née *Kantemir,* 1759
Oil on canvas, 97 x 83 cm
Pushkin Museum of
Fine Arts, Moscow

48. Pierre Gouthière
Decorative vase
Carved ivory and
giltbronze, c. 1780
Height: 43 cm
Hermitage, St. Petersburg

49. François Boucher
Hercules and Omphale,
c. 1730
Oil on canvas, 90 x 74 cm
Pushkin Museum of
Fine Arts, Moscow

Numerous Russian
diplomats, including the
Galitzins, took advantage
of the opportunities
offered by their postings
to Western European
countries to commission
works from the most
celebrated of contemporary
artists. Thus on his arrival
in Paris in 1757, Prince
Dmitry Mikhailovich
commissioned portraits
of his wife not only from
Van Loo (ill.47) but also
from Drouais.
It was in the early 1820s
that Prince Nikolai
Borisovich Yussupov
acquired Boucher's
masterly *Hercules and
Omphale* (ill.49) from the
collection of Prince
Mikhail Pavlovich Galitzin.

47

lost since the end of the eighteenth century, was redis-
covered in the Galitzin sculpture collection. In Naples
the family acquired a replica of *Hercules and the Nemean
Lion* after the Hellenistic master Lysippus (ill.46). The
Head of Hermes, copied from a fifth-century original by
Polyklitus, which entered the Hermitage from the
Laval collection had originally been in the Galitzin
Museum and had been wrongly described in the fami-
ly's 1817 auction catalogue as "Perseus. Marble bust
with gilt-bronze wings on the head."

One of the rarest antique objects to come from the
Galitzin treasure is undoubtedly the *Zeus Olearios,* a work
of the third-century B.C. (ill. 43). This large antique
cameo, long identified with Venice, turned up in
St. Petersburg at the time of the Napoleonic wars in the
collection of Evdokia Ivanovna Galitzin (*née* Izmailova,
wife of prince Sergei Mikhailovich), an exceptional
woman and Alexander Pushkin's muse. The Midnight
Princess, as she was known, left the cameo to Tsar
Nicholas I in 1850, after which it went to the Hermitage.

48

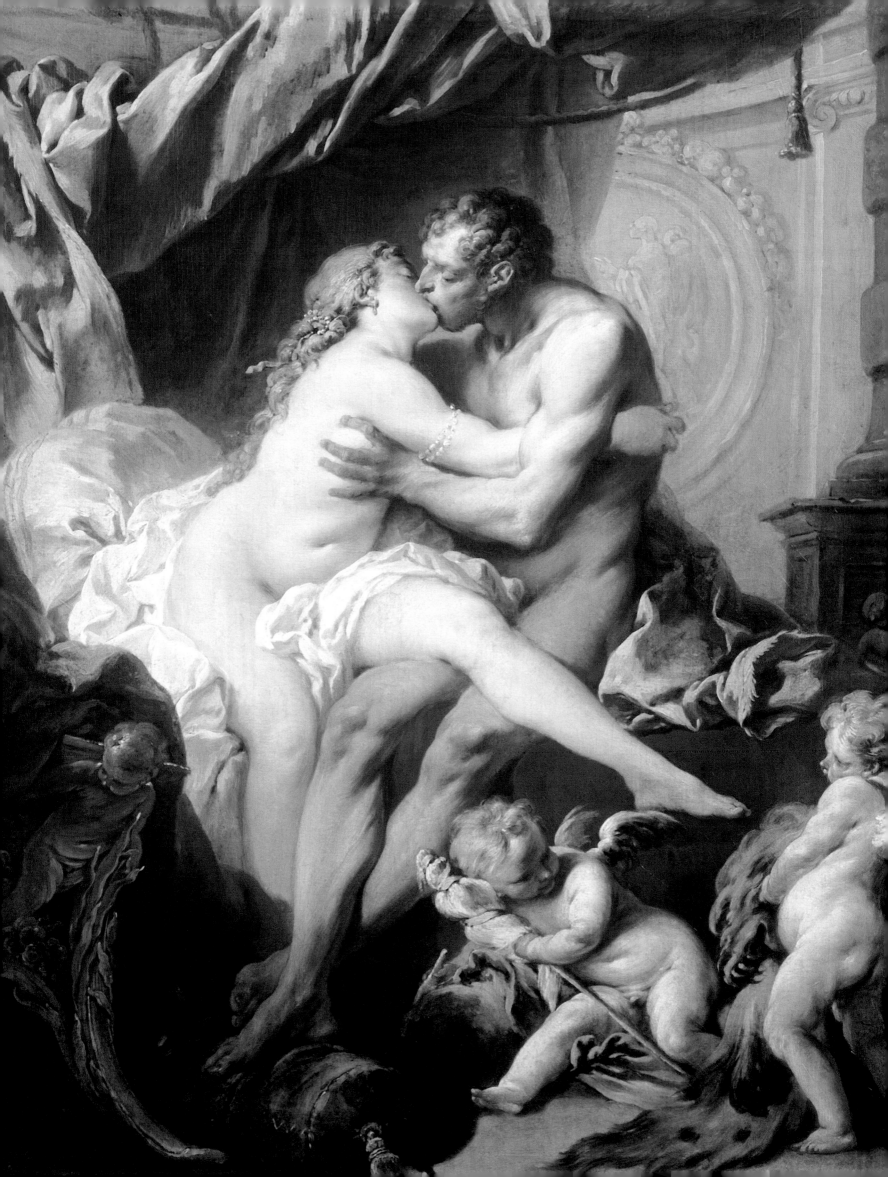

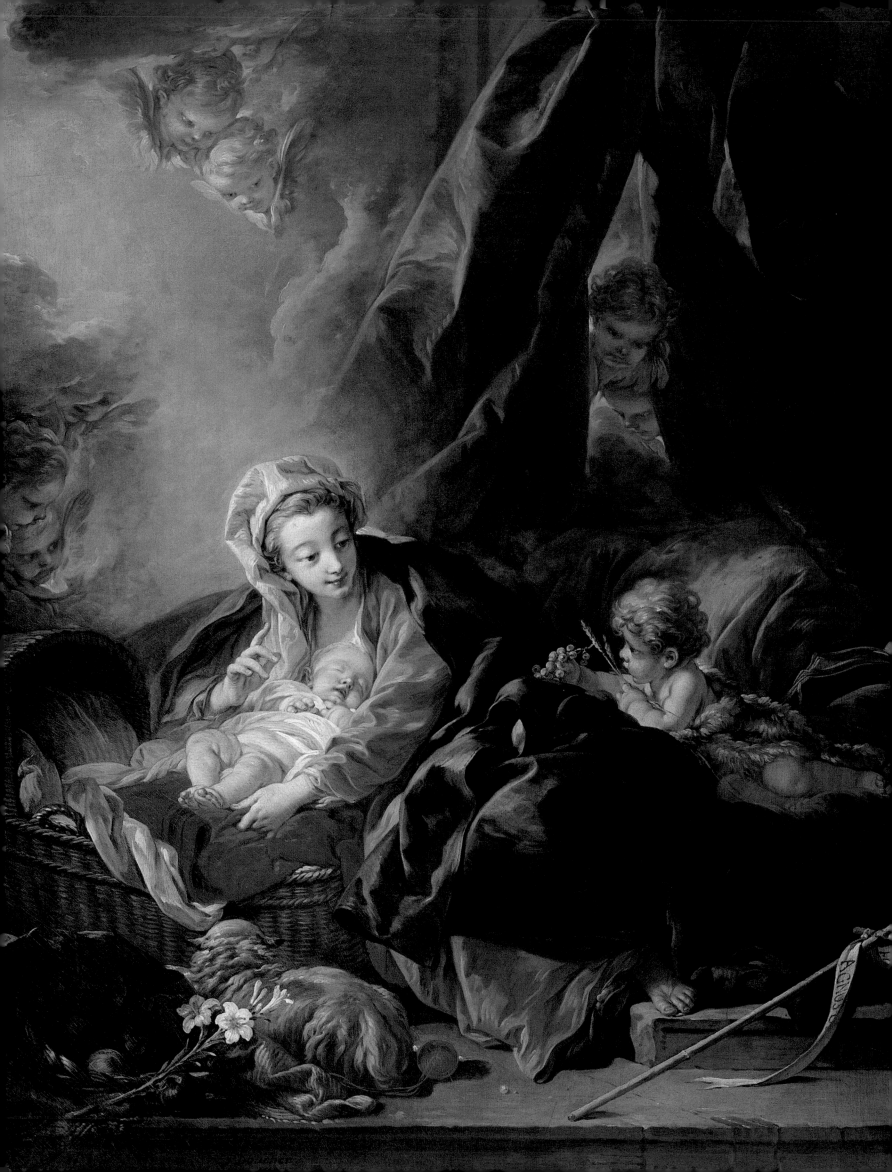

The Vorontsovs

The Vorontsovs, like the Sheremetevs, the Stroganovs, and the Yussupovs, contributed to Russia a number of important statesmen, diplomats, and military leaders. Princess Ekaterina Dashkova, *née* Vorontsova, thought of herself as a "Machiavelli in petticoats." She served as director of two academies and was an important collector. After his aunt's death, Count Ivan Vorontsov-Dashkov inherited her numerous belongings. Meanwhile, the princess' uncle, Count Mikhail Ilarionovitch Vorontsov (ill.51), held the office of chancellor while her brother, Count Semyon Romanovich (ill.52), held the post of ambassador in London.

An old family of the Russian nobility, the Vorontsovs owed their rise to the palace revolution of November 25, 1741, which brought Elizabeth, the daughter of Peter the Great, to the throne. The brothers Mikhail and Roman Vorontsov, who were instrumental in the plot, reportedly said that they had gained the highest posts in the Russian empire by hitching onto the back of the sleigh that bore the future empress toward the barracks of the Preobrazhensky regiment.

Once appointed chancellor, Mikhail Vorontsov became the patron of the scholar and encyclopedist Mikhail Lomonosov. According to some, it was at the Vorontsov Palace that Lomonosov, a self-taught man from deep within the Russian provinces, discovered the mosaics that would have such a profound influence on him as an artist. These included a portrait of Empress Elizabeth (Hermitage) and a St. Peter (Russian Museum), both created in Italy. It was after seeing them that Lomonosov made his mosaic portrait of Mikhail Vorontsov (Hermitage). Also to be seen at the chancellor's palace were the matched portraits of Peter the Great and Catherine I by Jean-Marc Nattier (Hermitage), the portrait of Mikhail Vorontsov's daughter as Diana by Louis Tocqué, and Carle Van Loo's *Allegory of Comedy* (ill.53).

It was through Semyon Vorontsov, the chancellor's nephew, that Catherine II, at the end of the eighteenth century, commissioned the English sculptor Joseph Nollekens to carve a marble portrait of Sir Charles Fox, England's foreign secretary (Hermitage). At the height of the Russo-Swedish War he had persuaded Parliament to keep the English fleet from entering the Baltic. On August 20, 1791, the empress wrote to

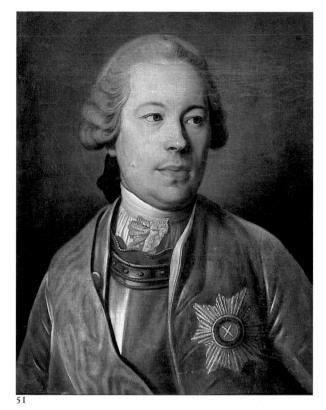

51

52

50. François Boucher
The Virgin and Child with St. John the Baptist, 1758
Oil on canvas,
118 x 90 cm
Pushkin Museum of
Fine Arts, Moscow

51. Unknown artist
Portrait of Count Mikhail Ilarionovich Vorontsov, Chancellor of the Empire
Oil on canvas,
57.5 x 47.5 cm
Kuskovo Palace Museum,
Moscow

52. Jean-Louis Voille
Portrait of Semyon Vorontsov, Colonel in the Preobrajensky Regiment, future Count and Ambassador Plenipotentiary to London, 1774
Oil on canvas, 60 x 51 cm
Russian Museum,
St. Petersburg

The history of art in the eighteenth century was constantly and inextricably interwoven with political and social history, with marriage ties between noble families also bringing about the union of their art collections. In 1758, for example, a marriage was arranged between the young Alexander Sergeievich Stroganov (ill.26) and the daughter of Chancellor Mikhail Vorontsov (ill.51), himself a distinguished collector and benefactor of scholars and artists.

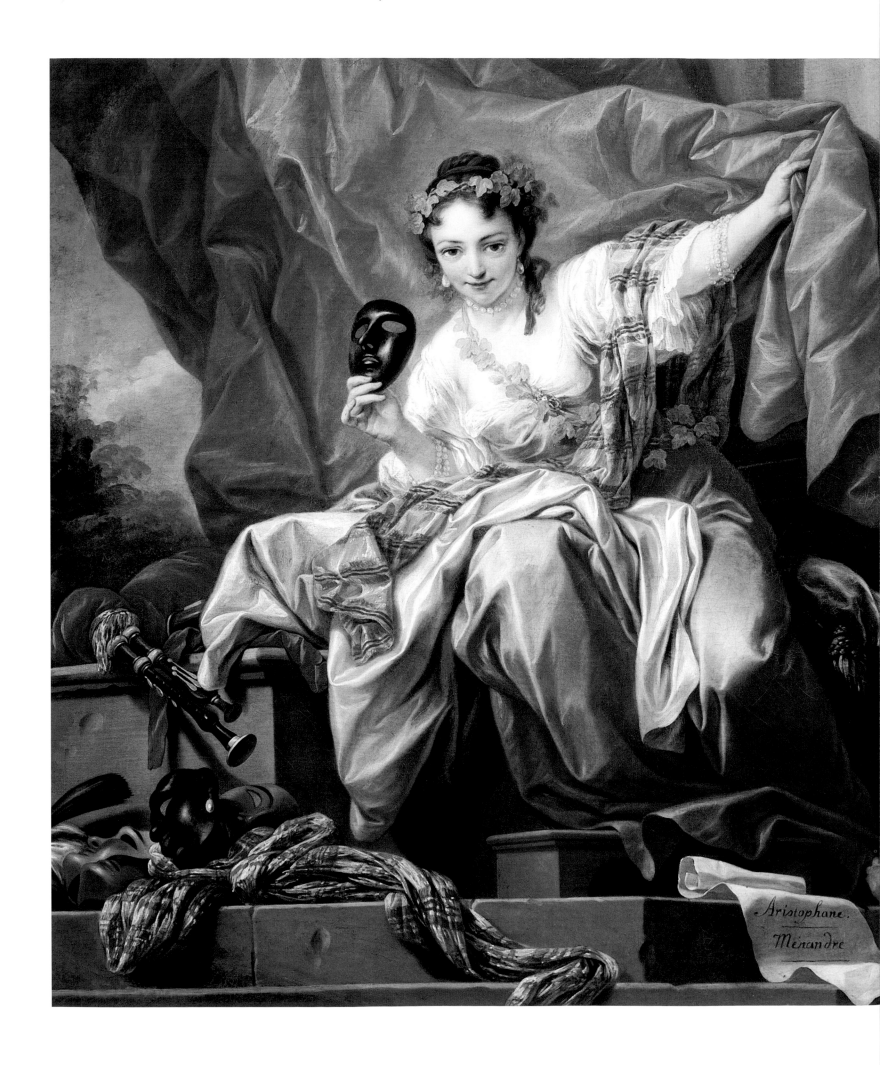

53. Carle Van Loo
Allegory of Comedy, 1753
Oil on canvas,
122 x 157 cm
Pushkin Museum of
Fine Arts, Moscow

54. The Vorontsov Palace
on Sadovaia Street,
St. Petersburg, built by
Bartolomeo Francesco
Rastrelli, 1749-57

55. Kaspar Georg von
Prenner
*Portrait of the Children of
Count Ivan Vorontsov,* c. 1755
Oil on canvas,
68.2 x 86.4 cm
Tretyakov Gallery, Moscow

The death of great art
lovers often made it
possible for others to
enrich their own collection,
adding an illustrious
provenance to its prestige.
Two overdoors by Carle
Van Loo *Allegory of Tragedy*
and *Allegory of comedy*
(Pushkin Museum,
Moscow; ill. 53) were
originally commissioned by
Louis XV's mistress the
Marquise de Pompadour
for her residence at
Bellevue and cost her
2,400 *Livres.*
After having been taken to
the Hôtel d'Evreux (now
the Elysée Palace in Paris),
they were inherited by the
favorite's brother the
Marquis de Marigny before
finding their way to the
Vorontsov collections.

54

55

Semyon Vorontsov: "I have placed the bust of Sir
[Charles] Fox in my colonnade at Tsarskoie Selo
between Demosthenes and Cicero."

In the nineteenth century Prince Mikhail Vorontsov
(1782–1856), governor-general of Novorosisk and
the tsar's representative in the Caucasus, had a palace-
museum unlike any other built in the Crimea, at
Alupka. The construction of this Tudor style building
went on from 1830 to 1844. There the canvases of
Hubert Robert and George Dawe hung side by side
with those of Russian painters such as Silvester
Shchedrin, Ivan Aivazovsky, and the brothers Grigory
and Nikanor Chernetsov. Prince Mikhail became one of
the founders of Odessa's Society of History and
Antiquities. He also assembled an important art col-
lection as well as antiquities that today, for the most
part, are preserved at the Archeological Museum of
Odessa and the Russian Museum in St. Petersburg.

53

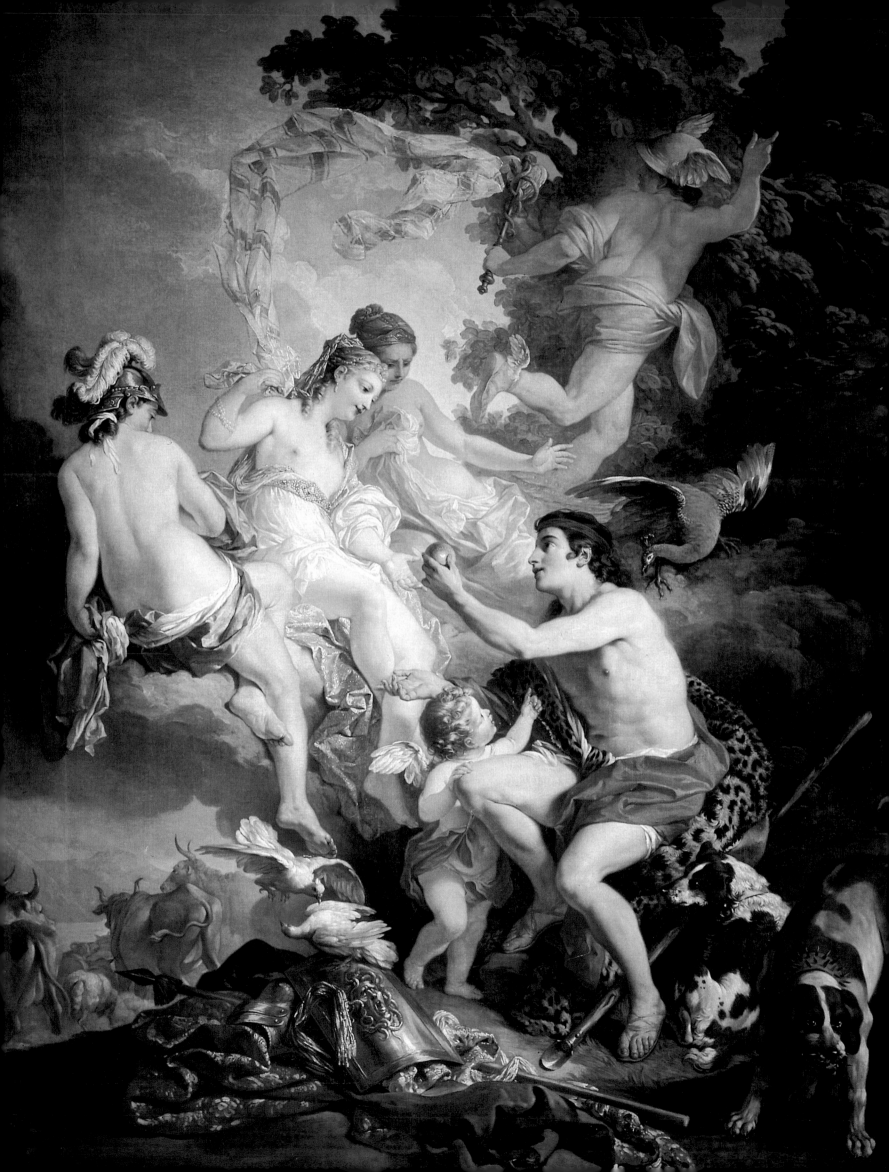

Count Ivan Shuvalov

The renown of the Shuvalovs dates back to the reign of Peter the Great. During his reign, Ivan Shuvalov's father served as commandant of Vyborg and then, under Empress Anna Iannovna, as governor of Arkhangelsk; his sons became pages at court. The true ascension of their family began, as in the case of the Vorontsovs, on the night of November 25, 1741, when all three Shuvalov brothers participated in the putsch that put Peter the Great's daughter, Empress Elizabeth I, on the throne. They gained high posts and were granted the title of "count" in 1746. Not only did Piotr take charge of the Ministries of War and Finance; he also, through marriage, became a relative of the empress. Meanwhile, Alexander served as director of the Secret Chancellery.

At the age of twenty-two, Ivan Ivanovich II (ill. 57), the Benjamin of the family, became the empress's favorite. Already the young chamberlain had begun communicating with the French encyclopedists—Voltaire, Diderot, and Helvetius. Voltaire wrote from Ferney declaring how astounded he was by the breadth of the knowledge evinced by a young man of barely twenty-five. To Helvetius in Paris, Count Ivan wrote that he would be the happiest of men if he could make his correspondent think well of a people "who, alas, had gained a reputation for barbarity in the eyes of many."

Ivan also counted among his friends the Russian encyclopedist Mikhail Lomonosov. In 1755 he founded Moscow University and, in 1757, the Academy of Fine Arts. As president of the latter, he brought foreign instructors to Russia, all the while that he was becoming a patron of Russian painters and architects, among them Anton Losenko, Feodor Rokotov, Vasily Bazhenov, Ivan Starov, Fedot Shubin, and Gavriil Skorodumov.

In 1758 he presented to the Academy of Fine Arts approximately one hundred canvases from his private collection. At the death of Empress Elizabeth, however, his career came to an abrupt end. In the spring of 1763 he was "advised" to travel abroad, actually to leave Russia for an undetermined period of time. In December 1770 he wrote to his sister from Rome: "My love for the arts and the company of foreigners, there is the whole of my pleasure." His circle at the time included such major Roman painters of the day as Bartolomeo Cavacceppi, Anton Raphael Mengs, and Giovanni Battista Piranesi. Piranesi dedicated the

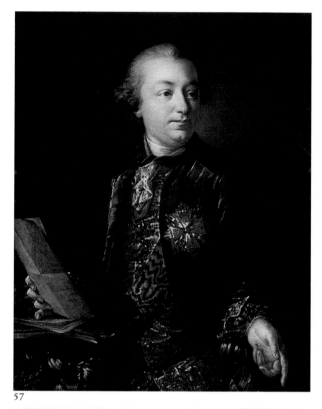

57

58

56. Louis Jean François Lagrenée (the Elder)
The Judgement of Paris, 1758
Oil on canvas,
286 x 253 cm
Tretyakov Gallery, Moscow

57. Anton Losenko
Portrait of Count Ivan Shuvalov, President of the Academy of Fine Arts, c. 1760
Oil on canvas, 85 x 70.5
Russian Museum,
St. Petersburg

58. Jean-Baptiste Greuze
Girl with a Doll, c. 1756–57
Oil on canvas, 65 x 55 cm
Hermitage, St. Petersburg

The story of the arts in Russia would have been very much the poorer without the contribution of Count Ivan Shuvalov (ill.57), with his vision of his country's artistic development, his indomitable support of the arts, his enlightened views, and his passion for collecting.
Founder of the Academy of Fine Arts in 1757, he was a tireless advocate of the importance both of the Western European example (sending Russian artists to study in Paris and Rome) and of the creation of a truly national school. After his protector's death (Empress Elizabeth I), he was given from Catherine the Great a *"consilium itinerandi"* (advice to travel), the equivalent of banishment. He took advantage of it to enrich his collections throughout Europe for about fifteen years.

59. Michael Sweerts
Portrait of a Young Man
(Self-portrait), 1656
Oil on canvas,
114 x 92 cm
Hermitage, St. Petersburg

60. A. Zyablov
The Study of Count Ivan
Shuvalov, 1779
Oil on canvas,
72 x 118 cm
National History Museum,
Moscow

61. Alessandro Magnasco
Bacchanalia, c. 1710
Oil on canvas,
112 x 176 cm
Pushkin Museum of
Fine Arts, Moscow

Interior views showing
private collections on
display—here the cabinet
of Count Ivan Shuvalov
(ill.60)—are rare; the works
are depicted in such precise
detail that is possible
to identify, for instance,
Michael Sweerts' *Portrait*
of a Young Man (ill.59, far
right on the painting) and
a *Bacchanale* by Magnasco
(ill.61, by the fireplace).
This "edge-to-edge"
hanging, typical of the
reign of Empress
Elizabeth I, gives a clear
indication of the varied
tastes of this great patron
of the arts, himself
depicted in a painting
propped on the floor rather
than in the flesh.
Dubbed the "Russian
Marquis de Pompadour"
by Voltaire, Shuvalov was
first in Russia to enter into
correspondence with the
great encyclopaedists.

59

second volume in his series of etchings, entitled *Vases and Candelabras*, to Count Ivan, which included this flattering inscription on the title page: "To His Excellency General Shuvalov, patron of the fine arts."

The onetime favorite of Empress Elizabeth shipped to St. Petersburg several "antiques" for his own collection (ills.62 and 64), which included many casts of classical statues, intended ultimately for the Academy of Fine Arts. The plasters were for teaching purposes, but the best of them would be cast in bronze as embellishments for Catherine II's park at Tsarskoie Selo.

Ivan returned to Russia only after an exile of fifteen years. His palace in St. Petersburg, built on Italianskaia Street in 1754 by Savva Shevakinsky, became a gathering place for all the capital's art-lovers. Oddly enough, Catherine II, who by this time was enamored of the

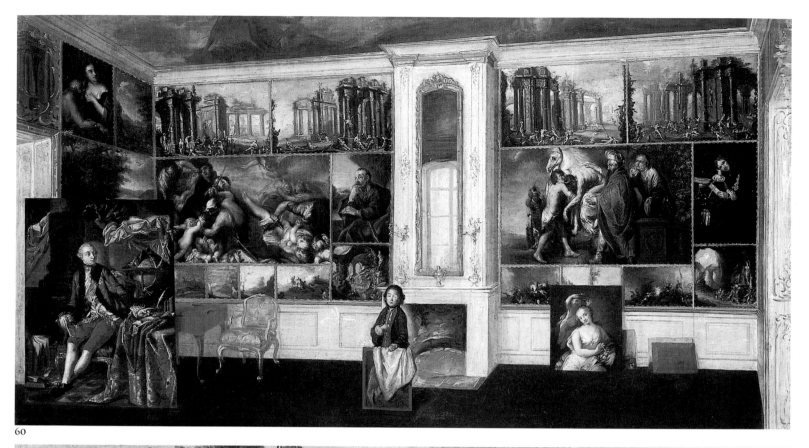

60

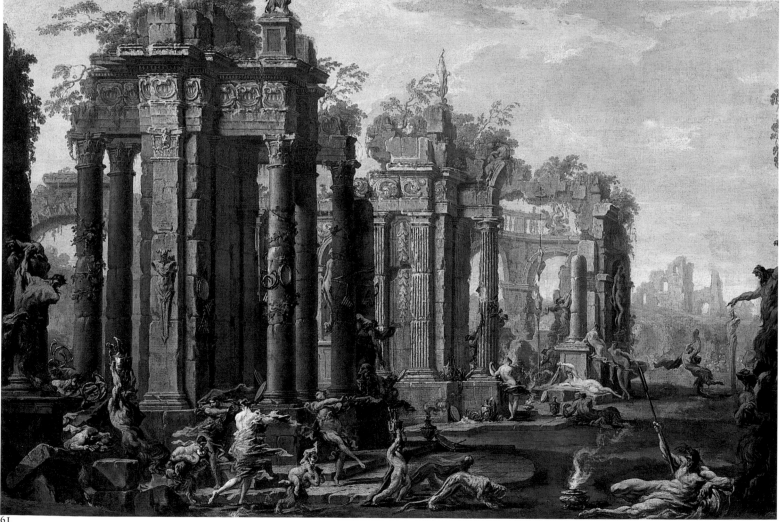

61

62

62. Rome, 1st century A.D.
The Sacrifice of Titus
Marble, 130 x 220 cm
Gachina Palace Museum

63. Rome, 1st century A.D.
Urn of Tertulllina
Alabaster; height: 29.5 cm
Hermitage, St. Petersburg

64. Roman copy of an
original from the early
5th century B.C.
*Head of a Goddess
(Hera or Demeter)*
Marble, originally with
agate eyes and curls in
either gold or gilt bronze;
height: 57 cm
Hermitage, St. Petersburg

63

64

"Greek" style in architecture, ridiculed the Shuvalov Palace as too archaic, "too much given to Alençon lace," meaning perhaps too rococo.

A painting by A. Zyablov, entitled *The Study of Count Ivan Shuvalov* and dated 1779 (ill. 60), portrays the count as a man still in his youth. Next to the fireplace stands a *trompe-l'œil* figure by Pietro Rotari's *The Kalmuck Servant*. It was in this same setting that the traveler Johann Bernoulli saw Count Ivan in 1778 during a visit to the celebrated collector, and he described the mansion in his writings. On the walls could be seen a series of four paintings by Alessandro Magnasco (Hermitage and Pushkin Museum, ill.61) and Andrea Celesti (Russian Academy of Fine Arts). Another painting, Michael Sweerts's *Portrait of a Young Man* (ill. 59), one of the most beautiful canvases from the Flemish school, has subsequently been recognized as a self-portrait. Most of these works were part of the 1758 gift to the Academy of Fine Arts. Twenty years later, when Count Ivan commissioned a replica of Rokotov's view of the Academy's painting gallery, it showed the whole of his first collection, which included the paintings that had previously hung on the opposite wall of Shuvalov's study: Charles de La Fosse's *Christ in the Desert*, Greuze's *Girl with a Doll* (ill. 58), and two views of waterfalls by Christian Wilhelm Dietrich (all in the Hermitage).

Count Ivan Shuvalov owned also a great variety of sculptures, urns, and mosaics, all of them interspersed with the paintings. In 1778 Bernoulli wrote a detailed description of these works: "I remember the following antique pieces: a splendid colossal head of Juno, with, in front of the sculpture, a leg found nearby. . . . a helmeted head of a man, much appreciated by Mengs, who thought it represented Achilles [see ill. 65]. . . . an antique copy of the Medici Venus. . . . a fragment of mosaic paving. . . , an imitation of the Capitol *Pigeons* mentioned by Pliny" (today all in the Hermitage). In 1784 Catherine II purchased the sculpture collection.

A lifelong bachelor, Count Ivan died without issue, leaving his collections to his nephew Feodor Galitzin and his niece Varvara Golovina, *née* Galitzin. The torch thus passed to the Galitzins and the Naryshkins (Sofia, the wife of Pavel Shuvalov, was born a Naryshkin). In St. Petersburg, the Naryshkin mansion, on the Fontanka Canal near the Anichkov Bridge, continued to be known as the Shuvalov Palace until the Revolution of 1917.

65. Roman copy of
a sculpture by Alcamenes,
5th century B.C.
Ares (Mars)
Marble, 92.5 cm
Hermitage, St. Petersburg

65

Count Grigory Orlov

The Orlov brothers—Grigory, Alexei, Feodor and Alexander—whose family name derived from the word "oriole" in Russian, or eagle, had relatively simple origins as the sons of a provincial governor. The most prominent of them were Grigory and Alexei, giants of men, both in physical size and strength and whereas Grigory was staggeringly handsome and virile, Alexei was somewhat disfigured and known as "Scarface."

In 1761 Catherine fell in love with Grigory (ill.67), who was a member of the imperial guards. It was after Empress Elizabeth's death that everything unraveled, principally because the new and pro-German Tsar Peter III—Catherine's husband—went against the prevailing anti-German sentiment that was best expressed in the Seven Years' War against Frederick the Great and his allies. Hardly had Elizabeth been buried than Peter decreed that peace talks should be opened with Frederick, this at a time when the Russian army was at the height of a successful campaign to occupy East Prussia. In lieu of continuing the conflict, Peter declared war on Denmark in order to regain Schleswig for his duchy of Holstein. Shortly thereafter, Grigory and his brother Alexei led a guards' revolt that stormed the palace at Oranienbaum where Peter was preparing to launch his attack against Denmark while also plotting to replace Catherine by his mistress. They arrested Peter, fetched Catherine at her hideaway at Mon Plaisir in Peterhof, drove her to the capital through the snow, handed her a saber, placed her on a horse in a guard's uniform, and she was acclaimed by the entire city.

The conspirators were handsomely rewarded and Grigory became the unquestioned empress' favorite for about ten years. Later on, Alexei was made an admiral of the fleet, Feodor was decorated during the Russo-Turkish war while Vladimir became president of the Academy of Sciences in spite of his young age.

Only Grigory possessed the soul of a collector, and he would spare nothing when it came to building on the Gachina estate given to him by the empress (ill.68).

67

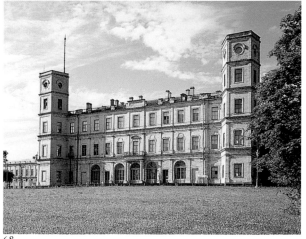

68

66. François Lemoyne
Woman Bathing, 1724
Oil on canvas,
136.5 x 105 cm
Hermitage, St. Petersburg

67. Vigilius Eriksen
Portrait of Count Grigory Orlov
Oil on canvas,
61.6 x 48.7 cm
Tretyakov Gallery, Moscow

68. The Gachina Palace
(garden façade),
built by Antonio Rinaldi,
1766-1781

Although of considerable artistic and architectural interest, the Gachina Palace (ill.68), some twenty-four miles from St. Petersburg, remains less well known than Peterhof, Tsarskoie Selo and Pavlovsk. Built for Grigory Orlov (ill.67) by Rinaldi, on the former's death in 1783, it was bought from his heirs by Catherine the Great, who gave it to the tsarevich Pavel Petrovich. It was to become one of his favorite country residences. Nicholas I had it restored throughout and carried out extensive alterations in about 1840. Following the assassination of his father and his own accession to the throne in 1881, Alexander III spent most of his time there, so becoming known teasingly as the "hermit of Gachina".

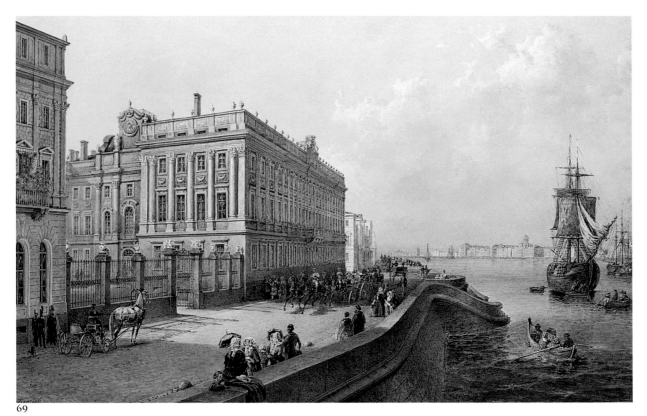

69

70

69. Vasily Sadovnikov
View of the Marble Palace on the Banks of the Neva, 1847
Watercolor
Hermitage, St. Petersburg

70. The Great Hall of the Marble Palace

71. François Lemoyne, after Correggio
Jupiter and Io, c. 1720
Oil on canvas, 138 x 106.5
Hermitage, St. Petersburg

"My angel, my lord, my inestimable little Grigory with honeyed lips, my falcon, my golden pheasant…" Catherine's passion for Grigory Orlov found expression not only in her letters but also in the residences she built for him. Most notably in the Marble Palace, the only building in St. Petersburg at this period that was not constructed of all too perishable wood, brick, and painted plaster.
The great first-floor ballroom, beyond question the most opulent and elegant of all Russian Neoclassical interiors (ill.70), is lined with precious marbles from the Urals and lapis lazuli.

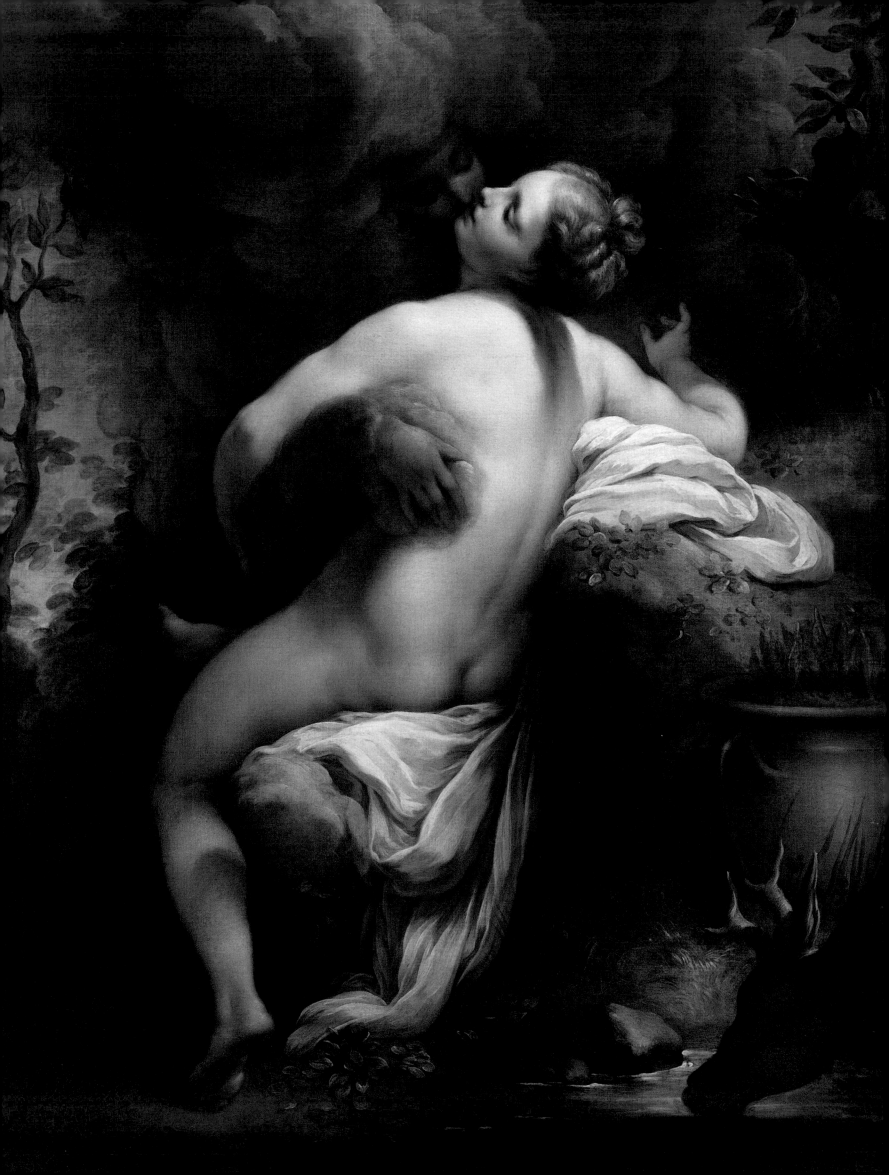

72. Johann Gottlieb
Scharff and Johann
Gottfried Gebel
*Snuffbox with the portrait
of Alexei Orlov*
Diamonds, gold, enamel
Hermitage, St. Petersburg

73. Jean-Pierre Ador and
Gavriil Kozlov
*Three snuff bottles from
the Orlov service,* 1770
Porcelain
Hermitage, St. Petersburg

74. Jean-Pierre Ador
The "Chesme" snuffbox,
1771
Diamonds, gold, enamel
Hermitage, St. Petersburg

75. Jean-Baptiste Pater
Dance beneath the Trees,
c. 1720
Oil on canvas,
147.5 x 101.5 cm
Hermitage, St. Petersburg

In 1780, Grigory Orlov
extended an invitation to
Jean-Jacques Rousseau to
come and philosophize at
Gachina, where "the air is
pure, the water
extraordinary, and pleasant
spots for walking are
propitious to thought".
But he was equally fond of
surrounding himself with
magnificence and luxury.
Understanding—and
sharing—his tastes,
Catherine plied him with
the most lavish of gifts,
including a large and
exquisite silver service,
comprising no fewer than
842 pieces, commissioned
from Roettiers in Paris in
1770 and subsequently
known as the Orlov
service.
Another of her gifts was a
portrait of herself mounted
in a diamond medallion,
which he and he alone was
privileged to wear on his
chest, until Potemkin
usurped his place in
Catherine's favors and in
1775 was in turn granted
this rare favor.

72

73

74

Rinaldi constructed a veritable château for him where, in 1766, the owner invited none other than Jean-Jacques Rousseau to come and settle. Gachina boasted not only a *Kunstkammer* but also an arsenal housing the rich collection of arms assembled by Grigory when he was commanding general of the Russian Artillery. Gachina had, in addition, a gallery of paintings, sculpture, antiquities, and contemporary works of art. Another gallery, called the Chesme gallery, was created to house three immense canvases by Jakob Hackert, all celebrating the 1770 victory of the Russian fleet over the Turks in Chesme harbor in the eastern Mediterranean. (The naval success had been attributed to Alexei Orlov, who thus became the Prince of Chesme.) Also at Gachina, Grigory created a large gallery of portraits. In the park stood the Chesme Obelisk and the Eagle Pavilion, both of them commemorations of victorious campaigns led by Alexei Orlov. Clearly, Catherine II never forgot her favorites, those to whom she owed her imperial crown. The Empress had the court painters represent the two brothers in equestrian mode (Hermitage), paintings that remained at Gachina until World War II.

Grigory shared the empress's bed until he was replaced by Grigory Potemkin. Shortly afterward, an epidemic of plague broke out in Moscow in 1771 and Orlov was dispatched to deal with the scourge, which he did successfully with his enormous energy. To cele-

brate his success the empress had commemorative medals struck and a triumphal arch—the Gachina Gate—erected at Tsarskoie Selo, the arch designed by Rinaldi. During the same period Catherine also had Rinaldi build Grigory a grand residence in the capital, despite the hero's having somewhat lost favor at court. This was the Marble Palace (ill.69 and 70), which once bore the inscription: "House of Gratitude." The décor included busts of the two brothers carved by Fedot Shubin and a pair of statues personifying *Morning* and *Night*, both placed on the grand staircase (all in the Russian Museum). Bas-reliefs in the large Marble Hall, one of the most successful of all Russian Neoclassical interiors, narrated the episode in which Alexei showed clemency toward his Turkish prisoners, thereby revealing himself a worthy successor to Scipio Africanus and the Roman general Paulus Emilius. To embellish the palace further, Catherine II, in 1772, offered Grigory several paintings from the imperial collection: Carle Van Loo's *Self-portrait*, François Lemoyne's *Woman Bathing* (ill.66) and *Jupiter and Io* after Correggio (ill.71), as well as a triptych by Jean-Baptiste Pater (ill.75) entitled *Dance Beneath the Trees* (all in the Hermitage).

Once fallen from grace, Count Grigory married his niece Ekaterina Zinovieva and then left Russia to live abroad. Tragically, the young countess died in Switzerland, leaving her disconsolate husband to go mad. The brothers took him back to Russia, where he died in 1783.

The empress bought Gachina Palace from the Orlovs, "with all the furnishing, the marble objects, the arms, etc." Now the residence of a onetime favorite was taken over by the heir apparent, the future Paul I, to whom it was a much favored country estate. A few years later, ironically, the Marble Palace would become the refuge of Stanislas II Augustus, who had just given up the Polish throne. In his gorgeous youth, as Prince Stanislas Poniatowski, he had, by many years, preceded Grigory Orlov in the bedchamber of the future Catherine the Great.

7

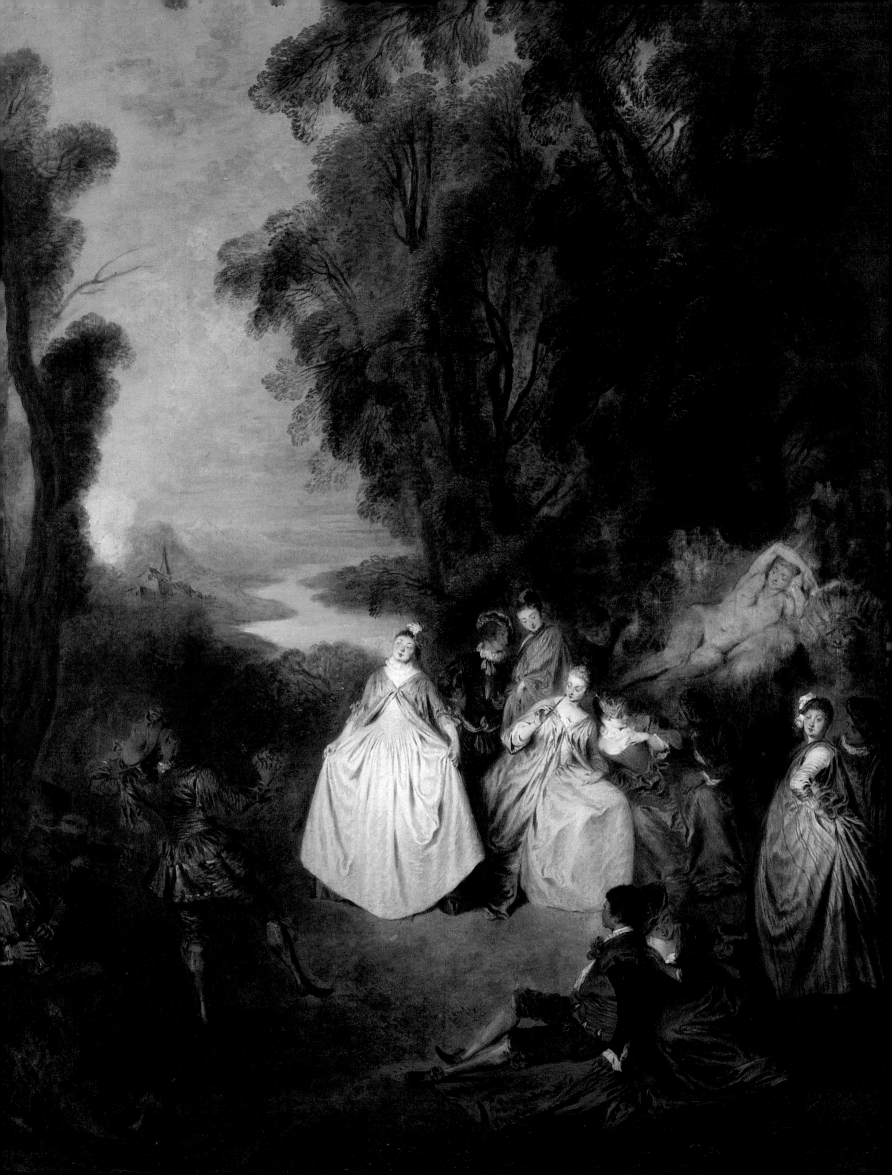

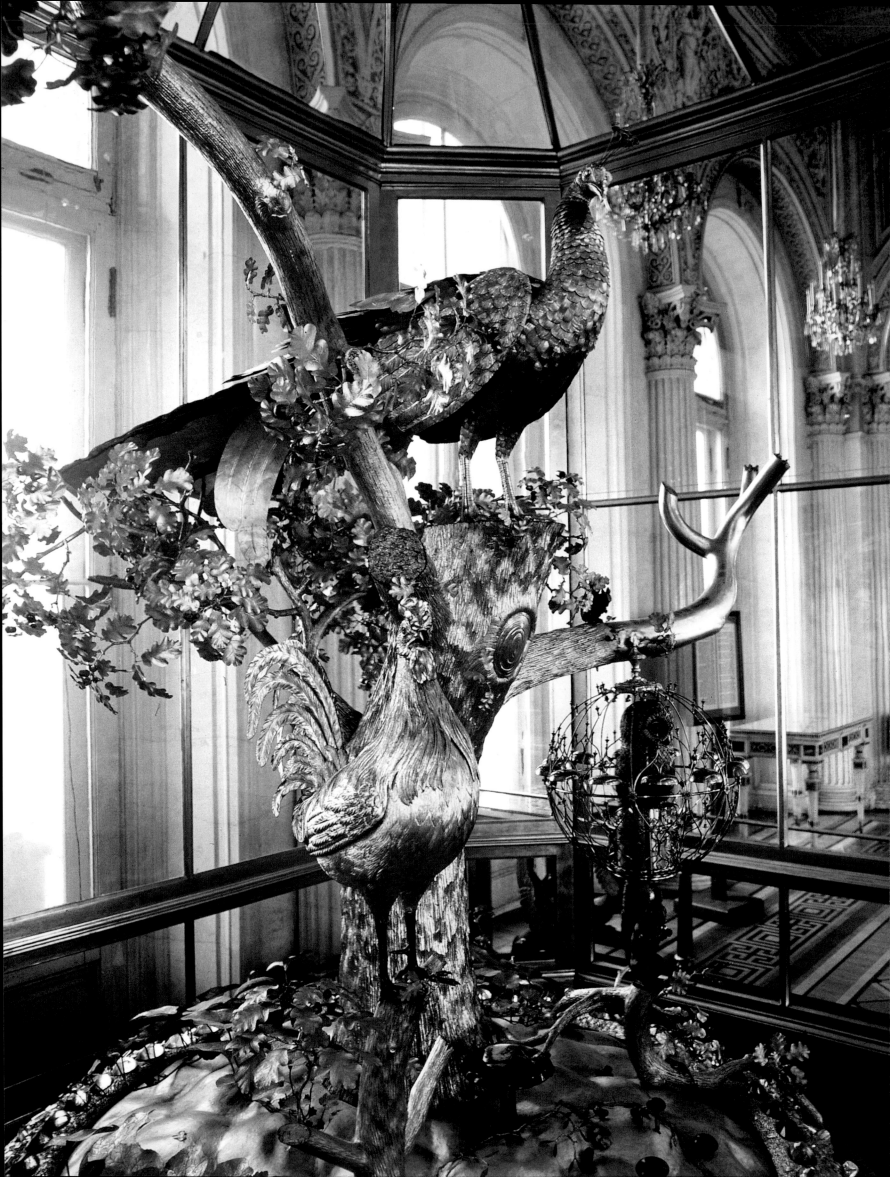

Prince Grigory Potemkin

The position of Catherine the Great's favorite left open by Grigory Orlov was briefly filled by Alexander Vassilchikov and then by Grigory Potemkin (ill.77), one of the most complex and contradictory figures of his time. While some saw him as a man of overriding ambition who dreamed of occupying the throne of Moldavia, of Courland, and even of Byzantium, others thought him a boudoir sybarite who began everything and finished nothing (to quote Emperor Nicholas I).

In 1762 when the palace revolution of June 26 placed Catherine II on the Russian throne, Potemkin was a seventeen-year-old noncommissioned officer in the imperial guard. During the summer of 1775, the empress penned a note to her frequent correspondent Baron Grimm: "General Potemkin is more in fashion than many others. . . . I have drawn away from a certain excellent but very annoying citizen (Vassilchikov), who has been quickly replaced, I don't know how, by one of the tallest, the funniest, and the most amusing originals of this iron century."

Potemkin was famous for his imitations of people and one day, in the presence of his empress, had been asked to perform. Everybody fell silent and looked at the floor when the young Potemkin made a perfect imitation of the empress herself speaking Russian with her usual German accent. Catherine instead was highly amused and thus Potemkin was taken up and became her favorite.

After the Ottoman Empire declared war against Russia in 1768, Potemkin departed to the front where he served under General Rumiantsev. He became a war hero after participating in the battle of Kagul where he pursued and defeated four thousand Turks and Catherine subsequently referred to him as "Alcibiades," the Athenian general renowned for his military strategy. His intimacy with the empress infuriated Alexei Orlov who, according to rumor, invited Potemkin to a game of billiards and hurt him in such a fashion that he lost an eye, gaining in the process the second nickname

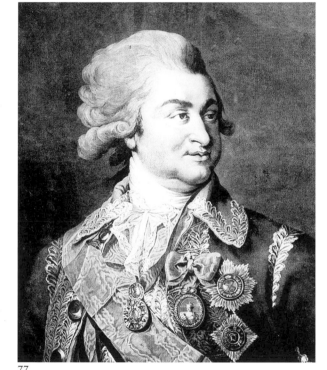

77

78

76. James Cox
Mechanical clock with automata, known as the "Peacock Clock,"
c. 1775
Gilt bronze, enamel, glass;
height: 300 cm
Hermitage, St. Petersburg

77. Copy of an original by Giovanni Battista Lampi
Portrait of Grigory Potemkin, Prince of Taurida, 1792
Engraving by James Walker,
39.5 x 28.8 cm
Hermitage, St. Petersburg

78. The Taurida Palace, St. Petersburg (garden facade), built by Ivan Starov for Grigory Potemkin, 1783–89

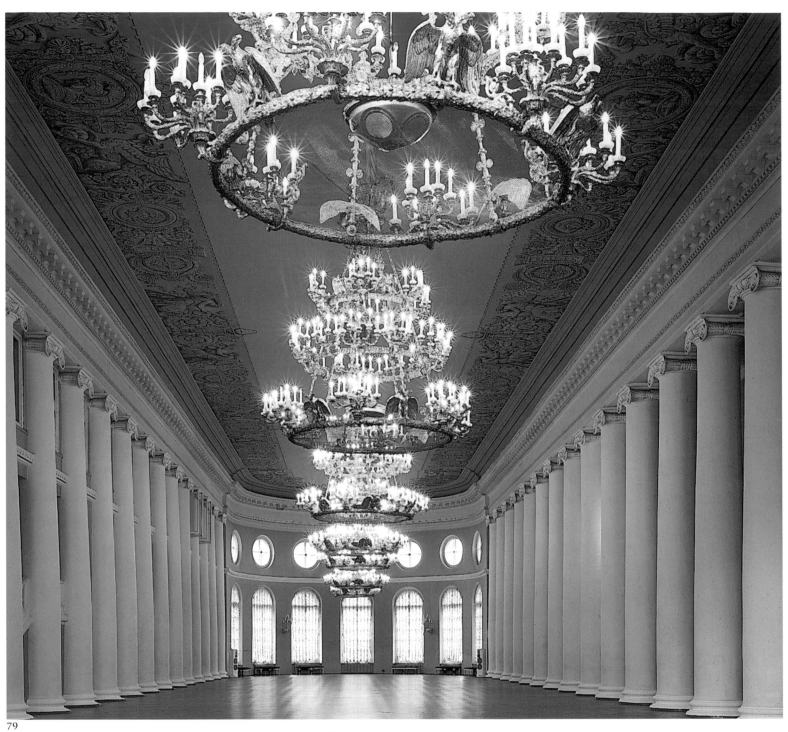

79

79. The Grand Ballroom or "Hall of White Columns," Taurida Palace

80. The Rotunda, Taurida Palace

The Prince de Ligne, a piquant observer of his times, maintained that it would take the stuff of one hundred ordinary men to make a Potemkin. Dubbed "Serenissimus" after being created a Prince of the Holy Roman Empire by Josef II, Potemkin was the only one of his contemporaries capable of rivalling Catherine the Great in intelligence and extravagance.

When on April 28, 1791 he threw a lavish reception for her at the Taurida Palace (ill.78), which she had recently restored to him (having bought it from him in order to defray his colossal debts), 3000 guests attended a costume ball in the "Hall of White Columns," 246 feet long, 50 feet high, and brilliantly lit by over 50 chandeliers (ill.79).

Catherine's entrance into this magnificent room was greeted by triumphal hymns sung by choirs to the accompaniment of an orchestra of 300 musicians. The following day she wrote to Baron Grimm in Paris: "Last evening Maréchal Prince Potemkin gave a magnificent ball in my honor at which I arrived at seven to leave at two …"

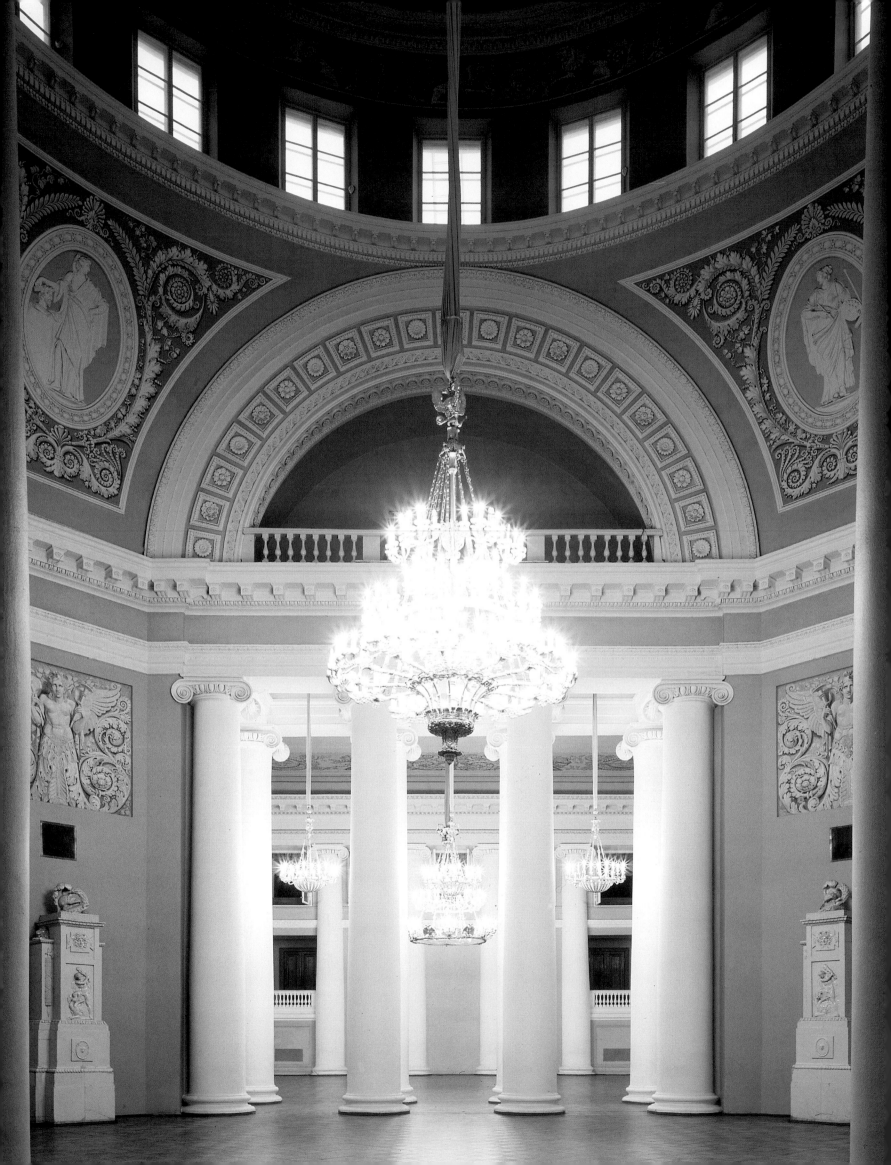

81

81. Paolo de Matteis
Justice Disarmed by Love and Vice
Oil on canvas,
231 x 285 cm
Pushkin Museum of
Fine Arts, Moscow

82. Mikhail Kozlovsky
Vigil of Alexander the Great
Marble,
192 x 123 x 81 cm
Russian Museum,
St. Petersburg

of "Cyclops." After he was made a prince of the Holy Roman Empire by Joseph II in 1776, Catherine added to those names that of "Serenissimus".

Potemkin soon found himself appointed head of the ministry of War and governor general of the Novorossiisk territory, an event that prompted Alexei Orlov to resign from all his posts and Grigory Orlov to leave in a sort of exile. For eight years, he remained the favorite of Catherine II, with whom he virtually co-ruled Russia. Catherine made him enormously rich thanks to large gifts of money, serfs, and property. Whereas the love affair waned, the confidential relationship between the two ended only with Potemkin's death in 1791. If contemporaries can be trusted, he himself recruited the new favorites for the imperial bed chamber in the form of Alexander Lanskoi, Semyon Zorich, and Alexander Dmitriev-Mamonov, all members of the guard.

As his residence in the capital, Potemkin chose the Anichkov Palace, once the property of Alexei Razumovsky (1719–1777), the morganatic husband of Empress Elizabeth. Meanwhile, Potemkin's favorite architect Ivan Starov set about building him a palace of his own, the Taurida Palace, in St. Petersburg (ill. 78 –80).

Having contributed to colonize the Crimea, recently won over the Turks, Potemkin had been made a Prince of Taurida (the region's ancient name). He had new cities erected there, such as Odessa, and Sebastopol. He also had vineyards planted, industries created, and ports and shipyards built, that still play a role in Russia's seapower.

His achievements were recognized by a long pilgrimage and visit from Catherine who traveled in an eight hundred–person entourage. As the legend still has it, she made her way acclaimed by the local population staged against cardboard houses, making up what

became known as Potemkin's villages, leaving a false impression that did little justice to his achievements.

Surviving documents provide a good idea of the Taurida Palace's furnishings, the luxury of which reflected the extravagance of its owner. These included a massive silver wine-cooler and a Meissonier silver soup tureen, part of the many objects that came from the collection of the Duchess of Kingston.

The duchess was simultaneously Countess of Bristol and had been tried for bigamy at the House of Lords, after which she sailed to St. Petersburg with a mutinous crew on a yacht she had built in Calais, having its dining room decorated by tapestry cartoons from the workshop of Peter-Paul Rubens (Hermitage). She had purloined great treasures from the Kingstons' mansion, Thoresby Hall, which she brought along to Russia, but after some time had to leave St. Petersburg in a confused and dilapidated state and her works were sold at auction. Many of them were purchased by Potemkin, and among these James Cox's enormous silvergilt and jeweled Peacock Clock, now in the Hermitage (ill. 76), Pierre Mignard's *Clemency of Alexander* (Hermitage), and Paolo de Matteis' *Justice disarmed by Love and Vice* (ill. 81).

Like many Russians, Potemkin suffered from "Anglomania," and enjoyed collecting English paintings. Together with Catherine the Great, they commissionned two paintings from Sir Joshua Reynolds (ill.84) while other works at the Taurida Palace were Thomas Jones's *Landscape with Dido and Aenaes* and William Marlow's *View of the Seashore* (both in the Hermitage).

Potemkin favored objects grand in scale as well as those made with precious materials. The paintings made for the Taurida Palace suffered somewhat from a kind of giganticism. A case in point is Francesco Casanova's *The taking of Izmail*, which measures roughly eleven by fourteen feet. Also housed in the palace was a chinoiserie desk by David Roentgen (Hermitage), a full choir organ with a clock by William Winerow (Menshikov Palace), and a clavichord with mother-of-pearl and tortoise-shell embellishments produced by the Gabran workshop in St. Petersburg (Pavlovsk Palace).

Potemkin had proposed to divide the Ottoman empire's European and Asian possessions into two vassal states, one governed by Grand Duke Alexander and the other by Grand Duke Konstantin, the two elder grandsons of Catherine II. Thus there is a double portrait by the British artist Richard Brompton of both grand dukes with the attributes of Alexander the Great and Constantine the Great (Hermitage). Among Potemkin's sculptures were Fedot Shubin's

Catherine as Legislator and Mikhail Kozlovsky's *Vigil of Alexander the Great* (ill.82).

The apotheosis of Potemkin's career was undoubtedly his great festivity at his palace in 1791, the year of his death, an event described by Gavriil Derzhavin. The hall was illuminated by five thousand torches burning, and a wind orchestra of three hundred musicians, together with an organ, accompanied choirs hidden in the two galleries. Curtains rose to reveal a theater where two comedies and a ballet were performed to entertain the empress. Catherine was so moved when Potemkin fell to his knees before her in gratitude and respect, that both wept before she drove into the night in her carriage. A few months later he was to die virtually alone on the steppes of Russia.

After Potemkin's death, Empress Catherine purchased from his heirs 368 paintings and dozens of sculptures, paying as much as 4,000 rubles for the statue of Alexander. Still, a number of works remained for the prince's nephews, one of whom wrote in his *Life and Acts of Prince Potemkin of Taurida*, "The prince was, to a maximum degree, a lover of the fine arts. In architecture, he favored the vast and the majestic . . . in painting and sculpture he liked perfection."

Multi-faceted and brimming with energy, Potemkin was quite remarkable in the scope and variety of his activities. While commissioning paintings from English artists (ill. 84) and buying antiquities for his different residences, he was also *de facto* head of state in the newly conquered Crimea and was closely involved in its economic development. On his estates, meanwhile, he tested out numerous techniques and systems intended, if they proved successful, to be reproduced on a more ambitious scale. He set up mirror factories, brandy distilleries, tanneries, sail-making workshops, and rope factories.

82

83. Joshua Reynolds
Cupid Untying the Zone of Venus, 1788
Oil on canvas,
127.5 x 101 cm
Hermitage, St. Petersburg

84. Joshua Reynolds
The Continence of Scipio,
1788–89
Oil on canvas,
239.5 x 165.5 cm,
Hermitage, St. Petersburg

Potemkin was a great anglophile, and generally acknowledged as such. During a visit to St. Petersburg in 1785, Lord Carysfort had drawn Catherine's attention to the lack of works by contemporary English artists in the imperial collections. Catherine promptly commissioned a painting from Joshua Reynolds on a subject of the artist's choice, and Potemkin added a request for himself. So it was that in 1789 the Empress received delivery of *The Infant Hercules strangling the Serpents*, symbolizing Russia's growing power, while Potemkin received *The Continence of Scipio* (ill. 84). The subject of this painting seemed flatteringly apposite, depicting as it did the ideal of the magnanimous military leader, who had vanquished the Carthaginians just as Potemkin had defeated the Turks.

The other Reynolds painting in Potemkin's collection, *Cupid Untying the Zone of Venus* (ill. 83), was a signed copy that Carysfort had commissioned for the Russian statesman of a canvas in his own collection.

83

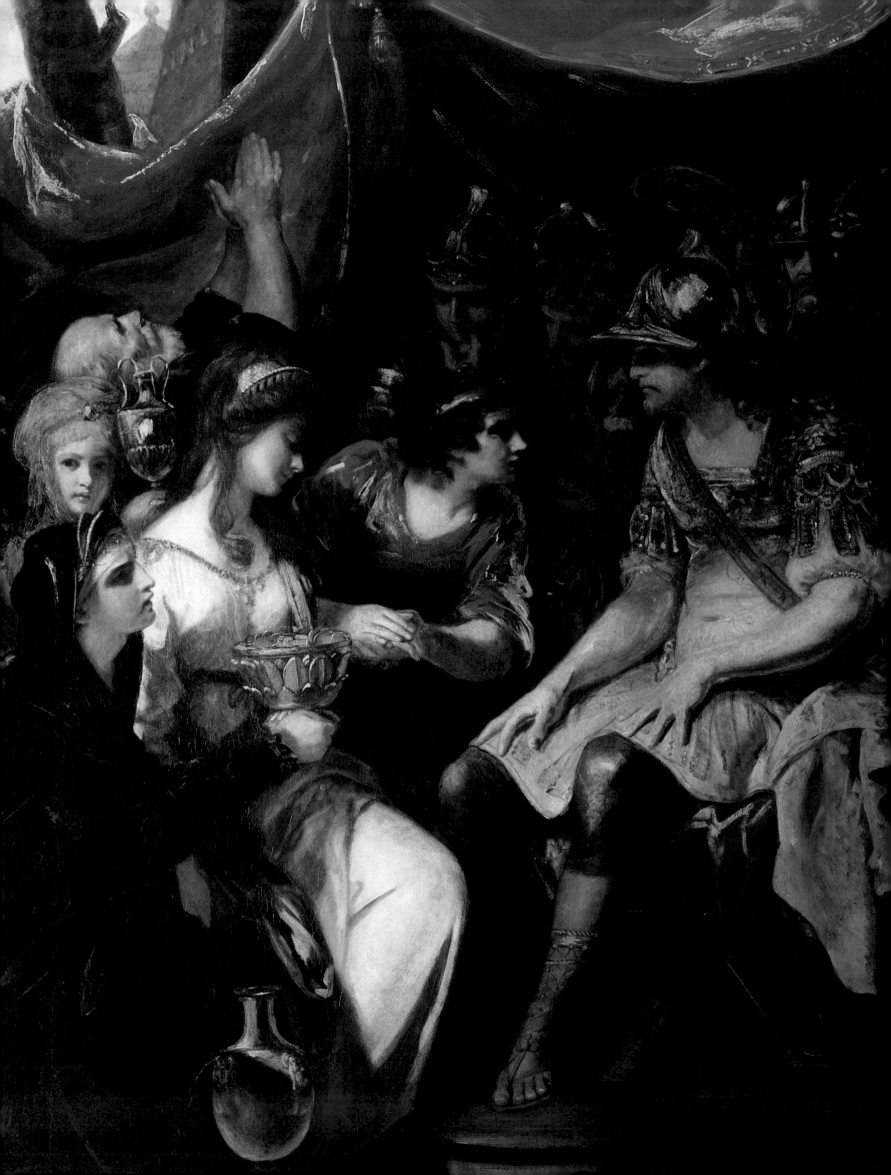

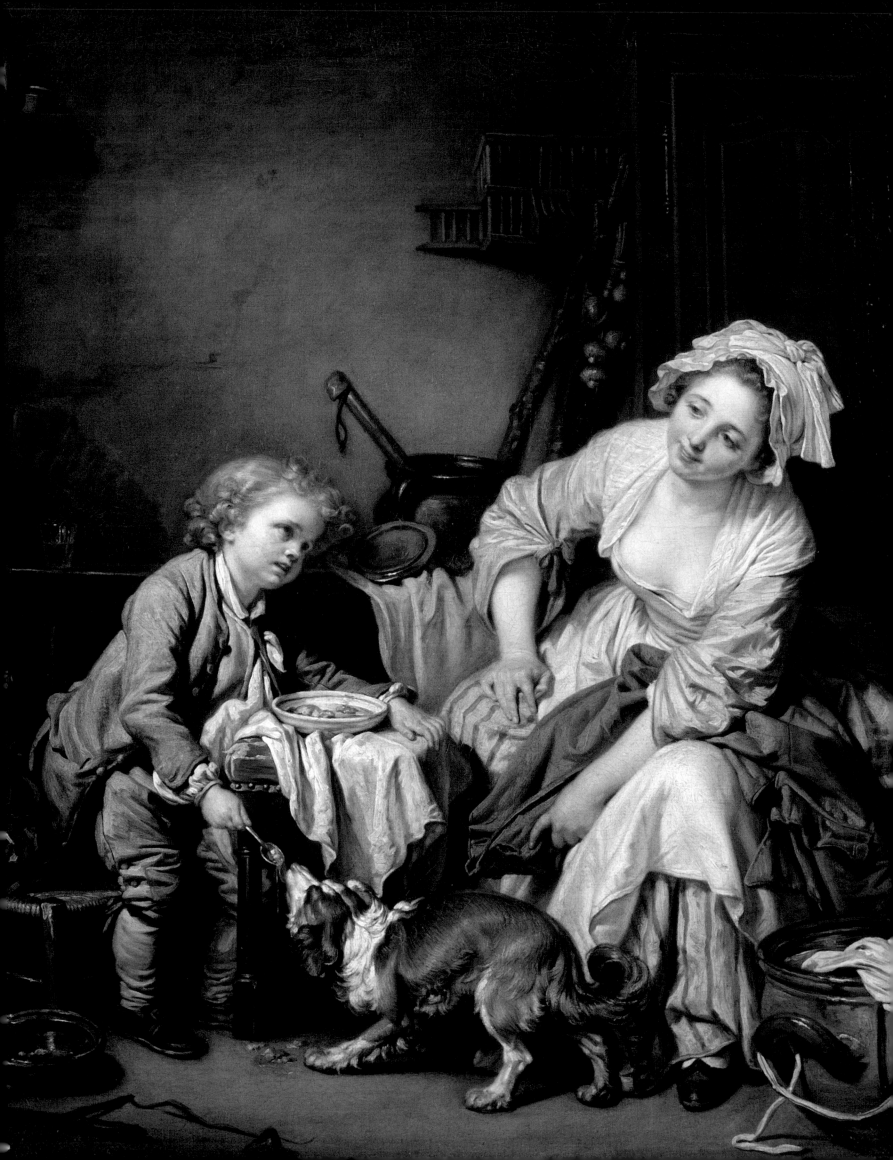

Prince
Alexander Bezborodko 1747-1799

Whereas the Orlov brothers and Grigory Potemkin came from the provincial nobility, Prince Bezborodko sprang from a family of senior Cossacks in the western regions only recently integrated to the Russian empire. The year in which Catherine II ascended the imperial throne, Alexander Bezborodko was a student in the Corps of Cadets in St. Petersburg, whence he entered the chancellery of Count Piotr Rumiantsev, governor of "Little Russia," as the Ukraine was then known. The empress, having noted how well composed the reports from this chancellery were, requested that one of the secretaries be sent to her. The choice fell on Zavadovsky and Bezborodko, who arrived in 1775. The first became the empress's favorite, for about a year and a half, while the second grew into an irreplaceable secretary (in her letters Catherine called him her *factotum*), then secretary of state, director of postal services and the imperial theaters, and eventually into a count, a prince, and, after the Peace of Jassy, a vice-chancellor (ill.86).

In 1783, the year the Crimea was annexed, Count Bezborodko, as he was then styled, had the architect Giacomo Quarenghi design for him a house next to the postal headquarters (ill.89). Beginning with the main entrance, fronted by a granite portico, its columns crowned with gilt-bronze capitals, every aspect of the splendidly furnished mansion served to emphasize the importance of the resident.

That same year, an astute courtier, Count Bezborodko engaged Dmitry Levitsky to execute a portrait of *Catherine II as legislator in the temple of the goddess Justice* (Russian Museum), a painting that appears to have been closely related to Gavriil Derzhavin's ode "Vision of Murza." Here the poet speaks of the altar at the foot of the divinity with its sticks of incense forever burning, symbols of an empress who neither slept nor rested in her commitment to the laws of her country.

It seems that another poet, Nikolai Lvov, together with Derzhavin, provided "ideological" inspiration for their patron at the same time as writing about him and his artistic archievements The latter described Bezborodko's palace in verses and urged Bezborodko not to be satisfied with surface brio in his ode "The Dignitary."

86

87

85. Jean-Baptiste Greuze
The Spoilt Child, 1765
Oil on canvas,
66.5 x 56 cm
Hermitage, St. Petersburg

86. Dmitry Levitsky
Portrait of Prince Alexander Bezborodko, c. 1795
Oil on canvas, 82 x 67 cm
Pavlosk Palace Museum

87. Etienne-Maurice Falconet
Cupid Making Threats, 1758
Marble, 85 cm
Hermitage, St. Petersburg

Alexander Bezborodko (ill. 86) amassed his collection, containing no fewer than three hundred paintings, within a mere five years, achieving this feat by turning the political and dynastic upheavals of the French Revolution to his advantage.
To the spoils of the Revolution he also added treasures from the dazzling collection of the Duc d'Orléans, the regrettable sale of which in London in 1798 released on to the market a number of masterpieces, including some from the Régent's collection.

88. The country residence of Prince Alexander Bezborodko, rebuilt by the architect Giacomo Quarenghi at Polustrovo, St. Petersburg

89. Giacomo Quarenghi
Design for the Bezborodko Palace, St. Petersburg
Drawing
Hermitage, St. Petersburg

At the center of the Bezborodko mansion was a painting gallery, which terminated in a half-domed niche housing a marble statue by Etienne-Maurice Falconet, the French sculptor who had been commissionned to create *the Bronze Horseman* which Catherine II had dedicated to Peter the Great on a site close to the Neva. Falconet's *Threatening Cupid* (ill.87) was displayed on a plinth that bore a two-line verse by Voltaire translated into Russian by Ivan Dmitriev :

Whoever you are, you see your master
Now, later, sooner or faster.

Derzhavin was even moved to compose an entire erotic poem dedicated to the sculpture. In 1795, the now Prince Bezborodko wrote to Ambassador Semyon Vorontsov: "Having already passed through several phases in my life, I'm now, all of a sudden, seized by a passion for paintings. The successive bankruptcies of the French have allowed me to acquire several excellent works, most of them from the Flemish school. In brief, thanks to my ardent passion and the help of friends, as well as a sum of 100,000 rubles spent for this purpose over a period of almost three years, I've been able to establish a beautiful collection that, in number as well as in quality, surpasses that of Stroganov (Alexander Sergeievich). I'm still waiting for several canvases from Warsaw and four others from Italy. Would it be possible to find something good in England so as to expand my gallery? I'm particularly interested in Italian pic-

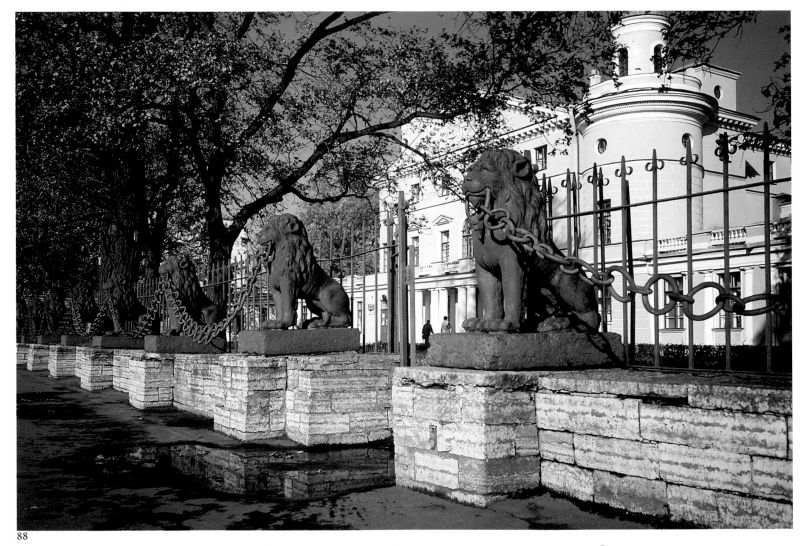

88

89

74

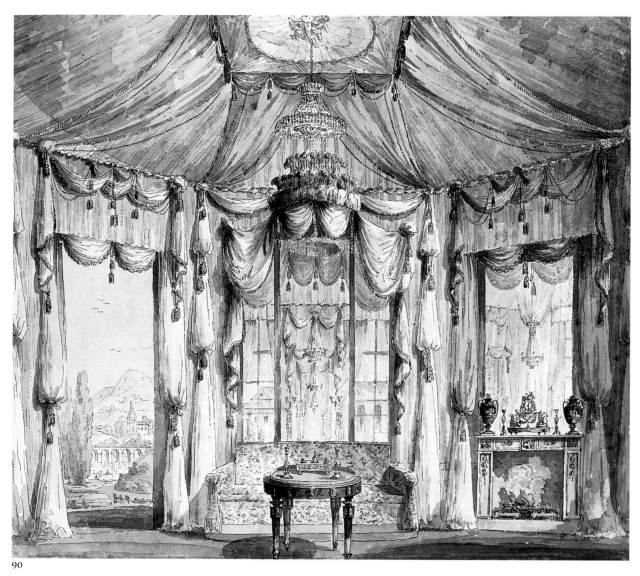

90

91

90. Nikolai Lvov
Design for a drawing-room in Alexander Bezborodko's residence
Drawing
Hermitage, St. Petersburg

91. *Sèvres vase*, c. 1780
Porcelain, gilt bronze;
height: 190 cm
Hermitage, St. Petersburg

The elaborate detail of the designs drawn up for decorative schemes for the Bezborodko residences (ill.90) accurately reflects the zealous and painstaking care that was lavished upon them at the time, and not only by the proprietor. A surviving design by Quarenghi for his St. Petersburg residence was laid out around an immense canvas by Hubert Robert entitled *The Washerwoman*, which was remarked upon by the Polish king Stanislas Augustus during his visit in 1797.

tures. As for landscapes, perhaps Claude Lorrain, none of whose work I own. I do possess a Salvator Rosa, not to be equalled by any in the Hermitage, and often Stroganov and the professors (of the Academy of Fine Arts) come to admire it in my house."

Stanislas II Augustus, the exiled king of Poland, offered Bezborodko two paintings from his own collection, *The Miraculous Draft of Fishes*, attributed to Rubens's atelier (Museum of Fine Arts, Irkutsk), and Nicholaes Maes's *Crown of Thorns*. In 1798 the happy collector wrote to Nikolai Lvov: "The King of Poland has offered me two famous pictures. The first, *The Acts of St. Paul*, is a large Rubens in which the apostles are rendered as fishermen." In the same letter he also mentions the acquisition of an "excellent Greuze," *The Spoilt Child* (ill. 85).

When Prince Bezborodko told his friends about some new acquisition, his tone was always exultant. To Lvov he wrote: "Four Batonis, which the Poles judge to be 'very good' and which truly are among the best things here. . . ." Two of these admirable pictures, *Minerva, Protectress of the Arts* and *Voluptuousness (Beauty Seduced by Riches)* are today in the Hermitage.

In the bedchamber at his residence were a marble bust by Fedot Shubin (Russian Museum), sixteen landscapes by Claude Joseph Vernet, as well as a large silver cup on a pedestal made by Bunzel. It had been crafted after a drawing by Nikolai Lvov and depicted the major events of Catherine II's reign (Hermitage).

Prince Bezborodko took great pride in an enormous Sèvres porcelain vase, no less than two meters high, which the owner fondly called "my little blue wine cask" (Hermitage ; ill.91), and in the Meissonier silver services which he had acquired from the collection of the Duchess of Kingston, all mingled together with Greek vases from the collection of Count Mikhail Valitski (Hermitage).

In the summer of 1797 Prince Bezborodko wrote to his nephew Grigory Miloradovich: "Just arrived are two groups of bronzes from the famous Girardon, which Colbert himself had presented to Louis XIV. One of them features the Abduction of Proserpine by Pluto; the other, the Abduction of Oreithyia by Boreas on a Boulle pedestal." In the nineteenth century these bronze pieces could still be seen in the house of Grigory Kushelev near the Simeon Bridge in St. Petersburg.

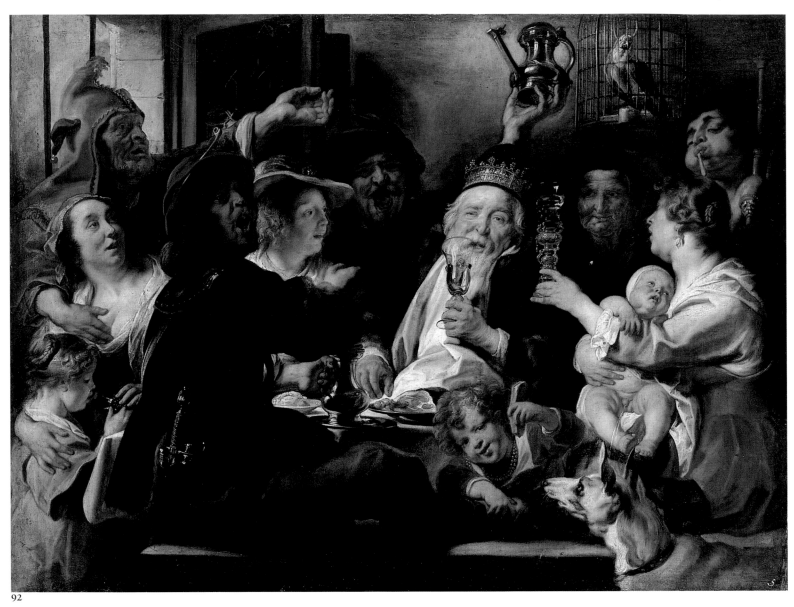

92

92. Jacob Jordaens
The Bean King, c. 1638
Oil on canvas,
157 x 211 cm
Hermitage, St. Petersburg

93. Peter-Paul Rubens
*Christ wearing the Crown of
Thorns,* before 1612
Oil on canvas,
125.7 x 96.5 cm
Hermitage, St. Petersburg

In the eyes of some
observers Rubens pushed
artistic boldness to new
extremes, endowing the
face of Christ in his *Ecce
Homo* in the Bezborodko
collection (ill.93) with his
own features.

In Moscow Quarenghi designed a palace for Prince Bezborodko, a structure that now houses the Bauman Technical College. While thinking about this new residence, Bezborodko wrote to his friend Semyon Vorontsov: "I have decided to spend the money for a new house in Moscow, which will at least show future generations that taste existed in our century and in our country."

A bachelor without issue, Prince Bezborodko quite naturally worried about the fate of his art collections. Above all, he wanted the painting gallery to remain intact, and so toward the end of his life he drew up a testamentary note: "The pictures that constitute the best part of my movable possessions, my treasure, are not to be sold for the maintenance of my brother and my nephew, because they can easily do without it." Unfortunately, the gallery would subsequently be parceled out between the prince's nieces, Liubov

Kusheleva and Cleopatra Lobanova-Rostovskaia. Later their sons would both buy back or resell the *objets d'art* and paintings originally amassed by Alexander. Finally, in 1869, a large auction was held in Paris.

Not until the arrival of Count Nikolai Kushelev-Bezborodko (1834–1862) did a Bezborodko descendant seize the torch of the prince-collector. Count Nikolai set about acquiring a number of then contemporary romantic and Barbizon school paintings; equally important, he stopped the dispersal of the family collections, simply by leaving them to the Academy of Fine Arts. From there many of the canvases passed into the Hermitage, following the Revolution of October 1917. Others would find their way to Irkutsk and Kishynev, the Pushkin Museum of Fine Arts in Moscow, and the palace at Ostankino near the capital, as well as abroad, including Kiev, Prague, London, Helsinki, Dublin, Philadelphia, and Rio de Janeiro.

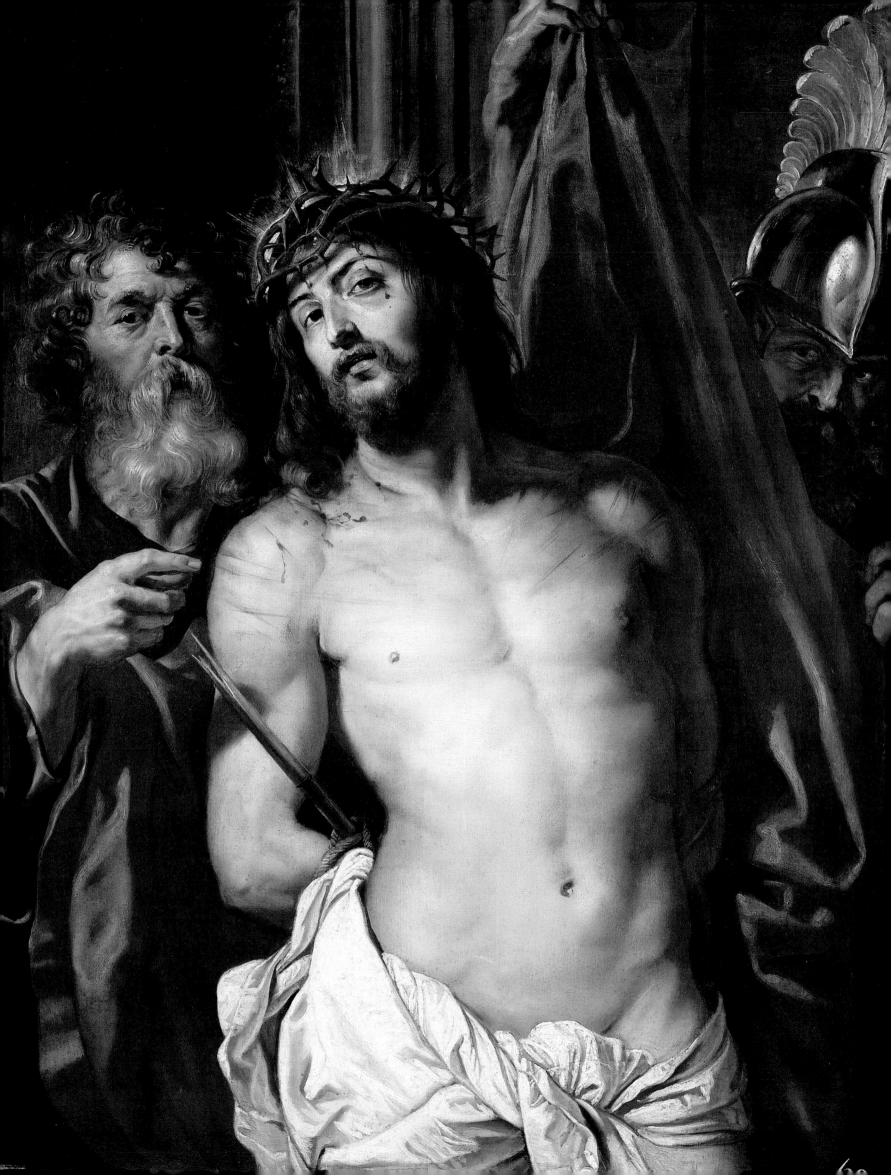

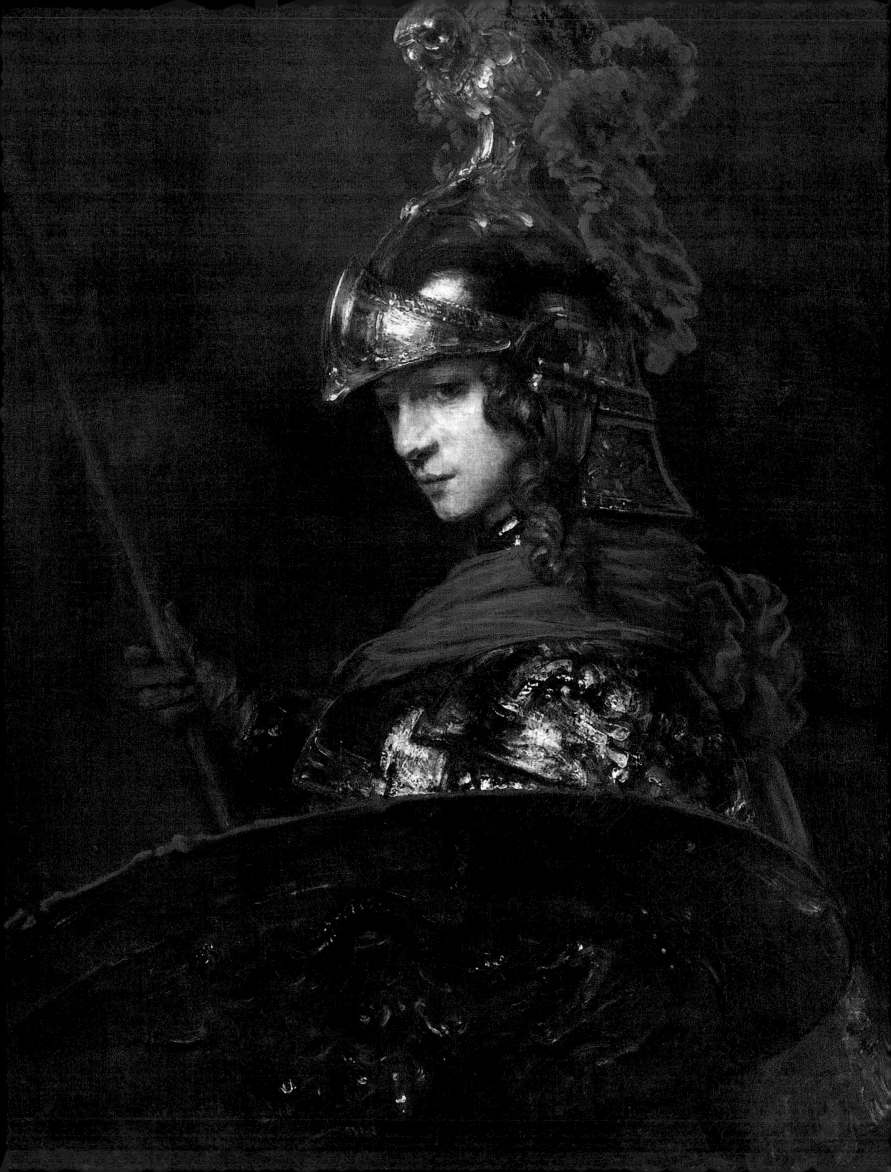

Alexander Lanskoi

From the age of twelve Alexander Lanskoi (ill.95) grew up at the court of Catherine II as a playmate and school companion of Grand Duke Pavel Petrovich and Alexei Bobrinsky, the latter being the empress's son by Grigory Orlov. Lanskoi himself was the son of a Smolensk military officer with the rank of lieutenant in the cavalry regiment. The rise of young Lanskoi began in 1778. During the autumn of the previous year he had been a staff officer under Grigory Potemkin, before entering the imperial palace as *aide-de-camp* to Catherine the Great. She had Major Ivan Nikolaievich Korsakov as a favorite before Potemkin engineered the arrival of his enchanting, beautifully mannered, and high born fellow horse guardsman Sasha (a nickname for Alexander) Lanskoi. Catherine's secretary Alexander Bezborodko described him as "a veritable angel," and he was an ideal companion and pupil for Catherine, who developed his taste for painting and architecture.

The Lanskoi family took little pleasure in this promotion, finding it scandalous that their strapping son had become the favorite of an aging fifty-one year old empress. For his Morshansk estate, Sasha's brother Yakov Lanskoi commissioned a painting entitled *The Last Judgment*, with the Lanksoy family portrayed as the just in Heaven, except for Alexander, shown as disfigured by the fires of Gehenna where he must expiate his degrading sins. Nonetheless, it was directly on Palace Square, facing the Winter Palace itself, that the architect Yuri Felten built the residence of the new favorite.

The first collections assembled by Alexander Lanskoi were modest, limited it would seem, to a library and a group of miniatures, the latter copies from the imperial collection. Catherine II, for example, wrote to her "agent" Baron Grimm, playfully pretending to be Lanskoi's secretary: "The head by Greuze is much coveted by General Lanskoi. If you procure him a miniature copy of it in enamel, he will jump like a deer, and his already beautiful coloring will become still more vivid. . . ." Baron Grimm carried out his commission, replying in kind to Her Majesty's pleasantry and making cautionary remarks about the collecting *"maladies"* suffered by the protégé: "As for these *maladies*, part and parcel of general gluttony, I have seen some formidable symptoms in my role as imperial *archiatre* (doctor) for this sort of infirmity." Soon Alexander would begin amassing prints as well. Once again, Baron

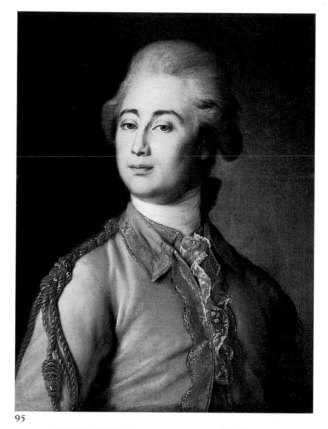

95

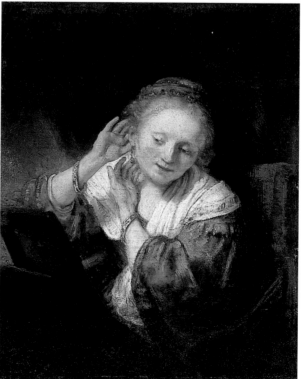

96

94. Rembrandt van Rijn
Athena (Alexander the Great),
1663
Oil on canvas,
118 x 91 cm
Gulbenkian Foundation,
Lisbon

95. Dmitry Levitsky
Portrait of Alexander Lanskoi,
1790
Oil on canvas,
62.8 x 49.7 cm
Tretyakov Gallery, Moscow

96. Rembrandt van Rijn
Young Woman with Earrings,
1657
Oil on canvas.
39.5 x 32.5 cm
Hermitage, St. Petersburg

So discerning and confident an eye did Alexander Lanskoi (ill.95) display in the selection of the works that made up his collection—not to mention his library—that it is easy to forget that he was only a young man of twenty at the time.

Lanskoi's residence, which stood opposite that of Catherine the Great on Winter Palace square itself, was reputed to be filled with treasures from floor to ceiling. His voraciousness as a collector prompted the empress to write to Baron Grimm, her agent in Paris: "You are my whipping boy, but M. Lanskoi has many more working for him throughout the city."

97. Giovanni da Bologna
(Giambologna)
*Hercules and the Sacred Hind of
Arcadia*
Patinated bronze; height:
38 cm
Hermitage, St. Petersburg

98. Giuseppe Valadier
"Breteuil" surtout de table
Marble and coloured
stones, gilt bronze; height:
30 cm
Hermitage, St. Petersburg

Like Catherine the Great
and many other
connoisseurs at this time,
Lanskoi was obsessed with
antiquity. The empress
bought an imposing *surtout
de table* in coloured stones
and gilt bronze, after
designs by the great Roman
goldsmith Giuseppe
Valadier (ill.98), from the
French diplomat the Baron
de Breteuil and
subsequently offered it to
her favorite as a gift.

Grimm takes the role of the stricken favorite and offers his empress a mock lesson in how the collecting disease is likely to progress: "Until now I have been quite happy with a fine black-and-white sheet representing [Raphael's] School of Athens; now, however, should I not require a colored one? Then it will be an Aurora by Guido, and then a third print, after which the malady becomes incurable."

In 1781 Catherine II asked Baron Grimm to acquire for her the Baudouin collection of paintings and the engraved gemstones belonging to Louis de Breteuil: "You would do well . . . to make haste to Lübeck so that by spring the whole will arrive here. Truth to tell, it is not for me, but I will pay you, if you please, out of my own money and as if it were for me." This collection, that she gave to Lanskoi, contained 119 canvases, among which were nine Rembrandts, six Van Dycks, four Van Ostades, and three Ruysdaels. The collections were dispersed after the Revolution and now Van Dyck's *Portrait of Jan van den Wouwer* hangs in the Pushkin Museum of Fine Arts in Moscow. Rembrandt's *Denial of Peter* and *Portrait of Titus* are now both at the Rijksmuseum in Amsterdam, while his *Alexander the Great* (ill.94) hangs at the Gulbenkian Foundation in Lisbon; the rest are now preserved at the Hermitage. Many of the miniatures made for Lanskoi by Piotr Jarkov belong to the Russian Museum in St. Petersburg.

In addition to paintings, Lanskoi possessed not only prints, gems, and coins but also several dozen small bronzes (now in the Hermitage) and other precious objects. One particularly interesting work is a table decoration made of colored gemstones, a work by the Roman artist Giuseppe Valadier. It had arrived in the Russian capital in 1777, only to disappear from the Hermitage inventories by the end of the eighteenth century. The piece did not return to the museum until the beginning of the twentieth century. In 1926 it was joined by Valadier's album of watercolors. Spread out upon the table, the ensemble measures more than seven feet in length and features images of the major buildings and monuments of ancient Rome (ill.98).

In the summer of 1784 Lanskoi came down with diphtheria and died. On July 27 of that year the empress wrote to Baron Grimm: "My happiness is over. I thought I too would die at the irreparable loss of my best friend just eight days ago. Sobbing and in deep sorrow, I must tell you that General Lanskoi is no more."

Catherine repurchased from her favorite's heirs the whole of his collections and library. She also had the splendid parquets in the Lanskoi residence taken up and reinstalled in the Agate Rooms at Tsarskoie Selo. The grieving monarch commissioned Karl Leberecht to create a medal representing, on one side, the portrait of the deceased favorite and, on the other, an obelisk with the inscription: "From Catherine, to friendship." In the park at Tsarskoie Selo, the architext Charles Cameron erected a monument to Lanskoi emblazoned with the same [larger] medal together with another line, inscribed above: "What great pleasure for noble souls to see virtue and merit crowned by praise from all." In 1830 Tsar Nicholas I had the bronze plaque removed, deeming it "too compromising for the dynasty." He also had Levitsky's portrait of Lanskoi removed from the Hermitage exclaiming "It has no place here!"

There is no denying, however, that during the few years allowed to him, Alexander Lanskoi became a collector and bibliophile of the first order. After his death Catherine II wrote: "I hoped that he might become the helpmeet of my old age. He applied himself, he learned, he acquired my taste. When I was raising this young man, he shared my problems when I had any and took pleasure in my joys." As for contemporaries, they were unanimous in judging him the best of the favorites taken up by the Russian empress.

Only Nicolas I and the intransigent Lanskoi family strove, obstinately, to erase the young favorite from the collective Russian memory. Later Prince Alexei Borisovich Lobanov-Rostovsky (1825-1896) purchased the Levitsky portrait after discovering it in an old villa abandoned by the Lanskois who would bitterly reproach the sellers: "We ourselves would happily have paid ten times the price simply to expunge his memory from the history of our family."

97

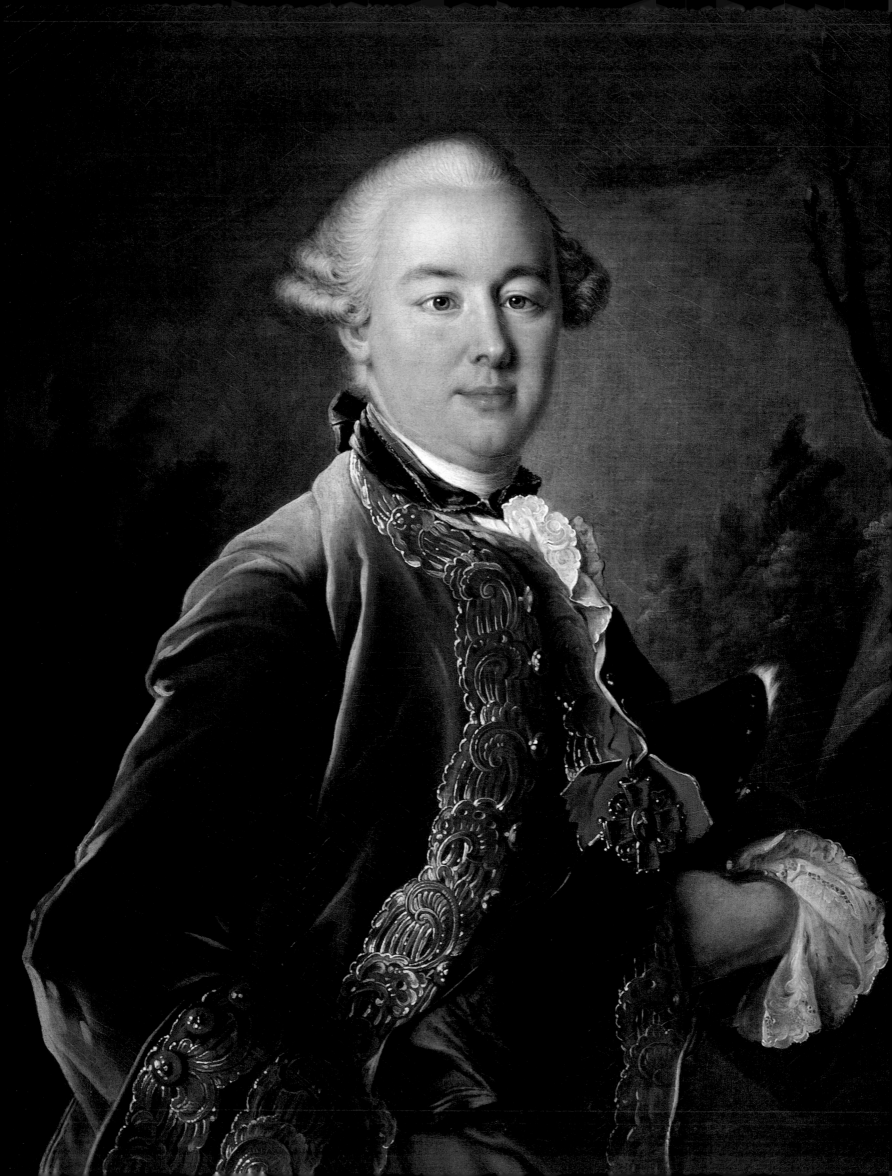

The Sheremetevs

The Sheremetevs first came to the fore in the six-teenth century as boyars and military com-manders. By the beginning of the eighteenth century Boris Petrovich Sheremetev (1652-1719), who had been one of Peter the Great's field marshals, already had the instincts of a collector. Describing his foreign travels at the end of the 1690s, where his interest for art began, Count Boris boasted that in Vienna he had received "several valuable paintings." In Rome the pope presented him with an image of "the Savior at prayer in the Garden of Olives before the Passion." Meanwhile, cardinals and bishops also made gifts to the Russian dignitary including "a box in worked silver, set with pre-cious stones, as well as a cup made of seashell, incrusted with silver and gold." This nautilus cup remained, until the Revolution of 1917, at the Sheremetev residence in St. Petersburg known as "Fontanny Dom," or the "Fountain House," that was first built in 1712 on the Fontanka Canal as a one-story wooden dwelling.

Count Boris can be justly considered the founder of the collections owned by this illustrious family as it was during his lifetime that the Sheremetev houses began to be furnished with pictures and prints, mirrors and costly furnishings, silver vessels, and Chinese and European porcelain. Count Boris, like Peter the Great, also started a family *Kunstkammer*, a haven for all man-ner of "curiosities," including shells, botanical illustra-tions, war trophies, and other collectibles.

Piotr Borisovich Sheremetev (1713–1788; ill. 99), the marshal's second son, married Princess Varvara Cherkaskaia, a wealthy heiress and lady in waiting at court, thus becoming one of the richest men in Russia. He was now the largest serf owner after the tsar as Varvara herself brought 60,000 serfs to the family. Piotr Sheremetev commissioned Savva Shevakinsky to design a new palace on the Fontanka (ill.104). At his Kuskovo estate near Moscow (ill.105), Count Piotr set up a gallery hung with five hundred paintings, a good many of them portraits—those of the count and his wife had been executed by the French painter Louis Tocqué. However, it was to the Argunovs, a dynasty of local artists who were his serfs on the Kuskovo estate, that Count Piotr turned for the portraits of his con-temporaries and ancestors. Ivan Argunov alone painted a dozen members of the Sheremetev family (ill.99).

The picture collection at Kuskovo grew so large that special buildings had to be constructed to house it: the

100

101

99. Ivan Argunov
Portrait of Count Piotr Borisovich Sheremetev, c. 1760
Oil on canvas,
92 x 73.5 cm
Ostankino Palace Museum, Moscow

100. Nikolai Argunov
Portrait of Countess Praskovia Ivanovna Sheremeteva, known as *"Portrait with a Red Shawl,"*
1789
Oil on canvas
Kuskovo Palace Museum, Moscow

101. Nikolai Argunov
Portrait of Count Nikolai Petrovich Sheremetev
Oil on canvas, 67 x 54 cm
Rostov-Yaroslavl Museum

The Sheremetev family was typical of the Russian aristocratic dynasties who took up residence in St. Petersburg in the wake of the tsars but never forgot their Muscovite roots. Count Piotr Borisovich (ill.99) divided his time between his St. Petersburg palace on the Fontanka, built by Shevakinsky c.1730-40 (ill.104), and his estates at Kuskovo, on the outskirts of Moscow. There, he made it a point of honor to encourage his master serfs to perfect their craftsmanship, to the point where they rivaled the most accomplished professionals. One of these serfs, Nikifor Vasiliev, created marquetry work of virtuoso skill, while another family on the estate, the Argunovs, produced three generations of portrait painters (ill.99-101).

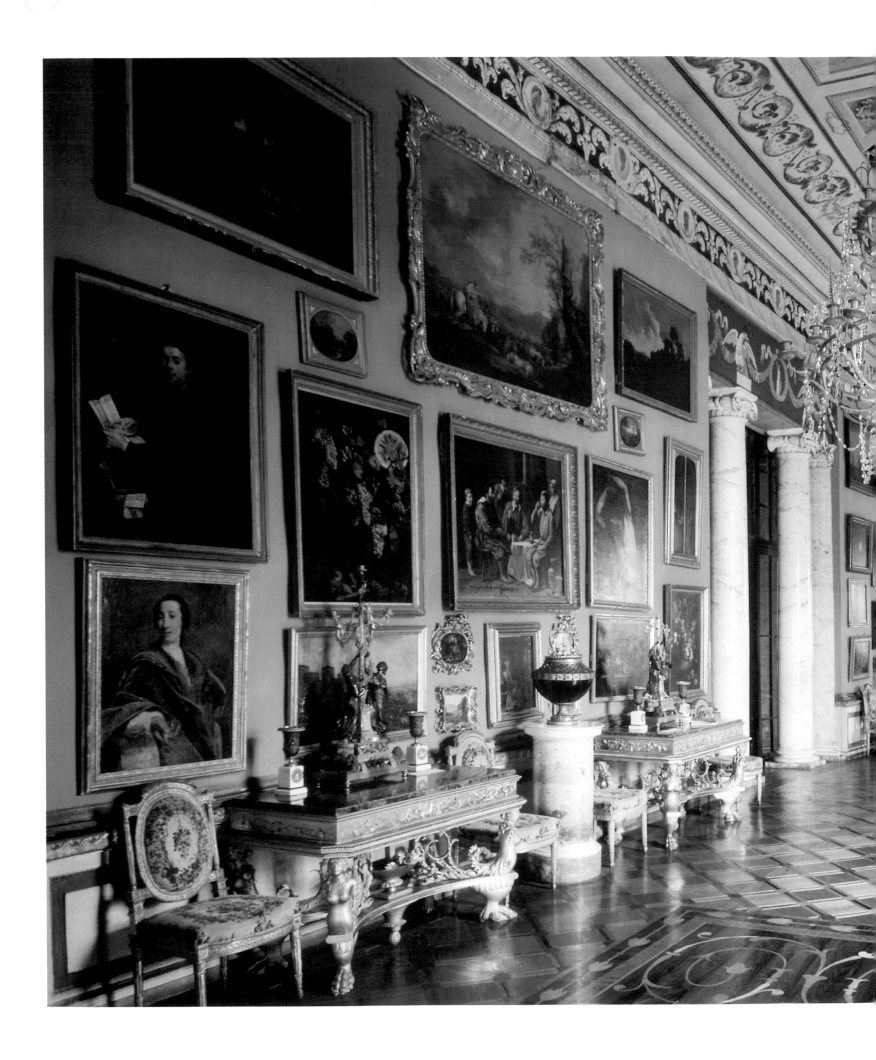

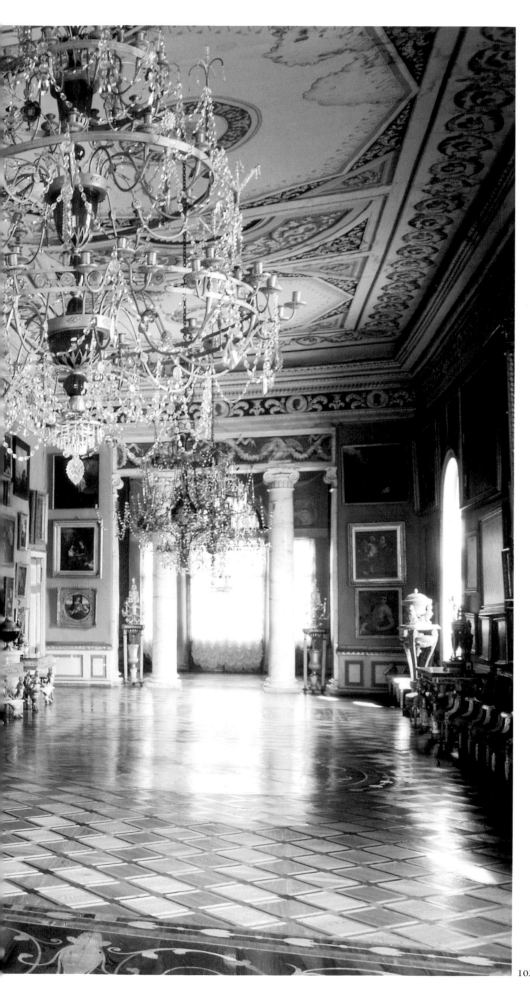

102. The painting gallery in the Ostankino Palace, Moscow

103. Christophe Ritter
Covered cup, late 16th century
Chased silvergilt; height
25.5 cm
Hermitage, St. Petersburg

Preserved–uniquely in Russia–with its late eighteenth-century décor, furniture and collections virtually intact, Ostankino Palace (ill.102) bears witness to the enlightened interests of the great Russian noble Nikolai Petrovich Sheremetev, who was so liberal in his views that he displayed no compunction in marrying one of the female serf actresses from his private theater troupe.
The count made a point of keeping up with all the latest fashionable plays in Paris, having them translated into Russian to be performed by his own actors.

102 103

104. The Sheremetev Palace in St. Petersburg, known as the "Fountain House"

105. The Ostankino Palace, Moscow, built for Count Nikolai Petrovich Sheremetev in 1790

106. Elevation of the Ostankino Palace, shown in cross-section

The private theater at Ostankino, occupying the central section of the palace (ill.105), was a rare combination of elegance and technical bravura. When the Polish king Stanislas Augustus visited Ostankino in 1797, he was astonished to find that, when all the guests left the theater after watching a play, they were able to return within less than half an hour to find that the auditorium had been transformed into a ballroom, with polished floorboards where only a few minutes before the stage and orchestra pit had been.
So consuming was Nikolai Petrovich Sheremetev's passion for the theater that he had one also installed in his palace on the Fontanka (ill.104).

Dutch Maisonette for the Dutch school (1749–51) and the Italian Maisonette for the Italian school (1754–55). One part of the collections was kept at "Fountain House", which also by then contained the marshal's *Kunstkammer*. An inventory of 1764 suggests that this "cabinet of curiosities" filled several rooms. Once married, Count Piotr retired and settled in Moscow in 1768.

At his death the collections passed to his son Nikolai Petrovich (1751–1809 ; ill.101). Collector and patron like his ancestors, Count Nikolai also had a passion for theater, which he indulged by commissioning a veritable palace of the arts at his estate at Ostankino near Moscow, where the collections and the theatre came together as a whole (ill. 102 and 105). The construction got under way on a large scale after a design competition was held in 1790 (ill. 106).

Without question, the builder of the Ostankino palace was the most important collector in the five generations of Sheremetevs. Count Nikolai, too, never ceased to be involved with the talented Argunov family. In 1795, after moving to St. Petersburg, he wrote to his steward concerning Nikolai Argunov: "My plan is to have him come and spend some time here, at the court gallery, where skilled masters make copies of the most beautiful and rare canvases, so that he can observe and thus perfect his own art."

However, Count Nikolai dedicated the greater part of his patronage to the theater. On April 13, 1797, he brought to Ostankino an opera by the French composer André Grétry, to celebrate Tsar Paul I following his coronation in Moscow; later that year the production was repeated for the former King of Poland, Stanislas II Augustus. So taken by the theater, Nikolai married his leading actress Praskovia Kovaleva, a Sheremetev serf whose stage name was Zhemchugova (or Pearl) (ill.100). Having freed her in 1798, he married her in 1801. Just two years later she died giving birth to an heir. Anxious to legalize his son's existence, Count Nikolai made an official request that his marriage to the former serf actress be recognized. Dmitry Troshchinsky, secretary of state to Alexander I, replied as follows: "His Imperial Majesty has deigned to reply that you are free to contract the marriage, on the date and with the person of your choosing, and that these

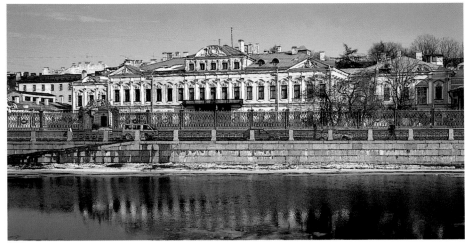

104

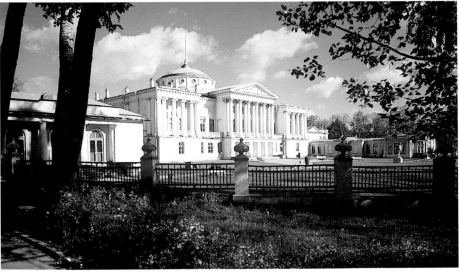

105

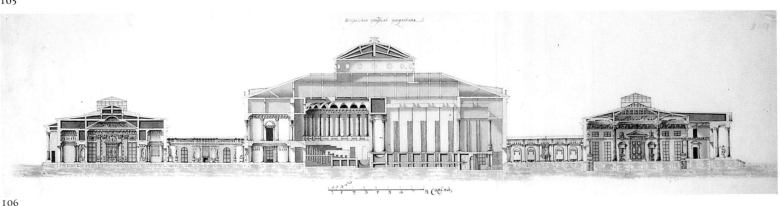

106

107

108

circumstances in no way alter the favorable disposition that His Imperial Majesty maintains in your regard."

Their son, Count Dmitry Nikolaievich Sheremetev (1803–1871), continued the work of his father, becoming the patron of the painter Orest Kiprensky. He also undertook to redecorate the palace on the Fontanka which, as a reflection of the Sheremetev's wealth, had passed through several architects including Starov, Quarenghi, and Voronikhin. Count Dmitry's son, Sergei Sheremetev (1844–1918; ill. 107), "was one of the last supporters of the culture of Russian estate owners," as Yuri Bakhrushin put it. Interested primarily in history, Count Sergei published, in a dozen volumes, the works of the poet and historian Pavel Viazemsky. In his will he wrote these words addressed to his son Pavel: "After us be also the conservator of the written witnesses to the past life. Preserve these sentiments with a love for your country, and transmit to the following generation the devotion of our old line which has served its nation with honesty."

On January 22, 1918, Pavel Sheremetev, handed the keys of the Palace to the Department for the Protection of Monuments of the Past of the Soviet of the Worker and Soldier Deputies. It was opened as a "Museum of Eighteenth-Century Life," which, however, closed in the mid-1920s, leaving the Sheremetev art collections to be dispersed. The palace fell into disrepair after the Revolution, but has been beautifully restored. It presently contains a museum of musical instruments as well as several rooms displaying private collections formed in the twentieth century and others devoted to the much-loved poet Anna Akhmatova, who lived there from 1924 to 1952.

109

107. Count Sergei Dmitrievich Sheremetev, c. 1900

108. The porcelain collection of Count Sergei Dmitrievich Sheremetev, late 19th century

109. The cabinet of Count Sergei Dmitrievich Sheremetev on his estate at Mikhailovskoie, in the district of Podolsk, province of Moscow, late 19th century

Count Sergei Dmitrievich Sheremetev (ill.107) was the very epitome of the great Russian aristocrat and intellectual, who viewed the advancement of knowledge (in his case through historical research) as a patriotic duty. Instead of making his career within the imperial civil service, he chose to devote his life to study–and the publication–of the extensive Sheremetev family archives, believing that in so doing he was making a more useful contribution to society. Clearly imbued with the same spirit of altruism, in January 1918 his son Count Pavel Sergeievich made a most unexpected gesture, solemnly handing over the keys of the Fontanka Palace–and of its collections–to the Petrograd Soviet.

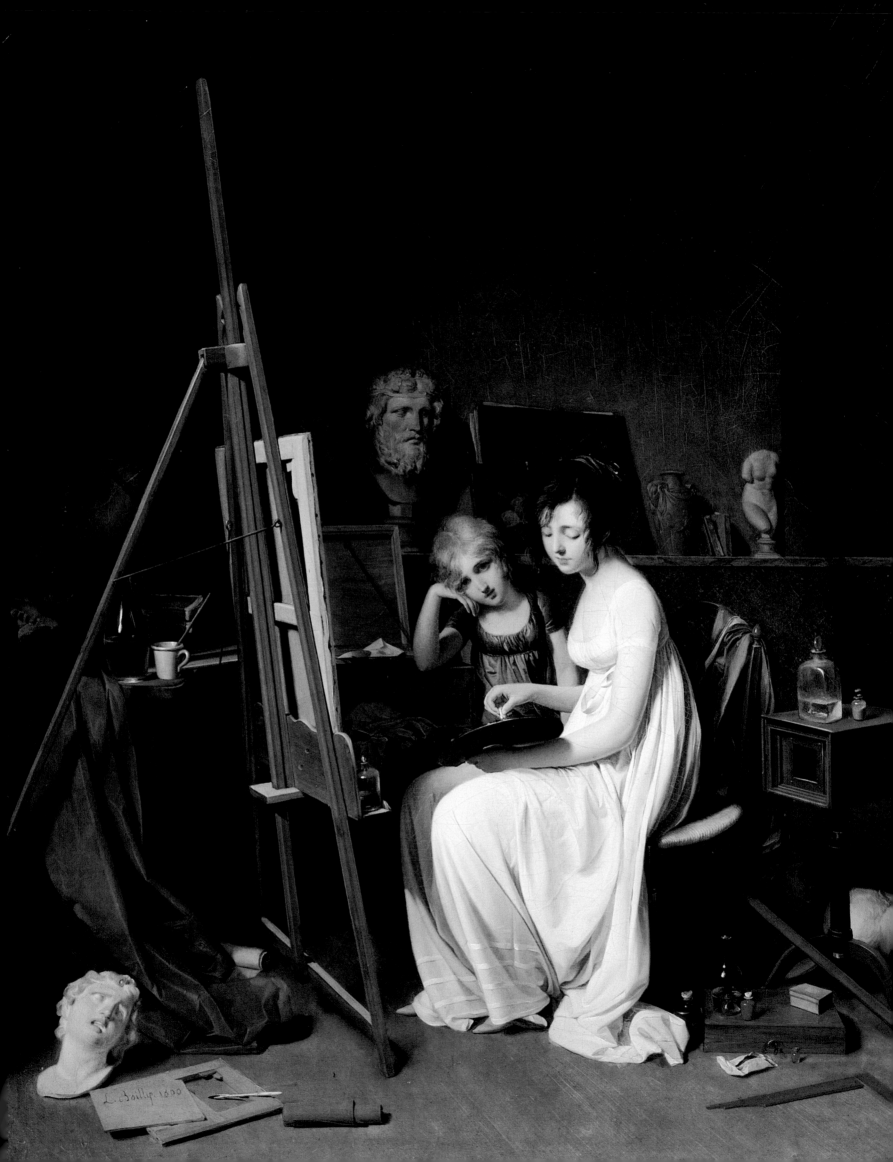

The Yussupovs

Legend has it that the Yussupov line stretches back to an ancient Arabian family of great antiquity, and notably to Al-Omar Abubekir ben Raiok, believed to be the ancestor of Yussuf, a powerful sixteenth-century khan of the Mongol tribe known to history as the Golden Horde. Yussuf maintained friendly relations with Russia and his sons were received at court in Moscow, where they were offered extensive lands in recognition of their services. In the following century one of their descendants, Abdul Murza, settled permanently in Russia, converted to the Orthodox religion and took the name Prince Dmitry Yussupov (d. 1694). His grandson, Boris Grigorievich (1696–1759), held a high office at the court of Empress Elizabeth I and was the first Yussupov to visit Europe, so anticipating the career of his son Prince Nikolai Borisovich (1751–1831; ill.111), the Yussupov family's first—and greatest—collector.

After serving in the imperial guard, Nikolai Borisovich embarked on his first journey to the West: he was to be away for three years, from 1774 to 1777, on a tour that was to prove a turning point in his life. The budding connoisseur first attended lectures at the University of Leiden, before visiting London, Madrid, Paris, and finally Italy. While in Paris he was introduced to the city's flourishing art market, stimulated during this period by sales of paintings belonging to, among others, the Prince de Conti, the Duc de Saint-Aignan and the farmers-general Blondel de Gagny and Randon de Boisset. Within a year of Yussupov's return to St. Petersburg, in 1778, the visiting German astronomer Bernoulli described his collection as remarkable, not only for its paintings but also for its intaglios.

In 1782, Nikolai Borisovich left Russia once more, this time in order to join the heirs to the imperial throne (traveling as the Comte and Comtesse du Nord) on a grand tour of Europe that they had undertaken the year before and was to last eighteen months. As Tsarevich Pavel Petrovich had inherited the tastes of his mother Catherine the Great, no leg of this journey with Grand Duchess Maria Feodorovna was complete without a visit to the studios of the greatest artists then active in each country. In Rome these included Pompeo Batoni, Angelika Kauffmann, and Jakob Philipp Hackert, and in Paris Claude Joseph Vernet,

111

112

110. Louis-Léopold Boilly
Studio of a Lady Artist, 1800
Oil on canvas, 63 x 51 cm
Pushkin Museum of
Fine Arts, Moscow

111. Heinrich Füger
*Portrait of Prince Nikolai
Borisovich Yussupov,* 1783
Oil on canvas,
112 x 87 cm
Hermitage, St. Petersburg

112. Antoine, Baron Gros
*Equestrian portrait of Prince
Boris Nikolaievich Yussupov,*
1809
Oil on canvas,
321 x 835 cm
Pushkin Museum of
Fine Arts, Moscow

Nikolai Borisovich Yussupov (ill.111) was, with Ivan Shuvalov and Alexander Sergeievich Stroganov, one of the most cosmopolitan and enlightened connoisseurs of art that Russia has ever known. In the course of his life, which straddled two centuries and was an unusually long one for the period, he occupied numerous posts both within Russia and abroad. This gave him the opportunity to nurture his tastes and to assemble an outstanding collection of masterpieces; Italian, Dutch, Flemish and above all French works which remain today one of the crowning glories of the Russian museums. He had his son, Prince Boris Nikolaievich, portrayed by Baron Gros, wearing a seemingly Mongol costume to echo their illustrious ancestry (ill.112).

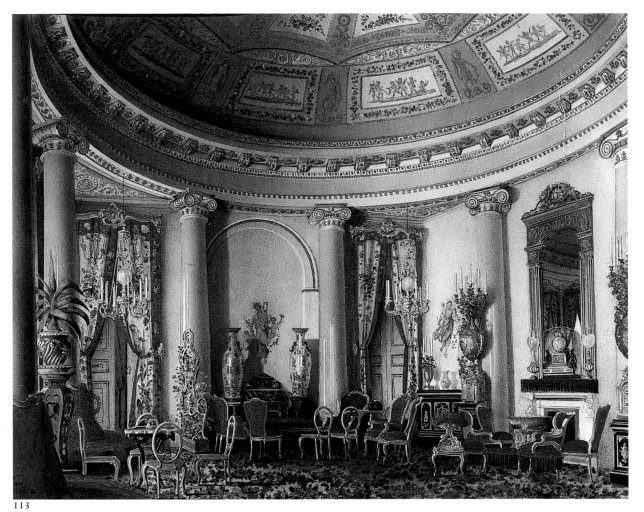

113

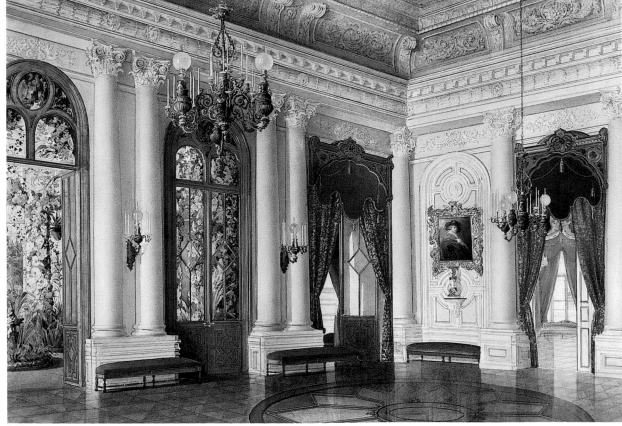

114

113. A. Redkovsky
*The Rotunda in the Yussupov Palace on the Moika,
St. Petersburg*, 1867
Watercolor
Russian Museum,
St. Petersburg

114. A. Redkovsky
*The White Hall in the Yussupov Palace on the Moika,
St. Petersburg*, 1866
Russian Museum,
St. Petersburg

115. The Theater in the Yussupov Palace on the Moika, St. Petersburg

Over the years the Yussupovs made their residences in a succession of different palaces in St. Petersburg. The first (home to Boris Grigorievich, father of Nikolai) stood on Millionnaia Street. Here Nikolai Borisovich had spent a few years before, on his return from Europe in 1790, commissioning the architect Quarenghi to build a new residence on the Fontanka. This was sold when he left St. Petersburg for Moscow, and it was his son Boris Nikolaievich who was to bring the collections back to St. Petersburg.
There he installed them in a new palace on the Moika, sumptuously refurbished by the architect Mikhailov, as testified by watercolors painted in the 1860s.
In the painting of the *Salle Blanche* or White Hall (ill.114) it is even possible to identify the portrait of himself in Spanish costume that Nikolai Borisovich commissioned from the Austrian painter Füger. Another program of refurbishment in the late nineteenth century was to endow the palace with a spectacular private theater in the Baroque style (ill.115).

90

115

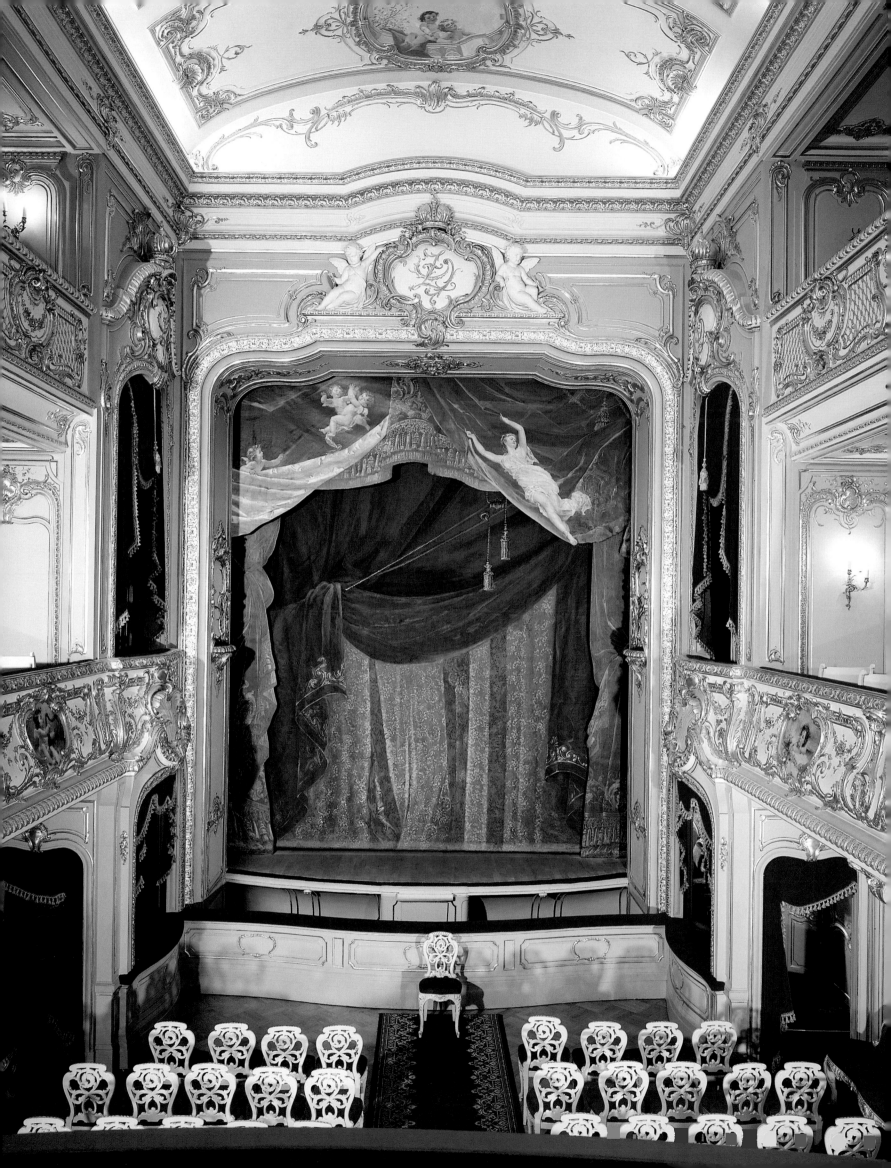

Hubert Robert, Jean-Baptiste Greuze, and Jean-Antoine Houdon.

In 1784 Yussupov was appointed envoy plenipotentiary to Italy, where he spent a period of five years in Turin, Rome, Naples, and Venice. He used this as an opportunity to forge special relationships with the connoisseur Reiffenstein (already an agent for Catherine the Great) and the banker-painter-antiquary Thomas Jenkins, who specialized in dealing in antique sculptures. While continuing to expand his collection of old masters, Yussupov now developed an even more avid interest in works by contemporary artists, commissioning paintings from Angelika Kauffmann, Batoni, and the landscape painter Hackert. In Paris, meanwhile, he not only offered commissions to Vernet, Robert, and Greuze but also kept up lengthy correspondences with them, so keeping abreast of the latest developments in the art world and of the most recent works by artists such as Fragonard, Elizabeth Vigée-Lebrun, and François-André Vincent.

On his return to Russia in 1789, Yussupov was awarded a string of distinguished appointments. As director of the imperial theaters from 1791 to 1802; director of the imperial porcelain, glass, and tapestry factories from 1792; honorary member of the Academy of Arts in 1794; minister of the *Apanages* (Imperial Estate grants) from 1796; and director of the Hermitage from 1797 to 1799, he was well placed to exert a direct influence on the development of the arts in Russia. In 1793, Catherine arranged a marriage for him with one of her

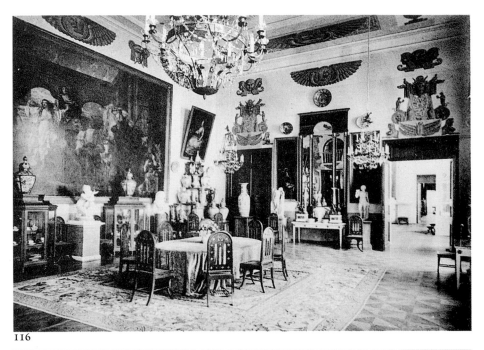

116

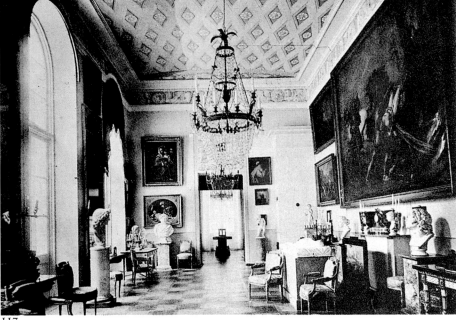

117

116. The dining room in the Arkhangelskoie Palace, before 1917

117. The hall of antiquities in the Arkhangelskoie Palace, before 1917

118. The Arkhangelskoie Palace on the outskirts of Moscow, viewed through the entrance gates

Despite their loss of the finest pieces from the Yussupov collections, sent back to St. Petersburg by Prince Boris Nikolaievich in 1837, the interiors of the family palace at Arkhangelskoie remained no less impressive than in their heyday.
These photographs (above) show a mixture of Russian and French furniture that was characteristic of the elegant residences of Russian connoisseurs, and paintings that were highly indicative of the tastes and affections of the patrons who commissioned them.
In the dining room, for example (ill.116), we can identify the Batoni portrait of Grand Duchess—and future Empress—Maria Feodorovna of which Nikolai Borisovich had sought permission to have a copy made, as he had accompanied the imperial couple on their visits to the painter's studio in Rome. The *Salle des Antiques*, or Hall of Antiquities (ill.117), meanwhile, boasted an immense composition by Angélique Mongez on the subject of *Theseus and Pirithous*, exhibited in Paris at the Salon of 1806.

118

favorite ladies-in-waiting, Tatiana Vasilievna Engelhardt, niece of the great Potemkin and a collector of precious objects and intaglios in her own right.

A description of Yussupov's picture gallery, in the palace built for him on the Fontanka river by the architect Quarenghi from 1790, has survived in an account penned in early 1803 by the German traveler Heinrich von Reimers. Among the collection's treasures, von Reimers mentions Canova's *Cupid and Psyche*, delivered by the artist in 1796 (ill.131) and of which Yussupov had seen the original (now in the Louvre) in 1793; the great Tiepolos (including *The Meeting of Antony and Cleopatra* and *Cleopatra's Banquet*, ill.126 and 127) purchased in 1800 from the agent Concolo; and two portraits by Rembrandt (*Man with a Glove* and *Lady with a Fan*, now in the National Gallery of Art, Washington, D.C.). In addition to these, he also drew up an impressive roll-call of old masters of the Italian school (including works by Titian, Correggio, Domenichino, Albani, Furini, Carracci, Schedoni, and Ricci), the Dutch school (Victors, Bol, Potter, Wouwerman, and Dujardin) and the French school (Poussin, Claude, Bourdon, Le Brun, Valentin de Boulogne, and La Hyre), in addition to works by contemporary painters including, as well as those already mentioned, Mengs, Demarne, Boilly, and Borovikovsky.

In 1802, following the assassination of Paul I, to whom he had given constant and loyal service, Yussupov retired from public office and devoted his energies to expanding his collections. In Paris in 1808 he purchased and commissioned works from Jacques-Louis David (ill.130), Pierre-Narcisse Guérin, Pierre-Paul Prud'hon, Nicolas Taunay, Louis-Léopold Boilly (ill.110), and Horace Vernet. In a letter of 1811, David made reference to Yussupov's support for Neoclassical and pre-Romantic art, assuring him of "the pleasure that I and all those who work for Your Excellency are afforded by the knowledge that our works will be appreciated by a prince of enlightened tastes, and moreover with a passion interest in a difficult art."

In 1811 Yussupov took the decision to leave St. Petersburg and move to Moscow, selling the palace on the Fontanka and sending his art collections to his ancestral home on Kharitonievskaia street in Moscow, and above all to his new estate at Arkhangelskoie. Lying on the outskirts of the former capital, this estate had originally belonged to Prince Nikolai Alexeievich Galitzin. From its favored position on the crest of a hill, the elegant palace looked out over lands that swept down to the banks of the Moskva river, laid out in a series of terraces by the Italian landscape architect Giacomo Trombara. These Yussupov was to adorn with his collection of decorative sculpture commissioned from sculptors such as Paolo Triscornia. At its far end, the formal garden metamorphosed into an informal landscape garden on the English model, complete with

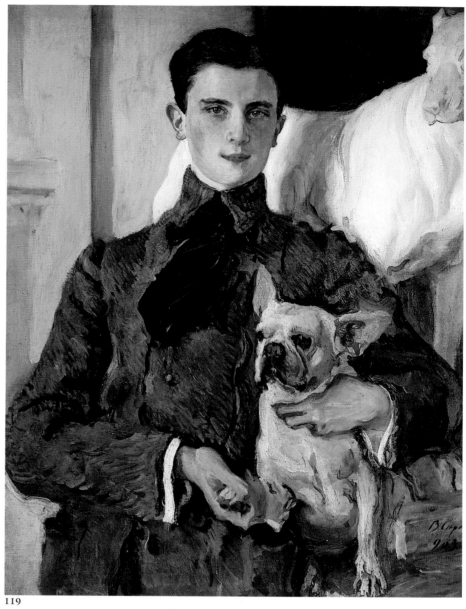

119

119. Valentin Serov
Portrait of Count Felix Sumarokov-Elston, future Prince Yussupov, 1903
Oil on canvas,
89 x 71.5 cm
Russian Museum,
St. Petersburg

Of all the Yussupov dynasty, the name of Felix, assassin of Rasputin in 1916, is the most familiar to us today. Valentin Serov, the greatest Russian portrait painter of the nineteenth century, painted his portrait when he was sixteen years old (ill.119), capturing with great sensitivity the young man's artistic temperament, as well his rather affected manner and his eccentric flamboyance. A close friend of the imperial family, Felix gained notoriety for his habit of visiting fashionable restaurants and cabaret bars incognito, dressed as a woman. Friends of his mother, however, recognised him by

her jewellery, to which he helped himself liberally — to the fury of his parents. Upbraided by Grand Duchess Elizaveta Feodorovna, sister of the tsarina, he agreed to fall into line and eventually married Grand Duchess Irina Alexandrovna, the tsar's niece.

His memoirs recounted that Serov took advantage of his sittings to inculcate him with liberal propaganda. Yussupov is credited with distributing his lands among his serfs and setting up charitable institutions and teaching establishments, projects to which the Revolution was to put an abrupt end in 1917.

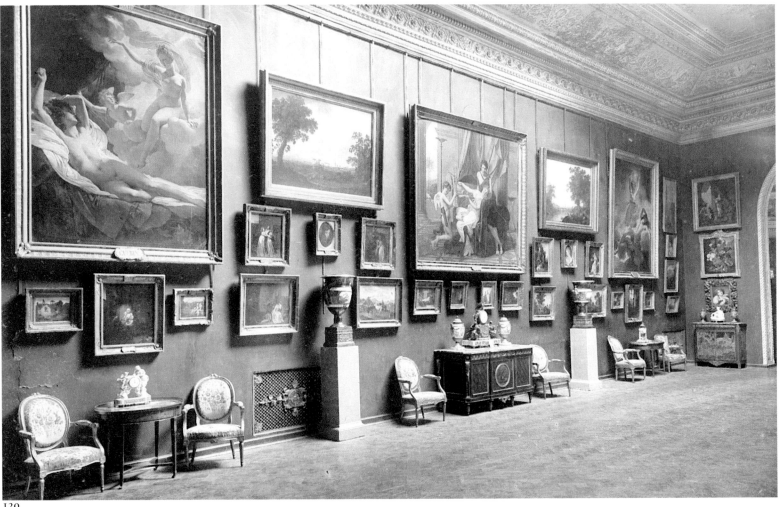

120

120. The picture gallery in the Yussupov Palace in St. Petersburg, before 1917

121. Correggio
Portrait of a Lady, c. 1518
Oil on canvas,
103 x 87.5 cm
Hermitage, St. Petersburg

Photographs of the Yussupov residences taken before the Revolution show precisely the manner of presentation—and the immense wealth—of the family collections. One of the picture galleries of the Moika Palace (ill.120) clearly shows three large neo-classical compositions commissioned by Nikolai Borisovich from David (*Sappho and Phaon*, in the center, ill.130) and Guérin (*Iris and Morpheus* and *Aurora and Cephalus*, to either side) during his stay in Paris in 1808. The hanging scheme follows the then customary practice of making no distinction between different schools and periods, with French nineteenth-century works such as Claude Lorrain's *Battle of the Bridge* (ill.123) rubbing shoulders with Guérin and David. It is enriched yet further by examples of the applied and decorative arts such as

French furniture and bronzes and large Russian vases.
Nikolai Borisovich took shrewd advantage of his position to make discerning acquisitions and place important commissions. When he accompanied Grand Duke Pavel Petrovich and Grand Duchess Maria Feodorovna on their celebrated grand tour of 1781-82, he both acted as their agent in artistic matters and followed the example of the tsarevich in commissioning numerous paintings. In 1800, as director of the Imperial Hermitage, he bought a group of paintings offered to the tsar by the dealer Pietro Concolo and rejected by him, including Correggio's magnificent *Portrait of a Lady* (ill.121) and two large Tiepolo compositions depicting scenes from the story of Antony and Cleopatra (ill.126 and 127).

architectural follies and pavilions (such as the Catherine Temple); commemorative columns (dedicated to Alexander I and Paul I); a private theatre, designed and built by Pietro Gonzaga, who also worked for the imperial theater in St. Petersburg; and even a zoo, where Yussupov bred llamas from stock given to him by Nicholas I. So lavish and opulent were both these embellishments and the collections displayed at Arkhangelskoie that this sumptuous domain soon became known as "Moscow's Versailles."

Old age was not to blunt Yussupov's passion for collecting in any way, especially as the period from 1810 to 1820 proved to be one of rapid expansion for the Moscow art market. Established Italian dealers such as Negri, Baci-Galuppi, and Cerfolio now found themselves working alongside Russian dealers such as Lukhmanov, the Shukhov brothers, Shulgin, Volkov, and Rodionov, all of whom opened premises in Moscow. In addition, the astute Yussupov took full advantage of events such as the sale of the collections belonging to the Galitzin hospital in 1817–18 (see p.39), where he bought François Lemoyne's *Apollo Pursuing Daphne* (ill.124), or of paintings belonging to Field Marshal Kyrill Razumovsky in the early 1820s. He also now expanded his collection of the French school with a magnificent cycle of paintings (including

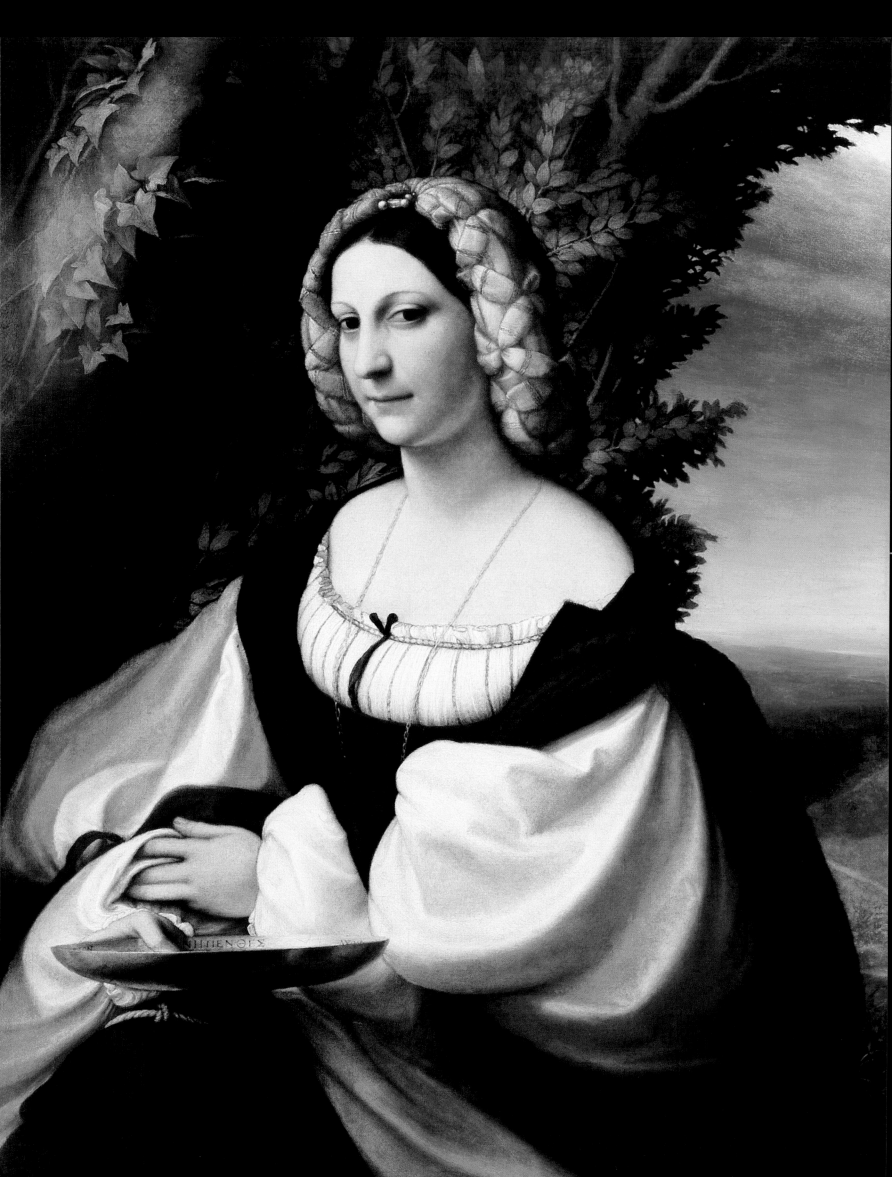

122. Rome, mid-1st century A.D.
Portrait of Augustus, Livia and Nero
Cameo, sardonyx; diameter: 8.3 cm
Hermitage, St. Petersburg

123. Claude Lorrain
The Battle of the Bridge (Battle between the Emperors Marcus Aurelius Valerius Maxentius and Constantine), 1655
Oil on canvas, 100 x 137 cm
Pushkin Museum of Fine Arts, Moscow

So remarkable a character was Nikolai Borisovich that Pushkin devoted a slightly melancholy poem to him: "Often have I revisited the time of Catherine: *Your books, your paintings, all your statues/Your formal gardens, all reveal/How you enjoyed the arts in hushed stillness …/Canova and Correggio adorn your life, You stand apart from the commotion/Over which you gaze from the heights of your balcony,/It is the eternal cycle of life that you observe,/In marble palaces and porphyry baths, Thus the great men of Rome moved towards their fall,/Nurturing the arts, at leisure and without regret.*" Yussupov shared the empress's passion for engraved gems, discovering history lessons in the images they bore. In his collection was a cameo (ill.122) in which Nero is depicted between Augustus and Livia, both symbolizing the *gens Julia*, in order to strengthen his claim to legitimacy against that of Britannicus, scion of the *gens Claudia*.

122

123

124. François Lemoyne
Apollo pursuing Daphne, 1725
Oil on canvas,
63 x 92 cm
Arkhangelskoie Palace
Museum, Moscow

125. Charles-Joseph
Natoire
Venus at Vulcan's Forge,
c. 1734
Oil on canvas,
64 x 53 cm
Pushkin Museum of
Fine Arts, Moscow

The acquisition dates of
the works in the collection
of Nikolai Borisovich
reveal a striking constancy
in its aims, regardless of
changing styles and
fashions. Determined to
create a panoramic survey
including works by all
major artists of the
eighteenth century at least,
he even bought
unfashionable works,
such as François Lemoyne's
Apollo and Daphne, at the
Galitzin Hospital sale
in Moscow in 1817-18
(ill.124). Other works
of Rococo inspiration
in his collection included
Boucher's *Hercules and
Omphale*, from the
collection of prince
Mikhail Pavlovich Galitzin
(ill.49), and *Jupiter and
Callisto*, and *Venus and Vulcan*
by Natoire (ill.125).

124

Hercules and Omphale, ill.49) by Boucher, which were also
the first works by this artist to reach Russia, and with
new canvases by Hubert Robert (including *The Shepherd
Boy* and *Landscape with a Bull*, ill.128 and 129) which
completed his monumental series of paintings dis-
played in two octagonal rooms in the Arkhangelskoie
Palace. One of the garden pavilions, known as the
Caprice, was also used as a picture gallery: outstanding
among the pictures here was an exceptionally fine set of
thirty portraits of female sitters by Pietro Rotari.

In 1827, anxious to hand down a record of his
treasures for posterity, Yussupov commissioned a five-
volume catalogue (three for paintings and two for
sculptures and other works), containing not only a
description but also—and quite exceptionally for the
period—a pen-and-wash sketch of each of his 520
paintings and 290 sculptures and other works.

A decade later, and six years after Yussupov's death,
his only son and heir Boris Nikolaievich (1794–1849;
ill.112) decided to transfer the greater part of the fami-
ly collections to St. Petersburg. There he continued to
add to them, even publishing a printed catalogue (in
French) in 1839. Since his father had sold the palace
on the Fontanka when he moved to Moscow, he found
accommodation for himself and the collections in
another Neoclassical mansion, this time on the Moïka.
Built by Vallin de la Mothe in about 1760 and altered
for Boris Nikolaievich by the architect Mikhailov, this
residence is still standing today. There Yussupov's

works of art were displayed in specially decorated gal-
leries, perhaps the most noteworthy among these being
the " Nikolai Hall," named in honor of the great col-
lector. Here the finest canvases in the collections were
gathered together, under the gaze (in another gesture
of filial admiration) of a marble bust of Nikolai
Borisovich (by Ivan Vitali, now in the Russian
Museum), displayed beneath a canopy.

Before the outbreak of World War I, Princess Zinaida
Nikolaievna, wife of Count Sumarokov-Elston and the
last surviving representative of the Yussupov line, was
granted permission to revive the family name for her se-
cond son, Felix, who—following the premature death of
his elder brother Nikolai in 1908—was now sole heir to
the family collections. Felix married the tsar's niece
Grand Duchess Irina Alexandrovna in a union blessed
with both wealth and beauty. The power and influence of
the magnetic figure of Rasputin were then at their
height, and Yussupov became convinced that the monk's
hold over Empress Alexandra Feodorovna—and hence
over the government of Russia—was a sinister one. With
Grand Duke Dmitry Pavlovich and other accomplices, he
hatched a plot to murder Rasputin on the night of
December 30, 1916. They poisoned him (to no avail),
shot him several times, and finally flung him into the
freezing waters of the Neva.

After the Revolution, Felix Yussupov made his
home in Paris, bringing with him only what little he
had managed to save of the immense family treasures.

126

127

128

129

Nowadays it is difficult to imagine the extraordinary popularity enjoyed in Russia by the works of Hubert Robert, which lasted from around 1775 to the early twentieth century almost without interruption. Returning to St. Petersburg after his long stay in Paris, Count Alexander Stroganov was responsible for the first appearance of the artist's work in Russia. He and Robert had met at the masonic lodge of 'The Nine Muses and Associated Friends', which counted many artists, connoisseurs and patrons among its members, and Stroganov had given Robert a commission for a series of monumental decorative works for his palace on Nevsky Prospekt. There followed a constant stream of commissions, and soon no Russian collection of any size was complete without an example of his work. These belonged to distinguished figures such as Grand Duke Pavel Petrovich, who visited Robert's studio in Paris during his grand tour of 1781-82; Prince Nikolai Borisovich Yussupov, who acted as agent to the Tsarevich and himself proved a loyal client (ill.128 and 129); Prince Bezborodko; Count Andrei Petrovich Shuvalov; Prince Galitzin; Prince Naryshkin; and Alexander I.

In the nineteenth century, the Counts Rostopshin, Vorontsov and Stroganov all followed suit, continuing right up to Grand Duke Sergei Alexandrovich and Pavel Kharitonenko (see p.246) on the eve of World War I. By this time it is estimated that there were no fewer than 150 or so paintings by Hubert Robert in Russia.

126. Giovanni Battista Tiepolo. *The Meeting of Anthony and Cleopatra*, 1747
Oil on canvas,
337 x 608 cm
Arkhangelskoie Palace Museum, Moscow

127. Giovanni Battista Tiepolo
Cleopatra's Feast, 1747
Oil on canvas,
338 x 600 cm
Arkhangelskoie Palace Museum, Moscow

128. Hubert Robert
The Young Shepherd
Oil on canvas,
65 x 108 cm
Arkhangelskoie Palace Museum, Moscow

129. Hubert Robert
Landscape with a Bull
Oil on canvas,
65 x 108 cm
Arkhangelskoie Palace Museum, Moscow

130

130. Jacques-Louis David
Sappho and Phaon, 1809
Oil on canvas,
225.3 x 26.2 cm
Hermitage, St. Petersburg

131. Antonio Canova
Cupid and Psyche, 1794–96
Marble; height: 137 cm
Hermitage, St. Petersburg

Nikolai Borisovich was the first among all Russian connoisseurs of art to develop a taste for the emerging neo-classical style. After being rebuffed on his first attempt to place a commission with David in 1787, in 1809 he succeeded in obtaining *Sappho and Phaon* (ill.130) for the sum of 12,000 *livres*. Another masterpiece of Neoclassicism, his *Cupid and Psyche* by Canova (ill. 131) now rubs shoulders with *Cupid, Hebe, The Dancer*, Napoleon's bust and various other works at the New Hermitage, thus constituting one of the most impressive group of works by the artist.

Most outstanding among these were two Rembrandt portraits, which he sold to the American collector Joseph E. Widener, with the stipulation that if ever the Romanov dynasty were to be restored to power the sale would be declared null and void. Today the paintings are the pride of the collections of the National Gallery of Art in Washington, D.C. Most of the works in the Yussupov collections were seized by the Bolshevik government at the Revolution, although some remained concealed until 1919, when the People's Commissariat for Public Instruction requisitioned the Yussupov estate.

A set of photographs of the interiors of the Yussupov residence, commissioned by Felix Yussupov in 1914, survive today as priceless records of the interiors in which the collections were displayed (ill.120), as well as of the lavish Neoclassical refurbishments carried out at the end of the nineteenth century and in the first two decades of the twentieth.

Initially transformed—like many other Petersburg palaces—into a museum of aristocratic life, the Yussupov palace was closed in 1928, when the 45,295 paintings and objects it housed were divided between the Hermitage Museum and the Russian Museum in Leningrad, the Pushkin Museum of Fine Art in Moscow, and the museums of Omsk and Vladivostok. After the art auctions staged by the Soviet government in the late 1920s and early 1930s, many of these works left Russia to join foreign collections, including those of the Hillwood Museum in Washington, D.C.

131

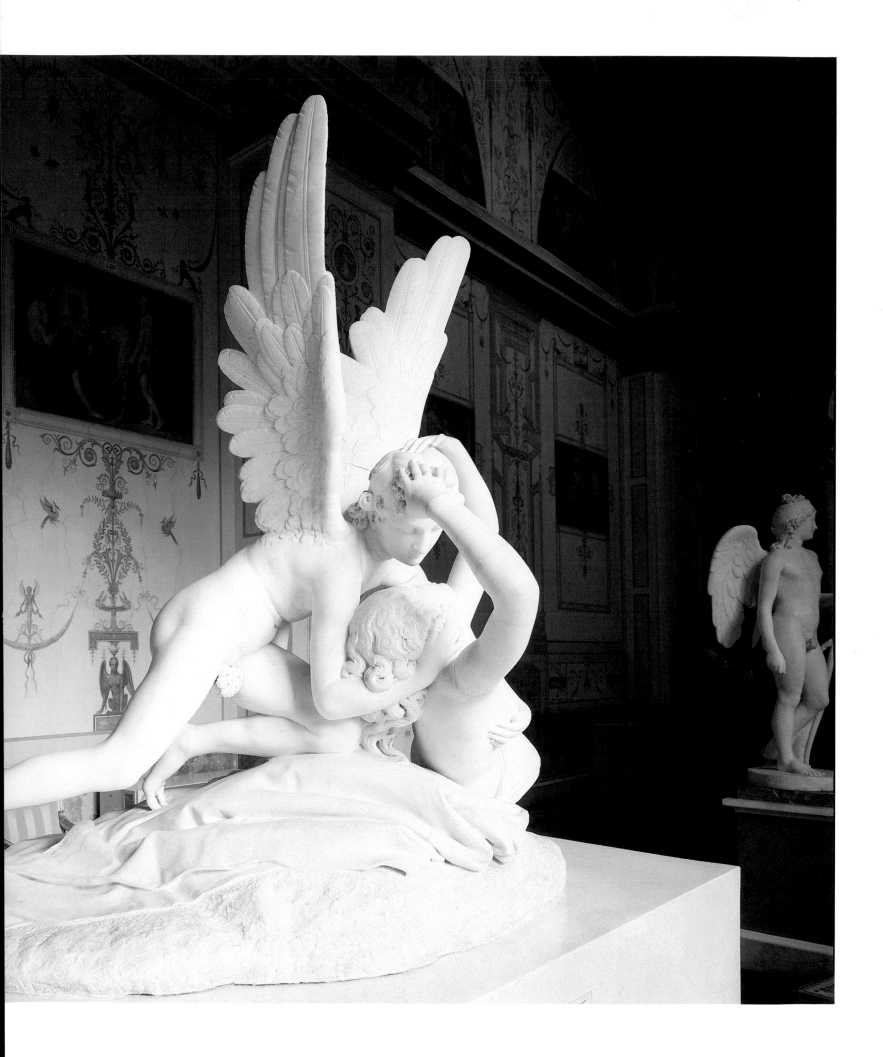

SERVANTS OF THE STATE
AND RUSSIAN
COLLECTORS ABROAD
The 19th century

By the beginning of the nineteenth century, Catherine the Great's political and military acumen and Paul I's obsession with his army had combined to make Russia a strategic military power without equal in Europe. The elite in every sphere of society was at the service of the Tsar Alexander I ("*le bel Antinoüs*" as Napoleon dubbed him), whose glory was all the more exalted in the wake of the Russian military machine's crushing victory over the emperor of the French. But the sovereign who is remembered as the "liberator of Europe" (ill.133) was also a distinguished connoisseur, a worthy successor to his grandmother, who oversaw his education in his youth, and to his parents.

It was during the reign of Paul I that the Hermitage had begun to acquire the character of an imperial museum, evolving from the purely private collection that it had been originally, with the first detailed inventory being drawn up in 1797. Under Alexander it was to become a state institution, comparable to the Louvre in France, the British Museum in London and the Berlin Museum, founded in 1805. In that same year the official statutes of the Hermitage were drawn up, to be followed in the following year by the statutes of the Armory Palace in the Moscow Kremlin, and a policy was put in place whereby one or more state officials were made responsible for assisting the sovereign in making acquisitions.

In 1808 accordingly, Franz Labensky, curator of paintings, traveled to Paris to buy Caravaggio's *Lute Player*, with the aid of the then director of the Louvre Dominique Vivant Denon. In 1814, ignoring the protests of Napoleon's former enemy the Landgrave of Hesse, it was the tsar himself who acquired thirty-eight paintings from the collection of the Empress Josephine (which had formerly hung in the gallery at Kassel until Napoleon plundered them) and four Canova statues, all for the sum of 940,000 francs. To these he then added the magnificent Gonzaga Cameo (from the collections of the dukes of Mantua and of Queen Christina of Sweden), a personal gift to the tsar from Josephine. In 1815 it was the Spanish section's turn to be swelled by the addition of the Zurbarán and Velázquez paintings from the collection of the British banker William Coesvelt.

133

132. Yegor Ivanovich Bottmann
Portrait of Tsar Nicholas I,
1849
Oil on canvas
Peterhof Palace Museum

133. George Dawe
Portrait of Tsar Alexander I,
1826
Oil on canvas,
87.9 x 60 cm
Peterhof Palace Museum

A few years later, finally, the imperial museum received its first works by Russian artists. Paintings by Orest Kiprensky were put on display from 1823, and the following year saw the creation of a special department for Russian works such as Briullov's *tour de force*, *The Last Day of Pompeii* (ill.173), commissioned by Anatoly Demidov and shown in the Hermitage in 1834.

The reign of Nicholas I (ill. 132), known as the "Iron Tsar" because of his ruthlessness in putting down the Decembrist rising following the sudden death of Alexander I in 1825, was nonetheless a period of outstanding progress in the arts, notable in particular for the creation, on the tsar's initiative, of a large public museum (after Peter the Great's *Kunstkamera*).

Following the rapid reconstruction of the Winter Palace after the devastating fire of 1837, the poet Vasily Jukovsky, tutor to the grand duke and heir apparent Alexander Nikolaievich, suggested to the latter's elder sister Grand Duchess Maria Nikolaievna that the

Alexander I (ill.133) was favorably disposed towards the Empress Josephine and her children, Queen Hortense and Prince Eugène. In 1814, when he bought the latter thirty-eight paintings from the Kassel Gallery at the same time as he bought four Canovas for the imperial Hermitage, his generous gesture none the less carried a double meaning. A magnanimous ruler on the one hand, he was also the Viktor in war, bringing back to Russia the spoils plundered from the vanquished. It was Alexander who was to confer on the imperial museum its first statutes, so transforming it from a private collection into a state institution.

134. Konstantin
Ukhtomsky
*The Antique Sculpture Hall in
the New Hermitage*, c. 1850
Watercolor on paper,
42.0 x 55.5 cm
Hermitage, St. Petersburg

Known to history as the
"Iron Tsar," obsessed with
all things military and
supposedly devoid of any
aesthetic sense, Nicholas I
(ill.132) was in fact
discriminating enough to
buy paintings by Caspar
David Friedrich on his
honeymoon in 1817. At
the age of only twenty-
three he already shared this
taste with his brother-in-
law, later the Prussian king
Friedrich-Wilhelm IV.
The creation of the New
Hermitage was for him a
development that carried
quite as much significance
as a major political
decision. On the eve of his
death, when the Russian
army had just suffered
crushing defeat in the
Crimea, he is reputed to
have asked to be carried
through the rooms of his
new museum (ill.134),
murmuring at every turn,
"My God, it is truly
beautiful."
Under his rule, many a
masterpiece from Russian
private collections had
found its way to this
temple of the arts.

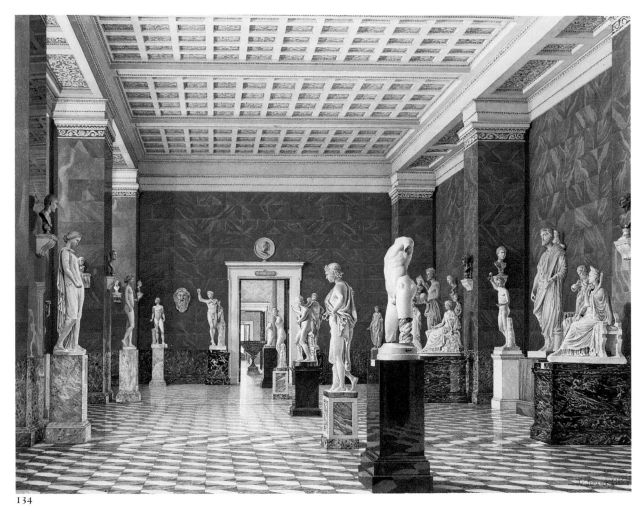

134

imperial residence should be transformed into a
"second Vatican." This was the project to which their
father was to devote himself, with unflagging energy.

On a visit to Munich in 1836, Nicholas had been
greatly impressed by the Glyptothek (sculpture gallery)
and Pinakothek (painting gallery) that Leo von Klenze
(1787–1864) had built for the Bavarian king Ludwig I
in 1830 and 1836. In 1839 he invited von Klenze to
draw up plans for a palace that would also be a museum,
the New Hermitage, with a facade in Greek Revival style
to echo the classical collections within. The 4,500 or so
paintings in the imperial collections were examined by a
special committee and divided up into four categories;
the tsar then decided that 1,219 of them should be sold
at auction. This regrettable event excepted, the
museum's collections continued steadily to grow, and in
a manner that became increasingly systematic. The tsar
took every possible step to ensure that complete sets of
paintings or unusual examples should be brought into
the collection, just as in the days of his grandmother.
Such accessions included the Spanish paintings of the
minister Godoy in 1831; Venetian works from the
Palazzo Barbarigo in 1850; paintings from the collec-
tions of the Dutch king William II in 1850 and
Maréchal Soult in 1852; and antique sculptures from
the collections of Count Lebzeltern in 1826 and Pavel
Demidov in 1851 (ill.169).

Inaugurated with great pomp in the spring of 1852,
the New Hermitage also offered a feature that was
unprecedented: a prodigious collection of works from
antiquity, gleaned not only from the collections of
Catherine the Great, but also from archeological exca-
vations recently carried out in southern Russia.

Private collections also flourished during this period.
But now a new breed of collector began to emerge from
a different social class: that of high-ranking state offi-
cials who boasted no ancient aristocratic pedigree.
Diplomat collectors from noble families, such as Vasily
Trubetskoi, Alexander Gorchakov, and Nikolai
Rumiantsev, were now joined by young career diplomats
including Nikolai Khitrovo (ill.156), Dmitry Tatishchev
(ill.156), Alexander Bludov, Karl Nesselrode, Viktor
Kochubei, Arkadi Nelidov, and Avraam Norov.

In a process that might be termed "democratiza-
tion," other distinguished functionaries, including
Feodor Prianishnikov, Philipp Wiegel, Pavel Svinin, and
Nikolai Smirnov, were now joined by collectors such as
the merchant Alexander Sapojnikov and the banker
Alexander Stieglitz (ill.187), not forgetting a number
of artists themselves. The painter Vasily Vereshchagin
built up a collection of costumes, weapons, and craft
works, his fellow-artist Viktor Vasnetsov specialized in
icons, while the architect Auguste de Montferrand col-
lected Western European paintings.

When Alexander II came to the throne in 1855, his reign seemed equally promising for the arts, as he too had had a love of art instilled in him by his tutor Jukovsky. From 1856 to 1859 a new inventory was drawn up, this time omitting the paintings that hung in the imperial family's private apartments and so helping to confirm the Hermitage's status as a museum. The imperial archeological commission also rose to greater prominence with the discovery of more antiquities in the burial mounds of southern Russia. And with the sensational acquisition of Gian Pietro Campana's immense collection of antique sculptures in 1861 (under the very noses of the British Museum and the Louvre), the museum's department of antiquities came to rival the best in the world. The enrichment of the imperial Hermitage mirrored the growth—and hence by logical extension the dispersal—of an increasing number of private collections put together by Russian connoisseurs.

Far from being concentrated on Russian territory, throughout the nineteenth century this category of collector formed a large and wealthy community scattered throughout Europe, subjects of the tsar who chose to reside abroad for all or part of every year. Aristocrats fleeing the rigors of the Russian winter for the French Riviera at the beginning of Lent, the official end of the Petersburg "season"; grand dukes obliged to go into exile after contracting morganatic marriages; figures who were not favored at court; diplomats who had decided to make their homes abroad. All these and more were well placed to take advantage of their presence in Europe not only to establish elegant salons, both cultural and political, but also to amass impressive art collections. The grandest of these was undoubtedly the one built up in Paris and Florence by Anatoly Demidov, following in the family tradition, which earned him the title of prince of San Donato from the grand duke of Tuscany. The most interesting, meanwhile, because of the scientific methodology it adopted, was that created in Paris a little later by the diplomat Alexander Basilevsky.

Of these private collections formed by Russians living abroad, a number either remained permanently in western Europe (such as those of Count Razumovsky in Vienna, Count Semyon Vorontsov at Wilton House in Great-Britain, and Ivan Turgenev in France) or were sold at auction, on one or more occasions (including those of Pavel Saltykov in Paris in 1861; Prince Anatoly Demidov of San Donato in Paris and Rome in 1870, 1880, and 1969; Prince Semyon Abamalek-Lazarev in Rome in 1969; the sculptor Mark Antokolsky in Paris in 1901; and Count Grigory Sergeievich Stroganov in Paris in 1910). Others, such as the Naryshkin collection of applied art, formed in Paris and presented to the tsar in 1870, and the Kushelev-Bezborodko gallery in Moscow, bequeathed to the Academy of Arts in 1862, returned to St. Petersburg. A few, finally, generally formed during the reign of Alexander II, entered the Hermitage collections under Alexander III.

Alexander Basilevsky, for example, had conceived his collection, as a means of illustrating the history of Christian art from the first to the sixteenth centuries, and in this he was virtually the first collector to set out systematically to amass works of art on such a precise theme. The acquisition of the collection by the Hermitage in early 1885 was to have major repercussions as, together with Nicholas I's Arsenal at Tsarskoie Selo, it was to form the basis of the museum's entire Medieval and Renaissance departments. As for the department of antiquities, the most significant event came in 1884, with the acquisition of the works of the diplomat Piotr Saburov, which gave the Hermitage one of the world's most outstanding collections of terra-cotta statuettes from the Greek necropolis at Tanagra. These were joined four years later by the sculpture collection of Count Bludov, containing works he had bought in Athens.

The one conspicuous area of weakness of the private collections of St. Petersburg was their almost total lack of interest—with the honorable exceptions of Chancellor Gorchakov and above all Nikolai Kushelev-Bezborodko—in contemporary art, whether Russian or western European. Stieglitz and Polovtsov, meanwhile, were ahead of their time in their high level of commitment to patronage and funding. The school of technical drawing and the associated museum of the decorative and applied arts that they established were to lay the foundations for the tremendous blossoming in the field of design that was to take place in Russia in the late nineteenth and early twentieth centuries.

135. Konstantin Makovsky
Portrait of Tsar Alexander II,
1881
Oil on canvas,
163.5 x 108 cm
Tretyakov Gallery, Moscow

Alexander II (ill. 135) had as his tutor the poet Vasily Jukovsky, who many years before had been in the service of his grandmother Empress Maria Feodorovna, and who had accompanied him on his grand tour of Europe in 1837, designed to broaden the horizons of the tsarevich as he then was. Jukovsky inspired a love of the arts in his pupil. When they were in Paris, they visited the studio of Ingres and commissioned from him a *Madonna* (Pushkin Museum of Fine Arts, Moscow) flanked by St. Nicholas (in honor of Nicholas I) and St. Alexander Nevsky (in honor of the grand duke). Following the example of his father, who had commissioned numerous views of the interiors of the imperial palaces, Alexander II commissioned watercolors of the New Hermitage (ill. 134).

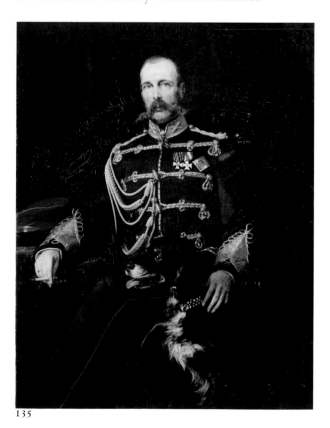

135

Duke Maximilian
of Leuchtenberg
and Grand Duchess
Maria Nikolaievna

The children of the Empress Josephine did not enjoy great popularity in France, especially after her divorce from Napoleon. Her ex-husband's numerous brothers and sisters and their families treated them with contempt, taunting them with the soubriquet *beauharnaille*, an amalgam of Beauharnais and *canaille* (meaning rascal). Tsar Alexander I, by contrast, viewed them as victims, declaring on his arrival in Paris in 1814 that he both liked and respected the Beauharnais family: indeed Prince Eugène, "a prince among chevaliers," Empress Josephine and Queen Hortense had conducted themselves with considerably greater dignity with regard to Napoleon than many others who should have remained loyal to the fallen emperor. At one stage the tsar even favored putting Eugène de Beauharnais (1781–1824; ill.139), then viceroy of Italy, on the French throne, but was overruled by Talleyrand's famous "principle of legitimacy." The Congress of Vienna gave the viceroy a payment of five million francs in return for his Italian possessions, and his father-in-law made him a duke of Leuchtenberg in 1817.

His son Maximilian, the second duke, went to Russia on cavalry maneuvers in 1837, and created an excellent impression there. A year later he was back in St. Petersburg, as noted by the tsar's eldest daughter Grand Duchess Olga in her diary: "In four days it has become quite clear that Max and Maria [ill.141] were made for each other." The tsar granted his permission for the match, on condition that his beloved daughter did not leave Russia to live abroad. Curiously, in the statement he issued to mark this event he declared that it was an honor to ally his dynasty with that of Napoleon. Yet this alliance with the offspring—indirect though the relationship might have been—of Russia's bitterest enemy can only have been construed as a less than desirable match for the Romanovs. Nonetheless, on July 2, 1839

137

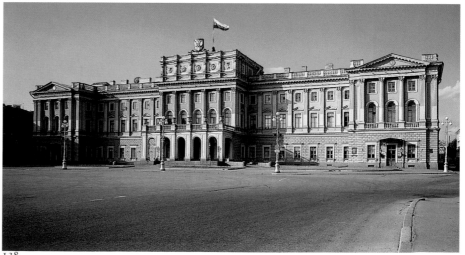

138

136. Antonio Canova
The Three Graces, 1813
Marble; height: 182 cm
Hermitage, St. Petersburg

137. The Pompeian
Hall in the Marinsky
Palace, St. Petersburg

138. The Marinsky Palace
(facade overlooking
St. Isaac's Square),
St. Petersburg, built by
Andrei Stackenschneider,
1840-45

139. Joseph Karl Stieler
*Portrait of Eugène de
Beauharnais,* 1815
Oil on canvas, 69 x 55 cm
Pushkin Museum of
Fine Arts, Moscow

So deeply attached was
Tsar Nicholas I to his
eldest daughter Maria that
he refused to countenance
a marriage that would
require her to live abroad.
It was doubtless for this
reason—quite independently
of any personal inclination
on the part of the Grand
Duchess—that he consented
to her marriage to a
relation of Napoleon.
Although a German prince,
he was was crucially a non-
reigning one who could be
persuaded to make Russia
his permanent home.
No expense was spared in
fitting out a new palace
(ill.138) for the young
couple, specially
commissioned from the
architect Andrei
Stackenschneider and
strategically positioned
opposite St. Isaac's
Cathedral, close enough to
the Winter Palace for the
Tsar to be able to pay his
daughter daily visits.
The Duke of Leuchtenberg
fitted perfectly into the
life of the capital, putting
his personal interests and
wide-ranging scientific
knowledge—unusual in a
prince—at the service of his
new country. In 1843 he
became president of the
Academy of Fine Arts, and
in 1844 he was put in
charge of the country's
mining and geological
activities. His enthusiastic
interest in new
developments in
electroplating prompted
him to set up a factory
using the process to
produce decorative items
in gilt bronze.

139

the marriage was duly celebrated in the chapel of the Winter Palace.

That same year another Frenchman, Astolphe, Marquis de Custine, was also in Russia, where he attended the ceremony as a guest. In his book *La Russie en 1839,* which caused a sensation on publication, he gave the following description of the event: "The imperial chapel is not large; it was filled with representatives of all the crowned heads of Europe and many of Asia, with a few foreigners such as myself, granted admission in the wake of the diplomatic corps. . . . I have seen little to compare with the magnificence and solemnity of the Emperor's entrance into the gilded, shimmering chapel. . . . A love match consecrated in richly embroidered robes and in a setting of such splendor is a rare thing, and added the final touch to this fascinating scene." He was unable to disguise his distaste for the young bridegroom, however: "The Duke de Leuchtenberg is a tall young man, strong and well-shaped; his features are undistinguished. . . . his figure is handsome but lacks nobility, his uniform becomes him and makes up for the elegance that is wanting in his person."

Chernyshev Palace was to be considerably enlarged and refurbished for the young couple, and the architect entrusted with the task was Andrei Stackenschneider. In fact they did not take up residence in what was now known as the Marinsky Palace (ill.138) until 1845. Contemporary observers were particularly struck by the winter garden, overflowing with flowers and inspired in its decorative scheme by the famous fountains of the palace of Bakhchisarai. Lush foliage and exotic birds, cascades and fountains all conspired,

according to Anna Tiucheva, a maid of honor, to create "truly a mirage of springtime in the midst of the January cold and frosts." At the center of the garden stood a statue of Diana by Emile Wolff, and numerous other sculptures embellished the interiors of the palace. The grand duchess's reception salon, for example, boasted Antonio Canova's *Three Graces* (ill.136), a statue of *Cupid with a Bow* by François-Joseph Bosio, and *Shepherd with a Lamb* by Antoine Chaudet (all three now in the Hermitage). The architectural qualities of the building, meanwhile, were amply demonstrated by the twin *tours-de-force* of the two-story Pompeian Hall (ill.137) and the Rotonda.

The palace chapel (ill.140), decorated in 1845 with icons by Cosroe Duzi, was repainted a few years later by Prince Grigory Grigorievich Gagarin, vice-president of the Academy of Fine Arts, who had studied painting in Rome when his father Prince Grigory Ivanovich was Russian ambassador there. The chapel was restored and reconsecrated in 1990. In 1843 Maximilian of Leuchtenberg was appointed president of the Academy, and after his death in 1852 the position passed to his widow. Accounts of the collections created by the couple bear witness to their deep and discerning interest in art.

In 1844 Duke Maximilian had presented Nicholas I with a mosaic from Pompeii, which had come from Malmaison and which was installed in the dining room of the empress's villa at Peterhof, on the outskirts of St. Petersburg. After visiting Pompeii in 1851, the Duke of Leuchtenberg also presented the Hermitage with Roman antiquities unearthed during excavations undertaken in his presence, following up this gift with another the following year of ancient Egyptian artefacts, including granite sarcophagi and a seventh-century basalt statue of Cleopatra (still in the Hermitage collections; ill.147).

Maximilian's salon at the Marinsky Palace boasted Canova's masterly *Mary Magdalene,* while a portrait of the empress Josephine by François Gérard hung in his study (ill. 147; both works now in the Hermitage). Karl Briullov, meanwhile, received a commission for a work on the mythological erotic theme of *Diana, Endymion and the Satyr* (Tretyakov Gallery).

After the premature death of her husband in 1852, Grand Duchess Maria Nikolaievna devoted herself to her collections with even greater ardor. Having moved to Florence, in 1862 she installed herself in the Villa Quarto, formerly the possession of Napoleon's brother Jérôme Bonaparte, once king of Westphalia, and appointed the prominent painter and collector Karl Liphardt as her advisor. In his memoirs, Liphardt's son observed of this period: "They went almost daily to visit museums, private collections and the antiquaries of Florence and its environs. . . . The antiquary Gagliardi had premises on Campo Santa Maria Novella

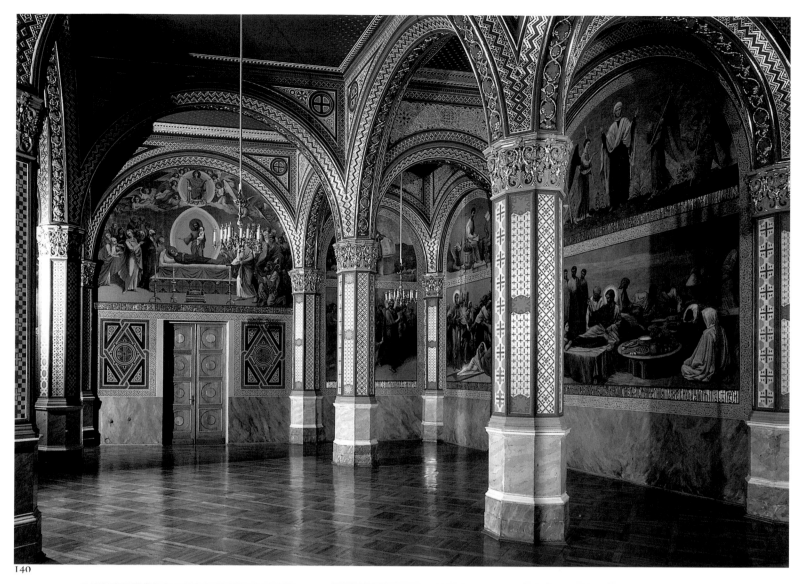

140

141

142

140. The St. Nicholas Chapel in the Marinsky Palace, with wall paintings by Prince Grigory Gagarin, vice-president of the Academy of Fine Arts

141. *Grand Duchess Maria and Duke Maximilian of Leuchtenberg, shortly after their marriage, c.* 1839
Engraving
Hermitage, St. Petersburg

142. Franz Xaver Winterhalter
Portrait of the Grand Duchess Maria Nikolaievna, 1869
Oil on canvas, 56 x 46 cm
Pushkin Museum of Fine Arts, Moscow

143. Paris Bordone
The Virgin and Child with
St. John the Baptist and
St. George, c. 1530
Oil on canvas (transposed
from wood), 90 x 120 cm
Pushkin Museum of
Fine Arts, Moscow

144. Vittore Ghislandi
(Fra Galgario)
Portrait of a Young Boy, 1732
Oil on canvas, 67 x 52 cm
Hermitage, St. Petersburg

145. Pietro Perugino
Virgin and Child
Oil on canvas (transposed
from wood), 51 x 38 cm
Pushkin Museum of
Fine Arts, St. Petersburg

146. Lorenzo Costa
Portrait of a Woman, c. 1500
Oil and distemper on
canvas, 57 x 44 cm
Hermitage, St. Petersburg

Two dynasties, each with
a passionate love of art,
were united in the
Leuchtenberg household:
the Romanovs, avid
collectors from Catherine
the Great to Nicholas I,
and the Beauharnais.
Maximilian was the
grandson of the Empress
Josephine, whose collection
at Malmaison remains
famous to this day, and had
inherited the paintings of
his father Prince Eugène,
who himself had added to
his inheritance from his
mother, first as viceroy of
Italy and afterward in
Munich.
In 1863, engravings of
forty-three of the most
outstanding works were
published in St. Petersburg
by M. Wulf.

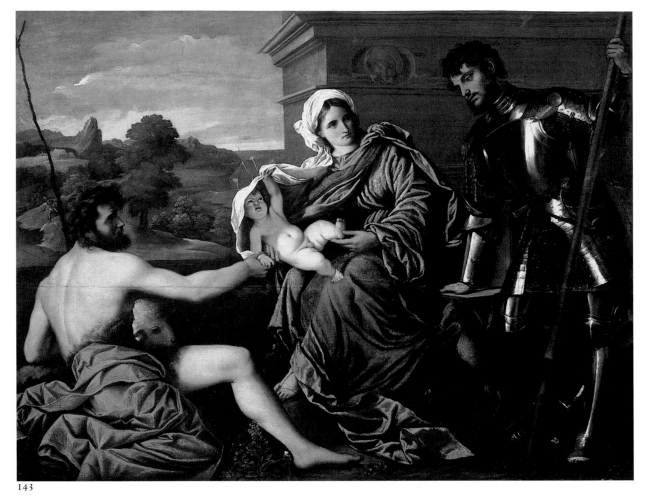

143

144

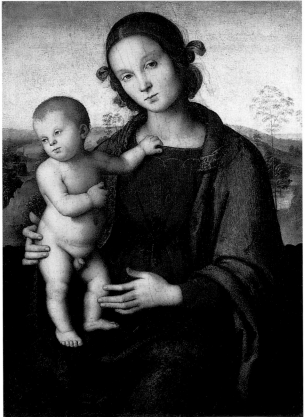

145

147. Egypt, 1ˢᵗ century B.C.
Portrait of Cleopatra VII
Basalt; height: 104 cm
Hermitage, St. Petersburg

148. François,
Baron Gérard
Portrait of Empress Josephine,
1801
Oil on canvas,
178 x 174 cm
Hermitage, St. Petersburg

149. Antoine, Baron Gros
*Napoleon Bonaparte on the
Bridge at Arcole,* 1796–97
Oil on canvas,
134 x 104 cm
Hermitage, St. Petersburg

Although a considerable
part of the Empress
Josephine's collection had
to be sold after her death
in 1814 in order to pay off
her massive debts, some of
the jewels of French early
nineteenth-century
painting (ill.148 and 149)
found their way to Russia
in the wake of the
Leuchtenberg marriage in
1839.

147

148

where the Grand Duchess was zealous in her purchases of paintings, sculptures and furniture for the complete refurbishment of her residence."

Maria Nikolaievna then made a second marriage, to Count Grigory Stroganov (1823–1878), so that on her death in 1876 her collections were divided between their joint heirs: prince Nikolai of Leuchtenberg and his brothers Evgeny and Georgy, their sisters Princess Maria of Baden and Princess Evgenia of Oldenburg and their half-sister Countess Elena Stroganova. A year later, items from the Villa Quarto were sold at auction in Florence, but in 1884 her son Nikolai mounted an exhibition at the St. Petersburg Academy of Fine Arts

consisting of masterpieces from the paintings collection that had remained in Russia. In 1913, the Society for the Defence and Protection of Artistic Monuments organized an exhibition at the Hermitage entitled *The Heritage of Grand Duchess Maria Nikolaievna.*

In the years that followed the collections became more and more widely dispersed: paintings once owned by the dukes of Leuchtenberg may now be enjoyed in the museums of Europe (notably Vienna), the United States (New York City) and Russia (Kursk, Moscow, and St. Petersburg), while masterpieces from their silver collections may be found in New York City and Paris.

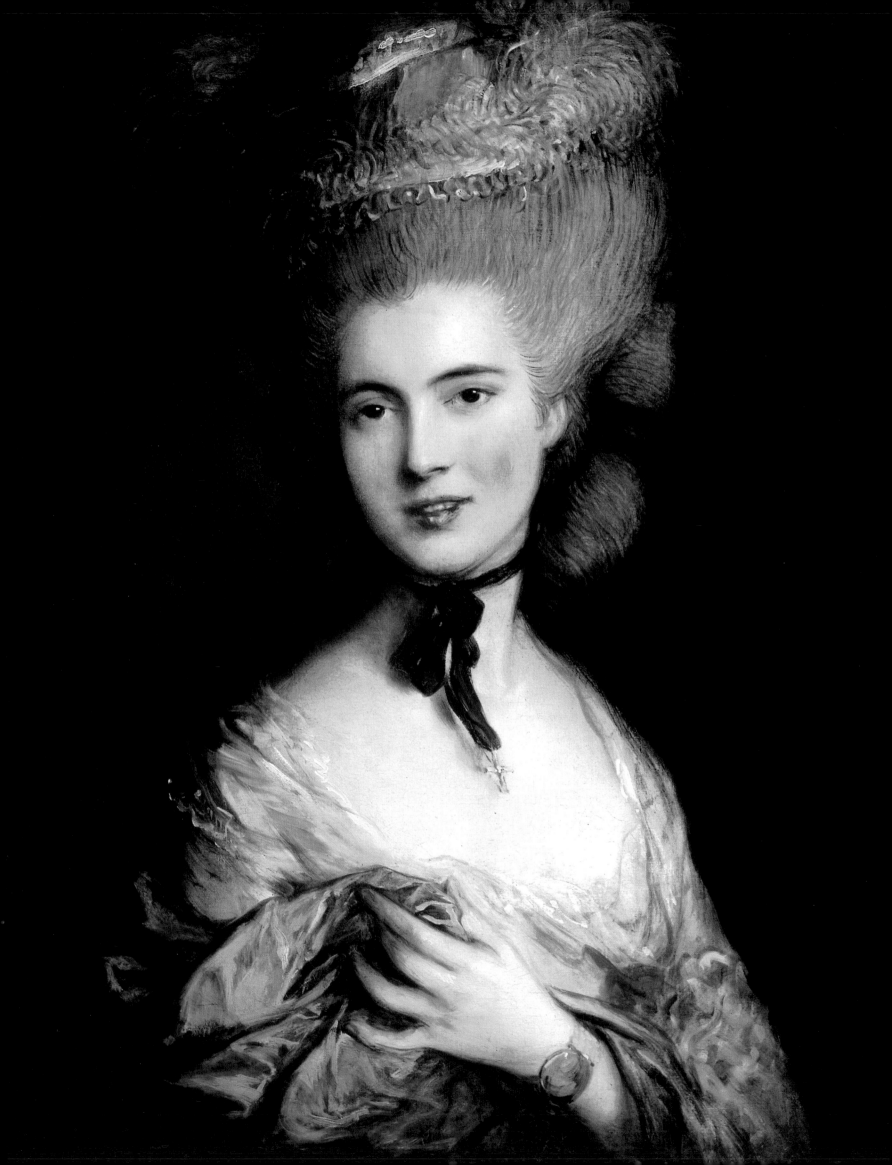

The Khitrovos

The Khitrovo line rose to prominence in the seventeenth century as a boyar family very closely linked with Tsar Alexei Mikhailovich, Peter the Great's father; at this period Bogdan Khitrovo presided over the Armory Palace. Later their fame was slightly tinted with scandal as one of them was involved in a conspiracy against Catherine the Great, three others were accused of cruelty to their serfs, and in 1811 Nikolai Khitrovo was banished to Viatka for his part in the Speransky affair (Speransky, a close advisor to Alexander I, had been accused of spying for the British government).

From the beginning of the nineteenth century, however, it is for their achievements, the rewards they garnered, and the high offices they held that their family is principally remembered. Nikolai Feodorovich Khitrovo (1771-1819) served as a major-general in the army during the Napoleonic Wars, and undertook diplomatic missions to European states for Alexander I. During his time in France and Italy he amassed an exceptional collection of intaglios, the most remarkable of which was perhaps a cameo that he acquired from the abbey of Saint-Germain in Paris, which at the time was believed to be the wedding ring of Mary and Joseph, complete with their engraved portraits. This highly venerated object, sent to the Russian general by the abbey's monks in 1795, was indeed of Roman origin, but in fact bore the portraits of Drusus the Elder and Antonia, the parents of Emperor Augustus; it may now be seen in the Hermitage (ill.153).

It was also in Paris, in the early years of the following century, that he acquired the great "Trajan cameo" (in fact showing Constantine), which had been retouched by the engraver Benedetto Pistrucci in 1799 (ill.151). Following this purchase, Khitrovo bought from the French diplomat Lalemand a set of gemstones that in the sixteenth century had embellished the Studiolo Grimani, and which the Venetian state had presented to Lalemand in 1797 in recognition of his services. In Naples in 1803 he acquired another treasure: a medieval cameo depicting Joseph and his brothers, from the collection of the English ambassador Sir William Hamilton (now in the Hermitage).

So highly regarded was the collection that the eminent archeologist Emilio Quirino Visconti drew up a catalogue of the General's gemstones (now in the

151

150. Thomas Gainsborough
Portrait of a Lady in Blue,
c. 1780
Oil on canvas, 76 x 64 cm
Hermitage, St. Petersburg

151. Rome,
4ᵗʰ century A.D.
Cameo of Trajan, or *Large Khitrovo Cameo*
Sardonyx, 18.5 x 12.2 cm
Hermitage, St. Petersburg

By the late nineteenth century, the Hermitage had earned an enviable reputation as a state museum, of a quality that enhanced the prestige of the empire as a whole. In accordance with the universalist ethic that underlay all museums at this period, and which was inextricably linked with their role as educational establishments, private collectors strove constantly to assemble entire categories of works, whether large or small, with the essential aim of filling any gaps in public collections.

Thus Alexei Khitrovo, master of the imperial hounds, put together a small and highly select group of some of the finest English portraits (ill.150 and 154), with the intention of bequeathing them to the Hermitage on his death.

152. Greece, early 5ᵗʰ century B.C.
Hercules and the Nemean Lion
Amphora; height: 20.5 cm
Hermitage, St. Petersburg

153. 1ˢᵗ century B.C.
Drusus the Elder and Antonia
Cameo, sardonyx,
Hermitage, St. Petersburg

154. Henry Raeburn
Portrait of Mrs. Bethune,
c. 1790
Oil on canvas, 76 x 64 cm
Hermitage, St. Petersburg

At any given period there will always be collectors who are influenced in their choices by prevailing tastes and fashions. The eighteenth-century passion for cameos and intaglios, for example, so evident in the collections of the Duc d'Orléans or Catherine the Great, was also a characteristic of other contemporary collectors including Count Stroganov, Prince Yussupov—as well as less prominent figures such as General Nikolai Khitrovo. In 1805, in a gesture intended to curry favor with Tsar Alexander I, Khitrovo presented him with the remarkable collection of intaglios that he had amassed in France and Italy (ill.151 and 153). By chance, the Greek painted vases (ill.152) that he then turned to collecting were subsequently purchased by Comte Laval in 1817, and in 1852 were acquired by Nicholas I for the New Hermitage—so joining Khitrovo's collection of engraved gems in the museum collections.

Bibliothèque Nationale in Paris.) When Khitrovo was preparing to leave the French capital in May 1804, Visconti showed no hesitation in assuring him by letter that the "Trajan cameo" had not been retouched and was indisputably authentic, an "unsullied masterpiece." The whole process of its purchase is known through their correspondence. Apart from his passion for engraved gems, Nikolai Khitrovo also had a keen interest in painting and bought works by Claude Joseph Vernet-highly sought after by Russian amateurs at the time-as well as bronze statuettes, *The Abduction of Dejanira* by Gian Bologna (Hermitage) among others.

In 1804 Khitrovo presented the collection that he had brought back to Russia with him to Alexander I, in order to please the sovereign. Six years later he married Elizaveta Kutuzova, daughter of the distinguished marshal Mikhail Ilarionovich, prince of Smolensk, and traveled first to the Crimea for treatment for tuberculosis and afterwards to Florence, where he was appointed ambassador to the Tuscan court. On his departure, he entrusted his second collection, consisting of 333 painted vases (ill. 152), to the director of the imperial public library, Alexei Olenin.

In 1817, Khitrovo's wife sold this collection to Comte Laval, and in 1852 it was acquired by Nicholas I for the New Hermitage.

153

152

Alexei Zakharovich Khitrovo was descended from a branch of the family that had become allied by marriage to the counts Mussin-Pushkin and the princes Galitzin: his grandfather had been a government inspector and master of ceremonies at the imperial court, and he himself was master of the imperial hounds. In the closing years of the nineteenth century, Khitrovo's residence on Sergeievskaia street was well known to all the connoisseurs of St. Petersburg, its rooms (in the words of the painter Alexander Benois) "filled with fine French furniture, bronzes and porcelain; while portraits by Hoppner, Gainsborough, Romney and Lawrence, subsequently donated to the Hermitage, gazed down on us from their walls."

As we have seen, during the reign of Catherine the Great and after, the Hermitage gained some extremely fine paintings of the English school; now Khitrovo took the decision to enrich this section still further, and drew up a will including a bequest of the seven English portraits that had formed the nucleus of his collection. Yet, convinced by the events of the first Russian revolution in 1905 that he could no longer live in the land of his birth, he then left for Paris, taking with him—as Benois records—"his English portraits, even though they had been destined for the Hermitage. When I asked him if he really intended to deprive the museum of such masterpieces, he even exclaimed: 'But of course, I'm not going to leave them for King Witte! (the then Prime Minister)' But afterward, during the prime ministership of Stolypin, he nonetheless brought the paintings back to Russia, and for a time they embellished the walls of the Hermitage." In 1916, indeed, when all the outstanding questions regarding the Khitrovo bequest were finally settled, the collector's gift finally found a permanent home in the museum's collections. So it was then that the Hermitage gained Thomas Gainsborough's *Portrait of a Lady in Blue* (ill. 150), George Romney's *Portrait of Mrs Harriet Greer*, Henry Raeburn's *Portrait of Mrs E. Bethune* (ill. 154) and John Opie's *Portrait of Miss Frances Winnicome*.

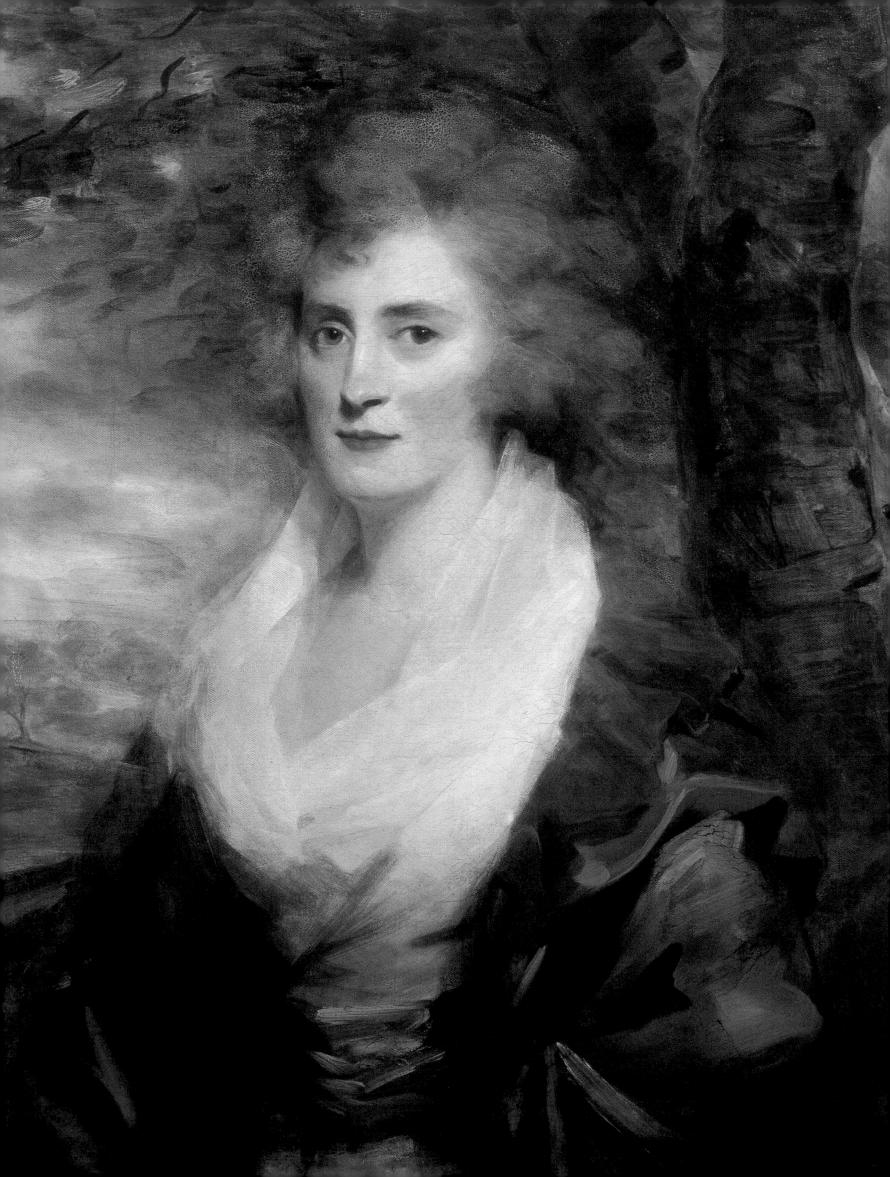

155

Dmitry Tatishchev

Bugler boy to the imperial horse guard at the tender age of fourteen, Dmitry P. Tatishchev (ill.156) was a nephew of Princess Ekaterina Dashkova, president of the Academy of Sciences, and of the powerful counts Vorontsov, one of whom was chancellor and the other ambassador to Britain (see p.49): it was to these illustrious and influential family connections that he owed—in part at least—his subsequent meteoric career and glittering success.

When a team was being appointed to produce the *Dictionnaire de Russie* in 1783, the young Lieutenant Tatishchev was chosen as one of the eight assistants to the members of the Academy; and in 1795 he was himself elected an academician. During the Russo-Turkish war he served as a volunteer in Grigory Potemkin's army, and at the Jassy peace negotiations he acted as assistant to the plenipotentiary Count Alexander Bezborodko, who shortly afterward dispatched him to Istanbul as *chargé d'affaires*.

Having left Turkey in order to rejoin the army, in 1794 Tatishchev was awarded the Order of St. George for his part in the assault on Warsaw. Subsequently he resumed his diplomatic career, becoming Russian ambassador to Naples from 1802 to 1808, senator in 1810, ambassador to Madrid in 1812 and finally ambassador to Vienna for twenty years from 1822, while simultaneously serving as great chamberlain to the court and member of the council of state.

The man of letters Nikolai Gretch has left us the following description of the Tatishchev residence in Vienna in 1837: the ambassador, he wrote, lived "in the vast and splendid residence of the Prince of Liechtenstein. The decoration of the rooms is at once sumptuous and discriminating. The Knights' Hall is particularly dazzling. . . , with statues in each of its corners of knights at arms, both mounted and on foot. But the most outstanding feature is the collection of paintings, which is of quite remarkable quality."

In amassing this collection, the ambassador had displayed no hesitation in running up debts which (not for the first time) were settled by his aunt, Princess Dashkova, and even by Alexander I and Nicholas I, anxious to ensure that Tatishchev would be able to continue to represent Russia with due dignity. He also possessed two residences in St. Petersburg, one on Karavannaia Street and the other in the New Holland district. But in 1841 Tatishchev began to lose his sight, and went on indefinite leave. Four years later he died in Vienna, in the impoverished lodgings of his faithful servant Pierrot. He left debts of 30,000 rubles and a magnificent art collection in St. Petersburg, which he bequeathed to Nicholas I.

The terms of his will, preserved in the Hermitage archives, shed light on his *modus operandi* as a collector: "During the many years I have spent abroad, a little over 36 altogether, between 1805 and 1841, I found myself in places where political events had profoundly affected the fortunes of numerous aristocratic families, whether in Naples or in Sicily, in other regions of Italy or in Spain. . . . The French invasions had brought about the downfall of rich and noble families, obliging them to sell their possessions, and in consequence numerous objects and above all paintings of exceptional quality might be purchased for a song. . . . More than once in Vienna, I had the occasion thus to acquire old masters and *objets d'art*." The catalogue appended to the will lists 185 paintings, of which 60 were subsequently sent to Moscow, with sumptuous furnishings, to embellish the Kremlin. Many of the sculptures were sent to St. Petersburg whereas the weapons collection went to the Arsenal that Nicholas I had created at Tsarskoie Selo.

The Napoleonic Wars were to bring about a revolution in tastes in collecting. Where before there had been a marked predilection for the work of Italian Renaissance and Mannerist painters, as well as for the seventeenth-century Dutch and Flemish schools, now

156

155. Jan van Eyck
The Crucifixion and *The Last Judgment*, side panels of the *Adoration of the Magi*, c. 1430
Oil on canvas (transposed from wood); each panel:
56.5 x 19.7 cm
The Metropolitan Museum of Art, New York, Fletcher Fund, 1933

156. Vasily Tropinin
Portrait of Dmitry Tatishchev, 1838
Oil on canvas,
72.5 x 57 cm
Museum of the Academy of Fine Arts, St. Petersburg

Italian painting before Raphael and the early Dutch masters were "discovered" with enthusiasm. This evolution in taste appears to have been led by Cardinal Fesch, archbishop of Lyon and uncle of Napoleon. Simultaneously, Spanish painting made its long overdue debut in Europe, where it dominated the collections of members of Napoleon's circle such as Maréchal Soult and Général Sebastiani. Nor was Tatishchev to remain unmoved by this new *zeitgeist*.

In the spring of 1846, a committee consisting of the curators Franz Labensky and Florian Gille found accommodation for Tatishchev's collections in the French painting gallery in the Hermitage. Following a systematic review, however, the paintings were soon divided into schools and assigned to the appropriate galleries in the New Hermitage, as may be seen in contemporary watercolors by Edouard Hau and Luigi Premazzi. A further 111 canvases were accommodated in the library of the new museum's Fine art gallery.

The Tatishchev collection was as remarkable for its Dutch old masters as for its masterpieces of the Italian school. The rarest of these—the two side panels of a Jan van Eyck triptych, *The Crucifixion* and *The Last Judgment* (ill.155)—have been in the collections of the Metropolitan Museum of Art in New York since 1933. The missing central panel, showing *The Adoration of the Magi*, was stolen from Tatishchev when he was in Spain.

Robert Campin's diptych showing *The Holy Trinity* and *Madonna and Child before a Fireplace* (ill.157 and 158) is another masterpiece reunited by Tatishchev. It should be noted that, along with Cardinal Fesch and the Boissière brothers, he was one of very few collectors of the period to show any understanding of the strange Gothic charm of early Dutch painting. Nor were these canvases selected at random, as may clearly be seen from the caliber of the other Dutch paintings in the collection: Jan Provost's *Virgin and Child* (ill.160) and *The Betrothal of St. Catherine* and *St. Jerome*, attributed to Adriaen Isenbrandt (all in the Hermitage). Three other paintings that hung in the Great Palace of the Kremlin are now in the Pushkin Museum in Moscow.

The Spanish painters who were only beginning to become known in Europe were also well represented in the Tatishchev collection. The *Virgin and Child* by Luis de Morales (ill.159), *Portrait of the Commander of the Order of St. Iago* by Juan de Pareja, Juan del Castillo's *Guardian Angel* and two paintings by unknown masters of the seventeenth century were the jewels of the Spanish gallery in the New Hermitage. The Academy of Fine Arts, meanwhile, inherited a copy of Murillo's *St. Peter*.

Also in the collection were some rare mosaics of the sixteenth to eighteenth centuries, and eight trays of intaglio copies. Contemporary painting, by contrast, was notable by its absence, with the exception only of Anton Raphael Mengs's portrait of *St. John* and portraits of Peter the Great and Catherine the Great

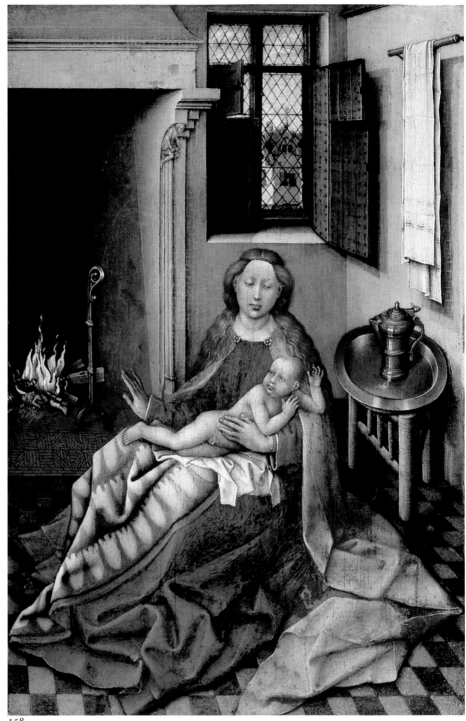

158

157. Robert Campin
The Holy Trinity, c. 1430s
Left-hand panel of a diptych
Oil on panel, 34 x 24.5
Hermitage, St. Petersburg

158. Robert Campin
Madonna and Child before a Fireplace, c. 1430s
Right-hand panel of a diptych
Oil on panel, 34 x 24.5
Hermitage, St. Petersburg

The eighteenth century offers numerous examples of Russian collectors who took advantage of diplomatic postings abroad to commission works from local artists or to scour foreign markets for old masters, especially of the Italian, French, Spanish, and Austrian schools. Generation after generation followed suit throughout the nineteenth century, including notably Dmitry Tatishchev, ambassador to Naples, Madrid, and Vienna, who testified to the growing interest at this period for works by fifteenth-century masters (ill.157 and 158). Overwhelmed by his resulting debts, he safeguarded his collection by bequeathing it on his death to Tsar Nicholas I, who duly chose to settle Tatishchev's debts rather than run the risk of losing this priceless ensemble for the Hermitage.

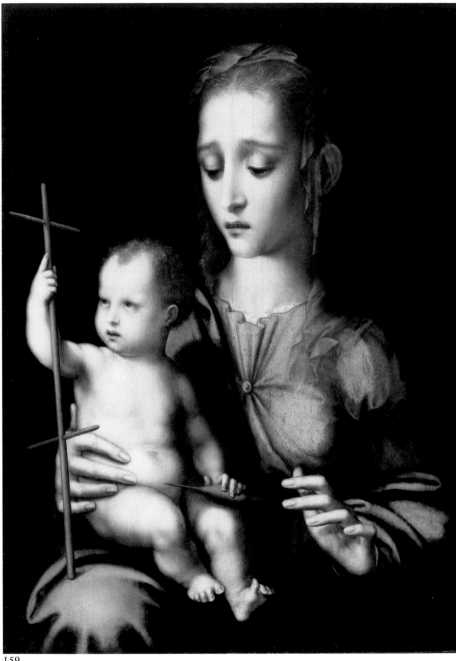

159

159. Luis de Morales
Virgin and Child with a Cross-shaped Distaff, c. 1550
Oil on canvas,
71.5 x 52 cm
Hermitage, St. Petersburg

160. Jan Provost
Virgin and Child
Oil on panel, 63.5 x 47 cm
Hermitage, St. Petersburg

883 plaster casts and glass moldings of celebrated gemstones to be found in other European collections. Arranged in ebony trays in a gilt-wood casket, these were probably displayed in the "Blue Salon" of Tatishchev's private residence, which appears to have been devoted exclusively to cameos and intaglios.

Tatishchev's invaluable catalogue also details not only the name of the artist responsible for each piece but also those of its previous owners. One of the highlights of the collection, for example, is a group of mounted stones of exceptionally fine workmanship. Many, we learn, were acquired in Florence: twenty-one from the collection of Prince Stanislas Poniatowski, ten from the Sestini collection, and four from the Riccardi collection. Those bought in Rome, meanwhile, came from the Borghese, Lancelotti and Santa-Croce collections. Tatishchev's *dactyliothèque* had the additional virtue of offering something of a historical survey of this art, including examples of archaic and classical Greek workmanship. Of the numerous gemstones engraved in Italian workshops of the third to first century B.C., the finest examples in this collection undoubtedly date from the late Republican era and the reign of Augustus, including *Theseus slaying the Minotaur* by the Master of Solon; the goddess Nike, or Victory, in her chariot by the workshop of Rufos, and portraits of Cicero and Antony the Younger by Master Gyllos. In terms of numbers, this group is nevertheless dominated by European works of the eighteenth and nineteenth centuries.

The most interesting intaglios were those produced by the Pichler family of engravers, some which were quite possibly commissioned by Tatishchev, such as Luigi Pichler's portraits of Alexander I and of Tatishchev's wife (a celebrated beauty to whom the poet and Prince Piotr Viazemsky dedicated a famous madrigal).

The collection also serves to document changes in tastes over the years: fired by his admiration for the masters of French Rococo, for instance, Tatishchev bought the large intaglios depicting *Venus and Adonis* and *Cupid* by the engraver Vincent Jeffrois. Then he developed a taste for the more austere Neoclassical style, acquiring dozens of works by artists such as Edouard Burch, Nathaniel Marchant, Filippo Rega, and of course the Pichler dynasty.

Now that we are able to view this outstanding collection in its entirety, we can appreciate the application and discrimination with which Tatishchev built up his "sanctuary" of blue and ashen grey chalcedony, ice-blue sapphires, warm amber topaz and deep red garnets: the purest of the earth's mineral treasures, engraved with subtle and virtuoso skill.

by Hyacinthe Rigaud and Giovanni Battista Lampi respectively.

But the most singular feature of all was Tatishchev's collection of gemstones, a "museum within a museum" consisting of an ebony casket made by the master cabinetmaker Johann Volkmann in St. Petersburg in 1837. With its silver handles and its twelve decorative intaglios set into its external woodwork, this was an exceptional piece and a rare one of its kind to have been preserved to this day. In his catalogue, Tatishchev gave a loving description of this *dactyliothèque* (meaning literally "finger case," a name he coined from the Greek), which contained 141 gemstones, each in its own numbered red velvet compartment. The catalogue also lists

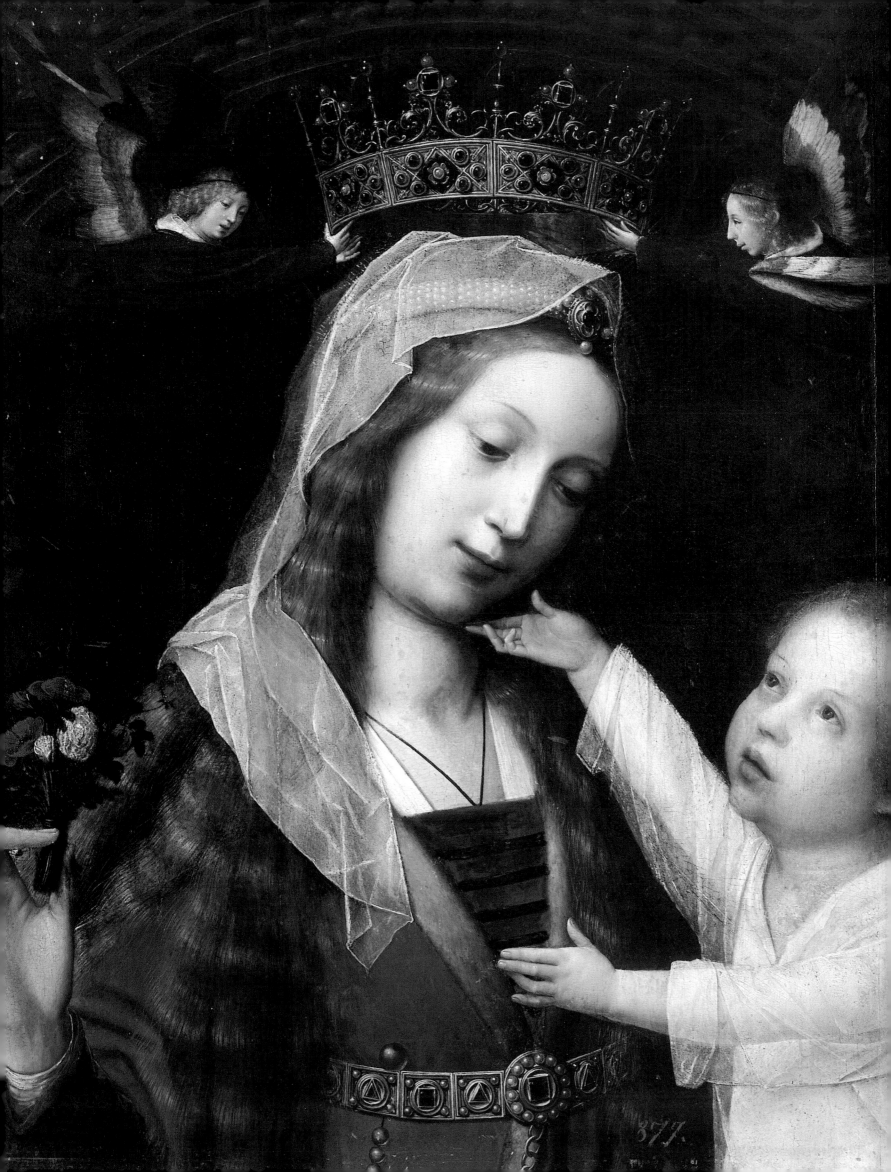

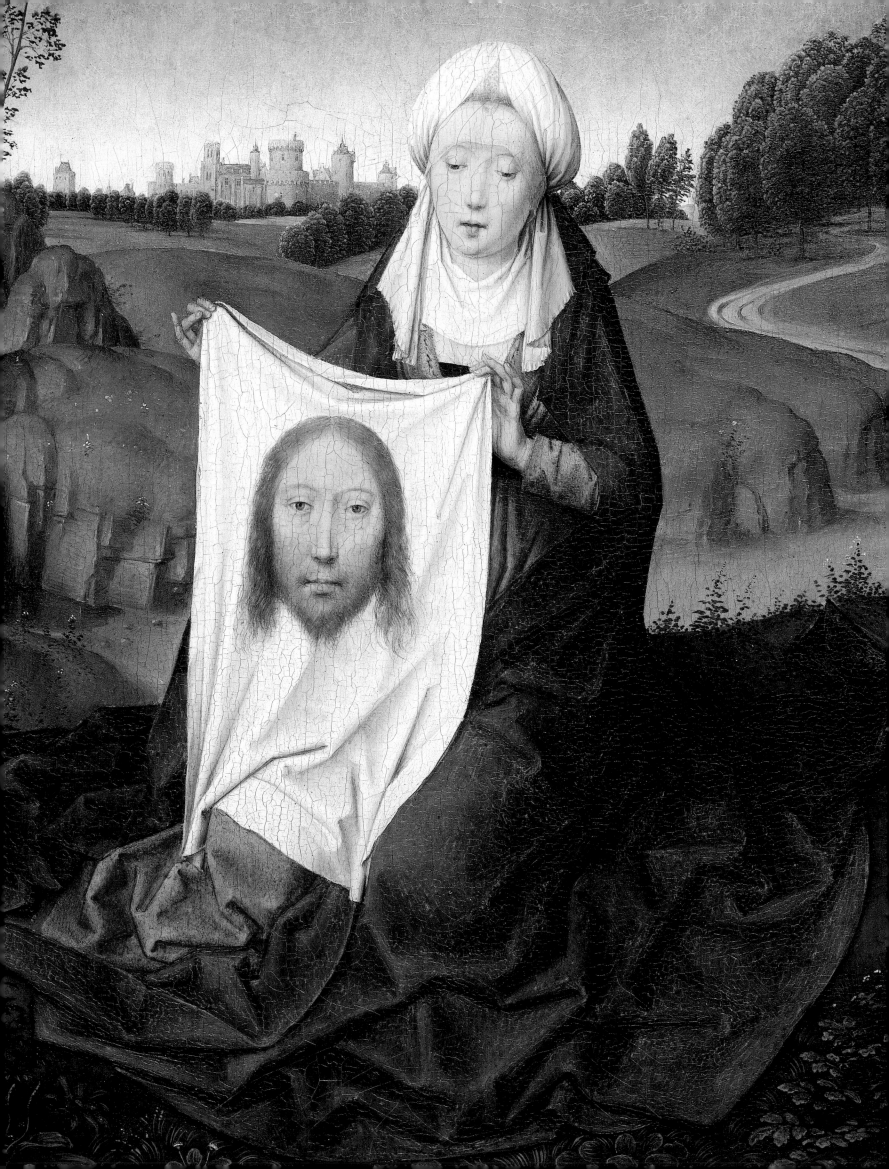

The Demidovs

The mighty Demidov dynasty was founded in the late seventeenth century by Nikita Antufiev (1656–1725), one of the many smiths then working at Tula near Moscow. As well as supplying weapons to the imperial army (the speciality of the Tula workshops), he also established mining businesses in the Urals and Siberia, and in 1720 was awarded with a hereditary title "for faithful service, and in particular for zeal and application in the creation of copper and iron works." It was not long before his descendants developed an enthusiasm for the arts. As early as 1716, his son Akinfy Nikitich (1678–1745; ill.162) is said to have marked the birth of the tsarevich Piotr (by Peter the Great's second wife, the future Catherine I) by presenting the tsar with a collection of some 200 Scythian silver pieces in the animal style (ill.3).

Akinfy's son, Nikita Akinfievich (1724–1789; ill.163), corresponded with Voltaire and also became a patron and benefactor of artists, most notably during his three-year grand tour of Europe in the company of the sculptor Fedot Shubin. His *Journal of my Travels 1771–1773*, published in 1776, offers interesting insights into his purchases and commissions from a variety of artists, including one in 1772 for portrait busts of himself and his wife Alexandra Evtikhievna "on our return from Rome" by "Mr Shubin, *pensionnaire*" (bought by the Tretyakov Gallery at the Pratolino sale in 1969). During his time in Paris, Nikita Akinfievich offered lodgings to the painter Jean-Baptiste Greuze and amassed a large collection of his works; these he bequeathed to his son Nikolai Nikitich (1773–1828; ill.165), an even greater connoisseur and the true founder of the family collections.

Having already spent a great deal of time in Paris before the French invasion of Russia in 1812, Nikolai Nikitich decided after the fall of Napoleon to leave his estates at Tula and make his home in the French capital. After the death of his wife Elizaveta Stroganova in 1818, he left Paris for Rome, where—according to Stendhal—he lived at a furious pace. There he undertook to finance archeological excavations at Tivoli (on the villa of Quintilius Varus) and Rome (near the Villa Santa Croce), which unearthed statues later restored by the sculptor Vescovali. Further excavations on the Esquiline Hill revealed the vestiges of an ancient sculpture work-

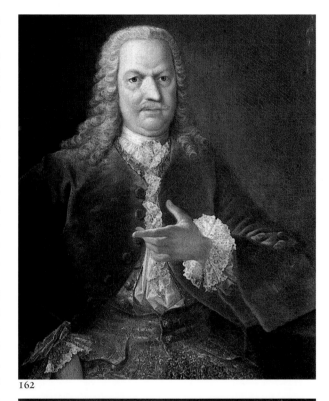

162

163

161. Hans Memling
St. Veronica, c. 1470–75
Oil on canvas,
31.1 x 24.2 cm
National Gallery,
Washington, D.C., Samuel
H. Kress Collection

162. Georg Christoph
Grooth
Portrait of Akinfy Demidov,
before 1745
Oil on canvas,
114.5 x 90 cm
Treyakov Gallery, Moscow

163. Louis Toqué
*Portrait of Nikita Akinfievich
Demidov,* 1756-58
Oil on canvas,
138 x 111 cm
Pushkin Museum of
Fine Arts, Moscow

Like the Yussupov and Stroganov dynasties, over a number of generations the Demidov family created one of the most impressive private collections in Russian history. With unlimited means at their disposal and unburdened by the responsibilities of high office that would have required them to live in Russia, they amassed the majority of their collections while abroad, in France and Italy. Living first in Paris, then in Rome and finally in Florence, Nikolai Nikitich Demidov (ill.165) numbered among the most passionate collectors. With tastes that were ahead of his time, he manifested a very early interest in fifteenth-century Dutch painting, acquiring Hans Memling's *St. Veronica*, now in the National Gallery of Art, Washington D.C. (ill.161).

164. Jacques-Louis David
Andromache Mourning Hector,
1783
Oil on canvas, 58 x 43 cm
Pushkin Museum of
Fine Arts, Moscow

165. Bertel Thorvaldsen
*Portrait of Nikolai Nikitich
Demidov*
Marble; height: 44 cm
Hermitage, St. Petersburg

166. Jean-Honoré
Fragonard
The Fountain of Love, c. 1747
Oil on canvas,
63.5 x 50.7 cm
The Wallace Collection,
London

In 1773 Nikita
Akinfievich Demidov
(ill.163) was living in
Paris, as was Alexander
Sergeievich Stroganov, in
whose company he met
Chardin, visited the
studios of Lagrenée the
Elder and Claude Joseph
Vernet, and became the
benefactor of Greuze by
buying some twenty-five of
his paintings.
Following in his footsteps,
his son Nikolai Nikitich
(ill.165) evinced a strong
interest in French painters
of the last quarter of the
eighteenth century such as
Fragonard (ill.166) and
David (ill.164)—an interest
shared by few other
connoisseurs at this time.
Similarly, he was well
ahead of his
contemporaries in buying
French furniture of this
period, mingling it with
Neoclassical or Empire
pieces in his newly built
Villa San Donato.
He had malachite quarried
from the mines that he
exclusively owned in the
Urals (at the emperor's
irritation) and sent it to
various Western capital
cities to be mounted in gilt
bronze by the best
craftsmen such as
Pierre-P. Thomire
(ill.170).

164

165

or twelve feet of soil covering the pavement of the
Forum from the Capitol to the Arch of Titus." But, in
the event, these plans were never to come to fruition.
On the evening of Maundy Thursday, the day before
Good Friday, a troupe of French actors had performed
a comic play at Demidov's residence that not only went
on until a quarter past midnight but also featured a
character called St. Leo. Pope Leo XII was far from
amused, however, and ordered Demidov out of Rome.
Going first to Pisa and then to Lucca, he finally settled
in Florence, where he was appointed Russian ambassa-
dor to the Tuscan court in 1824. Outside the city at
San Donato, he built an extremely large and opulent
villa, to plans by the architect Silvestri, where he took
advantage of his new position not only to make con-
stant additions to his own collections but also to
endow numerous hospitals and charitable foundations,
thus earning himself the title of count of San Donato.

By the time he died in 1828, the Demidov collec-
tion was reputed to contain some 500 masterpieces,
listed in three inventories (in French, Italian, and
Russian). Among its highlights were paintings by the
Italian masters, including the *Tagil Madonna,* discovered
in sensational fashion in the attic of the Demidov fac-
tory at Nijni Tagil in the Urals in 1924, then attrib-
uted to Raphael and subsequently discovered to be an
early copy of Raphael's *Virgin with the Veil*; by the Dutch
masters, including *St. Veronica* by Hans Memling
(ill.161); Govaert Flinck's *Golgotha* (Kunstmuseum,
Basel); and a large number of French paintings, includ-
ing some thirty by Greuze, a few Bouchers, *The Fountain
of Love* by Fragonard (ill.166), *Andromache Mourning
Hector* by David (ill.164), two seascapes by Claude
Joseph Vernet, and two interiors by Granet.

Nikolai Nikitich left his sculpture collection to his
eldest son Pavel Nikolaievich (1798–1840), who sent
its contents back to St. Petersburg to adorn his resi-
dence on Bolshaia Morskaia Street. On his death in
1840, the French architect Auguste de Montferrand
(who built St. Isaac's Cathedral) bought the above
mentioned bronze of Trebonianus Gallus in the hope
of selling it on to Tsar Nicholas I for the New
Hermitage, then under construction; but after his
death his widow took it back with her to Paris, and in
1896 it was bought by the Metropolitan Museum of
Art in New York. Fortunately, in 1851 Pavel Demidov's
brother, Anatoly Nikolaievich (1812–1870), sold the
Hermitage fifty-three other sculptures and bas-reliefs
that he had inherited, including a rare statue of Marcus
Aurelius (ill.169), for the sum of 100,000 rubles,
together with three contemporary works including a
portrait of Nikolai Nikitich by Bertel Thorvaldsen
(ill.165) and a large marble sculpture of *Ganymede* by
Adamo Tadolini.

But of all the collectors in this impressive dynasty,
the best-known is without doubt Anatoly Nikolaievich

shop, complete with six statues: three of these entered
the papal collections, while the remaining three satyrs
went to Demidov. His antique sculpture collection also
included a remarkable set of portrait busts of the Roman
emperors, and above all an outstanding bronze statue of
Trebonianus Gallus, one of the soldier-emperors of the
third century (Metropolitan Museum of Art, New York).

Nikolai Nikitich now hatched an even more ambi-
tious plan, "to remove" (in Stendhal's words) "the ten

168

169

167. Paolo Veronese
The Beautiful Nani
Oil on canvas,
119 x 103 cm
Musée du Louvre, Paris

168. Nicolaes Berchem
A Southern Harbor Scene,
c. 1650
82.9 x 103.7 cm
The Wallace Collection,
London

169. Rome, 2nd century
A.D.
Marcus Aurelius
Marble; height: 211 cm
Hermitage, St. Petersburg

It is thanks to Stendhal that we know the entertaining details behind Nikolai Nikitich Demidov's precipitate flight from Rome to Tuscany, at the very point when he planned to undertake an excavation of the whole of the Forum, "all that lies between the Arch of Titus, the Temple of Venus and the Basilica of Constantine at one end and the Colosseum and the Arch of Constantine at the other."

By a happy quirk of fate, part of his collection of antiquities (ill.169) was to enter the New Hermitage collection in 1851, when it was purchased by Nicholas I for the museum that was to be inaugurated there the following year. The vicissitudes of history have subsequently ensured that these works are virtually the only ones from the Demidov collections that remain in Russia today.

Demidov (ill.174), not only because of the prestigious nature of his acquisitions but also because he lapped up all the attention that went with them. Educated abroad, principally in Paris, and unflagging in his travels, he is reputed to have spoken almost every European language but to be barely fluent in Russian. After his father's death he decided to complete the Villa San Donato, enlarging it and adding a small private theater, fountains and garden pavilions, vast hothouses, and even a zoo containing ostriches and kangaroos. He also continued his father's charitable works, and with his brother commissioned Lorenzo Bartolini, the greatest sculptor then working in Florence, to produce a private commemorative monument that was beyond question one the most imposing examples of its type to be produced in the nineteenth century. Anatoly Nikolaievich's original intention was to erect it in the gardens at San Donato, but then he conceived the idea of placing it on a lapis lazuli plinth within a mausoleum with walls of malachite mosaic and a gilt bronze dome, and charging an entrance fee to be donated to a charitable fund for the Florentine poor. In 1871, finally, the vast monument, completed by Pasquale Romanelli, was erected on the Lungarno Serristori (where Nikolai Nikitich had lived), now Piazza Demidov, where it may be seen to this day.

Anatoly Demidov devoted the greater part of his time to his tireless efforts to gain recognition as a great patron of the arts, and particularly of contemporary art,

170. Pierre-Philippe Thomire
Malachite Rotunda, before 1838
Malachite mosaic, marble and various hardstones, giltbronze; height: 670 cm
Hermitage, St. Petersburg

171. Jean-Baptiste Fortuné de Fournier
Ballroom of the Villa San Donato, 1841
Gouache on paper, 70 x 58.5 cm
Palazzo Pitti, Florence

Relations between Tsar Nicholas I and Anatoly Nikolaievich Demidov were strained. When the latter decided to make a gift to the tsar of the lavish rotunda in malachite mosaic that until that time had been the chief ornament of the Malachite Salon at the Villa San Donato, his gesture proved singularly unwelcome. In response to Demidov's suggestion that it should be placed in St Isaac's Cathedral, where the iconostasis was also of malachite mosaic, the tsar promptly relegated it to the Taurida Palace, where all the works damaged in the Winter Palace fire of 1837 had been put in storage. Not until 1953 was it transferred to the Hermitage, having stood in the monastery of St. Alexander Nevsky since 1862.
The lavish decorations of the Villa San Donato were legendary, and particularly those of the ballroom, now preserved only in a contemporary watercolor (ill.171). This sumptuous room was adorned with life-size marble portraits of Napoleon and his mother Letizia Bonaparte by the French sculptor Chaudet, a gift from Demidov's father-in-law Jérome Bonaparte. The Catholic chapel, specially furnished to meet Princesse Mathilde's requirements, boasted the admirable *Demidov Altarpiece* by Carlo Crivelli, now in the National Gallery in London (ill. 172).

both French and Russian. Thus in the late 1820s he commissioned Karl Briullov to paint his equestrian portrait, sadly unfinished (ill.174), a transparent demonstration of his yearning for the admiration of the public, which even informed his ostentatious choice of commissions and acquisitions. In around 1830, for instance, he asked the same artist to enlarge (to a monumental 13 1/2 by 19 1/2 feet) his sketch for *The Last Day of Pompeii*, which in its finished state was to enjoy a triumphant reception in Paris four years later (ill.173). Also in 1834, he bought the other star attraction of the Salon, *The Execution of Lady Jane Grey* by Paul Delaroche, for the sum of 8000 francs, and at the Exposition des produits de l'industrie in Paris he put on display a lavish rotunda with columns of malachite mosaic (ill.170). Commissioned by his father in 1827 from the mosaicist Francesco Sibilio and the French bronzesmith Pierre-P. Thomire, this was originally intended to house a bust of Tsar Nicholas I by Tadolini (now in the Hermitage).

Anxious to make a favorable impression on the tsar, who had grown a little weary of all the commotion that constantly attended this relentlessly mercurial subject, Demidov now spent a relatively lengthy period in St. Petersburg, presented the massive Briullov canvas to the sovereign and, following his father's example, founded a variety of charitable institutions and a literary prize. Having obtained, through the good graces of Tsarina Alexandra Feodorovna, an honorary diplomatic posting which enabled him to live outside Russia without risking having all his goods confiscated, in 1836 Demidov again attempted to curry favor with the tsar

170

171

by presenting him with the malachite rotunda—which unfortunately the tsar could not abide. In 1837 he decided to fund from his own pocket a major expedition to the Crimea and southern Russia, culminating in the publication of six volumes written by its twenty-two specialist participants and dedicated to Nicholas. But sadly the specialists were all French, and this venture found even less favor with the tsar.

Shortly before this, Demidov had attracted attention yet again by buying thirteen of the ninety-seven paintings put up for sale in Paris in April 1837 by the Duchesse de Berry (daughter-in-law of Charles X), consisting largely of Dutch landscapes, genre scenes and history paintings, including a superb Nicolaes Berchem composition entitled *A Southern Harbor Scene*, or *The Old Port at Genoa* (ill.168).

In this ceaseless quest for fame, Anatoly Demidov at last distinguished himself in 1840 by choosing for his wife Princess Mathilde, related to the Württemberg dynasty and hence to the Romanovs, and daughter of Jérôme Bonaparte, himself brother of Napoleon and formerly king of Westphalia. Known in Paris as "Nôtre-Dame des Arts" because of her liberal patronage of artists and writers, Mathilde was motivated in her acceptance of Demidov's proposal more by material interests than by personal inclination. Created prince of San Donato by the grand duke of Tuscany (a title given recognition in Russia only in 1872), he was showered by his father-in-law with Napoleonic memorabilia in which he nurtured an obsessive interest, to the point of opening a museum dedicated to the emperor of the French in the Villa San Martino on Elba. Demidov had taken as his wife a patron of the arts like himself, with

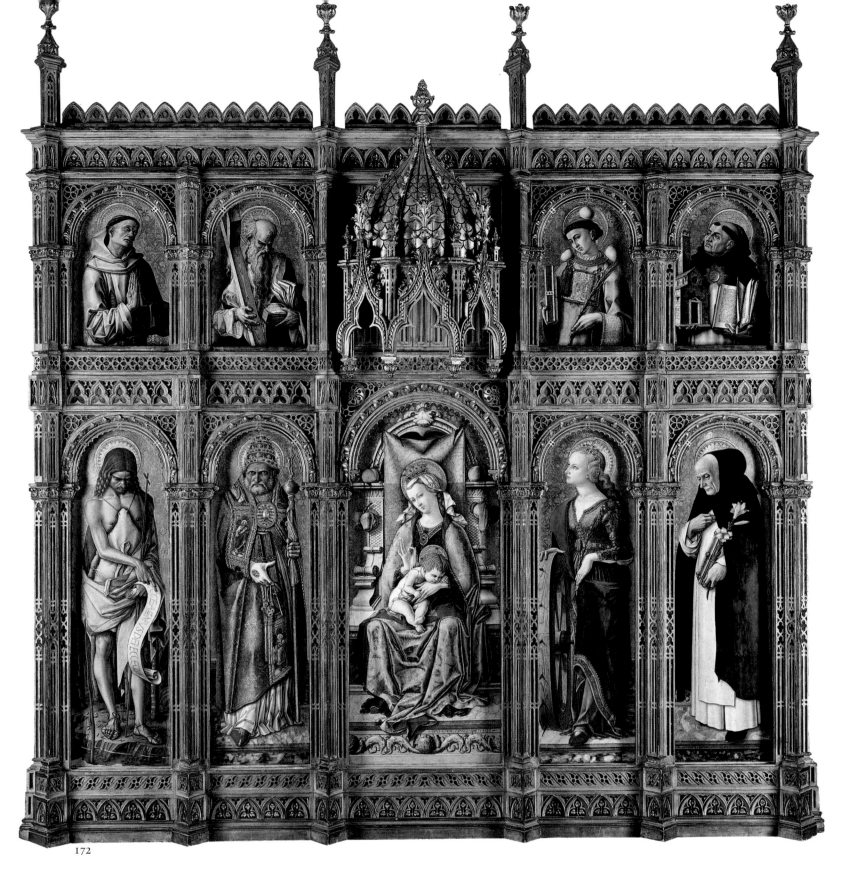

172

whom he seemed to have so many interests in common and after whom he named the Florentine palace and temple to the arts, known henceforth as Villa Matilda, but he had in fact concluded a dangerous bargain. It was not long before his fatal arrogance and her ferocious independence began to outweigh all the advantages of the social prestige and material comfort, their mutual desire for which had been the unifying factor in the their marriage. In 1846, following a series of violent arguments between the couple, the tsar himself (who on one occasion exclaimed to his cousin: "You

have no idea what sort of scoundrel you have married") laid down the terms of their separation.

After a brief period of enforced residence in Russia, Demidov succeeded in leaving the country in order to embark on a series of travels, making acquisitions as he went. In 1852 he purchased Carlo Crivelli's magnificent altarpiece, now named the *Demidov Altarpiece* (ill.172) from the Rinuccini family; and the following year, at the sale of the collections of the Duchesse d'Orléans, daughter-in-law of King Louis-Philippe, he bought six paintings. These included the celebrated

172. Carlo Crivelli
The Demidov Altarpiece,
c. 1470
Tempera on lime,
148.6 x 63.5 cm
The National Gallery,
London

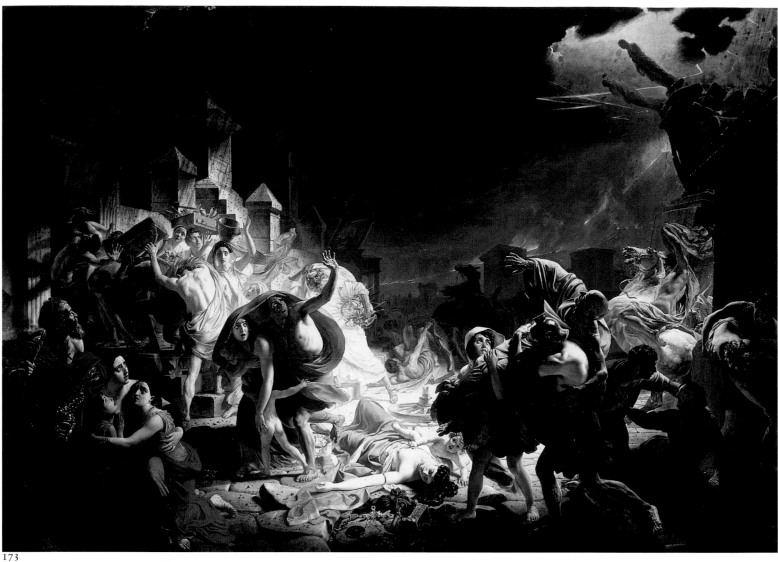

173

173. Karl Briullov
The Last Day of Pompeii,
1833
Oil on canvas,
456.5 x 651 cm
Russian Museum,
St. Petersburg

174. Karl Briullov
*Equestrian Portrait of Anatoly
Demidov* (unfinished)
Oil on canvas,
314 x 227 cm
Palazzo Pitti, Florence

175. Ary Scheffer
Francesca da Rimini, 1835
Oil on canvas,
166.5 x 234 cm
The Wallace Collection,
London

In the 1830s Anatoly Demidov gave special encouragement and numerous commissions to a handful of contemporary artists, both Russian and French. Highly typical of the Romantic period and its passion for drama, *The Last Day of Pompeii* (ill.173) is without question the best-known work by Karl Briullov—and the work that focused attention on the young Anatoly, then a mere eighteen years of age and making his debut as a collector. Painted in Rome while the artist was living in the Holy City and admired there by Stendhal and Sir Walter Scott, the vast canvas was first put on display—to immense acclaim—in Paris in 1834, before being sent to St. Petersburg. Anxious to curry favour with Nicholas I, Demidov

presented it to Nicholas I. The latter had it sent to the Academy of Fine Arts where it hung until 1851, when it was transferred to the rooms recently consecrated to Russian painting in the New Hermitage.
Having commissioned his own regal portrait from Brullov (ill.174), he gave work to other artists, in Florence-such as the French sculptor Félicie de Fauveau—and in Paris. From Delacroix he commissioned portraits, historical subjects and paintings on Moorish themes; from Eugène Lami highly spirited watercolors of contemporary subjects related to his own life; and from Denis-Auguste-Marie Raffet a constant stream of watercolors of scenes from his travels, on which he invited the artist to accompany him.

174

134

175

Antiochus and Stratonice by Ingres (Musée Condé, Chantilly), originally painted for the Duc d'Orléans and bought back again in 1863 by his brother the Duc d'Aumale, and the no less fêted *Francesca da Rimini* by Ary Scheffer (ill.175). Keen to add yet further to the adornments of the Villa San Donato, he also amassed an impressive collection of French eighteenth-century furniture and decorative arts, as well as an outstanding collection of arms and armor.

Paradoxically, and most unusually for a collector, Demidov mounted major public auctions of works from his collections in his own lifetime. Originally intended (in 1839 and 1861) to raise the overall quality of the collections, these quickly came to reflect the precarious nature of his state of health. Suffering from advanced syphilis and convinced that his end was nigh, in 1863 he sent an initial consignment of thirty-four oil paintings under the hammer, to be fought over by other great collectors of the time including the Rothschilds, the Péreires, Lord Hertford, and the Duc d'Aumale. These were followed in 1868 and in 1870, within a few months of the fall of the Second Empire,

by the contents of fourteen rooms at the Villa San Donato, including paintings, sculptures, furniture, porcelain, gold and silverware, and weapons, all sold in Paris in an atmosphere of feverish excitement, occasioned not merely by their exceptional quality but also by the enigmatic aura that surrounded their owner. On April 29, 1878, the very day after the last of these sales, Demidov finally lost his hold on life, at the age of fifty-seven.

His sole heir was his brother's son Pavel Pavlovich (1839–1885), who—himself an avid collector—proved a worthy successor to his uncle and restored the Villa San Donato to its former glory. In 1880, however, he abruptly took the decision to sell off the entire contents of the villa in a sale that was quite as sensational as those of 1870–78. He then moved to the Villa Pratolino, formerly owned by the Medici family, which he had bought in 1872; and there he died in 1885. At her own death in 1956, his daughter Maria, Princess Abamalek-Lazarev, bequeathed the remainder of the legendary collections to her nephew Paul Karageorgevich, prince of Yugoslavia, and it was he who in 1969 put it up for sale at the momentous Pratolino sales.

It is difficult to determine Anatoly Demidov's tastes with any certainty. Although he clearly did not lack discrimination, he appears in the case of some of his acquisitions to have been swayed more by the glamour of the previous owners or the prestige that was attached to the piece than by its contemporary standing as a work of art. Berchem's *A Southern Harbor scene* (ill.168), for instance, came from the prestigious collections of the Duc and Duchesse de Berry, sold at auction in 1837, while *Francesca da Rimini* by Ary Scheffer (ill.175) was formerly part of the no less celebrated collection of Ferdinand-Philippe, Duc d'Orléans, eldest son and heir of Louis-Philippe, who died tragically young in 1842.

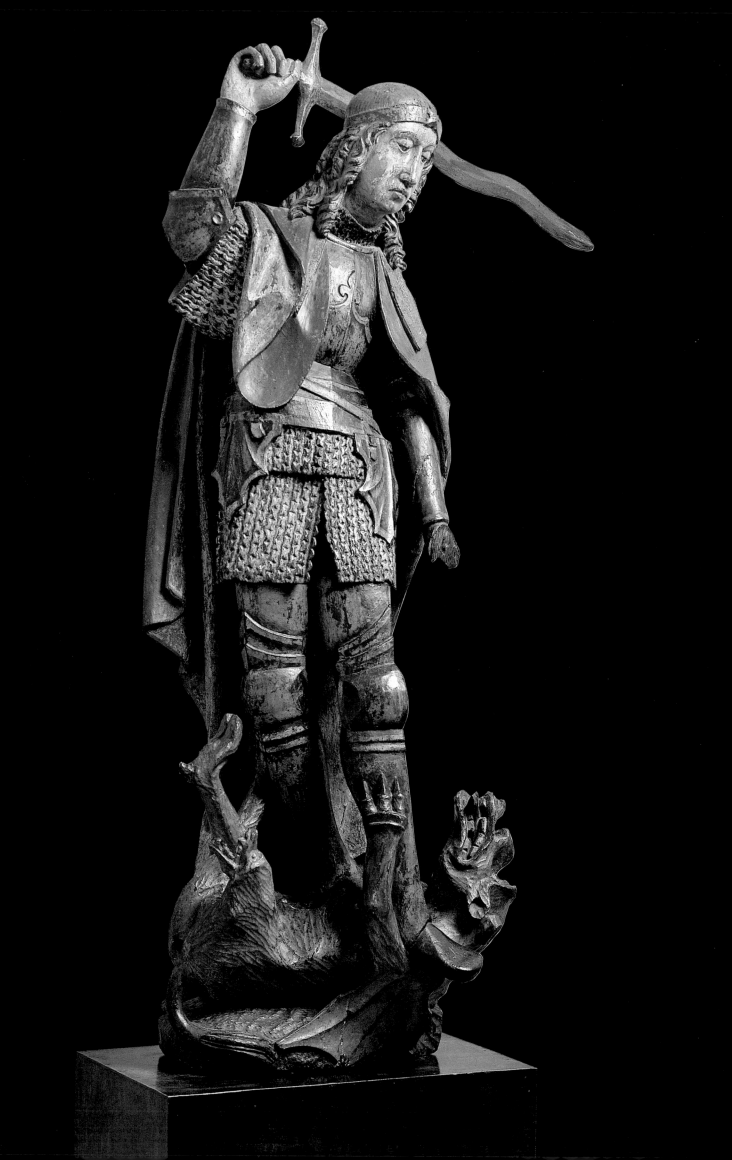

Alexander Basilevsky

Alexander Basilevsky was the scion of a noble family of long pedigree: his father was for many years chamberlain to the imperial court, and he himself entered the ministry of foreign affairs as a young man. From 1861 to 1863 he was Russian ambassador to Vienna, before rejoining his relations in Paris, where he became a prominent figure among the aristocratic Russian expatriate set. He died in Paris in 1899.

It was the Basilevsky *hôtel particulier* on Rue Blanche that saw the beginnings of the outstanding collection that is now the pride of the Hermitage collection. Until the middle of the nineteenth century, paintings and "antiques" had been deemed the sole objects worthy of the interest of genuine collectors. At that point, however, just as in the era of *Kunstkammer*, connoisseurs of art began to turn their attentions to all manner of "curiosities," and particularly to examples of oriental and medieval decorative art. But this interest was still general and vague, with very few collec-tors yet able to focus on specific areas and clearly defined goals. Basilevsky was to prove an exception to this rule. From the outset he perceived his collection as a single coherent whole: every work, every item was to illustrate the development of Christian art between the first and sixteenth centuries.

He made his first acquisitions in the 1850s. Then in 1861 he acquired a number of pieces at the sale of Prince Pavel Saltykov's collection: reliquaries, enamel caskets from Limoges and ivory carvings. He then concentrated on ceramics, gold and enamels from the Fould, Piot, and Pourtalès collections in Paris. At Paris's World's Fair of 1865, he was one of the principal contributors to the medieval section, with 150 items from his collection—a number that was to be doubled two years later at the exhibition of 1867.

Watercolors painted by Lavezzari and Vereshchagin (ill.177) in 1870 and now in the Hermitage offer us glimpses of the interior of the Basilevsky residence on

176. Holland, 15th century
St. Michael
Painted wood; height:
130 cm
Hermitage, St. Petersburg

177. Vasily Vereshchagin
The Gallery of Alexander Basilevsky in Paris, 1870
Watercolor on paper
Hermitage, St. Petersburg

Although some Russian collectors concentrated their attentions on a particular field, such as Italian or Dutch painting, this was generally not to the exclusion of all else. In Alexander Basilevsky's eyes, on the other hand, if a work did not illustrate the development of Christian art between the first and the sixteenth century it was not of much interest. He was also one of the few connoisseurs to whom the committee responsible for organizing universal exhibitions of art and industry decided to allocate an entire room, the better to display to the public the single-minded integrity of the enterprise. For Basilevsky a collection was not merely a group of works linked by period or place, but rather a statement on a theme. A view of his gallery in Paris, painted by his compatriot Vereshchagin (ill.177), encapsulates this obsessive desire to synthesize a facet of art history in its entirety. In the background sits the collector himself, the driving spirit behind this impressive project.

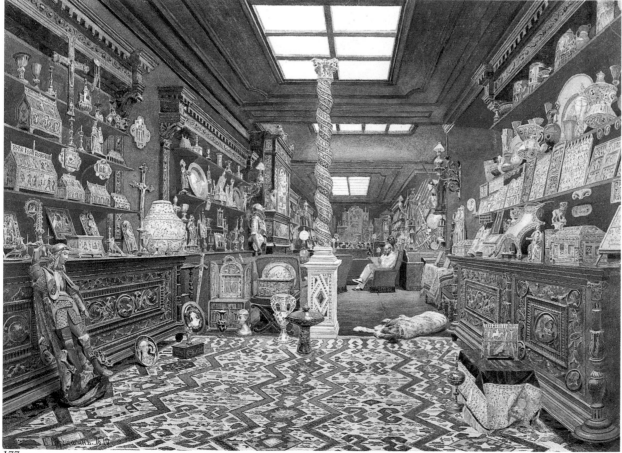

177

178

179

178. Florence,
15ᵗʰ century
Marriage Scene
Panel from a wedding chest
Painted wood,
49 x 167 cm
Hermitage, St. Petersburg

179. Studio of Bernard
Palissy
Venus and Cherubs, early
16ᵗʰ century
Ceramic; width: 27 cm
Hermitage, St. Petersburg

Rue Blanche. Arranged above some Italian Renaissance coffers are Limoges reliquaries and diptychs carved from bone, a Turkish glass lamp and an Iranian vase decorated with figures of polo players; in front of one of the coffers rises a wooden figure of St. Michael of Dutch workmanship (ill.176).

A detailed catalogue of the Basilevsky collections, drawn up by Alfred Darcel, was published in Paris in 1874 (*Collection Basilevsky: Catalogue raisonné précédé d'un essai sur les arts industriels du Iᵉʳ au XVIᵉ siècle*). At this point they numbered 550 items, and were still growing steadily: notable additions included a thirteenth-century Gothic crucifix from Friburg, and a fourteenth-century vase of impressive proportions, known as the "Fortuny vase" after its previous owner.

At the World's Fair of 1878, an entire room was given over to pieces from the Basilevsky collections—to overwhelming effect, as noted by a contemporary: "Monsieur Basilevsky's breathtaking room is quite beyond compare . . . What magnificence! Every one of the applied arts, from the early Middle Ages to the late sixteenth century, is represented here. It is truly a museum within a museum!" Basilevsky also went to considerable lengths to make his collections accessible to the public on a more regular basis, opening them to all interested parties every Friday, when he himself acted as a most amiable guide. On Mondays, meanwhile, he would issue invitations to his friends, who included Edmond Bonnaffé, Ernest Renan, and Leo Spitzer, among many others.

Also at this time, Basilevsky received a visit from the tsarevich, Grand Duke Alexander Alexandrovich

180. Egypt,
mid-16th century
Lamp
Glass, painted and gilded;
height: 36.2 cm
Hermitage, St. Petersburg

Basilevsky devoted almost forty years to forming his collection, which took on an intriguing political significance when it came to be sold in 1884. The event had been anticipated with eager impatience by the world of connoisseurs and dealers, who predicted that it would be an even more resounding success than the 1860 sale of the collection of Prince Pavel Saltykov, which had also taken place in Paris.
Yet the sale never took place. Instead, yielding to persuasion from his secretary of state Alexander Polovtsov, Tsar Alexander III bought the collection *en masse*, using funds from his private purse.
Even the French president Jules Grévy, not otherwise known for his interest in art, felt duty bound to go and admire this unique collection before it left France in order to return in triumph to St. Petersburg.

(the future Alexander III), as described to the St. Petersburg painter Mikhail Botkin by the tsarevich's traveling companion, the painter Alexei Bogolyubov: "While our emperor was still heir to the throne, he visited the Basileski (sic) collection in Paris, accompanied by myself, and it was on this occasion that he conceived the idea of purchasing it for Russia. "

Alexander Polovtsov, who had also visited the collection on Rue Blanche, was a fervent advocate of buying it in its entirety, writing to the court minister Count Ilarion Vorontsov-Dashkov in January 1884: "I propose . . . that we should also acquire the Basilevsky collection in Paris, put with it the finest pieces from the Arsenal at Tsarskoie Selo, and display the whole lot in the light and spacious galleries at present given over to the medal cabinets." In the autumn of the same year he wrote to the tsar on a more urgent note: "I have received a letter from Bogolyubov in Paris concerning the Basilevsky collection; it is his belief that, if we do not purchase it before the end of November, Basilevsky will from December 1 put in the hands of the valuer from Mannheim, and we shall have lost it forever." This had the desired effect: Alexander III not only gave his agreement, but also bought the collection from his own private purse.

The newspapers of the day were agog with excitement: "Yesterday evening," one of them reported, "on the strength of a simple telegram, the Basilevsky collection was sold to the Russian government for the sum of six million francs!" On February 12, 1885, Polovtsov noted in his diary: "We went to the Hermitage to see the Basilevsky collection. I am only too delighted to have played a part in its acquisition.

There is nothing comparable to be seen in Russia, and until now these pieces could be viewed only by those of my compatriots who had the means to travel; now they are accessible to the lowliest craftsman."

The Hermitage had gained 762 outstanding examples of the applied arts. Where before its representation of the applied arts had been limited largely to decorative features of the fabric of the building itself, now it had the material to create a new department in this field, devoted to the Middle Ages and the Renaissance.

180

Piotr Saburov

Piotr Saburov, who came from a family of high-ranking officials, entered the Russian diplomatic service where he rose to be ambassador to Athens and Berlin. The decade that he spent in Greece, from 1870 to 1879, happened to be one of intense archeological activity. Excavations carried out on the Acropolis revealed numerous sculptures and monuments from the period before Phidias that had hitherto been virtually unknown and caused quite a shock. French archeologists dismissed these painted polychrome statues sarcastically as *"bonnes femmes chinoises."* Their brilliant colors were indeed surprising, and their style and immediacy were no less disconcerting to eyes more accustomed to the cool serenity of classical Greek sculpture.

An archaic "portrait" of this type was bought by the Russian ambassador, and duly became known as the "Saburov head" (State Museum, Berlin). Saburov's collection also contained a number of funerary items. In the early 1870s, Greek villagers working in fields that lay over the site of the ancient Boeotian town of Tanagra began to discover painted terra-cotta figurines that had been placed in tombs some 2300 years earlier. Unlike the statuettes already known, usually Etruscan and of crude workmanship, these dated from the Hellenistic period after the time of Alexander the Great, and were of astonishing elegance and subtlety in both their form and their coloring.

When they became aware that archeologists and antiquaries were growing rich by selling these statuettes, the local peasants stopped cultivating their fields and instead set about digging them up wholesale. In due course the market was flooded with Tanagra statues and they were the star attraction at the World's Fair in Paris in 1878. Museums and private collectors fought over those that came up for sale, and "specialists" flooded the market with fakes.

With their unstudied ease and verisimilitude these figurines conjured up a world in miniature, shedding a new and altogether more intimate light on everyday life in ancient Greece. Far removed from the muscular heroes of Plutarch and the chilly perfection of classical Greek sculpture, these were lovely and graceful depictions of individuals going about their daily lives. Thanks to his position as ambassador to Athens, Saburov was perfectly placed to turn this situation to his advantage, traveling to the excavations to assemble a magnificent collection of Tanagra statues *in situ*. After the diplomat had left Athens for Berlin, he commissioned a sumptuous catalogue in German and French from the distinguished archeologist Adolf Fürtwangler that further enhanced its prestige.

In the spring of 1884, Saburov was recalled to Russia and chose this moment to put his collection up for sale, as he explained to Alexander Polovtsov, a member of the council of state: "My dear friend. . . . I have successfully disposed of part of my collection (the marbles and vases), and there now remains only the most valuable part, that is to say the terra-cotta statues, the terms for which I am presently negotiating with the museums of London and Berlin, but with the condition that the Hermitage should have first refusal." Count Vorontsov-Dashkov, minister to the imperial court, immediately informed Alexander Vassilchikov, director of the Hermitage, " Just as I was leaving the ball, Polovtsov informed me . . . of the sale of the Saburov collection. . . . The Berlin museum is our great and formidable rival. . . . May it please God not to allow its acquisition to confer even greater glory on the museums of Berlin, which are already so rich!"

The transaction was swiftly concluded. In March 1884, Saburov wrote to Vassilchikov: " Do not have any regrets about my marbles. . . . you would have been disappointed by them. . . . Germany is the land of pedantic scholars, who prefer ugly fragments of marble to beautiful objects. . . . The Hermitage has a particular fondness for aesthetic beauty, which it values much more highly than any purely archeological interest. When completed by my Tanagra statues, your Kertch Hall will outshine every other museum in the world in this respect."

Who could resist such flattery? By April 16, 1884, Polovtsov was able to write in his diary: "I am going to the Hermitage to see the terra-cotta figurines from the Saburov collection. I am delighted to have been able to help avert the danger of these pieces escaping from Russia, which is already so impoverished in works of art."

Soon after, in 1886, the collection was put on public display. Among the visitors was the artist Valentin Serov, who wrote to his wife in Moscow: " I went to the Hermitage. . . . It is a long time since I have felt a pleasure so keen as that I gained from these little Greek figurines, almost toys, but toys for which you would easily give a good half of chilly Roman sculpture." So profound an impression did this visit make on him, indeed, that ever after he would describe any object that gave him particular delight as "tanagretic."

181. Tanagra,
3rd century B.C.
Spinster with Eros
Terra-cotta;
height: 18.5 cm
Hermitage, St. Petersburg

With their grace and simplicity, the Tanagra statuettes (ill.181) caused a veritable sensation in St. Petersburg, so far removed were they from anything to which connoisseurs trained in the aesthetics of Winckelmann were accustomed. On seeing them for the first time, the painter Serov declared in a letter that he would willingly give "a good half of all chilly Roman sculpture" for them. A simple collection of inanimate objects could then assume tremendous political importance. Particularly striking in this respect was the cut-throat haggling and bargaining that surrounded the sale in 1884 of Piotr Saburov's collections of antiquities, which in the end were divided between the Berlin Museum, the British Museum, and the Hermitage. It is tempting also to question whether, in retrospect, certain collectors were not above taking shrewd financial advantage of this cultural rivalry between nations.

Piotr Semionov-Tian-Shansky 1827-1914

While in the eighteenth century the formation of art collections was the prerogative of sovereigns and their families, the high aristocracy, or royal favorites, the nineteenth century opened the way to imperial diplomats and civil servants, scholars and writers. Piotr Semionov (who adopted the suffix Tian-Shansky late in life, in 1906, in commemoration of his exploration of the Tian Shan mountain range in China), a distinguished geographer, traveler and explorer of Central Asia, not only succeeded in becoming a member of the council of state (ill.183), but also—and to the surprise of many—became a prominent collector and founder of the Semionov Museum.

Semionov devoted his youth to the study of science and to travels to distant lands, before taking up the cause of emancipation of the serfs. And then he was gripped by a sudden passion for Dutch painting and attending auction sales, which he complemented with a breadth of knowledge and depth of learning worthy of the greatest of European collectors. Soon his small and old-fashioned house on Vasilievsky Island in St. Petersburg boasted one of the finest collections of Dutch painting in Europe. Semionov augmented the already considerable interest of his collection by adopting a scholarly, systematic approach which was then quite exceptional, and which led him to concentrate his attentions on works by painters who were not represented in the Hermitage. Works by the great masters of the Flemish and Dutch schools, such as Rembrandt, Rubens and Van Dyck, were beyond his relatively modest means, and moreover were already in the Hermitage collections. Semionov therefore set himself a goal: to fill as many gaps as he could in the imperial collection of Dutch painting.

One day in the 1870s, he wandered into the Gostiny Dvor auction house and, having misheard the description of the lot in question, absent-mindedly added a ruble to the fifty that had been bid. When a higher bid failed to materialize, he found himself, rather to his bemusement, the owner of a massive Egyptian sarcophagus, complete with mummy. There was no question, needless to say, of dragging this unwieldy object back to his house on Vassilievsky Island. What was he to do with it? At this point the doors burst open, and in rushed two officials from the Hermitage, late arrivals with a brief to buy the sarcophagus. Semionov graciously allowed them to do so, bringing this comic and curious incident to an amicable conclusion.

The collector maintained a close watch on the market in art and antiquities, and kept the curators at the Hermitage informed of any interesting new arrivals. Sadly his advice was not always heeded. So it was that when one of Vermeer's works came up for sale in Moscow, it was bought by Abraham Bredius and is today one of the jewels of the Dutch collections, while the Hermitage remains without a single work by this master.

In 1886, at the antiquary Arkadi Kaufman's premises in St. Petersburg, Semionov lighted upon the panels of *The Healing of the Blind Man at Jericho* by Lucas van Leyden, which had sadly been sold at auction in 1854. Alexander Vassilchikov, director of the Hermitage, lost no time in acquiring them, so reuniting the panels of a polyptych that had been separated with such careless disregard.

According to contemporary accounts, the walls of the mezzanine, corridors, and stairwells of Semionov's house were densely lined with paintings. He now also included painting in his scholarly pursuits, publishing his *Essays on the History of Dutch Painting* in 1895, and following this in 1906 with a catalogue of his collection.

As he had intended from the outset, Semionov-Tian-Shansky eventually allowed his paintings—which by then numbered 720—to go to the Hermitage. In 1910, the museum gave him 250,000 rubles in payment for them: a sum representing about half of the valuation drawn up by the museum's own officials, and also of the amount offered to him by foreign buyers. The following year, furthermore, he presented his collection of engravings, estimated to be worth tens of thousands of rubles, to the Hermitage as a gift.

After Semionov's death, his estate was found to include a further seventy paintings that he had bought in the last years of his life. In 1915 the Hermitage mounted an exhibition entitled *In Memory of Piotr Semionov-Tian-Shansky*, which included sixty-two of the finest of his 720 paintings. Semionov was assiduous in keeping detailed notes of all his acquisitions, which enables us now to piece together the genesis of his collection. We know, for example, that he purchased three landscapes from the collection of Baron Kusov, while the superb *Portrait of a Widow* by Abraham van Tempel came from the collection of Auguste de Montferrand; *Landscape with a Rainbow* by David Teniers the Younger, meanwhile, came from the collection of Countess Kusheleva, and a *Still Life* by Frans Hals was bought from A. Andreiev, who had purchased it in turn at the Hermitage sale of 1854.

183

182. Hendrik Cornelisz
Portrait of a Girl with a Fan,
1645
Oil on canvas, 83 x 68 cm
Hermitage, St. Petersburg

183. Ilya Repin
*Portrait of Piotr Petrovich
Semionov-Tian-Shansky,
Member of the Council of State,
Honorary Member of the
Academy of Sciences and of the
Academy of Fine Arts,* 1901
Oil on canvas, 97 x 62 cm
Russian Museum,
St. Petersburg

As Alexei Khitrovo was to do with British portraits, Piotr Semionov-Tian-Shansky formed a unique collection of Dutch paintings (ill.182) with the principal aim of filling a corresponding gap in the Hermitage collection.

The Sapojnikov and Benois families

The early nineteenth century was marked by the emergence of collectors from a new type of background. For many wealthy dealers, entrepreneurs, and merchants, often risen only recently from the ranks of the peasantry, creating their own art collection was a way of raising their social standing.

The Sapojnikov family, for example, had grown rich on trade in fish, bread, and gold from mines in their native Astrakhan in southern Russia. The first of them to start a collection of paintings was Alexander Sapojnikov (1776–1827), who made a number of successful bids at the sales of both the Galitzin collection (1817-8) and General Korsakov's collection (1822). On his death, some of his paintings passed to his son Alexander Alexandrovich Sapojnikov (1827–1887), later to form part of the dowry of the latter's daughter Maria on her marriage to the architect Leonti Benois; they included *Huntsman with Dog* by Teniers the Younger, which featured in an exhibition mounted in 1908 by the journal *Starye Gody* (Old Times).

Also chosen by *Starye Gody* for this exhibition, and without doubt the most outstanding of the paintings in Maria's dowry, was Leonardo da Vinci's *Virgin and Child*. Known as the Benois Madonna, the painting is now in the Hermitage (ill.184). In 1912, however, its owner took the decision to sell it to a foreign buyer, and received an offer of 500,000 francs from the London dealer Joseph Duveen. This caused a public outcry, and a massive popular campaign was launched in favor of its acquisition by the Hermitage. As a result of this, Maria Benois was persuaded to accept the relatively modest sum of 150,000 rubles. In 1914, the Hermitage at last took possession of the painting, an event celebrated by *Starye Gody*: "All lovers and connoisseurs of art may congratulate themselves on a glorious event in the artistic life of this country: the acquisition

of the Benois Madonna by the imperial Hermitage. . . . We can only respond with gratitude to the patriotic sentiments of the owner, Maria Benois, which have inspired her to sacrifice a proportion of her profit in order that the painting should remain in Russia."

The collection amassed by Leonti and Maria Benois also included a number of architectural views by Canaletto, three of which were also included in the 1908 exhibition. In his memoirs, their grandson, the painter Alexander Benois (ill.185), described the artistic décor of his parents' house on Glinka Street in St. Petersburg. His father Nikolai's study, for instance, contained a gallery of family portraits "like the Tsar's," as he observed with pride. Paintings from this collection may nowadays be found not only in the Hermitage but also in a number of Russian museums, notably the Russian Museum and the Benois Family Museum at Peterhof.

184. Leonardo da Vinci
Virgin and Child (The Benois Madonna), c. 1478
Oil on canvas (transposed from wood), 49 x 31.5 cm
Hermitage, St. Petersburg

185. Leon Bakst
Portrait of Alexander Benois, 1898
Paper glued on cardboard, watercolor, pastel;
64.5 x 100.5 cm
Russian Museum, St. Petersburg

185

Baron Alexander Stieglitz
and Alexander Polovtsov

The names of baron Alexander Stieglitz (ill.187), court banker and later first director of the Russian state bank, and Alexander Polovtsov (ill.188), member of the council of state, are closely linked in the history of Russian culture. This is not merely because the latter was the former's son-in-law but also—and above all—because they shared a lifelong commitment to the support and development of education and training in the arts in Russia. Stieglitz founded the Central School of Technical Drawing, which was named after him, while Polovtsov devoted himself to enriching the museum of decorative and applied arts attached to the establishment, the kernel of which was formed by the two men's own private collections.

Baron Stieglitz's residence on the fashionable Angliskaia Naberezhnaia, or English Embankment, in St. Petersburg had been built by the architect Alexander Krakau from 1859 to 1862, and its sumptuous interiors are recorded in watercolors by Luigi Premazzi, now in the Hermitage (ill.190). Of the sequence of large-scale paintings specially commissioned from German artists, sadly a number were sold at auction in the 1920s by the state-run dealership of Antiquariat, which acted as middlemen for the Soviet government in selling off to foreign buyers works that all too often had been plundered from the country's museums. While some of these works have never returned to Russia, others have been brought back to the Hermitage; these include two works by Hans von Marées, *Cupid leading Psyche to Olympus*, from the ceiling of the Blue Salon, and *The Courtyard with the Grotto in the Munich Royal Residence*.

The baron's son-in-law Alexander Polovtsov was a civil servant, like most of the rest of his family. After graduating from law school in 1851, he entered the service of the imperial senate. We can only speculate as to what would have become of him had he not, in 1861, married the banker's adoptive daughter Nadzheda (1838–1908; ill.188), who according to family legend was in fact the illegitimate daughter of Grand Duke Mikhail Pavlovich, brother of Nicholas I. On the death of her adoptive father in 1884, Nadezhda found her-

187

188

186. Giovanni Battista Tiepolo
The Triumph of the Emperor,
c. 1725
Oil on canvas,
546 x 322 cm
Hermitage, St. Petersburg

187. Prosper d'Épinay
Portrait of Baron Alexander Stieglitz, 1883
Marble; height: 94 cm
Hermitage, St. Petersburg

188. C. Carolus-Duran
Portrait of Nadezhda Polovtsova, adopted daughter of Baron Stieglitz, 1876
Oil on canvas,
206.5 x 124.5 cm
Hermitage, St. Petersburg

189. Alexander Polotsov, member of the council of state, son-in-law of Baron Stieglitz

189

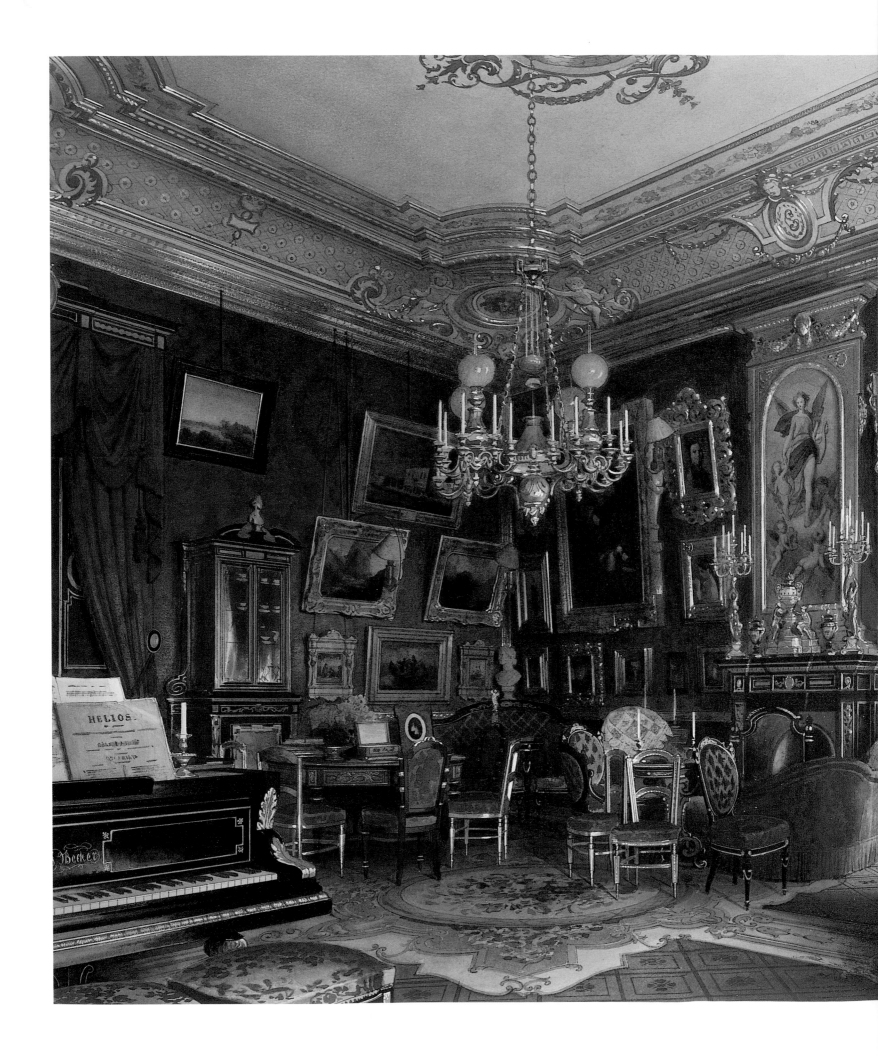

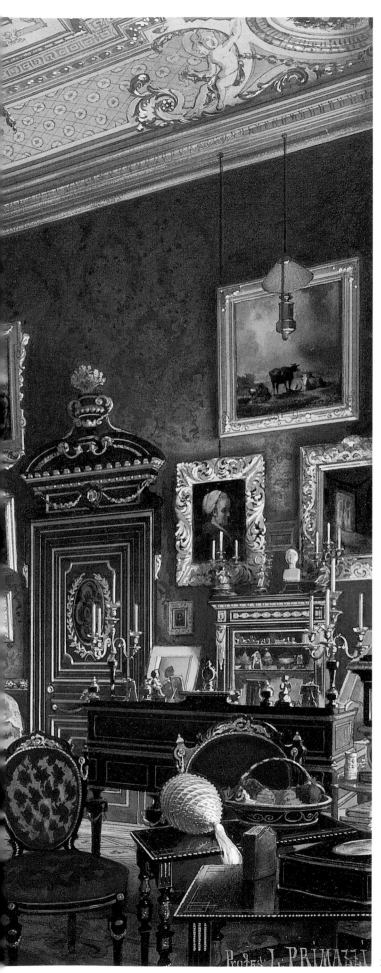

191

190. Luigi Premazzi
*The Cabinet of Baroness
Stieglitz in the Stieglitz Residence
in St. Petersburg,* 1869–72
Watercolor on paper
Hermitage, St. Petersburg

191. The library of the
Polovtsov residence, on
Bolshaia Morskaia Street,
St. Petersburg

Following the opening in
1857 of the South
Kensington Museum
(renamed the Victoria and
Albert Museum in 1899),
similar institutions,
highlighting the relevance
to the arts and crafts of
the industrial age of the
study of traditional
techniques, were
established in Vienna
(1864), Moscow (also in
1864), and Berlin (1867).
In 1876 Baron Stieglitz,
banker and voracious
collector (his wife's
cabinet in their

St. Petersburg residence
is pictured left, ill.190),
gave the sum of a one
million rubles to the
Russian state to fund the
setting up of a school of
art and industry and an
associated museum and
gallery for educational
purposes, both of which
were to bear his name.
On his death in 1884,
Stieglitz endowed the
school with a further nine
and a half million rubles,
which enabled it not only
to commission the
architect Maximilian
Messmacher to build a
sumptuous museum and
gallery in the eclectic taste
of the day (ill.192,193),
but also—and above all—to
put together one of the
most important collections
of decorative *objets d'art*
ever seen in Russia. This
now forms the nucleus
of the Hermitage's
collection of the decorative
and applied arts.

190

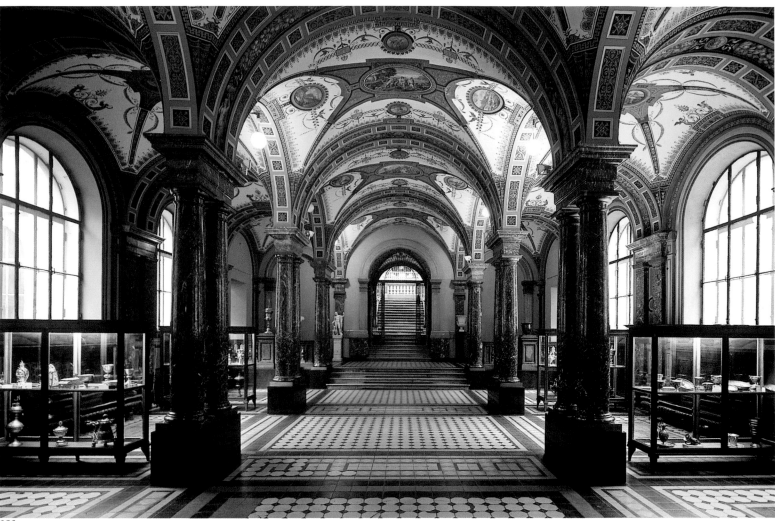

192

192. One of the exhibition halls of the school and museum founded by Baron Stieglitz in St. Petersburg

193. The Great Hall of the school and museum founded by Baron Stieglitz in St. Petersburg

The architecture of the Stieglitz Museum, built between 1885 and 1896, was inspired primarily by buildings of the Renaissance. The great central hall, for example (ill.193), beneath one of the largest glass roofs to be constructed in Russia at this period, was apparently based on the facade of the Libreria Marciana, Sansovino and Scamozzi's masterpiece in Venice.

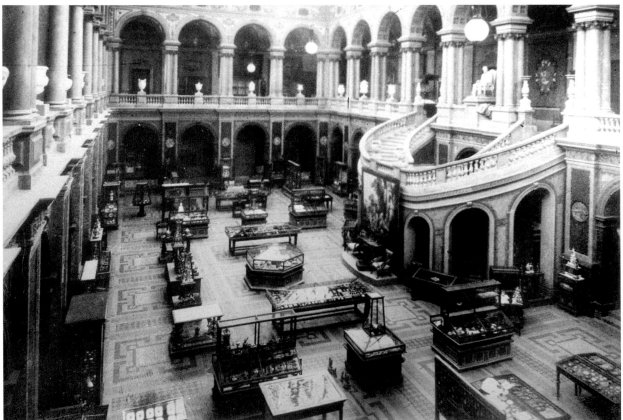

193

self sole heiress to a fortune estimated at some seventeen million rubles. Three years later, she sold the baron's residence on the English Embankment to Grand Duke Pavel Pavlovich, who had it refurbished and decorated by the architect Maximilien Messmacher, a project that lasted until 1890.

Polovtsov, meanwhile, had pursued a brilliant career, culminating in 1883 with his appointment by Alexander III as member of the council of state. He was one of the founders and later the president of the Russian Historical Society, and the *Russian Bibliographical Dictionary*, published on his initiative, offered an encyclopedic guide to prominent figures in Russian society. His thumbnail sketches of members of high society could be devastating in their coruscating accuracy: "These are ordinary men, lacking any education or application, and preoccupied above all else with sating their own appetites ... Grand Duke Konstantin, though respectable in his private life, was excessively limited in intellect while at the same time believing himself a genius: a highly dangerous combination ... While his two elder brothers [Grand Dukes Vladimir and Pavel] display an attitude of contempt towards the human race, the third [Grand Duke Sergei] is in turn held in utter contempt by the human race ..." Having thus dealt with the Tsar's immediate family, Polovtsov turned an even less forgiving eye on his colleagues: "The post of president of the committee of ministers is occupied by Ivan Durnovo, nicknamed 'Ivan the Great' [i.e. Ivan the Terrible] both because of his stature and ... because his head is as hollow as the bell of that name."

Polovtsov had assumed responsibility for creating a museum of decorative and applied arts for the Stieglitz school, while at the same time negotiating the purchase of the collections of Piotr Saburov and Alexander Basilevsky for the Hermitage. It was also his idea to create links between the Hermitage and the Arsenal at Tsarskoie Selo, so laying the foundations for a department of decorative arts at the imperial museum. It is hardly surprising, therefore, that when in 1883 the great archeologist Heinrich Schliemann sought to present Russia with 200 objects found during the excavation of the legendary site of Troy, he should address himself to Polovtsov.

Polovtsov's diaries offer an invaluable commentary on the history of the ambitious museum attached to the Stieglitz school. His entry for April 14, 1885, for example, observes: "We are engaged in examining the remarkable tapestries belonging to (Baron de) Gunzburg [Flemish tapestries now in the Hermitage]. Exceptionally pure examples of the seventeenth-century style." And in Paris on September 16, 1885: "My wife and I are receiving shopkeepers of all kinds, that is to say we are buying a mass of objects for the gallery of our design school."

194

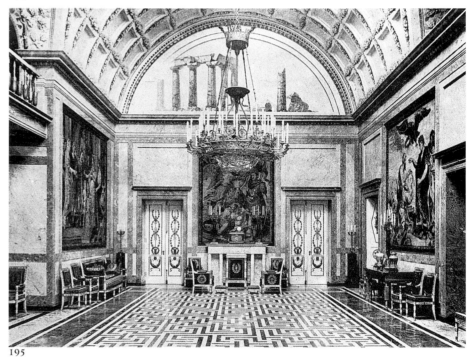

195

The magnificent history paintings by Giambattista Tiepolo that Polovtsov bought in Vienna in 1886 went first of all into his private collection before being transferred to the school (they are now in the Hermitage; ill.186), as described in his diary entry for June 7, of that year: "At the design school I sorted through the works that I would take home and those that would stay in the museum."

Polovtsov's residence was at 52 Bolshaia Morskaia Street in St. Petersburg, and today houses a branch of the Russian architects' union. Its interiors were laid out by the architects Nikolai Briullov, Maximilian Messmacher, and Harald Bosse (ill.191). We may imagine its décor from the list of works given by Polovtsov to the design school museum, and from the sale catalogue for the auction of his collections, which took place in Paris after his death in 1909. Of his two

194. The residence of Alexander Polovtsov on Kamenny Island, St. Petersburg, built by the architect Ivan Fomin, 1911–13

195. The Gobelins hall in the Polotsov residence

Alexander Polovtsov's house (ill.194) clearly demonstrates the revival of Neoclassicism in Russian architecture in the years preceding World War I.

196. Antonio Lombardo
*The Dispute Between Athena
and Poseidon,*
late 15ᵗʰ century
Marble, 86 x 107 cm
Hermitage, St. Petersburg

197. Antonio Lombardo
*The Birth of Athena
(Vulcan's Forge),*
late 15ᵗʰ century
Marble, 83 x 106 cm
Hermitage, St. Petersburg

The Stieglitz Museum
collections were hugely
enriched by the tireless
activities of Baron
Stieglitz's son-in-law,
Alexander Polovtsov
(ill.189), during his
innumerable journeys
abroad. While on his
travels he carried off
masterpieces from
celebrated collections such
as that of Spitzer in Paris
in 1892 (ill.196 and 197)
and, accompanied by his
wife and Prince Alexei
Borisovitch Lobanov-
Rostovsky, Russian
ambassador to Austria,
combed the antiquaries
of Europe.
From Vienna in 1886 he
brought back a famous set
of Tiepolos (ill.186); from
Bing in Paris the same year
a set of Chinese and
Japanese vases of the
thirteenth to seventeenth
centuries; and from
London a set of exhibits
in the Victoria and Albert
Museum.
After his death, his son
Alexander Alexandrovich
maintained close contacts
with the famous Madame
Langweil, the Paris-based
specialist in the art of
China and Japan, notably
buying part of her stock
when she streamlined her
business in 1913.

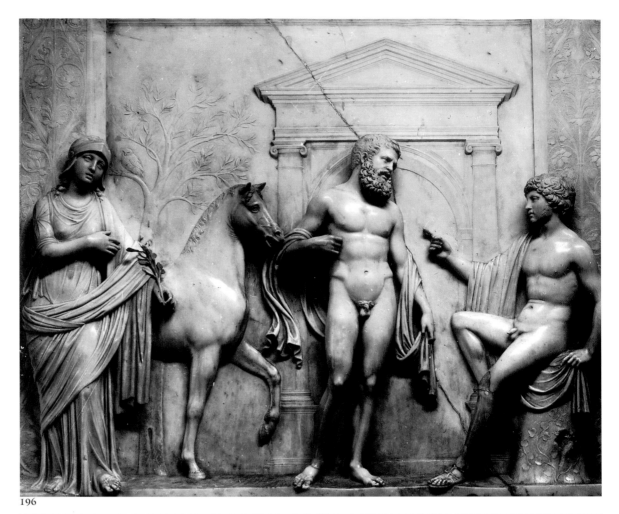

196

197

198

portraits by Jean-Baptiste Greuze, depicting the architect Gabriel and the engraver Wille, the first went to the Schlichting Collection in Paris and the second to the Musée Jacquemart-André, also in Paris. Three paintings by Pietro Liberi are now in the Kiev Museum of Western and Oriental Art, while works by Hoendecoeter and Tepfer went to the Omsk Museum of Fine Art. Vermeer's *Mistress and Maid* went to the Frick Collection in New York, while the Hermitage garnered many of Polovtsov's paintings, his seventeenth-century Flemish tapestries, and some thirty sculptures including the decorative marbles carved by Antonio Lombardo for the remarkable *studiolo* of Alfonso d'Este, duke of Ferrara (ill.196 and 197).

There can be no doubts about the patriotic motives that guided his skill and energy as a collector. The historic documents that he had published, the museum of the Stieglitz school and his personal collection all testify to his contribution to Russian culture. Yet there is an unmistakable note of bitterness in his diary entry for February 6, 1892: "In my youth, I remember seeing an inscription on the house that belonged to Count Rumiantsev, who bequeathed his collections to Russia. *Donated by Count Rumiantsev, for the benefits of education.* But nowadays, on my morning walks along the English Embankment, I see no trace of this inscription, and the residence in which the Rumiantsiev collection was preserved are presently enjoyed by Duchess Zina of Leuchtenberg." It is not difficult to imagine the thoughts and hopes of this secretary of state who, like Alexander I's chancellor, had striven for "the benefits of education" in Russia, nor his dismay at seeing the Leuchtenberg collections being squandered by an adventuress straight out of an Offenbach operetta.

198. After a cartoon by Peter-Paul Rubens
Tapestry from the *History of Constantine* hangings: *The Trophies of Constantine*
Paris, workshop of Raphael de la Planche, 1633-68
Wool and silk
Hermitage, St. Petersburg

Prince
Alexander Gorchakov

The Gorchakovs were an ancient noble family whose roots went back to the Rurikovich dynasty, the earliest tsars of Russia, who were related to many great aristocratic families such as the Sheremetevs, the Dolgorukis, the Uvarovs, and the Rumiantsevs. The most celebrated member of the family was Prince Alexander Gorchakov (ill.200), the minister of foreign affairs to whom Alexander II owed the success of his foreign policy, and who was rewarded with the Order of St. Andrew, the highest imperial award, and numerous other honors.

Before being appointed chancellor, Prince Gorchakov was Russian ambassador to London, Berlin, Florence, and Vienna. In St. Petersburg, where he had no private residence, he lived in his official quarters on the Winter Palace Square. But the overriding passion of his remarkable life was indisputably painting, and on top of his other achievements he was also to become a distinguished collector.

A manuscript catalogue of the chancellor's paintings has survived, and may be consulted in the archives of the Russian Federation (f.828, op.1, d.48). This lists 146 works, together with invaluable information concerning dates and provenance. As Gorchakov's fortune was modest, he was obliged on occasion to sell some of his paintings in order to buy others. Some of his paintings were gifts, such as Heinrich von Angeli's *Portrait of Franz Josef I* (now in the Hermitage), and his collection also featured sculptures or decorative works such as the tapestry *Hunt of Charles de Lorraine*, another gift from the Austrian emperor.

Gorchakov bought some paintings in Russia, but most of his acquisitions were made abroad. Thus *The Solemn Funeral Rites of Pope Leo XII in St. Peter's Basilica in 1829* (now in the Hermitage) came from the collection of Auguste de Montferrand. Gorchakov noted in his catalogue that he had refused to sell *Count Egmont before his Death*, by the Belgian painter Louis Gallait, to the Prince de Ligne; and that in buying Francesco Francia's *Entombment* (now in the Hermitage) he had thwarted Philipp Jacob Passavant's plans to acquire the painting for the Städelsches Kunstinstitut in Frankfurt. Of Eugene Joseph Verbœckhoven's *Still Life with a Hare* (also now in the Hermitage), the discerning Gorchakov observed: "The hare is so well painted that it could be by the hand of Weenix!"

After his death, the diplomat's youngest son, Konstantin Gorchakov (1841–1926), carried on his father's work. He devoted to his father's collection several rooms of the residence he built at 17–19 Mint Street in St. Petersburg while also adding his own acquisitions. Notable among these were a number of examples of the French school (a departure from his father's preference for Belgian painters), including a *Self Portrait* by Anne-Louis Girodet-Trioson, *Portrait of Konstantin Gorchakov* by Alexandre Cabanel (ill.201), and *Cows in a Field* by Constant Troyon (all now in the Hermitage).

Alexander Gorchakov's grandsons also continued this family tradition in their turn, with Mikhail Gorchakov acquiring two views of Venice by Canaletto (now in the Hermitage) from the Schwartz collection in St. Petersburg.

Some of Gorchakov's paintings joined the Hermitage during the 1920s, and others were sent via the state-run dealership of Antiquariat in 1933, 1936, and 1948. When in 1998 the Hermitage mounted an exhibition to commemorate the two-hundredth anniversary of Alexander Gorchakov's birth, it was able to put some fifty paintings from his erstwhile collection on display.

200

199. Louis Gallait
A Fisherman and his Family,
1848
Oil on wood,
39.5 x 31.5 cm
Hermitage, St. Petersburg

200. *Portrait of H.S.H.*
Prince Alexander Gorchakov
Engraving, c. 1875
Hermitage, St. Petersburg

201. Alexandre Cabanel
Portrait of Prince Konstantin
Gorchakov, 1868
Oil on canvas, 67 x 56 cm
Hermitage, St. Petersburg

The imperial chancellor Prince Alexander Gorchakov (ill.200) was most unusual among Russian collectors of his day in displaying an interest in contemporary European painting. This fact was possibly due to his postings as ambassador to the world's great capitals, followed by his appointment as foreign minister, all of which opened his eyes to outside influences in advance of his fellow countrymen.

201

MERCHANT PRINCES
OF THE MOSCOW RENAISSANCE
1850–1914

During the period of reform that followed the abolition of serfdom in Russia in 1861, it was inevitable that the social background of Russian collectors should reflect the fundamental changes taking place in Russian society as a whole. It was at this point that the "third estate"—the class of immensely rich merchants and industrialists—made their appearance on an equal footing in the world of collectors, in a development that went hand in hand with a degree of decentralization. Hitherto the lead in such matters had come from the court and the imperial capital; now, however, the initiative started to return to Moscow, and even to towns in the remote provinces.

When in 1862 the authorities decided to transfer the museum created by Count Nikolai Rumiantsev from St. Petersburg to Moscow, two hundred paintings were taken from the walls of the Hermitage, including Alexander Ivanov's imposing *Christ Appearing to the People* (now in the Tretyakov Gallery), which belonged to Alexander II and was the culminating work of the artist's career. The new Rumiantsev Museum was to be housed in the Pashkov residence, one of the finest buildings in Moscow. It was significant also that a few months earlier the city had seen the opening of a public gallery housing the collection of Vasily Kokorev (ill.205), who four years earlier had funded celebrations for the vanquished heroes of Sebastopol during the Crimean War. He maintained that all the failures of the country's high ranking civil servants were a result of their extinguishing of the spirit of the Russian people.

In 1856, Pavel Tretyakov (ill.211) had started his collection of Russian art, and in the late 1870s he wrote to Pavel Tchistyakov: "I intend to bring together paintings of the Russian school, as it is now, in the very throes of emerging." The results could hardly have been more convincing, as the critic Vladimir Stasov wrote to the painter Ivan Kramskoi in the autumn of 1880: "Only imagine, I have just been for the first time in my life to the Tretyakov Gallery!!! ... Highly impressive. The Russian school really does exist. And Tretyakov realized it ahead of everyone else." Everything about the Tretyakov Gallery, even down to its street facade designed by Viktor Vasnetsov, underlined the profound coherence of the collections of Russian art displayed there. This was a characteristic shared by many other private collections in Moscow, such as the gallery of Ivan Tsvetkov (ill.232), also designed by Vasnetsov, this time taking his inspiration from the architecture of the traditional Russian *terem*, or palace, and Piotr Shchukin's home and gallery, designed by the architect Boris Freidenberg (ill.288).

Muscovite artists such as these aimed to translate the spirit of old Russia, before the time of Peter the Great, into aesthetic terms. While this movement could be construed as a rejection by Moscow of the "Westernization" of St. Petersburg, it was also a manifestation of the new historicism that was so central to Russian art in the nineteenth century. In this respect, the contrast between the two cities was undeniable. When at the same period Baron Stieglitz (ill.187) commissioned a building for his school of technical design in St. Petersburg, he took his inspiration from the Italian Renaissance (ill.193).

Those who succeeded in creating significant collections at this time were in many cases wealthy merchants who had made their fortunes in the textile business (Soldatenkov, the Tretyakov, Ryabushinsky, Bakhrushin, Morozov, and Shchukin families), the tea trade (Ostroukhov, the Botkin family), the sugar trade (Kharitonenko), banking (the Ryabushinsky family), and building (Mamontov). It is not without significance, either, that many of them, such as Soldatenkov, the Morozovs, and the Ryabushinskys, were "Old Believers," or followers of the old, schismatic faith. Old Believers had always collected and preserved icons and sacred manuscripts, and it was undoubtedly this tendency that lay behind the new interest in Russian religious painting, accompanied by a concern to safeguard surviving icons dating from before the seventeenth-century reforms which had resulted in the Great Schism of the Russian Orthodox church. Pavel Tretyakov, for instance, owned a collection of six hundred icons, keeping them in his office rather than putting them on display in the gallery.

The earliest collections of icons in which religious painting was considered in a general' artistic context were those displayed by Ilya Ostroukhov (ill.248) in the Museum of painting and Icon painting that he founded. Stepan Ryabushinsky's plans to establish a museum of Russian icon painting, meanwhile, were thwarted only by the outbreak of the World War I.

202. Ivan Kramskoi
Portrait of Tsar Alexander III,
1886
Oil on canvas,
129 x 91.5 cm
Russian Museum,
St. Petersburg

In the second half of the nineteenth century the tsar continued to play a crucial role in the development of the arts in Russia, for example through the acquisition of prestigious private collections (such as those of Basilevsky and Saburov or that of the Galitzin family) for the imperial Hermitage, and through the creation of a large museum devoted exclusively to Russian artists (the Alexander III Museum).
Yet his status—and that of the imperial family as a whole—as leading patrons of the arts, was now under threat from ordinary private citizens. An anecdote relates the irritation of Alexander III (ill.202) and his brother Grand Duke Vladimir Alexandrovich, president of the Academy of Fine Arts, at finding so many paintings at exhibitions of works by Russian artists labeled "Property of Mr Pavel Tretyakov."
In something close to a snub, Tretyakov ignored the tsar's express wish that his paintings and those of his brother should join the collections of the new imperial museum then being created, quite deliberately leaving them instead to the city of Moscow.

In the second half of the nineteenth century, artistic life in Russia also started to coalesce into various circles, each of them formed around a different patron and collector. One of these, which sprang up on the estate of Princess Maria Tenisheva in the Smolensk region, concentrated its efforts, like the Stieglitz School in St. Petersburg and the Stroganov School in Moscow, on promoting art education among peasants and artisans. The aim of the princess (ill.254) was to revive traditional Russian craftsmanship, and to champion it in the face of competition from industry. Her allies in this venture were the painters Vrubel, Roerich and Malyutin, and for a time she was also associated with the periodical *Mir Iskusstva* (World of Art).

Another woman prominent in the field of collecting was Natalia Shabelskaia (1841–1904), who set up the Museum of Russian Applied Art in Moscow, where she displayed textiles, embroidery, headdresses, and decorations. After her death, part of her collection was presented to the Museum of the History of Moscow and part to the Russian Museum in St. Petersburg, while the remainder went abroad, to return to Russia in 1991 when it joined the collections of the Museum of Russian Folk and Decorative Art.

The industrialist Savva Mamontov (1841–1918; ill.239), a Moscow-based patron and collector, meanwhile founded an artistic circle on his estates at Abramtsevo which counted among its members such distinguished artists as Valentin Serov, Apollinary Vasnetsov, Mikhail Vrubel, Konstantin Korovin, Mark Antokolsky, Vasily Polenov, Elena Polenova, Isaac Levitan, and Ilya Ostroukhov. The aims of this group were to revive traditional techniques such as majolica and ceramics, fine furniture and woodcarving. They also set up a gallery of folk art at Abramtsevo, which gave rise to "forays" into local villages in search of wooden utensils, spinning wheels, traditional costumes, embroideries and the like. The ceramics produced by the Abramtsevo pottery, meanwhile, carried off the grand gold medal at the Paris World's Fair of 1900. They also became widely known and used throughout Russia, as did the folk art objects produced by the Talashkino workshops, which in addition supported craftsmen in the development of new forms.

In the 1880s the artist Elena Polenova declared: "Our goal is to capture the creativity of the people on the wing, alive and breathing, so that the people themselves may nurture and develop it." On their estate at Polenovo, she and her husband Vasily, also an artist, turned their home into a gallery where, alongside their own paintings, they displayed items made in the Mamontov workshops at Abramtsevo, as well as collections of Russian antiquities and crafts. The present museum at Polenovo is the result of the efforts of four generations of this family and their constant encouragement of artistic activity in neighboring villages and further afield. Like the famous Penates of Ilya Repin and Mamontov's Abramtsevo, the Polenovo museum is a workshop and gallery where artists, in the tradition of ancient Russian culture, promote a symbiotic relationship with their natural environment, which in turn provides them with their inspiration.

Another characteristic feature of the second half of the nineteenth century was the rise of provincial galleries, based for the most part on private collections, such as that of the textile magnate Dmitry Burylin at Ivanovo-Voznessensk. The collection of paintings of Bogdan and Varvara Khanenko formed the basis of the Museum of Western and Oriental Art in Kiev, while the collections of the Tereshchenko family and the sugar manufacturers Kharitonenko became the nucleus of the Museum of Russian Art, also in Kiev.

In 1885 the artist Alexei Bogolyubov, descendant of the writer Alexander Radishchev, bequeathed to the town of Saratov an impressive collection intended for the new Radishchev gallery (now the Radishchev Art Gallery of Saratov), consisting of 525 works, later complemented by gifts from other artists and collectors as well as from the Hermitage and the St. Petersburg Academy of Fine Arts. In 1880 the seascape painter Ivan Aivazovsky (1817–1900) founded an art gallery at Feodossia in the Crimea which he would later bequeath to the town, housing a collection of some fifty paintings, studies and sketches, largely his own work. Six years later in Kharkov, 2500 drawings collected by the founder of the local university, Vasily Karazin, and originally intended (in 1805) for the Arts Cabinet, were used to form the basis of a museum of manufacturing arts.

It was not unusual, in addition, for provincial museums and galleries to be opened by members of the local administration who shared the collecting spirit. Thus the art gallery in Irkutsk owes its foundation to Vladimir Sukachev (1849–1917), who in the 1870s assembled a private collection of paintings. In Samara, meanwhile, it was the chief magistrate Piotr Alabin (1824–96), a former collector, who took the initiative in founding an art gallery in 1897.

In St. Petersburg at the same time, in the wake of political and economic apathy, a weariness in matters aesthetic had overtaken the capital, and accessions to the Hermitage went into drastic decline. In his youth, Alexander III (ill.202) took drawing lessons from the painter Bogolyubov and amassed a somewhat eclectic private collection, but still the museum's annual acquisitions budget was limited to a mere 5000 rubles. Exceptions were made only for rare cases such as the Basilevsky and Saburov collections, which had the added attraction of offering diplomatic kudos and international prestige with regard to rival institutions abroad. Prince Alexander Vassilchikov, director of the Hermitage, deplored this state of affairs in vain, before

taking refuge in a reorganizing the works held in the various imperial residences. Only the creation of the Russian Museum, another political move prompted by strengthening nationalist sentiments within the country, seemed able to galvanize the tsar into action (even if the new museum was not inaugurated until 1898, during the reign of his son Nicholas II). Where art collections were concerned, the initiative now lay firmly with Moscow. Indeed, two Muscovite industrialists, Ivan Morozov and Sergei Shchukin, were the moving forces in one of the most momentous episodes in the history of Russian collecting, their passion for contemporary French art offering legitimacy and encouragement to artists who might otherwise have remained more or less unrecognized. As Théophile Gautier had observed on his travels in Russia in 1858-9, in St. Petersburg art collections had always lagged behind contemporary developments in art.

Not only did Morozov and Shchukin put together impressive collections of paintings by French artists of the avant garde, but they also commissioned works from their favorite artists to decorate their residences, as did other connoisseurs in Moscow. Thus Pavel Kharitonenko commissioned frescoes and portraits from François Flameng (ill.325), the younger Nikolai Ryabushinsky (ill.321) decorated his city residence and his dacha with works by « Blue Rose » painters, while the residence of Alexei Morozov (ill.283) was hung with panels by Mikhail Vrubel (ill.282).

Art historians never cease to be astonished at the collection of modern French painting that Sergei Shchukin (ill.297) managed to amass, necessarily working without the benefit of any historical perspective – which only much later would reveal its coherence and its astounding quality. His sole criterion of choice was his own remarkable intuition: if he liked a painting he bought it. It is difficult to imagine now the levels of courage it must then have required to return to Moscow with Impressionist paintings that were dismissed as "daubs" by most Russian artists and were still viewed as scandalous even within France.

Flying constantly in the face of majority opinion, which repudiated artists (whose works are now regarded throughout the world as masterpieces) as either charlatans or fools, Shchukin somehow contrived to maintain an uncanny awareness of significant developments in contemporary art. In 1914 Yakov Tugenhold observed: "The first Monet landscapes brought back to Moscow by Shchukin caused quite as much of a scandal as Picasso's work does today; it was no coincidence that a guest at Shchukin's house, moved to protest, should have chosen to mark his disapproval by attacking a Monet painting with a pencil."

Gradually, Shchukin turned his attention from the Impressionists to the Post-Impressionists: Paul Cézanne, Vincent Van Gogh, Paul Gauguin, Henri Matisse, André Derain, Maurice de Vlaminck, and

203

Albert Marquet. A close working relationship even developed between Matisse and the collector: when asked whether, in his view, the artist would have painted *Dance* (ill.307) and *Music* had Shchukin not commissioned them, Matisse's son Pierre replied, "But who would he have painted them for?"

After discovering Picasso, Shchukin opened his house to the public in 1909, transforming it into a true gallery of modern art that was to become enormously influential in the arts in Russia.

Tretyakov had succeeded in endowing his country with a gallery of Russian painting which was at once a place of sanctuary, a gauntlet flung in the face of St. Petersburg and a rallying cry for Russian artists to preserve their own distinctive voice. Now Sergei Shchukin became the champion of Western art not merely for his own satisfaction but also for what that art represented: liberation from the twin yokes of figurative art and formalism and the quest for a new aesthetic. In so doing he planted the seed in Russia soil of the revolution in painting that was to reach its dazzling culmination in the work of Russian primitivists such as Mikhail Larionov and Natalia Goncharova.

203. Ilya Repin
Portrait of Tsar Nicholas II,
1895
Oil on canvas,
210 x 107 cm
Russian Museum,
St. Petersburg

Ilya Repin was among the most sought after of the traditional painters working in late 19th century Russia. In addition to portraits of artists, men of letters and prominent collectors (including Nikolai Rimky-Korsakov, Leo Tolstoi and Pavel Tretyakov, ill.211; Savva and Elizaveta Mamontov, ill.235 and 236), he also painted official portraits of the imperial family (ill.203), and above all one of the most important group portraits in the whole history of Russian painting. Preserved in the Russian Museum in St Petersburg, together with Repin's preparatory studies for virtually all the figures (ill.183), the painting depicts a formal session of the imperial Council of State in May 1901. Nicholas II is shown surrounded by the elite among his imperial dignitaries—ageing, stiffly encased in uniforms encrusted with medals and regalia, and symbolically blind to the necessity of reform.

Vasily Kokorev

Born into the lower middle class of Vologda, Vasily Kokorev (ill.205) remained a sort of autodidact the whole of his life, exploiting his native intelligence to garner one of the largest fortunes in Russia. Merchant and entrepreneur, he also became a famous polemicist, as well as a patron of the arts and a collector who founded the first privately owned public gallery in Moscow.

Wealthy from a license for distributing wine, Kokorev was popularly known as the "license tsar." The considerable fame he enjoyed in the 1860s and 1870s derived as well from an immense hotel (ill.206) he had built in the heart of Moscow, on St. Sophia Embankment facing the Kremlin, nicknamed the "Kokorev Inn." He also played an active role in creating the horse-drawn tramway, and arranged a solemn reception for the soldiers who had taken part in the defense of Sebastopol. The convict writer Nikolai Tchernyshevsky dubbed him "our Harun al-Rachid," and "our Monte Cristo," as a reflection of his great popularity. He was also described by the Slavophile writer Sergei Aksakov as "a Russian gold nugget who, in himself, is a marvel of Russian nature."

Kokorev also drew attention for his radical views on peasant reform. His public statements and debates resonated in such publications as "The Route of the Combatants of Sebastopol," "Russian Eye on European Trade," "Economic Failures, as I Remember them since 1837," and so forth, articles in which Kokorev revealed an uncommon gift for analysis and an ability to find solutions to the most difficult problems. His great prestige had an influence among the highest functionaries of the empire, and ministers of finance and presidents of the council of state often sought him out for confidential advice on the nation's economic problems.

Kokorev was convinced that all the economic failures in Russia were a result of the extinction of the people's good, common sense and felt that only the

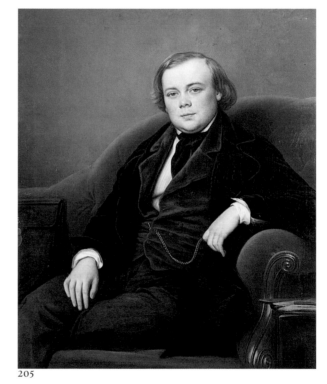

205

204. Karl Briullov
Portrait of Countess Yulia Samoilova retiring from a Ball with her Foster Daughter Amazilia Paccini, before 1843
Oil on canvas,
249 x 176 cm
Russian Museum,
St. Petersburg

205. Karl Steuben
Portrait of Vasily Kokorev,
1850
Oil on canvas,
122.5 x 100 cm
Sebastopol Museum of Art

206. View of the
St. Sophia embankment
and the Kokorev hotel in
Moscow, c. 1880

206

207. A. N. Grebnev
The Picture Gallery of Vasily Kokorev, 1864
Oil on canvas,
Donetsk Regional Museum

208. Karl Briullov
Portrait of the Artist with Baroness Ekaterina Nikolayevna Meller-Zakomelskaia and a Young Girl in a Boat, c. 1830
Oil on canvas,
151.5 x 190.3 cm
Russian Museum,
St. Petersburg

209. Sergei Ivanov
Young Boy at the Baths, 1858
Marble; height: 147 cm
Tretyakov Gallery, Moscow

When the Kokorev gallery was opened to the public in 1862 (ill.207), it became clear that the hanging scheme, while conforming to the decorative requirements then in force, was none the less dictated exclusively by chronology, school and country of origin. In this it was the direct expression of the collector's overriding concern that a private museum such as this should be above all else a means of imparting education and knowledge. With the inauguration of the Rumiantsev Museum in the same year and the growing importance of the Moscow school of painting and sculpture, the old capital now began to challenge St. Petersburg's artistic hegemony. From now on it was not only artists who questioned the dictatorial attitude of the St. Petersburg Academy of Fine Arts, but also the new social elites.

individual could find his way now that government policy had come to a dead end.

In his collecting and patronage, as in his business, Kokorev proceeded with vigor and purpose. He set up a dacha for painters in the Tver province, the first of its kind in Russia, and planned to create art studios along the Volga, in the Urals, Crimea, and the Caucasus, believing that Russian nature was as likely to inspire artists as did that of France and Italy.

It was probably around 1840 that Kokorev began to collect works of art. By 1863 he had already acquired almost five hundred canvases mainly by Russian, but sometimes by European, painters. Among the Russian artists were Dmitry Levitsky, Vladimir Borovikovsky, Karl Briullov, Alexander Ivanov, Silvester Shchedrin, and Ivan Aivazovsky. His collection of Western masters included such leading artists as Anthony van Dyck, Jan Bruegel, Gerard Ter Borch, Nicolas Poussin, Jean-Baptiste Greuze, and Constant Troyon.

The Kokorev Gallery, on Three Saints Street (today Bolshoi Vuzovsky Street), was in fact the first building constructed in Moscow to serve as a museum and a place that functioned simultaneously as a center for public education. Lectures were to be given in a hall designed in the form of a traditional Russian hut, or *isba,* about which the Russian man of letters Piotr Boborykin wrote: "Mr. Kokorev hopes that, in his Russian *isba,* a Russian will bring to Russians the warm, living Russian word."

Kokorev favored the period of Karl Briullov, and the painters he promoted worked in the "Russian style," such as Konstantin Trutovsky, Piotr Boklevsky, and Nikolai Sverchkov. The Kokorev Gallery had as its primary focus an excellent series of pictures by Briullov—more than forty in all—which ranged over several periods in the painter's career. On the center wall of the Briullov room (ill.207) could be seen the *Portrait of Countess Yulia Pavlovna Samoilova Retiring from a Ball with her Foster Daughter Amazilia Paccini* (ill.204, in the middle of the view) and the *Portrait of the Artist with Baroness Ekaterina Nikolaievna Meller-Zakomelskaia* and *a Young Girl in a Boat* (ill.208), as well as the images of the poet Vasily Jukovsky, Elizaveta Durnovo, and the painter Yakov Yanenko in armor. On finding himself unexpectedly in front of this "magical" wall, Mikhail Buturlin avowed that he had to weep.

The Kokorev Gallery opened its doors in January 1862 and the Rumiantsev Museum was not inaugurated in Moscow until several months later. The news-

paper *The Bee of the North* (*Severnaia pchela*) reported on January 26: "The painting gallery created by V. A. Kokorev, which had been built up over many years and had long been awaited in Moscow, opened to the public today for the first time. This gallery was especially conceived for Moscow, which, until now, possessed nothing with which to educate the public about art. Undoubtedly, it would be difficult to imagine a more honorable, more morally productive enterprise for our time than establishing a public painting gallery in Moscow." This museum, recorded by the painter Alexander Grebnev in 1864 (Donetsk Art Museum; ill.207), comprised eight galleries that, apart from the Briullov room, were devoted to landscape and genre. The European paintings hung in two galleries, one for works from the sixteenth to the eighteenth centuries and another for nineteenth-century works. Boborykin wrote in the year of the museum's inauguration: "May God grant that this truly patriotic example be suitably emulated by others."

Unfortunately, the Kokorev Gallery existed for only a few years, its life cut short when the founder was obliged to sell the building in 1864. Thereafter Kokorev hung the collections in his house on St. Sophia Embankment. In 1865 some of the Western pictures were sold and Kokorev, hoping to keep the Russian collection intact, proposed that the imperial court minister acquire the most important works for the collection of the Academy of Fine Arts. In 1869 he made a similar suggestion to Pavel Tretyakov, who refused to purchase the collection as a whole but agreed to acquire several paintings.

In the spring of 1870 Kokorev presented to Grand Duke Alexander Alexandrovich (the future Alexander III), heir to the imperial throne, a gift of paintings. Transported to the Anichkov Palace in St. Petersburg, the works were examined by a commission made up of Dmitry Grigorovich, Alexander Briullov, and Ivan Makarov. This resulted in a decision to accept 166 pictures, of which 100 were immediately dispatched to the Alexander Palace at Tsarskoie Selo. Later these same works were integrated with the collections of St. Petersburg's Russian Museum inaugurated in 1898.

By 1910 Kokorev's heirs had sold at various auctions whatever remained of his collections. One wonders whether it may have been the ephemeral life of Kokorev's public gallery that moved Pavel Tretyakov to establish the museum that bears his name and, luckily, survived him.

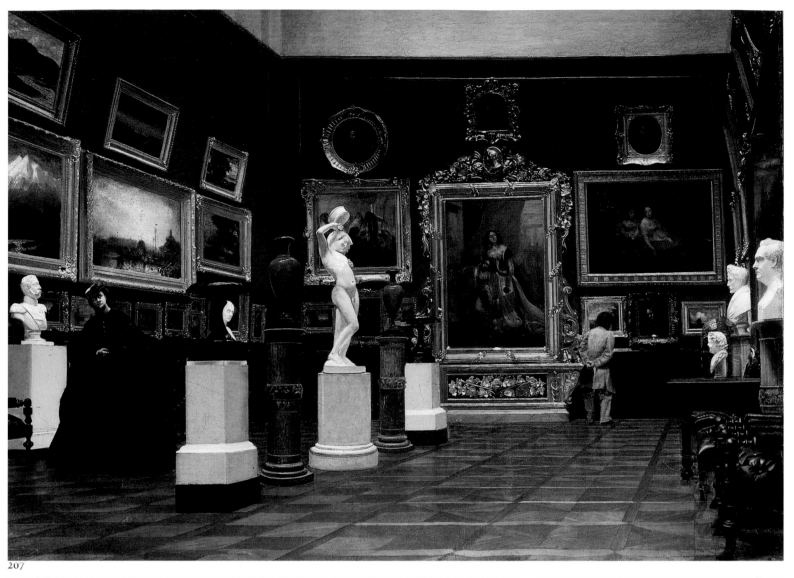

207

208

209

The Tretyakov Brothers

The Tretyakovs had been merchants from the time their ancestors left Maloyaroslavets for Moscow in the eighteenth century. In the middle of the following century, the commercial house known as Tretyakov Brothers prospered from the production and sale of textiles. Pavel Tretyakov (1832–1898; ill.211), the oldest brother, had been educated at home by tutors. According to the critic Vladimir Stasov, "While still a child P. Tretyakov developed a passion for engravings and lithographs on historical or other interesting subjects. He collected assiduously, purchasing these in markets or in small shops." Mainly he frequented the bazaar at the foot of the Sukharev Tower, where in 1854 he bought his first six paintings, all Dutch old masters. Two years later he acquired a pair of genre pictures of the Russian school: Nikolai Schilder's *Temptation* and Vasily Khudyakov's *Collision with the Finnish Smugglers*. These two works were just the beginning of what promised to be a brilliant future collection.

Pavel Tretyakov was twenty years old when he first visited the museums of St. Petersburg, which left an indelible impression. In great excitement he wrote to his mother: "I have just been to the Hermitage and seen thousands of paintings! Some of the greatest ones by Raphael, Rubens, van der Werff, Poussin, Murillo, Salvatore Rosa, etc., etc. I saw an endless number of statues and busts! Hundreds of tables and vases, other objects carved from stones I had no idea of."

Very soon Tretyakov set about educating himself in artistic matters, by traveling every summer around Europe, exploring all sorts of collections. As the great theater director Konstantin Stanislavsky was to later recall: "Who could have recognized the illustrious Russian Medici in that tall, thin figure, embarrassed and shy, who seemed more like a priest? Come summer, he set off to discover the canvases and museums of Europe, which he covered bit by bit on foot, adhering to a plan he had fixed that covered the whole of Germany, France, and even a part of Spain."

The young Tretyakov dreamed of creating a public museum, which he was to realize relatively soon. In

211

1860, during a visit to Warsaw, he dictated his last will and testament: "I leave the sum of 150,000 rubles for the establishment in Moscow of a public museum of art or a gallery of painting. I truly love art with a passion, and there can be no other wish than to put in place a public venue for the preservation of the fine arts, accessible to everyone, capable of being useful to many, and a source of pleasure for all. I have forgotten to mention that I hope to leave a national gallery that is composed of pictures by Russian painters." In so doing, he was making himself a follower of Vasily Alexandrovich Kokorev, Kuzma Terentich Soldatenkov and Gerasim Ivanovich Khludov, all three of whom had nearly exclusively collected Russian works.

At the time he prepared this statement, Pavel Tretyakov had no more than six canvases in the office of his house on Lavrushin Street in Moscow.

210. Ivan Firsov
A Young Artist, c. 1765–70
Oil on canvas, 67 x 55 cm
Tretyakov Gallery, Moscow

211. Ilya Repin
Portrait of Pavel Tretyakov, 1883
Oil on canvas, 98 x 75.8 cm
Tretyakov Gallery, Moscow

The first stirrings of the industrial revolution in Russia, combined with the development of the railways and growth in trade, favored the emergence of a new social class of fabulously wealthy merchants and industrialists. In their eyes, amassing art collections was undoubtedly, in the first instance, a way of gaining social confidence and recognition—as had been the case for the new social elites of the eighteenth century. Now, however, the approach of this new social class rapidly developed to become much more altruistic and politically aware.

Repin's portrait of the collector Pavel Tretyakov (ill.211) is therefore significant in depicting him against a background of paintings by the Wanderers, artists who had formed the first overt secession from the St. Petersburg Academy of Fine Arts in 1871, so opening the way to the celebration in art of Russia and Russian native values.

212

212. The residence
of Sergei Tretyakov
in Moscow

213. The Icon display
in the Tretyakov Gallery

214. Vasily Tropinin
*Portrait of Arseny Tropinin,
the Artist's Son,* c. 1818
Oil on canvas,
40.4 x 32 cm
Tretyakov Gallery, Moscow

213

Pavel Tretyakov's
collection and later gallery
(ill.217 and 218) devoted
exclusively to Russian art
represented a milestone in
Russia's aesthetic
development, which until
then had been dominated
by Western influences and
values. This renaissance of
an idealized Slavic
sensibility and aesthetic in
art mirrored similar
developments in literature
and music.
Conscious that Russia's
greatest artists in all fields
should be represented in a
Russian national pantheon,
the art-lover had their
portraits (ill.219) specially
painted for his gallery.

Eventually, as the collection grew, paintings used to
hang everywhere—in the dining room, the salon, the
bedrooms, the nursery, on the stairways. By 1872-74
he was planning to supplement the space in his house
with a building especially designed to shelter his pic-
tures. In 1881 he opened this gallery to the general
public and subsequently enlarged it twice.

A cheerful man, although shy and chaste, Tretyakov
was referred to as "Archimandrite," a Russian
Orthodox abbot, by his teasing bachelor pals, who
loved to taunt him about his enthusiasm for collecting.
In 1865 Tretyakov married Vera Mamontova
(1844–1899), Savva Ivanovich's daughter, to whom he
more than once had to explain—in order to avoid being
accused of miserliness—how he viewed the family
budget. "I am not stingy . . . and I even plan to budget
a voyage to America. . . . Money paid out to acquire pic-
tures, this is a serious goal. . . . Moreover, this money
goes to hardworking painters, toward whom life has
not been particularly generous. But when money is
spent in a useless way, even if it is but a single ruble,
that vexes and irritates me."

Little by little, Tretyakov had evolved his own aes-
thetic. For example, he rejected pretentious, academic

landscape painting and, for this reason, declined an
offer from the landscapist Alexei Bogolyubov: "I must
tell you frankly that I do not want this Venetian view;
such paintings are all too boring; I prefer to wait."

To the painter Apollinary Giliarievich Goravsky,
one of his circle, Pavel Tretyakov explained: "I do not
need lush nature, a splendid composition, or an effect
of light. I do not want a miracle. Just give me a puddle
of dirty water, as long as it reflects truth and poetry,
because in poetry perhaps lies the sole concern of the
artist."

In 1871, a group of independent artists who had
broken away from the St. Petersburg Academy of Fine
Arts founded the 'Society of Traveling Exhibitions',
becoming known as the Wanderers. Tretyakov lost no
time in getting to know them all, on occasion even
going directly to their studios to select the works he
wanted to buy. These would then be exhibited with a
notice reading, 'Property of P.M. Tretyakov', which
soon became viewed as a seal of approval and a badge of
pride for the artists concerned.

In the early 1860s, when Tretyakov bought Vasily
Perov's *Village Procession at Easter* (ill.220), his close
friend Vasily Grigorievich Khudiakov wrote to him:
"Rumor has it that the Holy Synod is about to ques-
tion you as to why you buy and exhibit such immoral
works. Perov should take care that he does not find
himself working his passage to the Solovky Islands
[where monks were imprisoned by the ecclesiastical
authorities] instead of Italy…"

Among the paintings bought by Tretyakov at the
Wanderers exhibition in 1871 were *Portrait of the writer
Ostrovsky* by Perov, *A Building of Rooks* by Alexei
Kondratievich Savrasov, *A Night in May* by Ivan Niko-
laievich Kramskoi and *Peter the Great submits his son Alexei
to interrogation at Peterhof* by Nikolai Nikolaievich Gay.

Vladimir Stasov, speaking about Pavel Tretyakov,
said: "He is St. Petersburg's worst enemy, because he
takes the best canvases to Moscow. An individual does
what the public institutions fail to do with passion,
fire, with ardor, and, even more surprising, with great
patience. It is said that in his collections there is not
one weak or bad painting, but for this to be true there
had to have been sure taste and thorough knowledge."

From the painter Vasily Vereshchagin, Tretyakov
bought a whole series of battle scenes. While in
Bulgaria the artist wrote to the collector: "I cannot tell
you what overpowering impressions I brought back
from my tour of the battlefields in Bulgaria. They are
nothing but fields of crosses . . . crosses as far as the
eye can see. Everywhere bits of grenades, soldiers'
bones left unburied. Only on one hill is there neither
human bones nor shell fragments; on the other hand,
one finds corks and broken champagne bottles. It
would be useless to protest, but it does make one
reflect. . . ." It is known that some generals advised

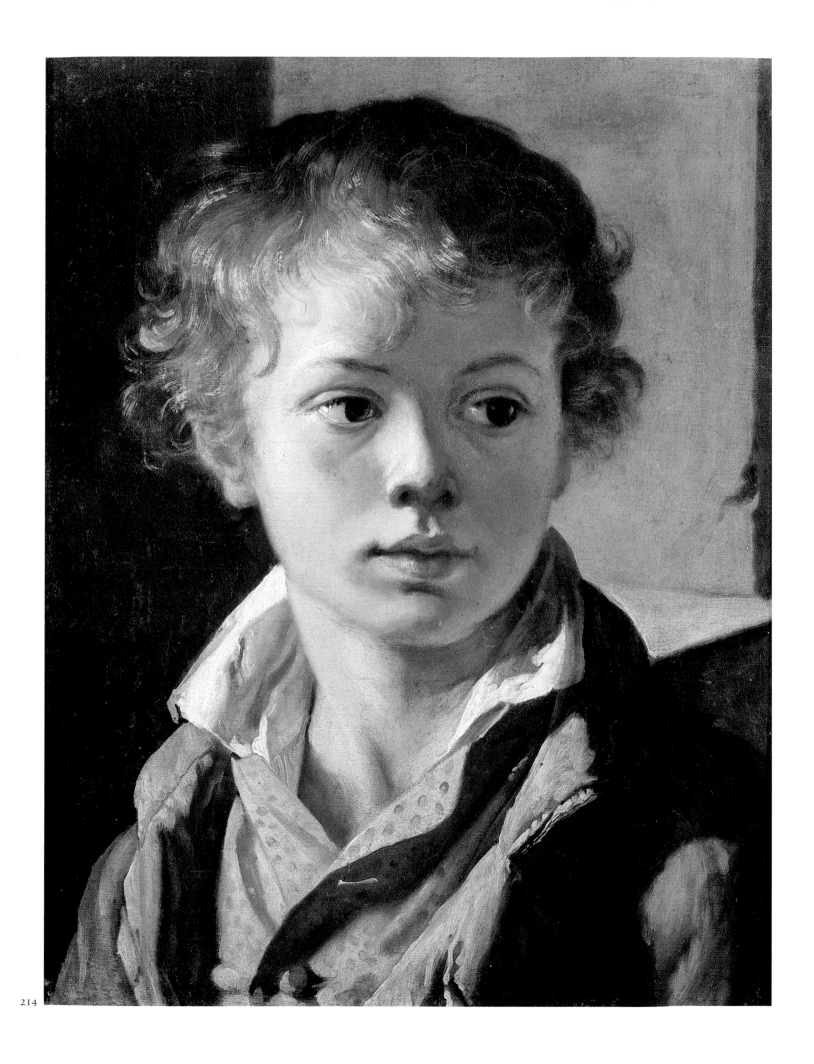

214

215. Vladimir Borovikovsy
Portrait of Maria Lopukhina,
1797
Oil on canvas,
72 x 53.5 cm
Tretyakov Gallery, Moscow

216. Karl Briullov
Lady on Horseback (portrait
of Giovanna and Amazilia
Paccini, foster daughters of
Countess Yulia Samoilova)
Oil on canvas,
291.5 x 206 cm
Tretyakov Gallery, Moscow

217 and 218. The
exhibition rooms in the
Tretyakov Gallery, in 1898

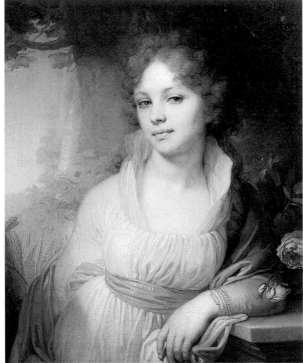

215

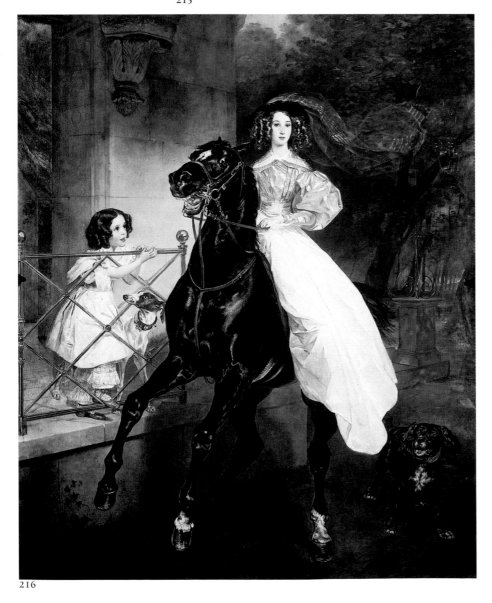

216

Alexander II to buy the "provocative" and "antipatriotic" works of Vereshchagin merely for the purpose of destroying them. Fortunately, the tsar did not heed their advice.

When, in 1885, Tretyakov purchased Repin's *Ivan the Terrible and His Son Ivan* (ill.221) (a painting inspired by the assassination of Tsar Alexander II on March 1, 1881), it prompted once more expressions of displeasure from high places. Konstantin Pobyedonostsev, the prosecutor for the Holy Synod, wrote to Alexander III: "Presently on view at the Wanderers exhibition is a painting that has caused some to feel outraged. Ivan the Terrible and the son he murdered. Today I saw this canvas, which filled me with nothing but disgust. Not a solitary touch of the ideal; nothing but naked realism, with the purpose of criticism and denunciation. It is difficult to grasp the idea of an artist who chooses to show, in all its reality, such a moment as this one. And why Ivan the Terrible here and now anyway?" Tretyakov was asked to sign an agreement not to exhibit the Repin picture, which had to be closed off in a separate room. A few months later, however, the ban was lifted, thanks to intervention by friends of the painter. (In 1913 a mentally ill man slashed the canvas, after which Repin himself restored it.)

In his gallery Tretyakov had installed a sort of Russian Pantheon, about which Repin wrote to the co-llector: "The portraits found there . . . represent men precious to the nation (ill.219), her finest sons who, by their disinterested actions, contribute usefully to the blossoming of their native land, because they believed in a better future for her and struggled to make it come about."

Contemporaries were conscious of the role played by the merchants in the realm of art collecting. Thus, when Pavel Tretyakov acquired Vasily Vereshchagin's Turkestan studies, a journalist took particular note of it: "We are not unaware of the fact that the most remarkable and beautiful Russian paintings realized during the last twenty or twenty-five years are not to be found in the Hermitage, or in the hands of Count Stroganov, Prince Galitzin, Prince Vorontsov, or the new Prince of San Donato, or yet in the houses of the Naryshkins and Sheremetevs. All the best works of contemporary Russian painting have been carefully chosen and collected by Pavel Tretyakov and by him alone. His is a serious affair that requires more than just money, but also effort, ability, and the love of art."

The visionary collector shed light on the nature of his ambitions in a letter to Leo Tolstoi in 1890: "Shall I tell you a few things about my collection of Russian paintings? Very often and for many years I have had strong doubts, but nevertheless I persevere.... And I don't do it for myself: it would be quite mistaken to imagine that I do.... I shall continue to persevere without concerning myself with the value of my paintings, but only with my passion. Because I truly love muse-

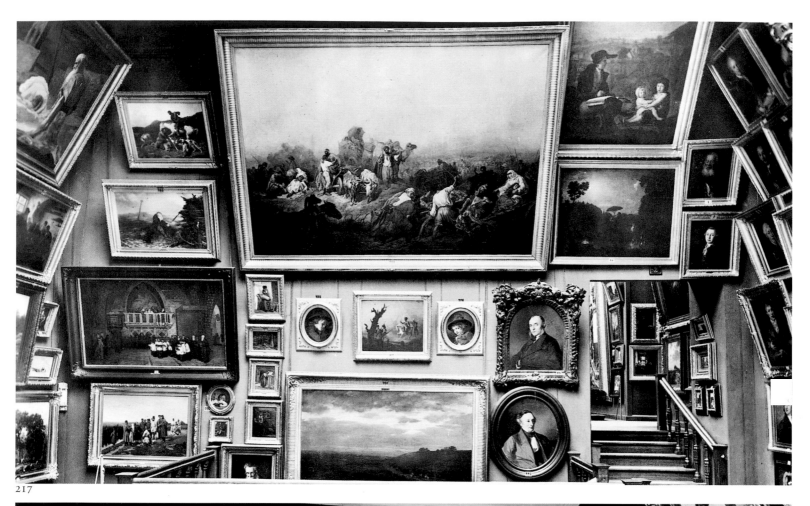

217

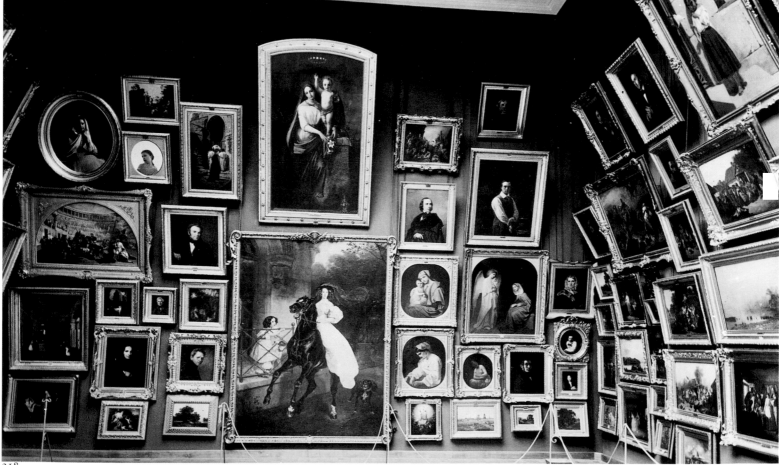

218

219. Vasily Perov
Portrait of the Writer Feodor Dostoievsky, 1872
Oil on canvas,
99 x 80.5 cm
Tretyakov Gallery, Moscow

220. Vasily Perov
Village Procession at Easter,
1861
Oil on canvas,
71.5 x 89 cm
Tretyakov Gallery, Moscow

The artists who formed the Wanderers group were fearless in their criticism of the contemporary Russian establishment. In *Village Procession at Easter* (ill.220), Perov pictured one orthodox pope and his acolyte, the latter reeling by the church porch while the other one lies down at his feet, already drunk.

ums and collections, where you can be refreshed and revitalized and leave daily cares far behind. And what I love, I want others to enjoy also."

Alexander Benois said of Sergei Botkin, Tretyakov's son-in-law, who collected mainly drawings and prints, "He had certainly put together his collection of Russian drawings, primarily by old masters under the influence of his father-in-law, a way to further the great cause of Pavel Tretyakov."

Sergei Tretyakov (ill.223), unlike his brother, played an active role in public life, having twice been mayor of Moscow, serving from 1877 to 1881. Until 1889 he headed the family enterprise, which collected and supported the arts, albeit with a preference for Western works. In this regard Pavel wrote to Repin: "My brother passionately loved painting, and if he did not collect Russian pictures, it was because I was doing it myself. On the other hand, he left a sum of money to be used only for the acquisition of Russian works of art." This sensitivity was characteristic of the entire family.

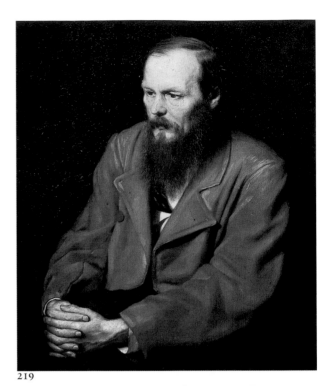

219

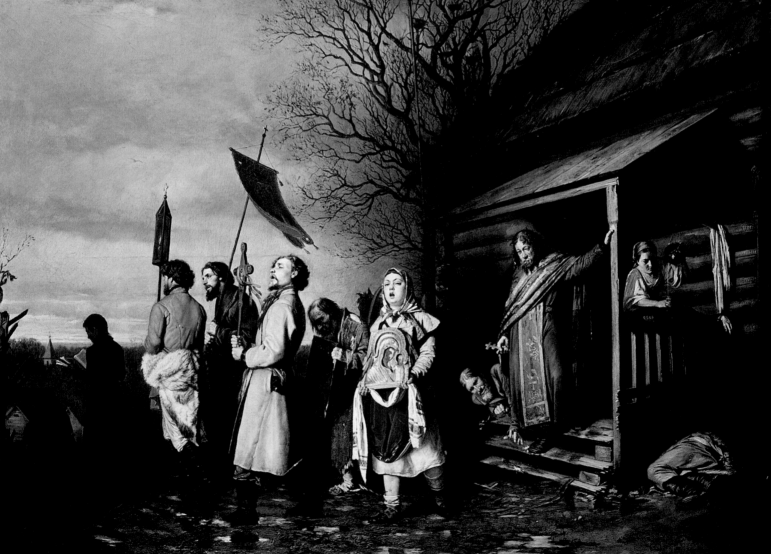

220

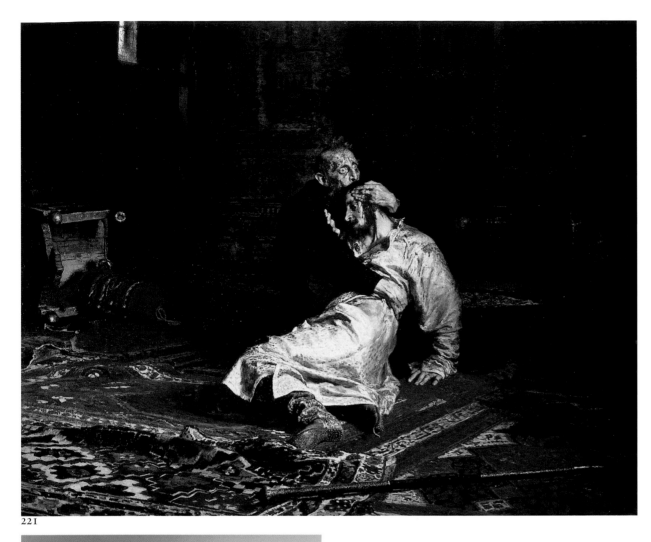

221

222

221. Ilya Repin
*Ivan the Terrible and his Son
Ivan, November 16, 1581,*
1885
Oil on canvas,
199.5 x 254 cm
Tretyakov Gallery, Moscow

222. Mark Antokolsky
Ivan the Terrible, 1875
Marble; height: 151 cm
Tretyakov Gallery, Moscow

In the years after the first
Tretyakov gallery opened in
1881, both its collections
and its popularity grew
steadily. The building
became too small, and new
rooms needed to be added
twice. From eight thousand
in 1882, the number of
visitors passing through its
doors annually rose to an
astonishing fifty thousand
in 1890. By this time the
gallery was costing Pavel
Tretyakov one and a half
million gold rubles a year
to run, and it was clear
that it could no longer
remain a private initiative.
Following the death of his
brother Sergei in 1892,
Pavel Tretyakov bequeathed
both their collections to
the city of Moscow, and the
new "Pavel & Sergei
Mikhailovich Tretyakov
Gallery" opened its doors
the following year.

Sergei Tretyakov made frequent journeys to France
for the family business. There he purchased a number
of canvases for his personal collection, occasionally
seeking the advice of writer Ivan Turgenev and artist
Alexei Bogolyubov. After looking at the French art
scene, he went on to take account of nineteenth-cen-
tury artists in Germany, Holland, and Spain. The art
historian and painter Igor Grabar praised "the very
fine, varied, and coherent taste" of Sergei Tretyakov,
who gathered a collection that now ranks among the
best in all Russia."

Among the oldest works acquired by Sergei, one
should note paintings by Jacques-Louis David
(ill.224) and Eugène Delacroix and his collection of
landscapes by the Barbizon masters, ranging from their
precursor Camille Corot (ill.225) through Théodore
Rousseau, Charles François Daubigny, Jean-François
Millet (ill.226), Constant Troyon, and Narcisse Diaz
de la Peña. Altogether he owned eighty-four canvases
by European painters (ill.228 and 229).

Originally, Sergei lived with his brother in the same
house on Lavrushin Street. Following his marriage,
however, he bought an old mansion on Pretchistensky
Boulevard, where he hung his collection of paintings.
The composers Piotr Ilich Tchaikovsky and Anton

223. Sergei Tretyakov,
c. 1885

224. Jacques-Louis David
Portrait of a Young Man,
c. 1800
Oil on canvas, 54 x 46 cm
Pushkin Museum of
Fine Arts, Moscow

The generosity and altruism that lay behind the formation of Pavel Tretyakov's collection also informed his relationship with his brother Sergei (ill.223). Determined that the two brothers should not enter into direct competition with one another, Sergei decided to focus his collecting skills on foreign artists, and particularly on the French painters of the Barbizon school (Millet, Corot, Troyon, Daubigny, and Rousseau; ill.225 and 226), who had been recommended to him by the Russian landscape painter Alexei Bogolyubov and the writer Ivan Turgenev.
Later he widened the scope of his collection to include more contemporary artists such as Jules Breton, Pascal Dagnan-Bouveret and Jules Bastien-Lepage (ill.229), and finally Romantic painters such as Delacroix, Géricault, and David (ill.224).

223

Rubinstein loved to visit him there, as did many other artists, and especially Russian painters who would get the opportunity to "admire the remarkable collection of foreign pictures ." This collection, however, remained inaccessible to the public because the owner spent much of his time abroad and then started living in St. Petersburg in 1889. In 1892 Sergei decided to sell his Moscow residence and transfer the entire collection to St. Petersburg, a plan that was never carried out though, because of his premature death. The paintings and drawings, as well as five Tanagra figurines, sculptures from the Russian school, and tapestries were inherited by his brother. As for his Moscow mansion, it was bought in 1896 by Pavel Ryabushinsky, father of the famous collectors.

Pavel Tretyakov's private museum had by the early 1890s become too large to be supported by even a rich merchant prince, and Alexander III wanted to aquire its paintings to add to those in his Russian Museum in St. Petersburg.

Pavel, however, decided to donate both his collection and that of his brother to Moscow, as he wrote to the city *Duma* (municipality): "Concerned about the need to support the creation of institutions useful to the public in a city that is dear to me, to contribute to the expansion of the arts in Russia, while also preserving for all time the collection I have amassed, I wish today to make a gift to the city of my entire gallery of paintings." By this time the gallery comprised 1,287 paintings, 518 drawing and engravings of Russian artists, 75 canvases by European masters, 15 statues,

and a collection of icons. Once the *Duma* accepted this generous gift, Pavel left Moscow and went abroad to escape the accolades and honors which he considered superfluous. Thus he wrote to Stasov: "I will give you no information about myself, inasmuch as I truly do not want to be the subject of whatever anyone may wish to publish."

The official inauguration of the museum, called the Pavel and Sergei Mikhailovich Tretyakov Gallery of the City of Moscow, took place on August 15, 1893. The gift did not stop Pavel from completing the gallery by enriching it each year with dozens of paintings, studies, and drawings. After he died in 1898, his daughter Anna Botkina became a member of the Tretyakov Gallery board of directors. Sergei's collection would be exhibited there in two special commemorative rooms, along with his portrait painted by Valentin Serov (ill.227). In 1925 the European paintings, the Tanagras, and the tapestries were transferred to the Pushkin Museum of Fine Arts, with a few pictures reserved for the Hermitage.

It has already been described above how Pavel Tretyakov detested all the publicity surrounding his name, even to the point of fleeing the ceremonies that marked the official opening of the gallery he had just presented to the city of Moscow. In this regard Viktor Vasnetsov wrote: "Tretyakov has achieved, with uncommon energy, a sublime thing for his country. He cannot but be conscious of this great historical feat, but he never puts himself forward, preferring to remain modestly hidden behind his own accomplishment."

224

225

226

225. Camille Corot
The Gust of Wind, 1864-73
Oil on canvas, 48 x 66 cm
Pushkin Museum of
Fine Arts, Moscow

226. Jean-François Millet
Gathering Dead Wood, c. 1860
Oil on canvas, 37 x 45 cm
Pushkin Museum of
Fine Arts, Moscow

Sergei Tretyakov was
much less systematic and
more impulsive than his
brother Pavel. In early
1882, for example, in order
to help the author
Turgenev out of financial
difficulties, he bought a
Rousseau painting (*Forêt de
Fontainebleau*) from him,
then sent it to Paris in
November of the same year
in exchange for "a
remarkable Troyon, a
Meissonnier and a
Courbet"—only to buy it
back again two years later,
to replace another
Rousseau painting.

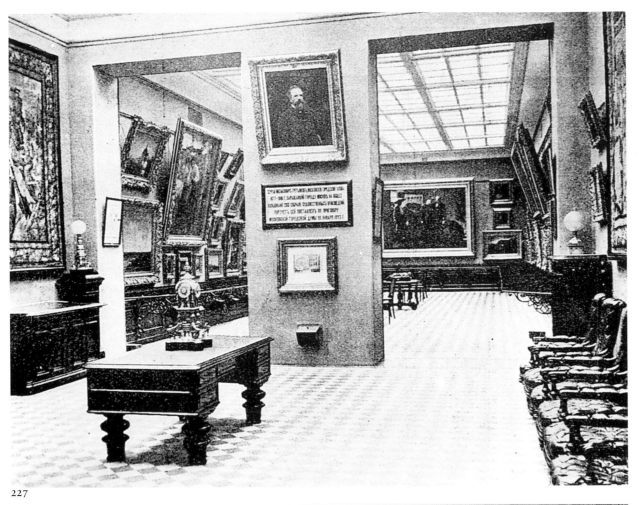

227

228

227. The exhibition rooms of the collection of Sergei Tretyakov at the Tretyakov Gallery in Moscow, c. 1900

228. Mariano Fortuny y Carbo
Connoisseurs of Engravings, 1867
Oil on wood, 53 x 71 cm
Pushkin Museum of Fine Arts, Moscow

229. Jules Bastien-Lepage
Village Love, 1882
Oil on canvas,
194 x 180 cm
Pushkin Museum of Fine Arts, Moscow

Although the canons of western aesthetic taste had begun to assume less importance for Russian artists, this did not mean that the links between the Russian and French schools faded away. In a letter to his daughter in 1901, for instance, the painter Polenov observed how strongly *The Marriage Blessing* by Pascal Dagnan-Bouveret, in Sergei Tretyakov's collection, had influenced the work of Konstantin Korovin and Valentin Serov. Serov meanwhile made a pilgrimage every Sunday to gaze on *Village Love* by Jules Bastien-Lepage (ill.229), which was also the favorite painting of Mikhail Nesterov. The painting is visible in a contemporary photograph of the rooms devoted to Sergei's collection in the new Tretyakov Gallery, which opened in 1893 (ill.227, on the left-hand wall).

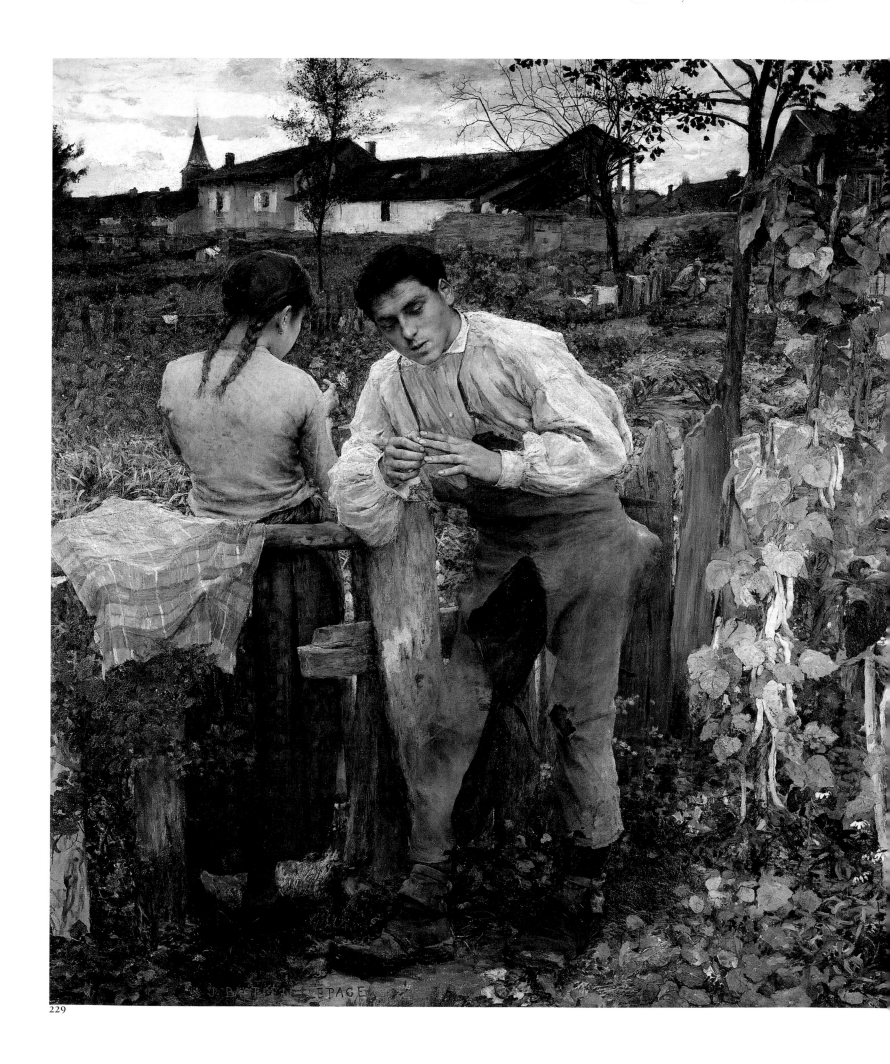

229

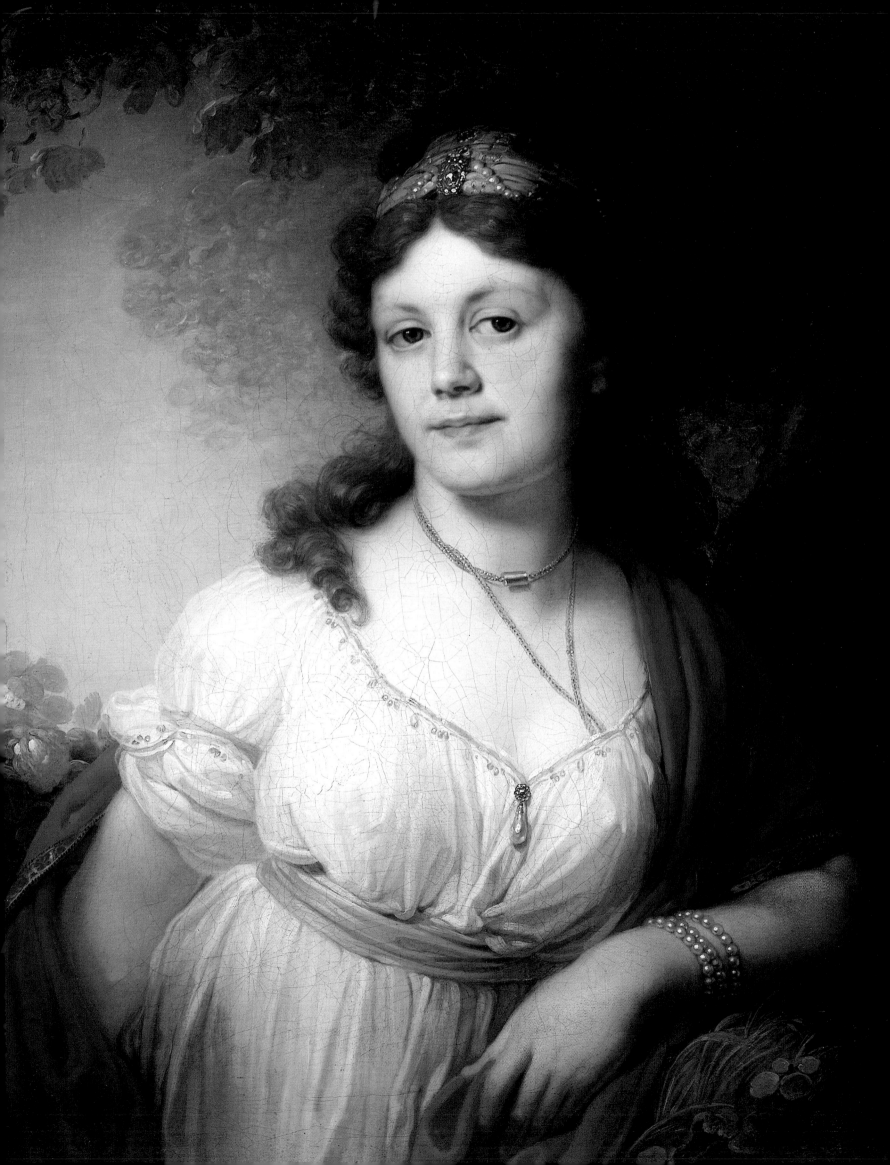

Ivan Tsvetkov

The son of a priest in the village of Astradamovka, Symbirsk province, Ivan Tsvetkov (ill.232) studied at the seminary before entering college and winning admission to the Polytechnic Institute of St. Petersburg, on a scholarship. When the climate of the capital proved too much for him, he continued his studies at the University in Kazan and later, in Moscow. After defending his thesis of 1873, he gave up the idea of teaching and took a position at the Shareholder Bank of Moscow, where he would work until the end of his life.

How could such a career support the desire to collect? Already in his student days Ivan Tsvetkov had developed an interest in art. In 1871 he made his first visit to the Galitzin Museum and its remarkable collection of paintings. "It was a revelation," he wrote. "I experienced a new, unsuspected pleasure and a new interest for life." Employed to give private lessons to the children of Prince Gagarin, Ivan traveled abroad with them in 1872. In the galleries of Berlin and Vienna he underwent his second and unforgettable epiphany. Back in Moscow, Tsvetkov set about making regular visits to private collections, the Rumiantsev Museum, and the Tretyakov Gallery. "It was more or less there that I lived, studying the pictures and relaxing," he wrote.

At the bank he was well paid and was able, little by little, to acquire works of art. From the start he favored Russian artists. Pavel Tretyakov helped the young Tsvetkov, who, aware that the most beautiful canvases had long since entered private collections, made drawings the focus of his acquisitions, after his first purchase in 1881 of a painting by Vasily Polenov now in the Tretyakov Gallery.

In 1898 Tsvetkov began to build, on the banks of the Moskova river, close by the Cathedral of Christ the Savior, a house from plans he himself had drawn up. Its four facades, however, were based upon sketches made by Viktor Vasnetsov, an artist whose work the collector admired. The dwelling turned out to be a kind of *terem*, a Russian palace in the old style that was hardly accessible to the public.

Tsvetkov, a member of the Tretyakov Gallery board from 1899 to 1905, openly defended his tastes, which had remained loyal to the painting of the Wanderers. "I don't understand the present fascination with decadence," he admitted, by which term he meant virtually all painting done after 1880, where he saw only "mis-

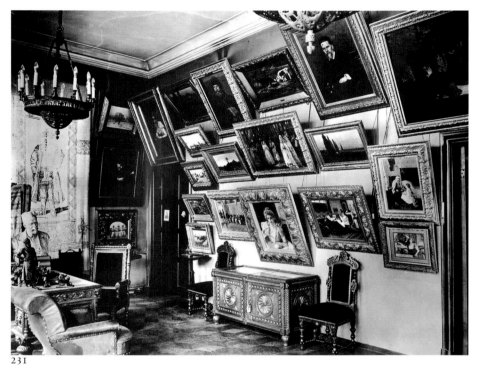

231

chief and madness of the colors." Moreover, he firmly refused to allow the Tretyakov Gallery to acquire the paintings of Vrubel, Roerich, Somov, and others, a policy that caused Serov, Ostroukhov, Polenov, and the critic Sergei Glagol (Goloushev) to resign from the Friends of the Fine Arts Society, an organization of which Tsvetkov was president in 1903–04.

In 1913 the Tsvetkov gallery included more than 400 paintings as well as 36 sculptures and 1,373 drawings and watercolors. The painting collection was dominated by the works of Vasily Tropinin, Vladimir Borovikovsky (ill.230), Ivan Kramskoi, Vasily Surikov and Viktor Vasnetsov.

The painter Yakov Minchenkov recalled his visit to the Tsvetkov gallery: "The master of the house came himself to greet us. Dressed in a velvet gown, in the Boyar fashion, with a gold-embroidered skullcap. The spitting image of Boris Godunov."

Ivan Tsvetkov remained the curator of his museum to the very end. He died on February 16, 1917, missing by months the upheaval of the October Revolution. In 1925 his museum was made a branch of the Tretyakov Gallery. He had said on one occasion: "At the Tretyakov it's a vast and divine study of the history of art; at my house it's only a summary."

232

230. Vladimir Borovikovsky
Portrait of Elizaveta Tiomkina,
1798
Oil on canvas,
71.5 x 58.5 cm
Tretyakov Gallery, Moscow

231. Interior of Ivan Tsvetkov's residence in Moscow, c. 1910

232. Ivan Tsvetkov, c. 1910

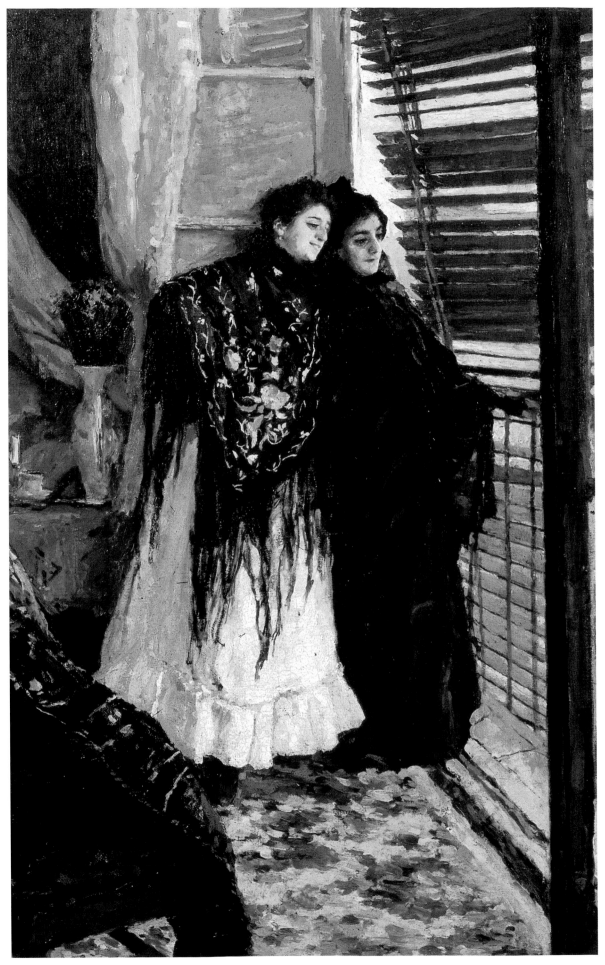

233

Savva Mamontov and Abramtsevo

Savva Ivanovich Mamontov (ill.234) was born in Yalutorovsk, a town in the Tobolsk province of Siberia. Savva's father, Ivan Feodorovich Mamontov, had made a bit of money as a government official, invested it in the new Baku oil fields and moved to Moscow in order to give his children a better education. He invested his Baku profits in the burgeoning railroads, building with partners a railroad from Moscow to Sergiev Possad. Later, this would prove to be the basis of a large fortune as the lines expanded to northern Russia, to Arkhangelsk and further to Murmansk and as far as the coal fields of the Donetsk basin.

Meanwhile, Savva graduated from the Institute of Civil Engineering in St. Petersburg and studied at the Moscow University Law School. The senior Mamontov wanted Savva to join him in railway building, only to discover that his son cared little for business and a great deal for the theater, where he spent every available hour. Ivan Feodorovich thereupon snatched Savva away from Moscow, sent him off to Baku, and immersed him in business. Regularly, he wrote to him, saying for example: "You tell me that you have mastered every aspect of the bussiness in a mere two weeks? Are you serious?" Savva was entitled to a salary, but before he could spend it Ivan Feodorovich sent him even further from temptations—all the way to Persia. Finally, however, the young Savva survived and came to the end of his trials. Just before returning to Moscow, he wrote to his family: "My God, it's incredible how one manages to adjust. Astonishing! What madness would have prompted me to go live in Persia? Never mind, I've come through, and I'm still alive. I've even acquired a few Persian habits, such as lying and cheating. If I arrive in Moscow with that baggage, I'll surely be sent packing. . . ."

Savva then took himself off to Italy, this time traveling for health reasons. In Milan he took courses in *bel canto* singing, and it was there that he met his future wife, Elizaveta Sapojnikova, in 1865. Together the couple took in the sights of Milan and Florence and later Mamontov said that this period was the most poetic in the whole of his existence.

Married at the end of the year, the young Mamontovs spent their two-month honeymoon traveling throughout Italy, with six stops in Naples.

234

Upon returning to Moscow, Savva had a house built for himself on Sadovaia-Spaskaia Street in Moscow. Despite the demands of his position as a major shareholder in the Railway Corporation, following the death of his father in 1869, he found it possible to devote ever more time to art. Frequent guests at his house included the architect Viktor Hartman, the painters Nikolai Nevrev and Ivan Astafiev, and the sculptor Mark Antokolsky. They were also visited by Vasily Polenov, Adrian Prakhov, and Ilya Repin, all painters. Meanwhile, Mamontov himself had become a sculptor. From 1873 to 1876, Savva organized a series of Thursday gatherings at his house, from which would emerge the Moscow community of art known as the Mamontov Circle.

From Viktor Vasnetsov, Mamontov commissioned three pictures for the Railway Corporation, but the other shareholders deemed them out of place in the company's headquarters and Mamontov bought them for himself. Beginning in 1880, two of the paintings could be seen in the owner's dining room: *Battle of Slaves against the Scythians* and *Flying Carpet* (ill.241). The third,

233. Konstatin Korovin
Before the Balcony: The Spanish Ladies Leonora and Amparo,
1886
Oil on canvas,
59.7 x 37 cm
Tretyakov Gallery, Moscow

234. Savva Mamontov,
c. 1890

A close friend of Mamontov, Konstantin Alexeievich Korovin (1861-1939) designed sets for Mamontov's private opera house very early in his career. His "Impressionist" paintings, saturated with color (ill.233), formed part of the exhibitions organized in St. Petersburg by Diaghilev in 1899, 1900 and 1902. At the 1900 World's Fair, his decorative panels attracted a great deal of attention. In Mamontov's residence, his works hung alongside others by Polenov, Repin, Vasnetsov, Surikov, Antokolsky, Nesterov, Levitan, and Vrubel.

235. Ilya Repin
Portrait of Elizaveta Mamontova Reading, 1879
Paper, crayon;
32.2 x 25.2 cm
Abramtsevo
Estate Museum

236. Ilya Repin
Portrait of Savva Mamontov,
1879
Paper, crayon;
32.3 x 25.2 cm
Abramtsevo
Estate Museum

237. Ilya Repin
Cavalcade at Abramtsevo,
1879
Drawing
Abramtsevo
Estate Museum

A much quieter personality than her husband, Elizaveta Grigorievna Mamontova (ill.235), *née* Sapojnikova, came from a family of wealthy textile merchants. She collected traditional Russian costumes and accessories, frequently used by Mamontov for the plays and musicals he liked to stage. In 1881-82, working on her own initiative, she had the chapel built at Abramtsevo (ill.238), a project to which all the artists of the colony on the estate contributed.

235

236

Three Princesses of the Underground Kingdom, went to Mamontov's brother, Anatoly.

Valentin Serov and Konstantin Korovin were still quite young when they first ventured into the Mamontov Circle. At the house on Sadovaia-Spaskaia, Serov painted portraits of Savva (now in Abramtsevo) and the opera singers Francesco Tamagno and Angelo Masini. In Mamontov's office, Mikhail Vrubel painted the *Seated Demon* and in one wing of the house, in the style of which Vrubel called "Roman-Byzantine," the artist modeled lion heads in majolica to be placed above

the entrance, as well as a splendid fireplace in the same medium (ill.245). The painter Ilya Ostroukhov flowered here as did his passion for icon painting, which would lead him to form a museum.

The group devoted mornings to watercolor painting, and evenings were reserved to drawing. They mounted exhibitions of works created at the residence or brought in from elsewhere. Vasily Polenov exhibited his *Jesus and the Fallen Woman* (Russian Museum, St. Petersburg), a painting he had worked on in the office, and anyone could come and admire it, as did, notably, Leo Tolstoi. Eventually, however, the picture would end up in the tsar's collection at the Winter Palace. It was also at Mamontov's that Tolstoi could see Nikolai Gay's *Crucifixion*, removed, at the demand of the Holy Synod, from the Wanderers's exhibition in St. Petersburg.

Collecting art and encouraging his circle were only aspects of the feverish, multifarious activity engaged in by Savva, albeit without much of a system. He managed to assemble some very interesting works, many of them gifts from practically all the major Russian painters of the period. Others he commissioned or bought on the art market or in exhibitions.

In his Moscow house Mamontov kept mainly the canvases of his circle, some of which, as noted, had been executed on the premises The small study, for instance, contained bronze busts by Mark Antokolsky of *Mephistopheles* and the *Head of John the Baptist* (Tretyakov Gallery); in the large study were canvases by Repin and Apollinary Vasnetsov and an Antokolsky statue depicting *Jesus before Pontius Pilate*. On the walls of the great

1879

237

238

239

238. The neo-Russian Church on the Abramtsevo estate, built in 1881-82

239. The main house of the Abramtsevo estate

240. A group of guests at Abramtsevo seated around Savva Mamontov, including the painter Viktor Vasnetsov and the sculptor Mark Antokolsky

The maintenance of a private opera house and an artists' colony (ill.240) at Abramtsevo required considerable financial means. Accused of embezzling funds from his business enterprises, Mamontov was arrested and his goods sequestrated. Even the pleas of his friends failed to sway the judges' opinion in his favor, and his situation remained precarious until his death.

hall hung paintings by Konstantin Korovin, *By the Balcony. The Spanish Ladies Leonora and Amparo*, (Tretyakov Gallery, ill.223), by Ilya Ostroukhov, Vladimir Makovsky and Nikolai Yaroshenko. The walls of the main staircase, meanwhile, were hung with works by Vasnetsov (*Valiant Knight at the Crossroads*, ill. 241) and Korovin. Mamontov also owned a collection of arms, Russian and foreign coins, icons in their original *repoussé* covers, decorative *objets d'art*, and applied arts.

In 1870 Savva purchased the Abramtsevo estate in the environs of Moscow, a property that had belonged to the Aksakovs, a celebrated family of Russian Slavophiles. While endeavoring to preserve all that was linked to a glorious past—associations with the great actor Mikhail Shchepkin and the writers Nikolai Gogol, Ivan Turgenev, Feodor Tyutchev, and Sergei Aksakov—the new châtelain had the architect Hartman build a spacious workshop, a chapel, and an *"isba* (hut) on cock's feet"* (inspired by Russian tales), designed by Vasnetsov. Abramtsevo would have, in addition, a pottery and woodworking studio. It was at Abramtsevo that Serov painted Mamontova's daughter Vera as a *Young Girl with Peaches* (ill.238), a work he presented to the sitter's mother, and also there that Ostroukhov's career as a landscape painter came into being.

In the woodworking atelier, attached to the school, Elena Polenova strove to revive the art of carved and engraved wood. She wrote, "we look for our inspiration and our models in the neighboring *isbas*." Her idea was to explore the countryside and purchase objects or make drawings of them in special albums. Thus began what would evolve into the

Abramtsevo Museum of Popular Art, which would exhibit such items as chests, tables, wooden vessels, spinning wheels, and even carts and sleighs. One section of the museum was to be devoted to clothing, towels, belts, and other similar items.

Ceramics, another popular handicraft developed at Abramtsevo, soon required the construction of a pottery where faïence tiles, majolica plates and bowls, stoves, and fireplaces would be produced by members of the Mamontov circle. Here Mikhail Vrubel executed his remarkable series of sculptures entitled *Sniegurochka*

240

241

241. Viktor Vasnetsov
The Flying Carpet, 1880
Oil on canvas,
165 x 297 cm
Nijni Novgorod Museum
of Art

A committed nationalist,
Viktor Vasnetsov (1848-
1925) was famous for his
evocative works based on
old Russia and its legends
(ill.241 and 242),
displayed, among other
places, at the Tretyakov
Gallery, which he decorated
in the 1870s.
In 1881-82 he designed
the sets and costumes for
Mamontov's production of
Sniegurochka by Ostrovsky,
before it was set to music
by Rimsky-Korsakov in
October 1885.

(The Snowmaiden), in which he represented all the characters in the eponymous play by Alexander Ostrovsky. The painter wrote to his sister of his infatuation with ceramics: "Again I'm supervising the fabrication of pieces in faïence and terra-cotta. This requires so much attention that I've begun to neglect painting." In 1900, at the World's Fair in Paris, objects made in the Abramtsevo pottery won a gold medal, as did products turned out by the woodworking studio, and in 1916 Abramtsevo ceramics would again be exhibited, this time in Moscow and Montreal.

Savva Mamontov's tireless activities encompassed not only patronage of the journal *Mir Iskusstva* (The World of Art), of his artists' colony at Abramtsevo and of the products of craftsmanship, but also – and perhaps even more famously – the field of music, in which his name became inextricably linked with that of one the greatest singers of all time, Feodor Ivanovich Chaliapin.

As early as the 1870s, Mamontov was in the habit of organizing theatrical or musical evenings either at his Moscow residence or at Abramtsevo, performed to a select audience of friends and acquaintances, including his wife's cousin Konstantin Stanislavsky, who was later to found the Moscow Art Theatre. In 1883, the burden of administration by which theatres had been hampered was relaxed, and it became possible to organise private performances that were exempt from imperial censorship.

Mamontov soon graduated from plays with sets by artists such as Vasnetsov and Polenov to operas staged in his own *Opéra Privé* or "Private Opera House" in Moscow, starting on 30 August 1885 with *Rusalka*, with music by Dargomijsky and sets by Vasnetsov. His early productions, in the years up to 1892, were to boost a renaissance in Russian music–with works by Rimsky-Korsakov for example–which mirrored the renaissance that was already taking place in painting. The stage had undergone a transformation, with sets that now prepared the public for the intensity of the action, and designs that were no longer merely accessories but were rather integral to the piece.

In 1896, at a fair at Nijnii-Novgorod, Mamontov met the bass Feodor Chaliapin, an encounter that was to provide a catalyst for another radical transformation in the staging of opera. Just as the collector believed that a painting was the expression of a particular emotion on the part of the painter, of his private vision, so the spirited young singer, then aged just twenty-two, was convinced that opera would be enriched by genuinely dramatic performances from the singers. Engaged on the spot by Mamontov, Chaliapin produced and performed *A Life for the Tsar* that same year, following this in 1897 with *Khovanshchina* and *The Maid of Pskov*, and then *Boris Godunov*. His success was immediate. Chaliapin and Mamontov developed a symbiosis not only of contemporary music and stage design, but also of singing

242

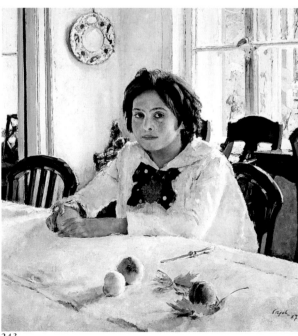

243

and drama, thus casting into the shade the performances to be seen in the imperial theatres, where "it was sufficient to sing the notes."

Just as Mamontov first had brought together music and contemporary artists as a *Gesamtkunstwerk*, Chaliapin brought together music and deeply psychological acting, the singer saying about his *Maecenas*: "To me, Mamontov stands for everything that is inspiring and creative."

Sergei Diaghilev, to whom this revolution is generally credited, did not in fact start his work in this field until 1899, when Prince Wolkonsky asked him to revise the annual publications of the imperial theatres. This he did with great success before turning to stage design. In 1906 he moved to Paris, and in 1909 he created the *Ballets Russes* at the Théâtre du Châtelet, turning the Western world on its head with the color and burning life of Russian creativity.

On September 11, 1899, Savva was suddenly arrested, on the charge that he had taken money from the Railway Corporation, which he directed, and had used it for illegal purposes. During the trial the prosecution failed to prove its case, and the jury declared him innocent. Nonetheless, the house on Sadovaia-Spasskaia had been sealed, and neither Mamontov nor his artist friends would ever return there. The seals remained in place for another two and a half years. A Moscow newspaper lamented: 'An icy chill rises from the cellars to the grand vestibule of this unfortunate building, muffled footsteps echo beneath its frosted vaults, and one feels frozen as though in the presence of a corpse [...] To the new arrival it is like living a nightmare in this modern Pompeii [...] Even if Mamontov has sinned, it does not follow that his art collection, whose only fault is to have been lovingly created by him, should share his sad fate.'

In the spring of 1902 Savva had to sell a number of his possessions in order to pay his debts and legal

242. Viktor Vasnetsov
Valiant Knight at the Crossroads, 1882
Oil on canvas,
167 x 299 cm
Russian Museum,
St. Petersburg

243. Valentin Serov
Young Girl with Peaches (portrait of Vera Mamontova), 1887
Oil on canvas, 91 x 85 cm
Tretyakov Gallery, Moscow

The artist Polenov recounted how deeply Valentin Serov was influenced by Pascal Dagnan-Bouveret's painting *The Marriage Blessing,* in the collection of Sergei Tretyakov, when he painted the portrait of Savva Mamontov's daughter Vera (ill.243).

244. Mikhail Vrubel
Mask of a Libyan Lion,
1891-92
High relief majolica,
44 x 46.5 x 24 cm
Tretyakov Gallery, Moscow

245. Mikhail Vrubel
Russian stove, c. 1890
Majolica
Abramtsevo
Estate Museum

246. Mikhail Vrubel
Egyptian Woman, c. 1890
Majolica;
33.3 x 23 x 23.1 cm
Abramtsevo
Estate Museum

244

245

costs. Valentin Serov and Ilya Ostroukhov persuaded the Tretyakov Gallery to purchase several works, while other pieces would be acquired by the Russian Museum in St. Petersburg or by private collectors. Mamontov settled in the suburbs of Moscow near the Butirskaia Gate, in a house belonging to the Abramtsevo pottery, which had been moved to the city in 1896. There he spent the last years of his life, completely absorbed in the making of ceramics. The house would soon be known as the "New Abramtsevo," a place visited not only by Vrubel and Serov but also by younger artists.

Savva Mamontov died on March 24, 1918. During the same year the Abramtsevo museum created on the old estate near Moscow would house all the collections that still belonged to the great patron's estate—that is, some two thousand items, including almost two hundred paintings and more than fifty sculptures. One of the museum's organizers was Mamontov's daughter, Alexandra, who would work throughout the 1920s to inventory and systematize the collections of peasant art. It seems Savva Mamontov, industrialist and collector without peer, did not work in vain; he remains an example of an honest life spent without compromise in the service of art.

Exceptionally talented but uncompromising and psychologically unstable, Mikhail Vrubel was dubbed the "Russian van Gogh." For many years he was supported financially by Savva Mamontov, who never interfered in the creative process but offered him the opportunity to work in new media such as ceramic, having just set up a ceramics workshop on his estate at Abramtsevo. There Vrubel produced works of striking expressiveness (ill.246) or of a stylized elegance that recalled both Russian medieval art and the native folk tradition (ill.245).

246

Ilya Ostroukhov

Born into a family of merchants, Ilya Ostroukhov (ill.248) studied at the Moscow Academy of Commercial Sciences. After graduation, he took a position at the Botkins' tea business. Before long he too succumbed to "collectionitis," the first symptoms of which were his desire to accumulate "curiosities of nature" (shells, minerals, etc.)

Ostroukhov discovered his love of art in the circle of Savva Mamontov. He then studied with the painters Alexander Kiselev, Pavel Tchistyakov, and Vasily Polenov, while also frequenting "Sunday evenings" in the studio of Ilya Repin. Next he took part in the 13th Exhibition of the Wanderers, exhibiting there a landscape entitled *Last Snow* (Polenovo Museum). In 1887, at the 15th Wanderers show, his painting *Golden Autumn* was purchased by Pavel Tretyakov (Tretyakov Gallery), who took a liking to the young artist, perceiving him to be someone with a secure sense of taste. Tretyakov would now consult Ostroukhov about acquisitions.

Within the Mamontov orbit, the artist closest in spirit to Ilya Ostroukhov was Valentin Serov. The two of them often exchanged witty and charming epigrams and it was Ostroukhov himself who suggested to Pavel Tretyakov that he buy *Young Girl Bathed in Sunlight*, the first work by Serov to enter the collector's gallery. He wrote immediately to the artist: "Your name is at the Tretyakov Gallery. This makes me very happy!"

Ostroukhov favored landscape paintings, progressing from the "situational landscapes" of Savrasov toward the "intimist" views painted by Polenov and Levitan. He explained it thus: "An occasion for the greatest celebration was the appearance . . . of the first intimist landscapes of Polenov at the very end of the 1870s. They trigger dreams that ripen within me and urge me on to master this magical art."

After the death of Pavel Tretyakov, Ostroukhov was elected a member of the gallery board, along with Anna Botkina, the founder's daughter, Valentin Serov, and Ivan Tsvetkov. Fourteen years later, the Moscow municipality, unhappy about the museum's "decadent" acquisitions, among them Vrubel's *Demon, Pan,* and *Fortune Teller* (ill.272), issued a veto removing Ostroukhov from the board. A year later though, in 1905, in view of a general protest he found himself elected a member of the board again. In 1889 Ostroukhov had married

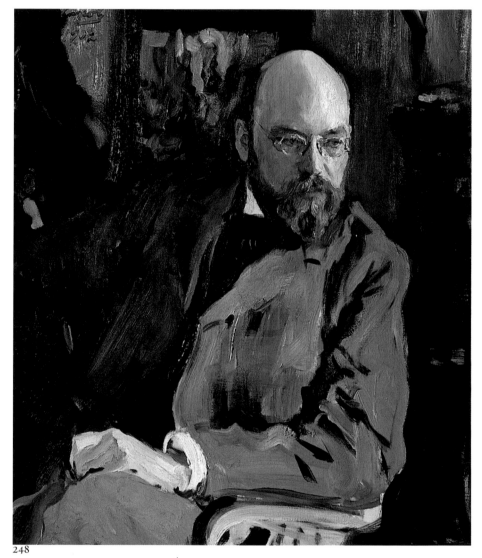

248

247. Novgorod,
late 15ᵗʰ century
The Miracle of Flora and Laura
Icon, tempera on wood,
47 x 37 cm
Tretyakov Gallery, Moscow

248. Valentin Serov
Portrait of Ilya Ostroukhov,
1902
Oil on canvas, 86 x 76 cm
Tretyakov Gallery, Moscow

After Princess Tenisheva withdrew her support, Ilya Ostroukhov was for a while the principal investor in the art journal *Mir Iskusstva* (World of Art), directed by Sergei Diaghilev. He was relieved of this responsibility by the artist Valentin Serov, who managed to persuade Tsar Nicholas II (whose portrait he was then painting) to support the publication from 1900 to 1904 by providing an annual grant of 10,000 rubles.

Ostroukhov was more than just a patron of art (having married a daughter of the great Botkin tea dynasty). Himself a painter of landscapes, he was far more receptive to the progressive tendencies of the new Russian school than other collectors such as Tsvetkov. In 1885 he was one of the artists who created the sets for a production of *Carmen* staged in Savva Mamontov's private opera house.

249. Cyprus,
early 5ᵗʰ century
Portrait of a Crowned Man
Carved limestone;
height: 16 cm
Pushkin Museum of Fine
Arts, Moscow

250. Palmyra,
2ⁿᵈ century A.D.
Tomb Sculpture of a Woman
Carved limestone;
height: 60 cm
Pushkin Museum of
Fine Arts, Moscow

251. A room in Ilya
Ostroukhov's residence

252. Byzantium,
late 14ᵗʰ century
Christ Pantocrator
Icon, tempera on wood,
122.5 x 80 cm
Pushkin Museum of
Fine Arts, Moscow

It is not impossible that
Ostroukhov intentionally
brought Greek, Roman,
and Syrian sculptures
(ill.249 and 250) and
Orthodox icons (ill.252)
face to face in his museum,
perhaps in an attempt to
demonstrate how the
sculpture of antiquity had
influenced Byzantine art,
which in turn informed
Russian religious painting.

249

250

Nadezhda Botkina, daughter of the millionaire tea-merchant and their house, on Trubnikovsky Street, was soon to become another Moscow museum.

The best Russian painters, from the eighteenth century to the modern era, found a place there with paintings by Antropov, Borovikovsky, Venetsianov, Briullov, and Fedotov, most of them now in the Tretyakov Gallery.

Two landscapes by Vrubel, and Levitan (gifts from the artists), Nesterov's study for his *Vision of the Adolescent Bartholomew*, and six works by Feodor Vasiliev, attested to the predominance of this genre in the Ostroukhov collection. At the same time, the artist and patron also took a particular interest in studies and sketches from the hands of Russian masters. The first acquisition he made for his museum was a study by Vasily Polenov for *The Boat*, a painting now in Kiev's Museum of Russian Art. As for the Wanderers,

251

Ostroukhov cared only for the painterly qualities of their works. Thus, in his collection, Shishkin, Savrasov, Vasiliev, Perov, and Kramskoi come across as major colorists.

Ilya Ostroukhov had also marshalled an outstanding collection of drawings, in particular portraits realized by Orest Kiprensky, Ilya Repin, Vasily Surikov, and Valentin Serov. In the realm of Western painting, the collection evolved into one the most singular. It included not only old masters such as Johann Liss's *Punishment of Marsyas* and Giambattista Tiepolo's *Two Saints* (Pushkin Museum) but also modern French painters, from Camille Corot to Edouard Manet.

Ilya Ostroukhov's holdings encompassed both Greek and Roman antiquities. At a time when the Hermitage owned not a single work of Archaic Greek sculpture in stone, the painter managed to acquire the admirable *Portrait of a Crowned Man*, a work of Cypriot origin (ill.249), the *Portrait of Faustina the Elder*, and the funerary monument of a woman (ill.250), this piece traceable to Palmyra (all in the Pushkin Museum).

Without doubt, however, the most precious collection amassed by Ostroukhov was the one composed of old Russian icons. Here we should recall that the collector supervised the cleaning and restoration of the frescoes and iconostases in the Kremlin cathedrals—that of the Dormition, of Saint Michael Archangel, and of the Annunciation—as well as in St. Basil's on Red Square and in the monastery Cathedral of the Trinity-St. Sergius outside Moscow. Yet the most important of

Ostroukhov's restorations was the one involving
Andrei Rublev's famous *Trinity*. In 1904 Ostroukhov
and Nikolai Likhatchev, the latter both historian and
collector, mounted an exhibition of the icons assem-
bled by Pavel Tretyakov. In 1912 they organized *Icon
painting and Antiquities of Art*, a show of forty-four icons
owned by Viktor Vasnetsov.

In his collection Ilya Ostroukhov had attempted to
induce a new kind of experience by hanging, side by
side, both icons and landscapes, portraits and still-life
paintings, which served to bring out the decorative and
formal aspects of all the works. Writing about
Ostroukhov, N. Shchekotova noted: "At a time when
our major museums were negligent in their preserva-
tion of icons, always in the worst corners of their
rooms, as if they were objects of shame, he placed them
in full light. He was the first to collect them not merely
as 'curiosities' or cultural samples of Russia before
Peter the Great, but, rather, as sublime works, like creative
manifestations of old Russian painting."

By itself, this Ostroukhov collection makes it
possible to reconstruct the true history of icon painting
in Russia, from two eleventh-century Byzantine works
Christ Pantocrator, (ill.254), and *St. Panteleimon* (Pushkin
Museum) to a fifteenth-century piece from the
Novgorod school *The Miracle of Flora and Laura*, (ill.247)
and a seventeenth-century Stroganov icon entitled
Hermitage of Zossima and Savvaty at the Solovkys (Tretyakov
Gallery). According to Sergei Shcherbatov, "all
Moscow and foreigners made visits to the museum
adjoining Ilya Ostroukhov's narrow house, a place that
became a veritable temple of the icon." In 1912 the col-
lector himself disclosed that "Matisse was literally
bowled over by the old icons; he spent entire days with
me in the monasteries, churches, and collections."

In 1918 the house-museum of Ilya Ostroukhov was
nationalized by decree. The resolution of the Council
of Commissars read in part as follows: "Immense are
the merits of I.S. Ostroukhov for the study of old
Russian painting. All those who work in this domain
are his students. In his person Russia possesses an
exceptional collector . . . who has devoted the whole of
his life to this cause."

Ilya Ostroukhov was asked to become curator of the
« Museum of painting and icon painting » he had
founded. But at his death in 1929 the museum ceased
to exist. The Russian paintings and the icons were
transferred to the Tretyakov Gallery, while the foreign
pictures, the Byzantine icons, and the antiques were
assigned to the Pushkin Museum of Fine Arts. Today a
few of the paintings can be seen at the Hermitage, the
Polenovo Museum, the Russian Museum, and the
Ivanovo Museum of Art, among others.

252

When Matisse visited
Moscow to stay with his
patron and benefactor
Sergei Shchukin in the
autumn of 1911, it fell to
Ilya Ostroukhov, friend
and distant relation of
Sergei Shchukin, to
organize the artist's
program of cultural events.
Shchukin had spoken of
Ostroukhov's collection to
Matisse, describing it as a
mixture of "magnificent
icons and bad paintings,"
and the artist was naturally
keen to see it. So powerful
an impression did the icons
make on him that it was
still fresh in his mind as
late as 1946, when, writing
in *Le Chemin de la couleur*, he
described what a revelation
they had been, and how
much they had helped him
in his understanding of
Byzantine art. With their
apparent simplicity, their
austere restraint and their
large areas of flat color
outlined in black, these
remarkable images could
hardly fail to delight the
master of pure painting.
In 1912, as a gift of
thanks, Matisse sent
Ostroukhov his painted
sketch for *Female Nude, Black
and Gold*, a composition of
1908 that hung in Sergei
Shchukin's collection.

Princess
Maria Tenisheva
and Talashkino

Princess Maria Tenisheva (*née* Piatkovskaia) was the natural daughter of a penniless noblewoman, which caused her considerable grief as a child. Later the Princess (ill.254) would recall how often she had envied other children because they lived with no "secret shame." Perhaps this was what drove her to revolt, to seek out values outside the caste system. From the poet Apukhtin, the writer Ivan Turgenev, and the musician Anton Rubinstein she found nourishment for her infatuation with the arts.

Living with her first husband, an officer by the name of Nikolaiev, with whom she led a dull, *petit bourgeois* life, also incited her to rebellion. At first drawn to singing, Tenisheva studied with the great teacher Marchesi in Paris. "Singing? It's a pleasant distraction . . . , but my soul needs it. . . . I should like to be rich . . . so as to create something that might be useful to humanity. . . , something durable," she wrote.

In 1892 Maria married Prince Viatcheslav Tenishev (1843–1903; ill.255), a major industrialist and renowned intellectual with an abiding interest in ethnography and sociology. A music lover, he played the cello and entertained such renowned composers as Piotr Ilich Tchaikovsky.

This second alliance was in part a marriage of convenience, a fact the new princess did not bother to conceal: "My youth enabled me to acquire a position, important connections, one of the oldest names in Russia, and an enormous fortune." Still, Princess Tenisheva spent several years not in the princely salons of the Tenisheva mansion on the English embankment in St. Petersburg, but at a metallurgic plant in Bryansk, where she was completely taken up with charitable activities—opening grammar schools, trade colleges, canteens, shops, and a club for the workers.

In 1893 the princess purchased the Talashkino estate in the province of Smolensk. Passionate about drawing, she took courses at the Stieglitz School and frequented the studio of the painter Nil Gogolinsky, before establishing her own art studio in St. Petersburg in 1894. Here gifted young people could prepare for admission to the Academy of Fine Arts, directed at the time by the painter Ilya Repin. In 1896 she opened her

254

255

own drawing school in Smolensk for the purpose of helping craftsmen to perfect their art and in 1899 she helped organize the 26th Exhibition of the Wanderers, held in Smolensk.

Meanwhile, the princess had started to build a collection of watercolors, with the idea of presenting the history of the medium "in the most complete way possible." In 1897 Alexander Benois assumed the task of preparing the catalogue for the exhibition of the Tenisheva collection of watercolors held at the Society for the Encouragement of the Arts. In the following year the princess gave all her Russian works (564 sheets by Albert Benois, Leon Bakst and A. Sokolov, among others) to the Russian Museum, which had just been founded in St. Petersburg, but was not interested by her European works.

It was also in 1897 that Benois, then in Paris, received a letter from his friend Sergei Diaghilev. "The Princess Tenisheva is in St. Petersburg" wrote the art publisher and impresario, "and we have entered into a great friendship. She is full of enthusiasm and I believe, money." Diaghilev was badly in need of the latter for his new magazine *Mir Iskusstva* (World of Art), and got his first backing from Tenisheva and the merchant prince and collector Savva Mamontov (see p.182).

253. *Teremok* (small palace) at Flenovo, near Talashkino, c. 1900

254. Ilya Repin
Portrait of Princess Maria Tenisheva
Drawing
Talashkino Estate Museum

255. Léon Joseph Bonnat
Portrait of Prince Viacheslav Tenishev, 1896
Oil on canvas,
119.5 x 92 cm
Hermitage, St. Petersburg

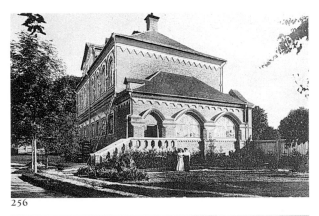

256

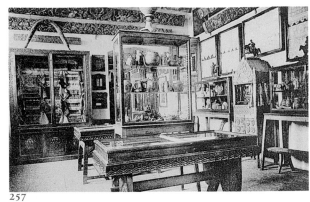

257

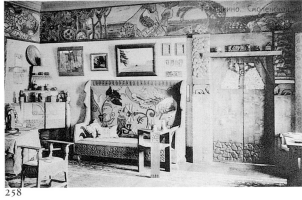

258

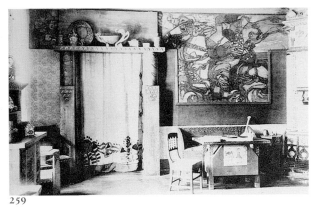

259

Princess Tenisheva was the principal financial investor in the avant-garde review *Mir Iskusstva* (World of Art), a collaborative venture by artists such as Alexander Benois, Yevgeny Lanceray, Konstantin Somov, Leon Bakst, Konstantin Korovin, and Valentin Serov, under the high-profile leadership of Sergei Diaghilev. Finding this forum too theoretical, in 1899 she withdrew from it and returned to her estate at Talashkino, not far from Smolensk, where she set up a gallery of traditional Russian crafts (including ceramics, embroidery, and woodcarving) and a center for artists working towards their revival (ill. 258 and 259).
The vision it espoused of pre-imperial Russia and its heritage owed more to an idealized concept than to historical reality. The enterprise came at an apposite moment, serving both to fix the validity of a return to original sources (and of the celebration of the Russian spirit) in people's minds, and to provide encouragement to innovative artists such as Nikolai Roerich and Mikhail Vrubel.

Maria Tenisheva maintained friendly relations with many of the participants of *Mir Iskusstva* including Alexander Benois, Mikhail Vrubel, Nikolai Roerich, Leon Bakst, Konstantin Korovin, and Valentin Serov, all of whom were regarded as "decadents."

At the gala dinner organized for the signing of the editorial contract, Vrubel proposed a toast: "I drink to the health of the Princess who promotes so-called decadence, but which, I hope, will soon be extolled as a renaissance!"

In 1898, after the first exhibition of their group , the princess bought two decorative panels by Vrubel, *Morning* and *Noon*, now in the Russian Museum, works first commissioned and then rejected by Savva Morozov. Tenisheva described Vrubel in her memoirs as "a man who, to the great shame of his contemporaries, was neither understood nor appreciated for his true worth. I was his fervent admirer. . . . Talents such as his appear only once in a century; they are the pride of those who come later. "

The critic Vladimir Stasov reacted to this group with particular ferocity. After the exhibition, he wrote : "Here is nothing but pure undiluted wall-to-wall madness, loathsome anti-art." Pavel Shcherbov's satirical review, published in the magazine *Shut* (The Jester) under the name of *Salzburg*, presented the exhibition in the guise of a rubbish dump, in which each item of garbage was allotted the catalogue number of one of the works on view. Stasov sent the piece to his brother, with a note explaining that "the numbers indicate paintings in the decadent dunghill style." Tenisheva herself made an appearance in a Vrubel panel, huddling

under a mouldy blanket, with Sergei Diaghilev, the exhibition's organizer, escorting her from a madhouse. The critic was pitiless, publishing article after article with caustic titles such as "The Inn for Lepers" and "The Poor of Spirit." And when Repin resigned as editor of *Mir Iskusstva*, his action was hailed by Stasov in a piece entitled "Wonder of Wonders." As for Shcherbov, he produced a new caricature, *The Idyll* (1898), in which Tenisheva appeared as a cow being milked by Diaghilev (ill.262).

Finally, however, Princess Tenisheva broke with *Mir Iskusstva*, convinced that the review had become too abstract in both action and program. "Love and beauty without a sense of usefulness. . . . What absurdity!" she wrote. None of this, however, stopped Tenisheva from continuing to acquire works from the World of Art group, such as Serov's gouache entitled *Winter*, Isaac Levitan's *The Clearing*, and Roerich's *Idols* (Russian Museum), among others.

Following the death of her husband in 1904, Tenisheva had to sell her 365 works by European painters which had not been accepted by the Russian Museum in 1898. After the auctions, the princess gave up her residence in St. Petersburg and moved to Talashkino, where she recommitted herself to her old cause of reviving traditional Russian crafts. For her workshops the princess recruited Sergei Malyutin (1859–1937), who not only built and decorated the spaces but also taught in them. In addition, she had him design a *teremok* (small palace), the Church of the Holy Ghost (ill.265) in the village of Flenovo, and the Talashkino theater.

260

Princess Tenisheva became the vital center of what was a world of effervescent artistic activity. "Talashkino had become a small, special domain," she would later recall, "where life boiled at every step, where everything pulsated, where a complex chain was forged, joined together link by link." Roerich echoed her memory: "I no longer recognize the students. After work, after the bench, scythe and rake, how they run toward the old hats for amateur theatricals, how they outdo themselves to speak . . . , how they play in the orchestra. How reluctantly they accept the fall of darkness and the end of activities." The scene he described was the school of agriculture, the art workshops, and the popular theater created by Tenisheva.

Not content merely to set up and organize Talashkino, the princess even conceived motifs for embroideries and dug up old formulas for dying thread and fabric. Her designs for sleighs, cradles, book covers, and furniture were equally superb. The musician Yanovsky wrote that "it was more like being in Renaissance Italy than in nineteenth-century Russia."

In 1901 she opened a shop in Moscow—the *Rodnik* (source)—through which to sell the objects made at Talashkino. Meanwhile, the archeologist Ivan Borshchevsky helped her to establish a museum at Talashkino, beginning with a structure erected by Sergei Malyutin. Later there was some thought of taking over one of the towers at the Smolensk fortress and finally, the Russian Antiquities Museum would open in the city itself (ill.256-57 and 261). As the museum was wrecked during the 1905 revolution, Princess Tenisheva removed her collections (amount-

261

262

261. Interior of Princess Tenisheva's museum at Smolensk

262. Pavel Shcherbov *Idyll*, 1898 Caricature of Princess Tenisheva Watercolor on paper Russian Museum, St. Petersburg

263

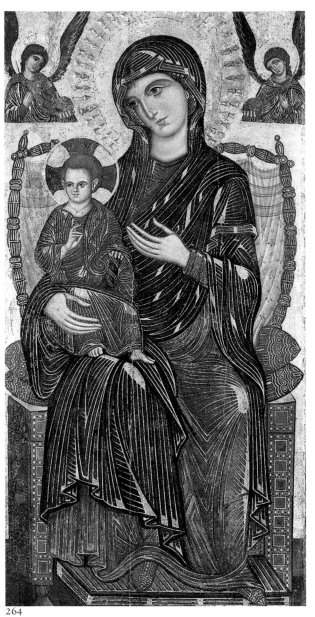

264

263. Moscow School, 16ᵗʰ century
Virgin and Child
Tempera on wood, 115 x 85 cm
Museum of Plastic and Applied Arts of the Smolensk Region

264. Pisan Master of the 13ᵗʰ century
Virgin and Child Enthroned, c. 1280
Tempera on wood, gilding
Pushkin Museum of Fine Arts, Moscow

265. The mortuary chapel at Flenovo, with frescoes by Nikolai Roerich, c. 1900

ing then to 5,695 pieces) to Paris for exhibition at the Louvre. Following their return to Russia in 1907, the princess offered the collections to the Smolensk branch of the Moscow Archeological Society. The key to the museum, created by the foundress in 1911, bore this inscription: "Come and possess, oh learned ones. In your hands I place my gift. Watch over this treasure chest so that the riches forever preserved in the city of Smolensk may remain in the service of the Russian people."

Today many objects have disappeared from the Smolensk museum. The *Virgin and Child Enthroned* painted by a thirteenth-century Pisan master now hangs in the Pushkin Museum of Fine Arts (ill.264). Still in place, however, are fifteenth-century royal gates, a *Saintly Visage* and a *Virgin and Child* (ill.263), both sixteenth-century works, as well as the seventeenth-century *Saints Flora and Laura*, among other icons.

In her Paris residence Princess Tenisheva set up her enameling studio, creating works that would be exhibited in Rome in 1911. In 1916 she defended her thesis, entitled *Enamel and Inlay*, before the Moscow Institute of Archeology and, by 1918, found herself in the Crimea, cut off from Petrograd by the civil war. She then departed for Paris, where she returned to making enamels in her studio on Avenue Duquesne and was visited by Nikolai Roerich, Prince Sergei Shcherbatov, and Ivan Bilibin, among others.

Maria Tenisheva died on April 1, 1928 and was buried in the old cemetery in Saint-Cloud. Two years later her doctoral thesis would be published in Prague, followed by the publication in Paris of her memoirs entitled *Impressions of My Life*.

For her obituary Roerich wrote these knowing words: "Tenisheva was a creator. She could have settled for a calm and prosperous life; she could have been one of those who live out their existence far from the upheavals of the human condition; but her desire for knowledge and beauty, for irresistible art and the creative enterprise would not allow Maria Tenisheva to stagnate in still water."

265

The Morozovs

Mikhail 1870-1903

Ivan 1871-1921

Alexei 1857-1934

At the outset of the twentieth century, wealthy Russian merchants and industrialists constituted a new class whose presence was felt with increasing force. No longer objects of ridicule, as in the nineteenth-century plays of Alexander Ostrovsky, they now competed for leading roles in the social and cultural life of the nation.

In his memoirs, *The Mask and the Soul*, the great singer Feodor Chaliapin proved deeply perceptive in his comments about the evolution of the Russian merchant: "The *mujik*, barely removed from his country life, sets out to make a fortune in Moscow selling honeyed tea in the Khitrovo bazaar—his little pâtés, his simple merchandise—all of which he merrily hawks to the passing crowds, never ceasing to observe, on the sly and from every angle, the life swirling about him. Often he finds himself spending the night among vagrants, freezing in the cold, and going hungry, but he is always good-humored. He does not groan and has hope for the future. And before long he's got himself a shop or a small factory. After that he becomes a leading merchant. A bit later his eldest son is buying Gauguins, becomes the first to want Picassos, the first to bring Matisse to Moscow. We the educated look at one another and go on sneering: little uncouth tyrant! Still, he and his kind have bit by bit gathered up some marvelous artistic treasures, founded galleries and theatres of the first order, built hospitals and hospices throughout Moscow."

This collective portrait bears the unmistakable features of the Morozovs. The family, with its many branches, sprang from the serf Savva Vasilevich, or Savva I (1770–1862) as he was known.

In 1812, after Napoleon's destruction of Moscow, he took advantage of the general shortage of fabrics to sell his own, produced in a small workshop some sixty kilometres outside the city, so gradually building up a company that was to become the largest textile firm in Russia. Appreciating the significance of the industrial revolution, he was the first to import machinery from Britain and raw materials from America, so rendering himself impervious to fluctuations in the market.

Savva had four sons—Zakhar, Abram (or Abraham), Vikula, and Timofei—who became directors of the lead-

ing textile mills in Russia, while also giving birth to four different "clans" of Morozovs. They controlled the market vertically, from the import of the raw materials and the manufacture of the finished goods to sales in their own retail outlets, enlarging their empire under the direction of the youngest brother, Timofei. One of his sons, Savva Timofeievich, commissioned a house in Moscow from the architect Feodor Shekhtel, who would later attract attention with his Yaroslavl station building and a mansion for Stepan Ryabushinsky. Not the least bit interested in the family business, Savva Morozov earned himself a place in history through his patronage of the arts, becoming the sole sponsor of Stanislavsky's Moscow Art Theater where, in plays by Chekhov and Maxim Gorky, modern stage design was born.

The brothers Ivan and Mikhail belonged to the clan founded by Abram, head of the Tver factories. Mikhail Morozov, like his younger brother, had been introduced to painting by Korovin and Khruslov. As the eldest son, he should have taken charge of his father's enterprise. Margarita Morozova, his widow, recalled: "From childhood, my husband had shown a lively interest in and great capacity for science and art, and since he had no

266. Paul Gauguin
Woman Holding a Fruit: Where are You Going?, 1893
Oil on canvas, 92 x 73 cm
Hermitage, St. Petersburg

267. The Morozovs and guests on their estate at Odintsovo-Arkhangelskoie, near Moscow. Alexei Morozov sits in front on the right; Ivan Morozov stands second from left.

After specializing in works by artists of the Barbizon school, which were rendered more accessible to Russian eyes by their similarities with the work of painters of the Russian Wanderers group, Mikhail Morozov was among the pioneering nonconformist collectors who were the first to take an interest in radical artists such as Gauguin (ill.266).

267

268. Valentin Serov
Portrait of Mika Morozov,
1901
Oil on canvas,
62.3 x 70.6 cm
Tretyakov Gallery, Moscow

269. Valentin Serov
Portrait of Mikhail Morozov,
1903
Oil on canvas,
215.5 x 80.8 cm
Tretyakov Gallery, Moscow

270. Margarita Morozova
with her children (from
left to right): Yura, Lena,
and Mika, in the Morozov
residence on the Smolensk
Boulevard, Moscow,
c. 1900. In the background
hangs Mikhail Morozov's
portrait by Serov (ill.269).

Portrayed by Serov with
a trenchant expression and
a commanding bearing,
Mikhail Morozov looms
over this contemporary
group portrait like a
guiding spirit of
unapologetically bold
tastes, in defiance of both
conventional taste and
tradition (ill.270).
With his early death at the
age of thirty-three, in
1903, the world of Russian
collectors lost one of its
most informed and
discriminating
personalities. The walls to
either side of his portrait
are densely hung with
numerous sketches and
paintings by Russian
artists.

desire whatever to devote himself to business and commerce, he was allowed freely to take up an activity of his own choice. He wanted to study literature and history at Moscow University, from which he graduated 1893 with a first-degree diploma. He then became a man of letters and professor at the university, while more than once traveling abroad to explore historic museums and monuments. He was among the patrons who responded to the appeal launched by Ivan Tsvetkov to help build and furnish the Alexander III Museum of Fine Arts (in St. Petersburg). Mikhail assumed the cost of creating one of the halls." She went on, saying: "Mikhail Abramovitch faithfully kept up with our Russian painters . . . and constantly bought pictures from them. The works that truly moved him he installed in a small, specially furnished room, where he hung and rearranged them with great care and much love. . . ." It was in Mikhail Morozov's study in his residence on the Smolensk road that Valentin Serov painted his famous portrait of the collector in 1903 (ill. 269), as well as one of his finest child portraits, depicting his son Mika Morozov (ill. 268; both at the Tretyakov Gallery).

From both his father and his grandfather, Mikhail inherited an interest in religious art, which would be reflected in his important collection of icons.

Blessed with excellent taste and the kind of intuition native to every self-respecting collector, Mikhail was also one of the first to appreciate the art of the Post-Impressionists—Gauguin (ill.266), van Gogh, and Bonnard. Indeed, it was in his gallery that these painters made their debut before the Moscow public, an initiative destined to influence other collectors, in particular Mikhail's younger brother, Ivan, as well as Sergei Shchukin.

In his brief but intense career as a collector, Mikhail succeeded in marshalling one hundred Russian and European paintings, as many as ten sculptures, and more than sixty icons. The collection grew until he had

268

269

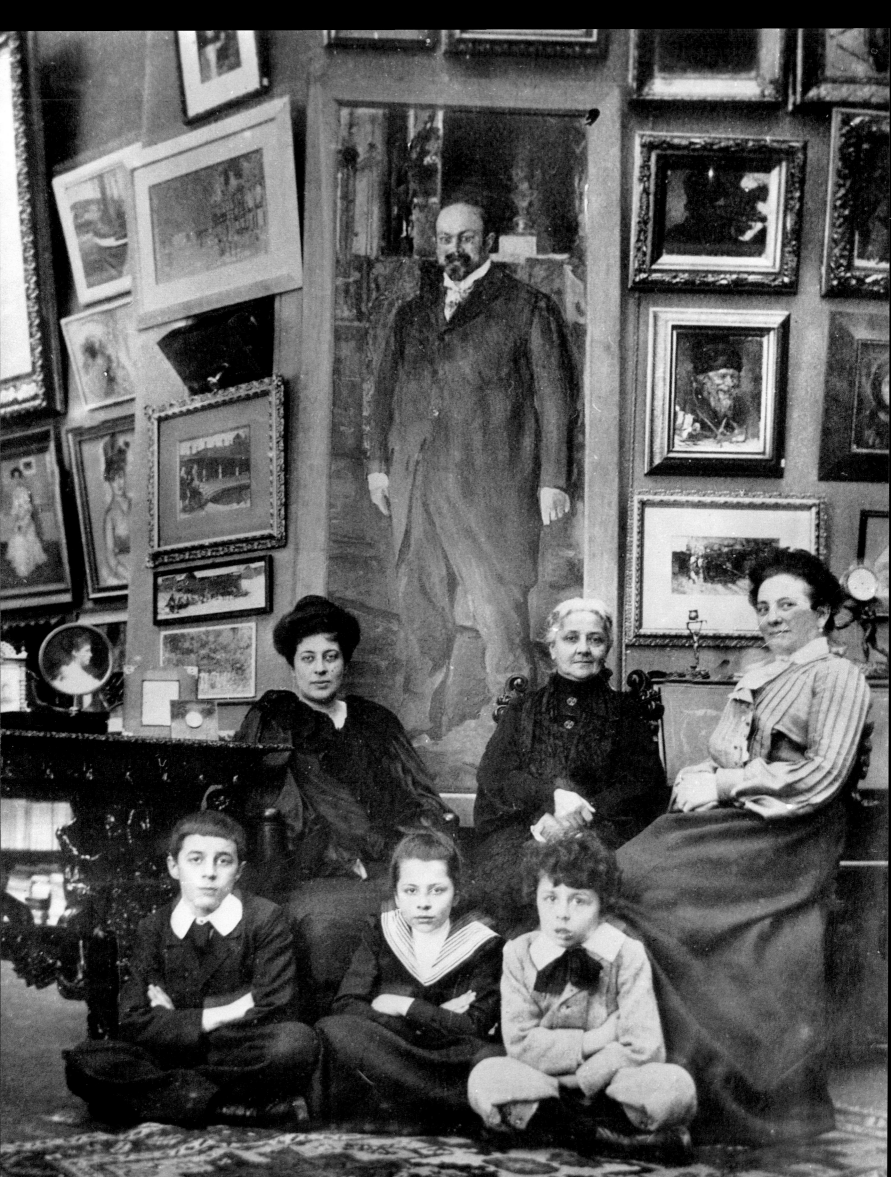

271. Mikhail Vrubel
The Swan Princess, 1900
Oil on canvas,
142.5 x 93.5 cm
Tretyakov Gallery, Moscow

272. Mikhail Vrubel
The Fortune Teller, 1895
Oil on canvas,
135.5 x 86.5 cm
Tretyakov Gallery, Moscow

After a difficult start to his career, the painter Vrubel met Konstantin Korovin, who in turn introduced him to Savva Mamontov, who–following the example of Princess Tenisheva–became his benefactor and protector. Vrubel's treatment of traditional Russian subjects became increasingly idiosyncratic in style as his brushwork became steadily more fragmented and mosaic-like (ill.272). Having initially taken part in the early exhibitions mounted in St. Petersburg by *Mir Iskusstva* (World of Art), in 1902 he joined the Moscow-based dissident group known as "The 36". The breakaway exhibition the latter group mounted was intended to demonstrate their independence from other artists whom they viewed as still too much in thrall to "insipid" Western art. Always an anguished character, Vrubel was eventually overcome by his mental instability; he died in hospital in 1910.

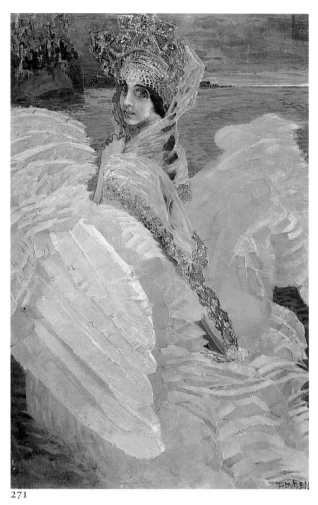

271

272

to hang works in the winter garden of his house. Russian works included *Chill Wind. Volga* by Levitan, a sketch by Nesterov for his *Vision of the Young Bartholomew,* and *The Fortune Teller* and *The Swan Princess* by Vrubel (Tretyakov Gallery, ill.271 and 272). Outstanding among the works by Western artists were *The Sea at Saintes-Maries-de-la-Mer* by van Gogh (Pushkin Museum of Fine Arts), *After the Bath,* a pastel by Degas, and Claude Monet's magnificent *Field of Poppies* (all now in the Hermitage).

Seven years after he died, his widow conveyed a good part of the collection to the Tretyakov Gallery. Later the European works would be consigned to the Pushkin Museum of Fine Arts, except for some pieces, which went to the Hermitage.

Ivan Morozov (ill.273), Mikhail's younger brother, studied at the Zurich Polytechnic, at the same time that he took courses in design and painting (from Konstantin Korovin and Yegor Khruslov), thereby satisfying a passion that had been with him since childhood. From 1892 to 1900 he ran the paternal mill, increasing its value threefold, and simultaneously became the owner of several plants for dying fabric and making printed calico. Ivan grew even richer from orders arising out of the Russo-Japanese war. After buying a house on Preshistenka Street, from the widow of his uncle, Ivan moved from Tver to Moscow in 1900

and began collecting pictures under the influence of his elder brother. Very impressed by Sergei Shchukin's activity, (see p.218-31), he established ties with several painters, especially Valentin Serov. Margarita Morozova, the widow of his brother, who died in 1903, reports that Ivan regarded his art collection as "respite from his monotonous life as a businessman. He said that the Slavic reverie so common among Russians, to the exclusion of the spirit of enterprise, was foreign to him."

The first painting Ivan purchased was a landscape by Isaac Levitan entitled *Beehives* (Tretyakov Gallery). In 1903 he bought Alfred Sisley's *Deep Freeze in Louveciennes* from Durand-Ruel in Paris. Thereafter he would make most of his acquisitions through such dealers in the French capital as Ambroise Vollard and Bernheim. Following the death of his brother Mikhail, Ivan set about with redoubled energy to complete his collection. Several years later he would own more than 250 works of contemporary French painting. among them *Red Vine at Arles* and *Cottages* by Vincent van Gogh (ill.275), *Bathing on the Seine* and *Portrait of Jeanne Samary* by Auguste Renoir, *The Montagne Sainte-Victoire* by Cézanne (ill.274), still lifes by Matisse, and *Girl on a Ball* by Picasso (ill.280).

Contemporaries were astonished at the breadth of taste and freedom of spirit shown by Ivan in his collecting. The art critic Boris Ternovets wrote: "It is clear

that in those years, which ended with the War of 1914, no modern European art collector or Western museum enriched its collections with such energy and impetuosity." Morozov made sure that in his house all the major artists of the period were represented at their best, an approach that set him apart from Sergei Shchukin, who concentrated on a small, select group of painters: "Untouched by the passion of Shchukin, always prudent and strict in his choices, fearing everything sudden, hesitant, conflicted, Morozov preferred to go about his quest peacefully," wrote Ternovets, who would become the curator of Ivan's collections.

In 1907 Morozov commissioned Maurice Denis to execute a series of decorative panels, entitled *Story of Psyche*, for the music room in his Moscow residence (ill.276). Two years later the French painter arrived in Russia to see how the panels had been installed. In his diary Denis noted that his host owned a good many pictures by Russian masters, from the "fine landscapist" Levitan through Golovin and Malyavin to Somov and Vrubel. After Denis advised him to complete the group of sculptures decorating the music room, Morozov commissioned Aristide Maillol to execute a series of four bronzes with the seasons as their theme. For the same space Denis designed the decor for eight ceramic vases.

From Pierre Bonnard, Ivan commissioned *Mediterranean triptych*, for the grand staircase in his mansion on Preshistenka Street (ill.279). He was the first to take note of Marc Chagall, buying three pictures from the totally unknown Russian artist, among them *The Hairdressing Salon* (Tretyakov Gallery). Nor did he ignore the artists in the « Knave of Diamonds » group, from which he acquired Mikhail Larionov's *Garden in Spring* and *Apple Tree after the Rain*, Natalia Goncharova's *Boys Skating* and *Orchard in Autumn* (all in the Tretyakov Gallery).

Ivan Morozov's collection of Russian works comprised 303 paintings and 7 sculptures. The critic Abram Efros wrote of the impression made on him by

273. Valentin Serov
Portrait of Ivan Morozov, 1901
Tempera on board,
63.5 x 77 cm
Tretyakov Gallery, Moscow

The contrast between Serov's portraits of Mikhail Morozov (ill.269) and his brother Ivan (ill.273) is striking. Yet Ivan's gentler expression and relaxed pose are none the less suggestive of the authority and confidence that characterized the best-known member of the Morozov family today. Behind him is a Matisse still life, *Fruits and Bronze* (painted in 1910), which has the effect of transforming the portrait into a manifesto for the avant-garde.

273

274

274. Paul Cézanne
The Montagne Sainte-Victoire,
1900
Oil on canvas, 78 x 99 cm
Hermitage, St. Petersburg

A pupil of the artist
Korovin, who had been
engaged by his mother
to teach him drawing,
Ivan Morozov went on
quite naturally to start
a collection of paintings
by Russian artists (amassing
a total of 430 by 1913),
from Levitan to Vrubel,
Larionov, Goncharova, and
even Chagall. In 1903,
after the death of his
brother Mikhail, he
broadened his interests
to include French painting,
in which his tastes proved
equally adventurous
(ill.274 and 275).

the Morozov gallery, which, unlike that of Shchukin, was rarely open to the public: "First one is surprised, then disappointed, and then once again gripped by curiosity. To begin with, one discovered, as if it were America, that half of the Morozov collection is composed of things typically Russian, of actual, living artists shown in exhibitions, painters who, being in conformity with the canons now established in Russia, could not be seated at the same table with members of the Parisian artistic aristocracy."

Thanks to his generous spirit and irreproachable taste, Ivan proved to be a creative and fruitful collector, without question one of the greatest in Russian history, both in the number of works he assembled and in their quality.

Ivan planned eventually to give his collections to the city of Moscow, and as Alexander Benois pointed out as early as 1911, this collection – together with that of Sergei Shchukin – promised to offer an understanding of the quest of modern artists to the public,

who would "only then be equipped to appreciate the true worth of Russian art in its entirety."

Nationalized in 1918, Ivan's private gallery became the basis of Russia's second "Museum of modern Western painting", created in 1919, and Morozov, although named deputy director of the new public museum, chose to emigrate at the end of 1918. He died abroad, in Karlsbad, in 1921.

In 1928 the Soviet authorities fused the Morozov and Shchukin collections, thereby creating the "State Museum of Modern Western Art", housed in the one-time mansion of Ivan Morozov. Twenty years later, at the height of the campaign against "cosmopolitanism," the museum's collections were slated for destruction, and only by the greatest of good luck were they saved, and then divided between the Pushkin Museum of Fine Arts in Moscow and the Hermitage in Leningrad. As for the Morozov mansion, it would thereafter be the headquarters of the Academy of Fine Arts, transferred from Leningrad to Moscow.

275

A cousin of both Mikhail and Ivan, Alexei Morozov, who belonged to the "Vikula clan," dedicated himself to business as of 1877. After the death of his parents in 1894, he became director of the Vikula Morozov & Sons Company. In 1900, however, he turned the management of the firm over to his brother Ivan Vikulievich (as opposed to Ivan Timofeievich), having surrendered entirely to the temptations of the collecting demon. Alexei took on the task of converting his father's house on Podsosensky Street into a proper museum. His collection of Russian porcelain numbered 2,459 pieces, many of them bought in Europe and then repatriated to their country of origin. Without this collection, it would have been impossible to reconstitute the history of porcelain-making factories in Russia from the end of the eighteenth century to the beginning of the nineteenth, including the Yussupov, Vsevolojsky, Polivanov and Dolgorukov manufactures. Their production was not intended for sale and is therefore extremely rare today.

Another of Alexei's interests was portraits, so much so that by 1912 he already owned nearly ten thousand engravings and lithographic prints of Russian personalities and, in 1912, he published the collection in several volumes entitled *Catalogue of my Portrait Collection*. He had, in addition, amassed 220 objects in Russian silver, 156 miniatures, and 219 icons from the thirteenth to the seventeenth century (now in the National Museum of History and the Tretyakov Gallery).

Margarita Morozova retained this memory of Alexei's house: "Every room on the main floor was filled with vitrines holding porcelains and icons. [Alexei] himself lived on the ground floor. . . . His study was done in two colors, with a high ceiling, entirely panelled in dark wood with five panels by Vrubel depicting Faust, Mephisto (ill.282), and Marguerite (Tretyakov Gallery)."

Immediately after the October Revolution of 1917, these collections almost disappeared. In March 1918 the anarchist organization Lesna, made up mostly of

275. Vincent van Gogh
Cottages, 1890
Oil on canvas, 59 x 72 cm
Hermitage, St. Petersburg

Among the Parisian art-dealers he frequented, Ivan Morozov was a particularly faithful client of Druet, who in 1908, acting on Morozov's behalf, paid 5,865 francs at a sale at the Hôtel Drouot for one of the last landscapes painted by van Gogh at Auvers-sur-Oise.

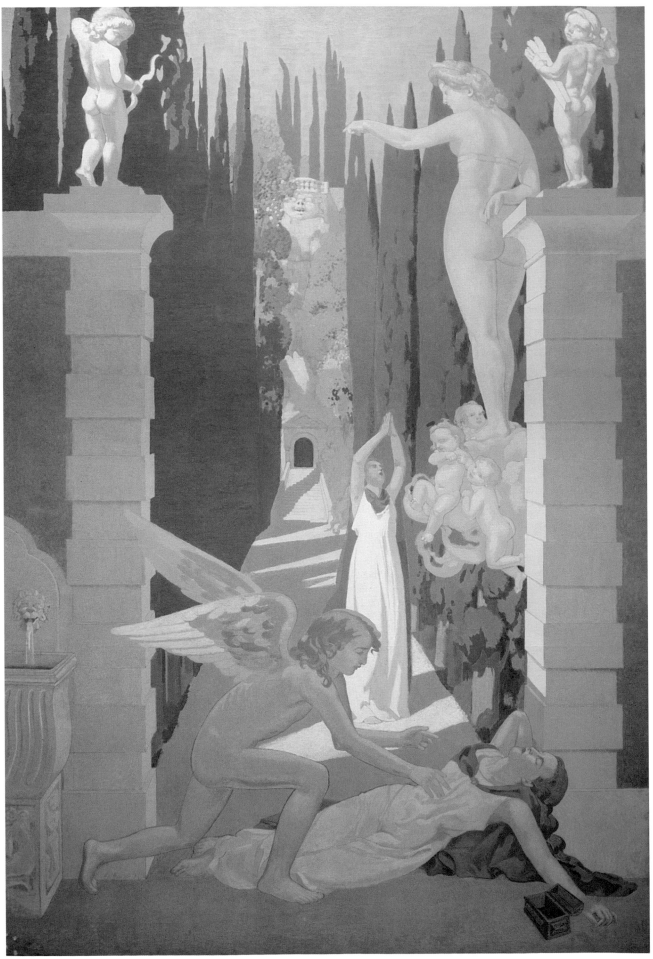

276

277

278

Ivan Morozov was very friendly with Maurice Denis, and was greatly impressed by the decorative cycle on the *Legend of St. Hubert* that the artist had painted for the collector Cochin in Paris in 1897. After buying *Sacred Wood at Guidel* (first exhibited at the Salon of 1906) and *Bacchus and Ariadne* from the artist, in 1907 Morozov commissioned him to paint five large panels on the theme of the *Story of Psyche* for the music room (or white room) of his Moscow house (ill.276-78). When Denis came to Moscow for their installation in 1909, he suggested adding a further eight smaller panels, as well as some sculptures by Maillol and ceramic vases. The dominant style of the panels, classical in tone and in a muted palette, is all the more intriguing when compared with the explosive colors and impulsive compositions of the van Goghs and Gauguins that Morozov was also buying at this time.

Letts, seized Alexei's house, remaining there until forced out at gun point toward the end of April. Meanwhile, the collections suffered irreparable damage. The snuff boxes had vanished, along with some of the miniatures, porcelains had been smashed, the remaining miniatures were scattered throughout the rooms, and the collector's archives destroyed.

Once the collections had been nationalized in 1918, Mikhail became a curator and set about cataloging them. The new "Museum-Exhibition of the Russian Artistic Past" opened to the public in December 1919, only to be converted into the Museum of Porcelain in 1921. Then, in 1929, Alexei's

276. Maurice Denis
Story of Psyche, 1908
The Vengeance of Venus: Psyche Opens the Box of Dreams of the Underworld and Sleeps
Oil on canvas,
395 x 272 cm
Hermitage, St. Petersburg

277. The music room in Ivan Morozov's residence on Preshistenka Street, Moscow, showing panels from the *Story of Psyche* by Maurice Denis, c. 1910.

278. Another photograph of the music room in Ivan Morozov's residence, Moscow, with two bronzes by Aristide Maillol, c. 1910.

279

279. Pierre Bonnard
The Mediterranean Triptych,
1911
Oil on canvas: left-hand
panel: 407 x 149 cm;
central panel:
407 x 152 cm; right-hand
panel: 407 x 149
Hermitage, St. Petersburg

collections were moved to the former Shchukin mansion, which housed the "Second Museum of Modern Western Painting", before all porcelain pieces were sent to the Kuskovo estate, that had once belonged to the Sheremetev family, in 1932. This was but one of many palaces that had been Sheremetev property.

As for the icons, they were parceled out between the Historical Museum and the Tretyakov Gallery in Moscow; the silver objects found a home in the Kremlin Armory Palace, while the collection of engravings ended up in the Pushkin Museum of Fine Arts.

At the Kuskovo Museum, the vast number of porcelains assembled by Alexei have now been integrated into the more than seven thousand pieces of porcelain preserved in the National Ceramic Museum. And the great collector's 156 miniatures have completed the collection at the Tretyakov Gallery.

In 1913 newspapers had carried the announcement that "Alexei Morozov bequeaths his remarkable collections of Russian engravings, miniatures, and chromos [lithographs], as well as those of Russian porcelain, crystal, and silver, all objects of enormous value, to the city of Moscow, for the purpose of founding a museum that will bear his name." But today, alas, his name is nearly unknown to the public, as his collections have been totally dispersed.

280

280. Pablo Picasso
Young Girl on a Ball
Oil on canvas,
147 x 95 cm
Pushkin Museum of Fine
Arts, Moscow

In 1911, Ivan Morozov commissioned Pierre Bonnard to paint an immense triptych to be placed on the top landing of the stairwell in his house (ill.279). The influence of the Russian fondness for winter gardens – and also for the French Riviera—was inescapable in the overwhelming impression of the blues and golds of a Mediterranean paradise that enveloped visitors to the house. Ivan Morozov's introduction to the work of Picasso and Matisse came about through Sergei Shchukin, who in 1908 sent him to the former's studio. Morozov's fascination with Matisse's work was to continue up to the outbreak of World War I, during which time his choice of compositions became steadily more advanced.

Morozov's admiration for Picasso, by contrast, was never on a scale to match that of Shchukin himself: while the latter possessed some fifty of his works, Morozov bought only three. The first, of 1901, was *Harlequin and his Companion*; the second, of 1905, was *Young Girl on a Ball* (ill.280); and the third, more surprisingly, was a Cubist portrait of Ambroise Vollard, which he bought from the Paris dealer in 1913 for the sum of 3,000 francs.

281. The library of Alexei Morozov in Moscow, c. 1900.

282. Mikhail Vrubel *Mephistopheles' Flight*, 1896 Decorative panel from the Gothic Study of Alexei Morozov in Moscow Oil on canvas, 190 x 240 cm

283. Valentin Serov *Portrait of Alexei Morozov*, 1909 Gouache and watercolor on paper Museum of Fine Arts, Minsk

284. The Gothic Study of Alexei Morozov in Moscow, c. 1900

Few collectors are now familiar with the name of Alexei Morozov (ill.283), cousin of Mikhail and Ivan, despite the fact that from 1900 he amassed an extremely important collection of Russian porcelain of the eighteenth and nineteenth centuries, without which our knowledge of the history of this technique would be incomplete.

It is now in the National Porcelain Museum, Kuskovo. Before the revolution, they were housed in his Moscow mansion, decorated by Feodor Shekhtel, a major practitioner of the "modern" style (the Russian "Art nouveau"), in an unusual Gothic Revival mood (ill.281 and 284).

281

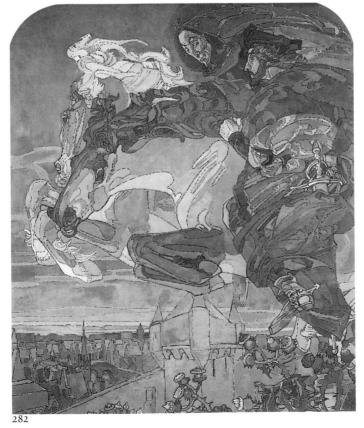

282

283

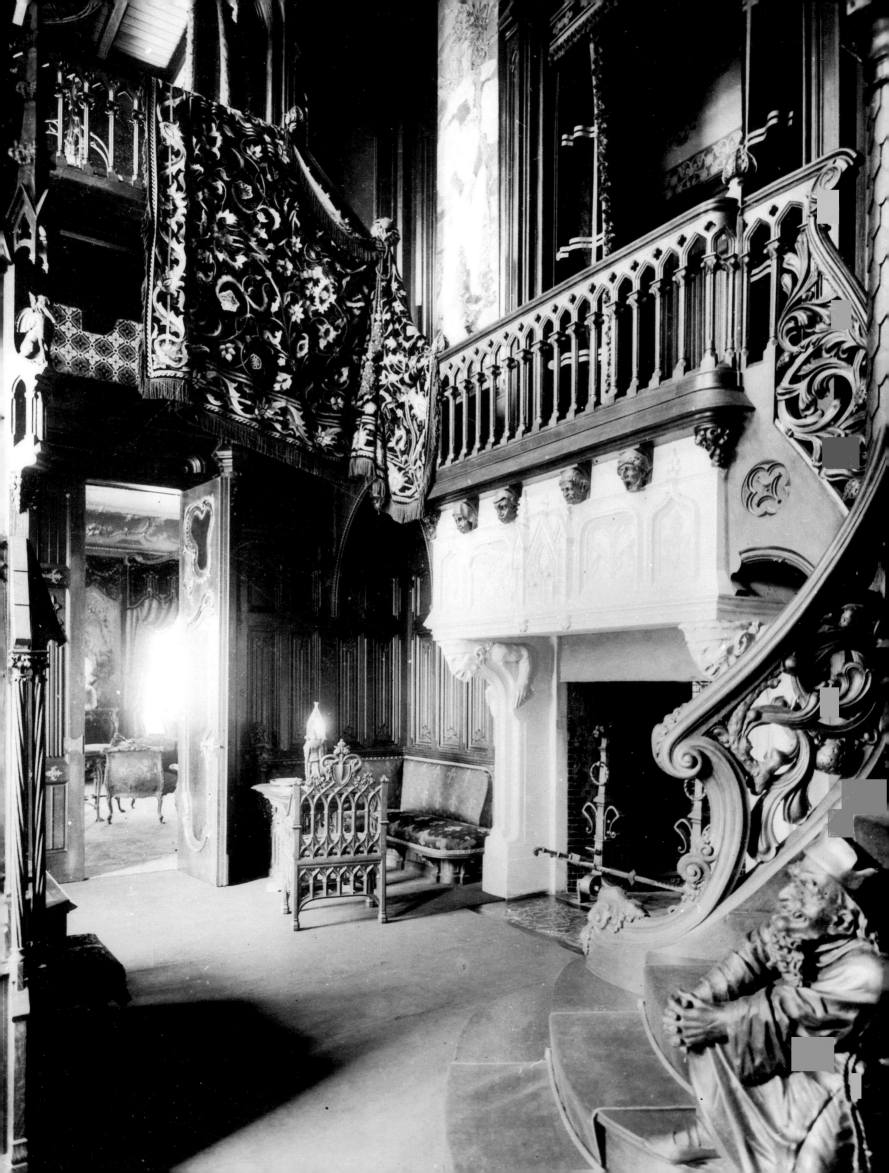

The Shchukin Brothers

Piotr 1853-1912

Dmitry 1855-1932

Ivan 1869-1908

Sergei 1854-1936

Every one of the four sons of Ivan Shchukin, a Moscow textile manufacturer and merchant, was to become a distinguished collector of art. Piotr (ill.286) dreamed of becoming a student at Moscow university and going on to a career in science, but their father was determined that all his sons should follow him into the world of commerce. Piotr was duly sent abroad for six months of studies designed to turn him into a businessman. On his return to Moscow, he wrote, "I began collecting engravings, lithographs, and drawings," but most of all, he was captivated by icons, and by portraits of distinguished figures such as actors, writers, scholars, military leaders, and statesmen.

"At the Nijnii-Novgorod fair," he went on, "I started acquiring oriental objects, just as later I took up collecting old Russian artifacts, such as a Cossack silver pot from the Urals." The collector Alexei Bakhrushin, struck by the singular approach adopted by Piotr in his collecting, observed: "Of all the collectors I know, he is the most serious. He never buys anything without assembling an entire bibliography on the desired object and reading up about it in books. This was how he studied domestic items and works of art, whether Japanese or Chinese items, antique Polish belts, Russian velvets and coins and medals. He could give you an entire seminar on each item, completely impromptu!"

Gradually Piotr Shchukin came to concentrate his attention on cultural and historical monuments, prompting remarks that his collections were a veritable museum of Russian antiquities. After the death of his father he gave free rein to his passion: cartloads of ancient objects would now arrive from virtually every part of Russia, and he frequently purchased entire collections, especially from members of the aristocracy.

Within his "museum," Piotr Shchukin was particularly dedicated to the sections containing religious artifacts, weapons, fabrics and carpets, precious objects, and utensils. The Russian section also embraced manuscripts and a great deal of traditional folk art, such as carved and painted spinning wheels, boxes and chests, bread boxes and cradles. He also possessed an important collection of icons. As for his interest in Eastern art, he explained: "I gave myself the

286

285. Edgar Degas
After the Bath: Woman Combing her Hair, c. 1885
Pastel on paper,
53 x 52 cm
Hermitage, St. Petersburg

286. Piotr Shchukin,
c. 1880

287. Hall in Piotr Shchukin's "Old" museum,
c. 1900

In a quest for historical authenticity and a faithful rendition of an seventeenth-century interior, the decorative scheme of the main hall of the Piotr Shchukin Museum (ill.287) reproduced an example included in a book sent by Peter the Great to Jacob Bruce.

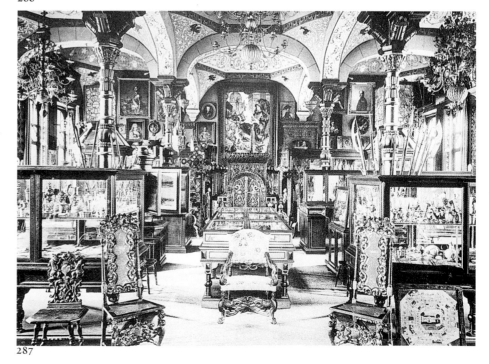

287

288. Piotr Shchukin's Museum on Malaia Gruzinskaia Street in Moscow, 1906

289. The drawing room of Piotr Shchukin's "New" Museum in Moscow, c. 1900

290. Hall in Piotr Shchukin's "New" museum, c. 1900

288

When designing the new museum that opened to the public in 1895 (ill.288), Piotr Shchukin and Boris Freidenberg were prompted by the growing contemporary interest in traditional Russian architecture to take their inspiration from the medieval wooden palace of the Muscovite sovereigns. Reflecting the insatiable curiosity of the period, the eclectic variety of the exhibits (ill.289 and 290) was intended to enable the discerning visitor to draw conclusions about the areas in which Western aesthetic values might have influenced Russian art, and those in which Russian art was most conspicuously autonomous.

challenge of collecting not only Russian pieces but also works from the Orient and the West, in order to demonstrate their influence on Russian culture."

Guided by the example of his brother Ivan, who lived in Paris and was familiar with contemporary art, Piotr Shchukin also bought a number of Impressionist paintings, for example *After the Bath* by Degas (ill.285) and *The Place du Théâtre Français in Paris* by Pissaro (ill.292). It was thanks to Ivan that he acquired such masterpieces as Sisley's *Villeneuve-la-Garenne-sur-Seine* (Hermitage; ill.291), Renoir's *Nude* (Pushkin Museum), and Monet's *Woman in a Garden* (Hermitage; ill.298). Later, however, he would part with his Impressionists works, selling them to his brother Sergei.

Piotr Shchukin also established archives of considerable value, buying over the years documents relating to forty-six distinguished figures from history, including the Demidovs, the Vorontsovs, the Shakhovskoys, and General Alexei Ermolov, conqueror of the Caucasus, not to mention a host of other documents.

Initially, Piotr Shchukin housed his collections in the family residence. Eager for more space though, he engaged the architect Boris Freidenberg to build a new mansion on Malaia Gruzinskaia Street (ill.288), a project completed in record time in 1892–3. This proved to be a species of museum in the form of an old Russian *terem* (palace), to which would later be added the New Museum (1897–98), linked to the earlier structure by an underground passage.

From 1895, Piotr Shchukin opened his private museum (ill.289 and 290) to scholars and connoisseurs of antiquities. It was here that Vasily Surikov came to research his painting of the Russian Robin Hood, *Stepan Razin*, that Apollinary Vasnetsov came to explore the maps of old Moscow, and that Valentin Serov came to study Persian miniatures. As the bibliophile Udo Ivask recalled, "In private, Shchukin, was a good, ordinary Russian, who, at times fixed by him, offered a warm welcome to all those eager to see his rich collections."

Anxious to keep together the hundreds of thousands of objects that made up his collections, Piotr Shchukin decided to present them to the Museum of the History of Moscow. In 1905. Accordingly, a sign went up on the pediment of his house on Malaia Gruzinskaia Street: "Branch of the Alexander III Imperial Museum of the History of Russia / Museum of Piotr Ivanovich Shchukin." With this gift Shchukin earned the title "Councillor of State," the equivalent of a general in the civil hierarchy of Russia. How could the son of a merchant not be flattered? As Pavel Buryshkin recalled: "I remember him very well; more than once he conducted me round his museum. He loved to put on the uniform coat of the Ministry of

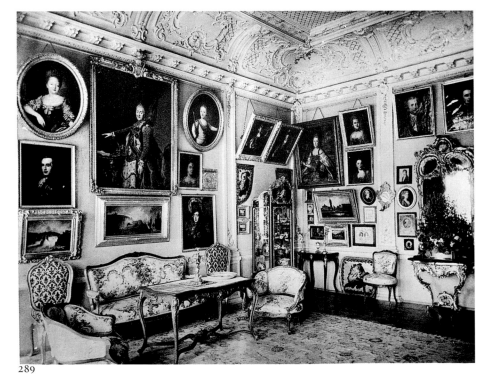

289

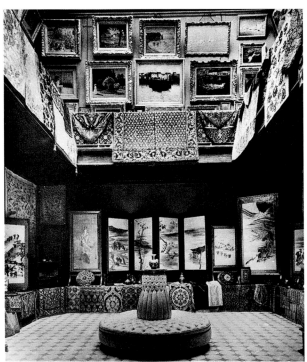

290

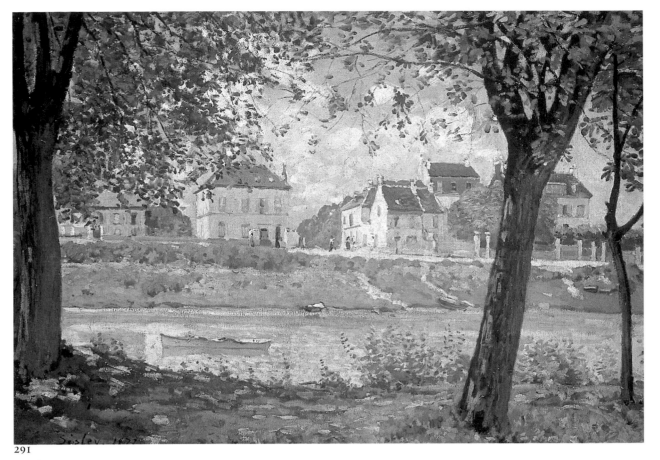

291

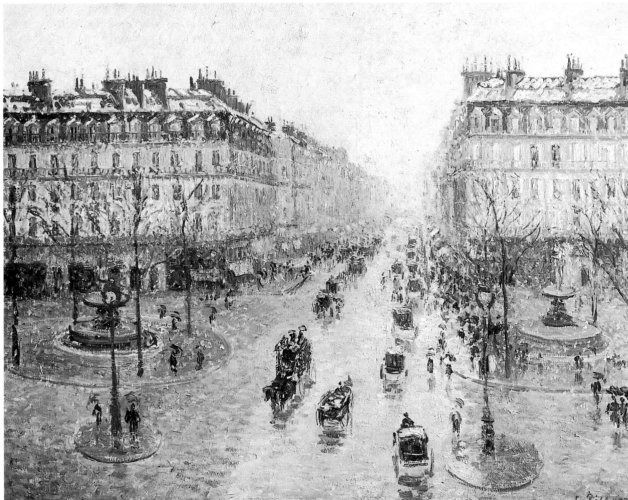

292

291. Alfred Sisley
Villeneuve-la-Garenne-sur-Seine, 1878
Oil on canvas,
59 x 80.5 cm
Hermitage, St. Petersburg

292. Camille Pissarro
The Place-du-Théâtre-Français in Paris, 1898
Oil on canvas,
65.5 x 81.5 cm
Hermitage, St. Petersburg

Amid the eclectic profusion of Piotr Shchukin's collections (including a dazzling array of portraits, parchments, ceramics, icons, silver, liturgical decorations, embroideries and rugs from China, India, Persia, Russia and Europe), his Impressionist paintings (ill.291 and 292) appeared almost incongruous. His first taste of Impressionism had come through his brother Ivan, who lived in Paris and who had introduced him to the famous dealer Paul Durand-Ruel. These paintings testify both to the breadth of his vision and to his desire for an encyclopedic understanding of art that he strove to share with his contemporaries.

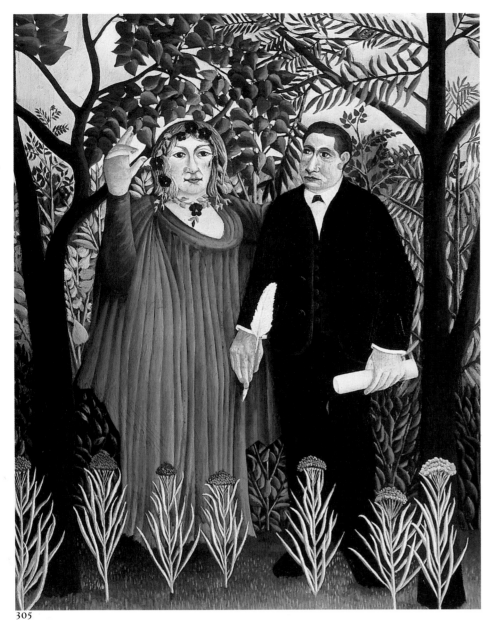

305

305. Henri Rousseau
*The Muse Inspiring the Poet
(Portrait of Guillaume
Apollinaire and Marie
Laurencin)*, 1909
Oil on canvas,
131 x 97 cm
Pushkin Museum of
Fine Arts, Moscow

306. Kees van Dongen
Woman in a Black Hat,
c. 1908
Oil on canvas,
100 x 81 cm
Hermitage, St. Petersburg

other canvases from the Tahiti cycle (ill. 304), largely those that were exceptionally beautiful, and hung them on the walls of his dining room in the Trubetskoi Palace. Yakov Tugenhold described the display in the journal *Apollo*: "The canvases are hung so close together, edge to edge, that, at first, one does not even notice where one picture ends and the next begins; it is like standing before a great fresco, an iconostasis."

The artist Martiros Saryan observed: "It was said that when he went to Paris to buy pictures, painters hid their most successful works because, with his sharp eye, Shchukin always chose the best." And the collector himself urged his daughter Ekaterina: "If you feel a psychological shock in front of a painting, buy it without further ado."

In addition to Durand-Ruel, it was inevitable that Shchukin should come into contact with another great champion of modern art, Ambroise Vollard, who from his gallery on Rue Laffitte had sold numerous avant-garde paintings to other pioneering collectors, this

time Americans such as the Havemeyers and Alfred Barnes. Shchukin also maintained close relations with Daniel Henry Kahnweiller, a young German dealer and follower of Vollard who had set up his business in Paris, and from whom Shchukin bought *The Muse Inspiring the Poet* by Rousseau (ill. 305) and *Woman in a Black Hat* by Kees van Dongen (ill. 306). Kahnweiller's claim to fame, meanwhile, lay in his unconditional support for the early Cubists, Picasso and Braque.

From 1905 to 1914, unlike Matisse and the Fauvists who exhibited their work at the Salons, Picasso refused to have his work shown in Paris, a decision in which he was encouraged by Kahnweiller, who kept only a few of his works on display and the rest in his reserve. It was thus in private collections (belonging to foreign expatriates for the most part) that the majority of Picasso's work could be seen : at the homes of the German Wilhelm Uhde, the Americans Gertrude Stein and her brothers Leo and Michael, or their compatriots from Baltimore Etta and Claribel Stone.

Shchukin had met Stein through Vollard, and their first encounter must have been an amusing one: on the one side the Russian connoisseur, shy and rather formal, accustomed to life in the vast Trubetskoi Palace in Moscow, waited upon by an army of servants, and on the other the Stein brothers and sister, the ultimate bohemians, as described by Apollinaire: "Their bare feet shot in sandals Delphic, they raise toward heaven their brows scientific." Shchukin quickly succumbed to the talents of their many artist and poet friends, including Georges Braque, André Derain, Georges Rouault, Marie Laurençin, and Emil Nadelman.

Unquestionably, however, it was in the art of Henri Matisse that Shchukin found one of his grandest and most enduring passions. Matisse himself recalled how it all began. After looking at a still life on the artist's studio wall, the collector turned to him and said: "I'll buy it, but I must first have it at home for several days, and if I can live with it, and if it still interests me, I'll keep it." The artist added that he had the good fortune to pass that first test, after which Shchukin commissioned a series of paintings from him for his Moscow palace. Having been captivated by *Joie de vivre* and the sketch for *Music* in 1908, he gave Matisse a commission for two large panels, *Dance* (ill. 307) and *Music* (Hermitage), for the staircase of the Trubetskoi Palace. When Matisse's nudes caused a scandal at the Salon of 1910, Shchukin wrote to Matisse revoking the commission, explaining that nude figures were scarcely decent. Immediately after, however, he reversed his decision: "I find your panel *Dance* to be of such nobility that I have resolved to brave our *bourgeoisie*'s opinion and hang on my staircase a subject with nudes."

One of Shchukin's guests reported that, after whisking his visitors through the rooms given over to nineteenth-century painters, the collector would guide

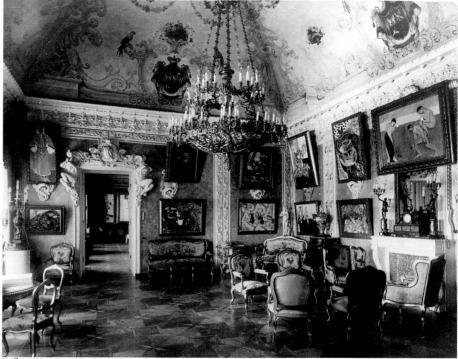

308

them toward the Matisse room. There "the master of the house lit up, his eyes glittering while he impatiently pointed to one painting and then another, all the while exhorting them: 'Don't look at them as paintings but as a porcelain dish or a faïence tile. It is a decorative panel, here to delight the eye! Is it not remarkable? Is it not splendid? What subtle combinations of colors, what taste, what daring! . . . For me Matisse is the best, the greatest, and the most immediate of all.'

'Come here, over here!' then exclaimed the Muscovite merchant with greying hair, setting off at a run through several rooms. We followed him. He threw open a large door giving on to an internal staircase, then retreated deep into a room lost in shadows. — 'Look! It's from here, from the darkness that you must look!' We saw the Matisse panels hanging above the stairs. On an infinitely green earth, under a sky of dazzling blue, human figures in vivid, brick red, naked, danced in a circle while holding hands. — 'But look, for heaven's sake!' cried the owner as if possessed. 'What colors! The whole staircase is lit up by this panel. Don't you see, don't you agree? '"

Although he already possessed some of his works, Shchukin did not meet Matisse until after the Salon des Indépendants of 1905 and the furious scandal provoked by *Luxe, calme et volupté*. At the Steins' apartment in 1906 he saw *Joie de vivre* (the inspiration for *Dance* of 1909; ill.307) again, followed in 1907 by the sketch for *Music*. The following year he bought *Game of Boules*, visible above the fireplace in his Moscow salon (ill.308). The hanging scheme for the twenty-one paintings by Matisse in this room (of thirty-eight in all) was devised by the artist himself when he came to oversee the installation of the of the two immense panels of *Dance* and *Music* on the main stair in 1911.

307. Henri Matisse
Dance, 1910
Oil on canvas,
260 x 391 cm
Hermitage, St. Petersburg

308. The Matisse room in
Sergei Shchukin's residence
in Moscow, c. 1913

307

309. The Picasso room in Sergei Shchukin's Moscow residence, c. 1914

310. Pablo Picasso
The Absinthe Drinker, 1901
Oil on canvas, 73 x 54 cm
Hermitage, St. Petersburg

311. Pablo Picasso
Old Jewish Man with Boy, 1903
Oil on canvas, 125 x 92 cm
Pushkin Museum of Fine Arts, Moscow

It was partly through his links with the American collectors Leo and Gertrude Stein that Sergei Shchukin came into direct contact with contemporary artists of the avant-garde. The salon of the Steins' Paris apartment at 23 rue de Fleurus was a meeting place for intellectuals and connoisseurs, and it was there that the Russian collector saw the first Picasso bought by Leo Stein from Clovis Sagot in 1905.

From that moment he decided to follow the artist's career and development closely, starting with numerous paintings from the Blue and Pink periods (ill.311). Also visible in a contemporary photograph of the Picasso room in Shchukin's residence (ill.309) are *The Absinthe Drinker* (ill.310; above the settee in the photograph), the portrait of Jaime Sabartès (or *The Beer Glass*), painted in 1901 (in the middle of the photograph), and one of the collector's Rousseau paintings (ill.305; top right in the photograph).

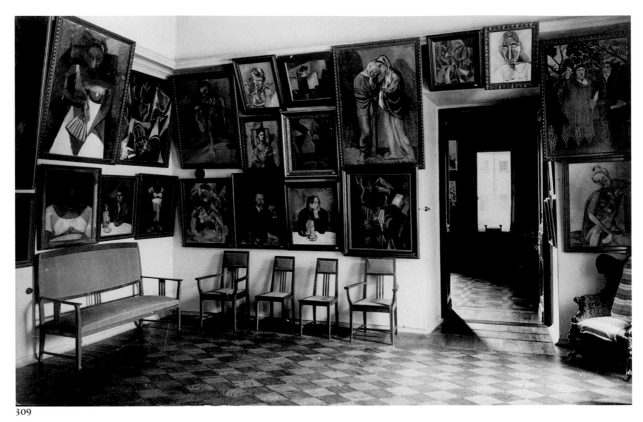

309

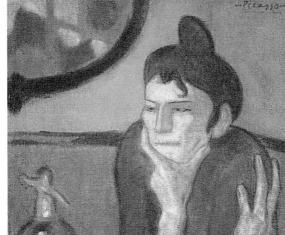

310

In the autumn of 1911, Matisse arrived in Moscow as Shchukin's guest. A foreign correspondent reported the event under the headline: "In Russia among the barbarians." The French painter found little to enthuse about at the Tretyakov Gallery in Moscow, and could not leave the Russian Museum in St. Petersburg fast enough. Icons, by contrast, he loved: "The Russians have no idea what artistic treasures they possess. I know the religious art of a number of countries, but nowhere have I seen such a revelation of mystical feeling, sometimes even of religious terror. . . . One must come here to learn."

Matisse proceeded to rehang his paintings in the Shchukin residence. By now there were twenty-five of them, some with themes suggested by the collector himself. Meanwhile, the presence of the French master had a profound effect upon Shchukin and the development of his taste. Immediately on returning to Paris he wrote to Matisse: "Your paintings give me great joy. I look at them every day, and I love them all." And in another note: "I have complete confidence in you. The public is against you, but the future is yours. . . . It is said that I do wrong to Russia and Russian youth in buying your pictures. One day I hope to prevail, but it will need some years of struggle."

It was at the Steins, once again, that Matisse first encountered Picasso, before they exchanged paintings. Matisse later took Shchukin to Picasso's studio at the Bateau-Lavoir, where the collector bought *Woman with a Fan*. He was to be a faithful supporter of the artist through good times and bad (though he never did appreciate *Les Demoiselles d'Avignon*), creating a unique collection of his work in Russia which would provide inspiration for the Russian avant-garde. From 1909 indeed, Shchukin opened his collections to the general public. Immediately, a flurry of professors from the School of Painting, Sculpture and Architecture sounded the alarm: "The contagion of modernism is now penetrating every class, even Serov's studio!" This

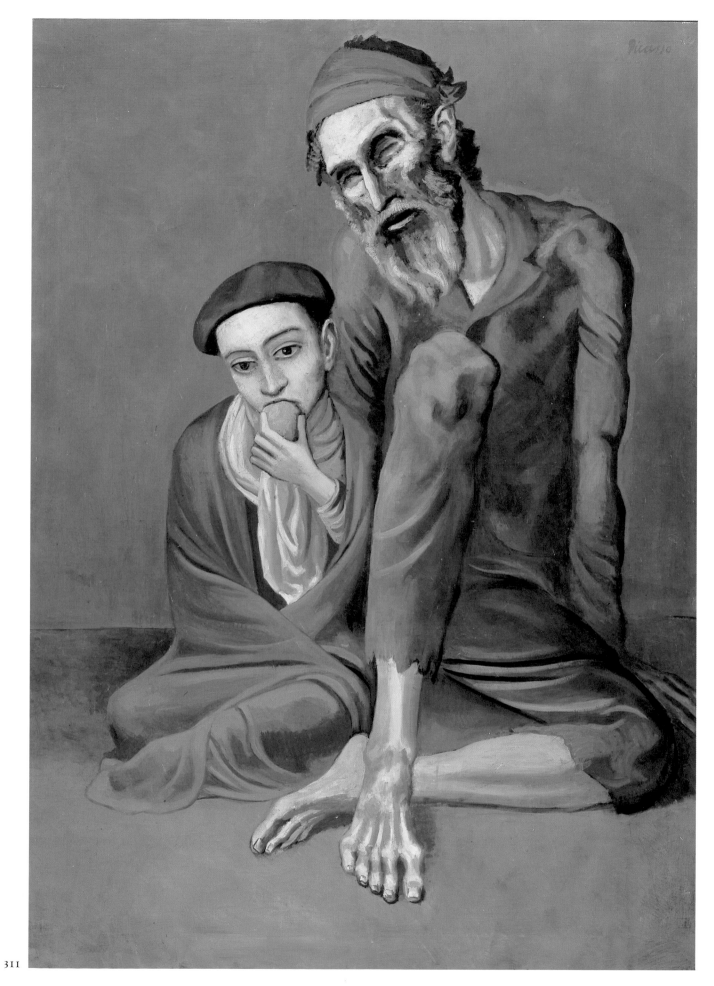

311

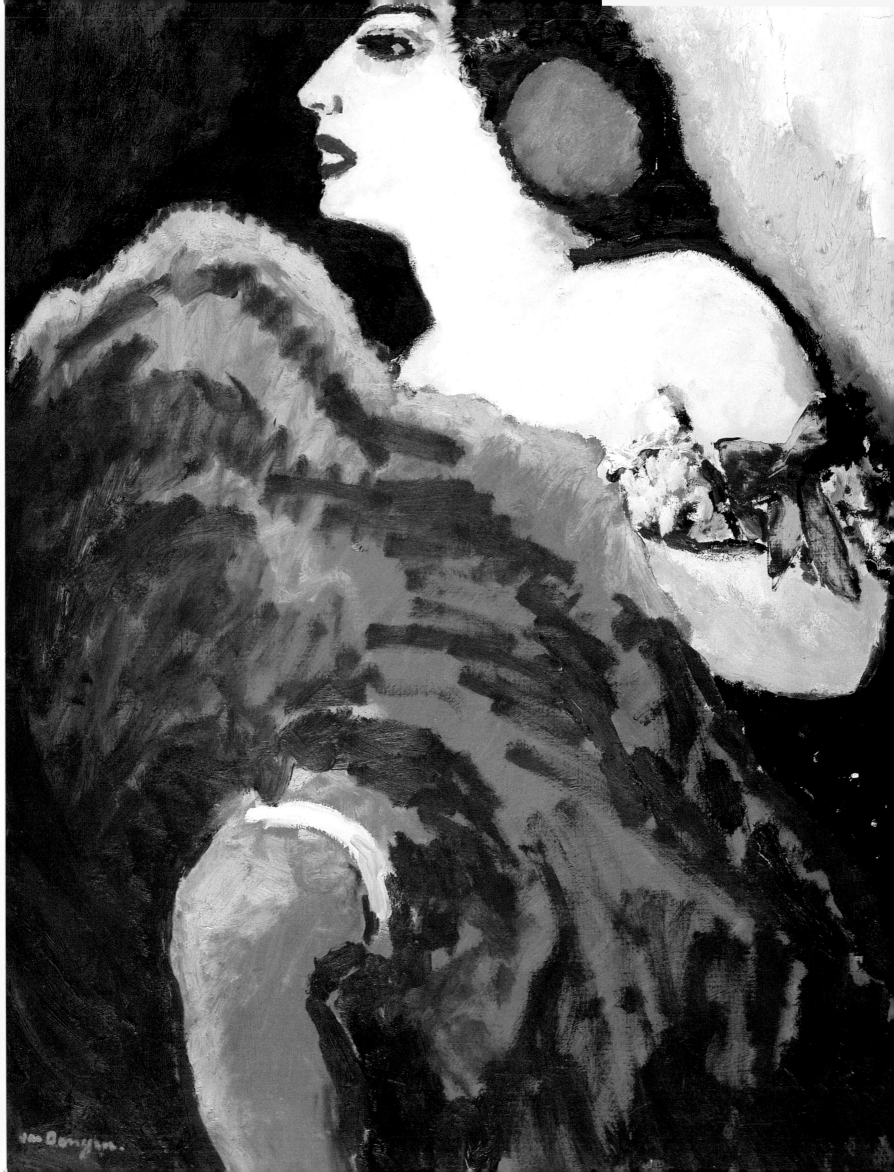

The Ryabushinskys

Mikhail 1880 - 1960

Nikolai 1877 - 1951

Stepan 1874 - 1942

Evfimia Nossova 1881 - 1960

Mikhail Pavlovich Ryabushinsky (ill.315), born into a family of well-known textile merchants and manufacturers, graduated from the Academy of Commercial Sciences in Moscow, as did his seven brothers (he also had five sisters). Mikhail then joined the family business—Ryabushinsky Brothers, Banking House—where he took charge of financial operations before becoming a director in 1902.

Like his older brothers had done earlier, Mikhail Ryabushinsky developed an appetite for art and underwrote exhibitions. In the first years of the twentieth century he began forming his own collection, which by 1909 boasted as many as one hundred Russian and foreign paintings. This was the year in which he purchased from the widow of Savva Morozov their mansion on Spiridonovka Street, preserving the frescoes that Vrubel had executed for them. In 1912 the collector acquired a group of fine panels by Konstantin Bogaievsky and hung them in the grand salon.

Mikhail also owned canvases by Dmitry Levitsky and Vasily Tropinin, but what he truly favored, according to the painter Valentin Serov, were works of the young artists of his time. In this he followed the example of Pavel Tretyakov, and once he had made his collection, he, too, announced in the press his desire to leave it to the city of Moscow in the future.

Mikhail Ryabushinsky bought not only works by contemporary Russian painters—including Serov, Vrubel, Golovin, Saryan, and Somov—but also paintings by European artists, such as Degas, Pissarro, and Zuloaga. Moreover, he owned watercolors on Chinese and Japanese silk, oriental carvings, and porcelain. Sculpture as well caught his eye, most especially pieces by Pavel Trubetskoi, Anna Golubkina, and Dmitry Stelletsky. The jewel of the collection, however, was a marble bust of Victor Hugo by Auguste Rodin (Pushkin Museum, ill.318). In 1901, after deciding to acquire the portrait, Mikhail obtained from the Parisian dealer a certificate of authenticity. In it the original owner declared that the bust had been a gift to him from his friend Rodin, who had executed it in his

315

presence and that of Victor Hugo himself, around 1882 or 1883, and that it was the last portrait bust made of the great French writer, and supposedly the best likeness. The Hugo marble stood in the hall of the mansion of Spiridonovka Street.

In 1917 Mikhail temporarily consigned a small part of his collections—twenty-five pictures and ten watercolors—to the Tretyakov Gallery before emigrating abroad. Seven years later, the Russian émigré press announced the discovery of the "Ryabushinsky treasure." What had been chanced upon was a secret hiding place in the mansion of Spiridonovka Street, an *oubliette* stuffed with forty canvases, eighty watercolors, numerous *objets d'art*, and the marble bust of Victor Hugo. By this time the owner was living in London and the rediscovered masterpieces were immediately incorporated into Soviet state collections. Today they are parceled out among the Tretyakov Gallery, the Pushkin Museum of Fine Arts, the Hermitage, the Saratov Museum, and the Museum of Russian Art in Kiev.

314. Kees van Dongen
Red Dancer, c. 1907
Oil on canvas, 99 x 80 cm
Hermitage, St. Petersburg

315. Mikhail Ryabushinsky, c. 1900

The Ryabushinsky family played a more prominent role in the official life of Moscow even than the Morozov or Shchukin dynasties. Pavel, the eldest of thirteen siblings, was editor of the Moscow equivalent of the *Wall Street Journal* and a member of the stock market and of the council of state for commerce; Vladimir was administrator of the Moscow Bank and a member of the Duma (municipal council); and Dmitry was a professor of aerodynamics and a corresponding member of the Académie des Sciences in Paris.
Mikhail (ill.315, above), one of the three brothers to form art collections, had no preference for any particular period or schools, acquiring works ranging from the Russian school of the eighteenth, nineteenth, and twentieth centuries to the Paris avant-garde.

14

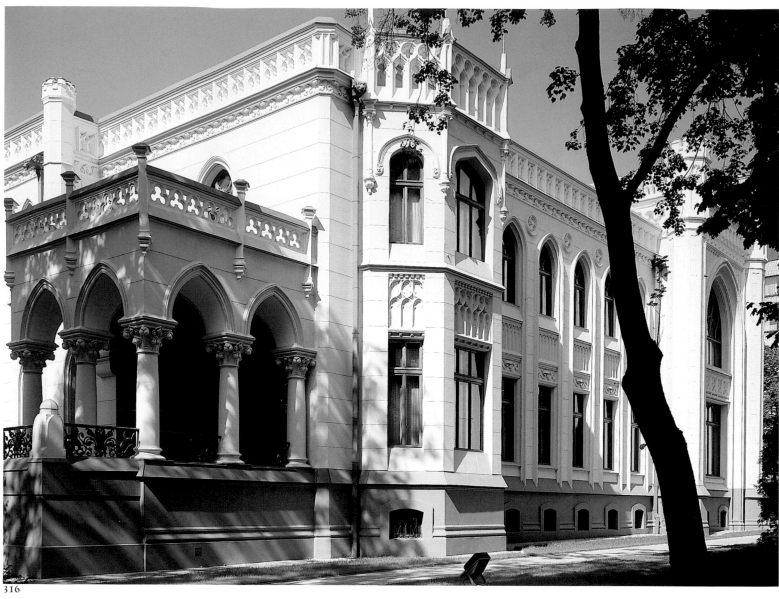

316

316. Mikhail Ryabushinsky's residence in Moscow

Mikhail Ryabushinsky's residence on Spiridonovka street in Moscow (ill. 316) was a typical example of a wealthy bourgeois dwelling in the old capital, highly eclectic in style.

Nikolai Ryabushinsky (ill. 321), like his brother Mikhail, graduated from the Academy of Commercial Sciences in Moscow; afterward, however, he took a very different path, having decided not to follow his brothers into the family enterprise. He sold his shares in the Ryabushinsky Bank after the death of his father in 1899 so as to devote himself to art and literature. Thanks to this, Nikolai found himself an object of ridicule within his own family, whose members called him "Nikolai the Naughty" or "Lorenzo the Magnificent," among other ironic appelations. More flattering, however, were the views of the painter and critic Alexander Benois, who wrote: "I could not but feel sympathy and a kind of respect for the merchant-Maecenas, who was making a serious effort to escape a condition imposed upon him by his class, his milieu, his education, and to enter a 'spiritual zone' that he imagined as more sublime and radiant."

Following the example set by *Mir Iskusstva* (World of Art), Nikolai Ryabushinsky launched *Zolotoie Runo* (Golden Fleece), a review that, from 1906 to 1909,

brought together the leading lights of Russian Symbolism, as well as the painters of the Blue Rose group: Martiros Saryan, Pavel Kuznetsov, Sergei Sudeykin, and Nikolai Sapunov. And although Benois had been sympathetic to Nikolai, he wrote about him to close friends in uncomplimentary terms, concerning the publisher's desire to run *Zolotoie Runo* himself. "Unfortunately," wrote Benois, "there is such a vacuum here that even this bloated mollusk could pass for a fish. . . . Is this the kind of guide we need, we dream of. What a sad outcome, indeed. Why couldn't we have had our Tretyakov, or even our Mamontov? So be it, we're going to collaborate with the *Golden Fleece*. We're going to dance around the golden calf. We're going to exhibit in Paris, at Ryabushinsky's brothel: that's how it goes." Clearly, despite his acerbic tone, articulated in a letter to Konstantin Somov, Benois agreed to collaborate with Ryabushinsky.

Nikolai ordered an extravagant residence built for himself on Petrovsky Park, then on the outskirts of Moscow but today within the city limits. Calling it the

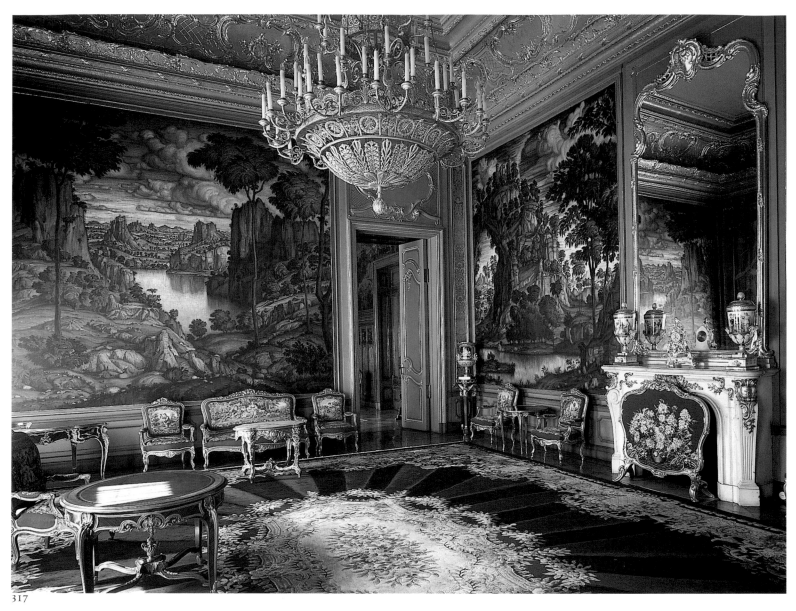

317

318

Black Swan (ill.322, 323), he turned the place into a magnet for bohemia where, according to rumor, he also organized "Athenian nights with nude actresses." At the entrance to the garden Nikolai the Naughty had placed a marble sarcophagus crowned with a bronze bull, which he hoped would be his tomb.

Nikolai Ryabushinsky was nothing if not ambitious in his projects, especially his scheme for erecting a "palace of the arts" in Moscow, a grandiose edifice meant to house a museum and a permanent exhibition of modern Russian art, as well as an auction room. It was all to be managed by a publicly held corporation. Where Nikolai truly succeeded, however, was in making himself famous within literary and artistic circles. As an editor and publisher, he was even received by Tsar Nicholas II, who expressed interest in *Zolotoie Runo*. In return, Nikolai presented the monarch with the first nine issues of the review, bound with a cover of his own design. Nikolai was the only Ryabushinky brother whose portrait appeared in an album of photographs entitled *Modern Russia in Portraits and Biographies* (1907),

317. The drawing room in Mikhail Ryabushinsky's residence in Moscow

318. Auguste Rodin *Victor Hugo*, c. 1883 Marble; height: 55 cm Pushkin Museum of Fine Arts, Moscow

According to tradition, the Rodin bust of Victor Hugo bought by Mikhail Ryabushinsky in 1901 (ill.318) was the last likeness of the writer to be taken during his lifetime.

235

319. Ignacio Zuloaga
The Dwarf Gregorio
Oil on canvas,
187 x 154 cm
Hermitage, St. Petersburg

320. Camille Pissarro
Boulevard Montmartre, Paris,
1897
Oil on canvas, 73 x 92 cm
Hermitage, St. Petersburg

The most flamboyant of the Ryabushinskys was beyond any question Nikolai (ill.321), whose personal extravagance and rash ventures were the talk of Moscow. In 1906 he founded *Zolotoie Runo* (Golden Fleece), an art journal which to some extent replaced *Mir Iskusstva* (World of Art), but at the same time claimed to be more intuitive and mystical in its approach. Citing Giotto, Shakespeare, and Bach as its inspiration, it laid great stress on the relationship between realist symbolism and the religious experience. It also organized art exhibitions featuring many of the artists who had contributed to *Mir Iskusstva*, as well as the Symbolist painters who in 1907 had formed the progressive Blue Rose côterie under the leadership of Pavel Kusnetsov.
Nikolai Ryabushinsky was not slow to take advantage of the prestige and media attention to be gained from featuring the fabulous private collections of Moscow, devoting one issue almost exclusively to the collection of Piotr Shchukin. In addition to old master paintings, his collection included contemporary works by French and Russian artists (ill.324 and 325), like that of his brother Mikhail (ill.319 and 320).

319

an honor accorded neither to Shchukin nor to Morozov. Moreover, when the critic Kornei Tchukovsky wrote of Pavel Ryabushinsky (the eldest of the seven brothers, and a millionnaire too) in his well-known newspaper, he made a point of calling him the "brother of the *Golden Fleece*." A few years earlier, who would have imagined that even the head of this powerful clan of industrialists would be identified by his relationship to his brother, the "naughty Nikolai"?

As a collector, Nikolai was interested in paintings both old and new. On the one hand, he bought works by Lucas Cranach, Jan Bruegel, and Nicolas Poussin, while on the other he acquired Kees van Dongen's *Red Dancer* (ill.314) and *Women* by Georges Rouault whose work Nikolai was the first Russian to own. After the Blue Rose exhibition closed in 1907, he purchased a number of pictures by Piotr Utkin, Sergei Sudeikin, Nikolai Sapunov, Martiros Saryan, and Pavel Kuznetsov.

By the end of 1909 Nikolai Ryabushinsky had gone bankrupt. In 1911 he was obliged to auction off a good part of his collection, primarily old masters, and sold his small collection of icons to Alexei Morozov. In the judgment of Pavel Buryshkin, "Nikolasha (as he was called in Moscow) was not considered serious, but he proved to be more clever than his brothers. Having thrown his fortune away before the revolution, he did not have to suffer from the latter." Having settled in Paris after the Revolution, he opened an Antique shop there. The remainder of his collection, which went to his brother Mikhail, would wind up in the state museums, divided among the Hermitage, the Pushkin Museum of Fine Arts, and the Tretyakov Gallery.

320

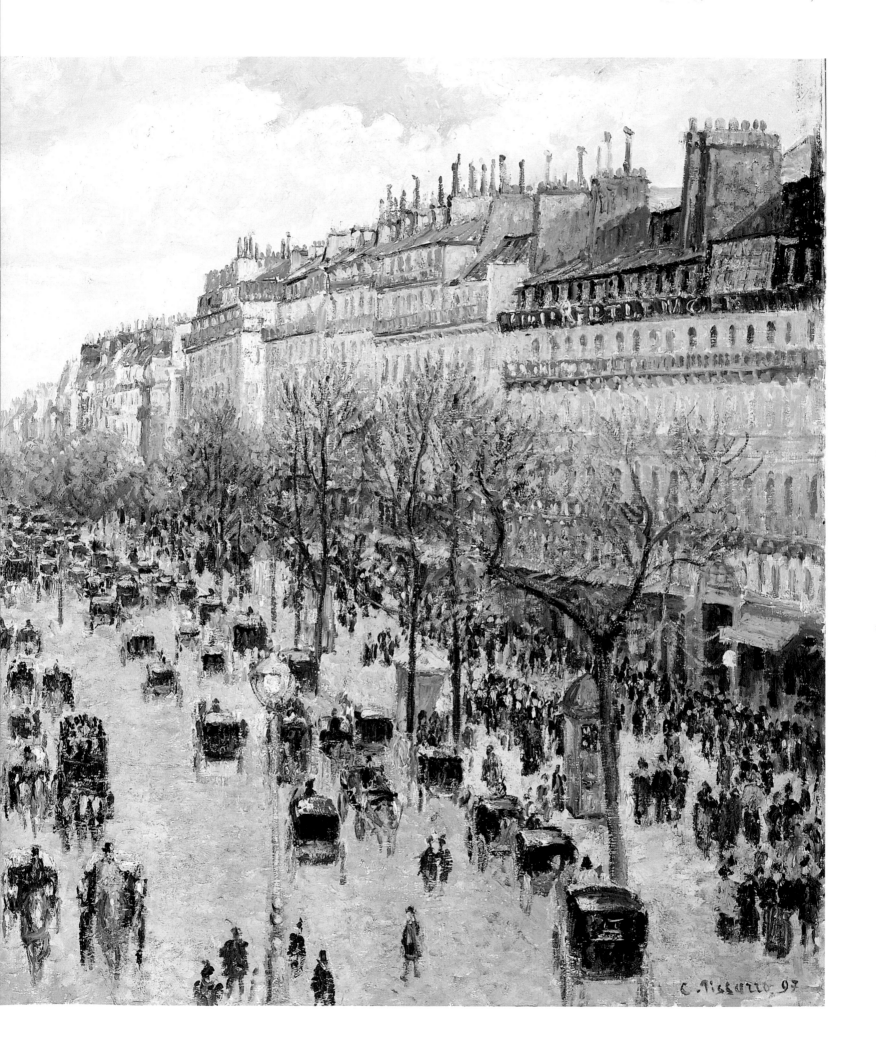

C. Pissarro, 97

321. Nikolai Ryabushinsky, c. 1890

322 and **323.** The study and entrance hall of the "Black Swan," Nikolai Ryabushinsky's residence, built in the Petrovsky Park in Moscow by the architects V. M. Mayat and V. D. Adamovich, c. 1910

324. Boris Kustodiev *The Japanese Doll*, 1908 Board, tempera, colored pencil; 73.7 x 86.2 cm Tretyakov Gallery, Moscow

325. Alexander Benois *Pyramid at Versailles, May, 1906* Paper glued on board, watercolor, pencil; 67.2 x 99.5 cm Tretyakov Gallery, Moscow

Relatively sober on the outside, Nikolai Ryabushinsky's residence, known as the "Black Swan," was a riot of Russian Art Nouveau style within, rendered all the more exotic by the acquisitions and lifestyle of the collector himself, who was fond of perfuming the air with incense. Numerous paintings by Russian artists rubbed shoulders here with works of the Paris avant-garde, including two Rouault compositions of 1907 and *Red Dancer* by van Dongen (ill. 314).

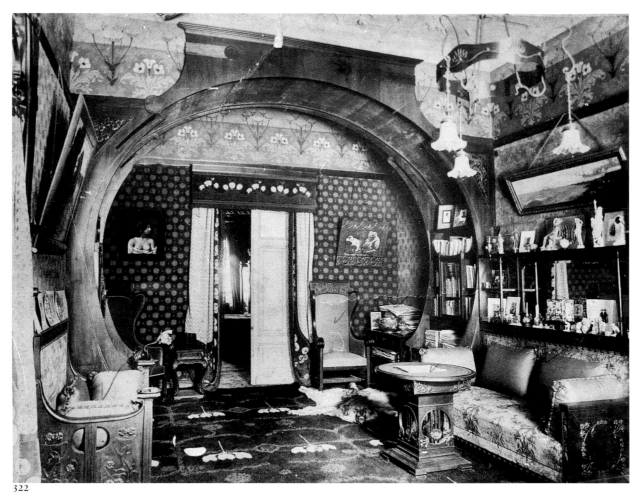

322

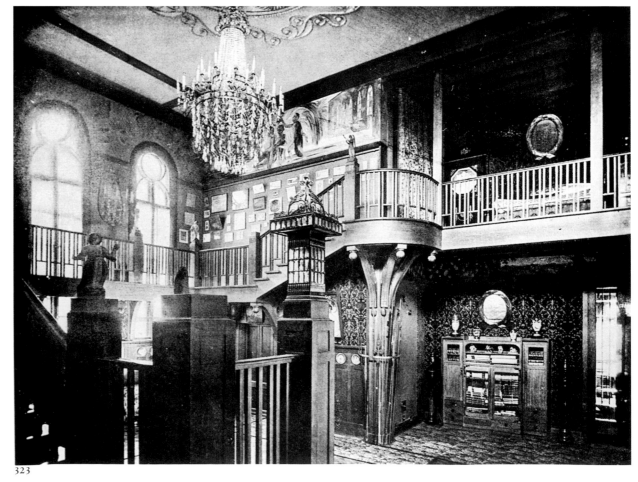

323

238

Nikolai's brother, Stepan Ryabushinsky (ill.327), also studied at the Moscow Academy of Commercial Sciences. After the death of his father, he took charge of the Ryabushinsky manufacturing operations and around the age of thirty he began to amass icons. Unlike other collectors among the Old Believers (whose ranks included the Ryabushinskys), Stepan regarded icons less as cult objects than as works of art. He acquired his first icon only in 1905, but by the time World War I broke out he owned one of the finest collections in Moscow, matched only by the holdings of Ilya Ostroukhov and Alexei Morozov. Profoundly religious, Stepan did not use icons to decorate either his office or his salon; rather, he hung them on the walls of the family chapel. He was also a pioneer among collectors in having his icons restored, even installing a workshop in his home, for which he employed Alexei Tyulin, a leading Russian restorer.

In St. Petersburg in 1911 and 1912, Stepan Ryabushinsky organized an exhibition of old Russian icons, followed in 1913 by a show of old Russian art. Mounted on the occasion of the tercentenary of the Romanov dynasty, the show brought together two hundred objects from the sponsor's own collection. Stepan, like Ilya Ostroukhov, became a forerunner in the scientific study of icons and his related work and publications brought him honorary membership in Moscow's Institute of Archeology. In 1914, the Moscow newspapers carried this announcement: "The eminent collector S. P. Ryabushinsky is preparing to create a museum of Russian icon painting, in which the precious icons of his collection will play a role. . . , in particular a series of icons recently acquired by him." The project fell through after war broke out in August 1914. In his luxurious residence on Malaia Nikitskaia Street which would later house the Maxim Gorky House-Museum (ill.326 and 328) on the second floor, the architect Feodor Shekhtel had installed a chapel for the display of the celebrated icons.

Stepan emigrated in 1917, leaving his collection to be taken over by the state and between 1924 and 1928 it was parceled to various museums. The most beautiful icons—fifty-four in all—went to the Tretyakov Gallery, while others wound up in museums in Perm and Kuban or were sold abroad. While in exile, Stepan and his brothers founded "Icon", a society that still fosters the study and dissemination of old Russian art.

Evfimia Nossova, *née* Ryabushinskaia, could easily hold her own with "Nikolai the Naughty" when it came to extravagance and an irrepressible desire to astonish all Moscow. It was in memory of her grandmother that she had been christened Evfimia (Euphemia), a name in vogue among the Old Believers, which, however, in no way kept her from becoming the most emancipated woman in the Ryabushinsky clan.

This young woman, full of caprice and vanity, succeeded in seducing Vasily Nossov, son of Russia's

"cloth baron." Nossov's father, as well as the entire Nossov family, opposed the marriage, but Vasily insisted, and so Evfimia came to reign over the Nossov household on Vvedensky (now Yuravlev) Square. She immediately set about modernizing this nest of merchants, still faithful to the Old Testament, who soon found their domestic environment transformed into what all Moscow called the "palace of Cosimo de' Medici." Valentin Serov, commissioned to paint frescoes on the walls and ceilings, produced twenty-nine sketches for the murals in the dining room on the theme of Diana and Acteon. These were finished by Nikolai Sapunov and Sergei Sudeikin, both friends of Nikolai Ryabushinsky. The walls would also be adorned with numerous portraits of Evfimia, painted by

Just as Diaghilev had mounted an exhibition of artists associated with *Mir Iskusstva* (World of Art) in St. Petersburg in 1899, including works by Monet, Degas, and Puvis de Chavannes, so in 1908 Nikolai Ryabushinsky organized the *Zolotoie Runo* (Golden Fleece) salon, at which he exhibited works by members of the Blue Rose group with 197 paintings by Pissaro, Redon, Vuillard, Degas, van Dongen, Bonnard, Cézanne, Braque, Marquet, Gauguin, van Gogh, and Matisse.

324

325

326. Stepan Ryabushinsky's residence on Malaia Nikitskaia in Moscow

327. Stepan Ryabushinsky, c. 1900

328. The staircase of Stepan Ryabushinsky's residence in Moscow, designed by the architect Fedor Shekhtel

The third Ryabushinsky son to become a collector, Stepan (ill.327), was quite different from his brothers, sharing neither the glamour of their private lives nor their taste in art. His interest was confined exclusively to ancient and medieval Russian art, and most particularly to icons, in which he became one of the most knowledgeable specialists of his time. His house, meanwhile, was a unique example of Russian Art Nouveau architecture, designed by Feodor Shekhtel (ill.326 and 328).

326

Konstantin Somov (Tretyakov Gallery ; ill.331) and Alexander Golovin among others. In addition, there was to be a marble portrait bust carved by Anna Golubkina (Russian Museum).

Inevitably, perhaps, Evfimia caught the "collecting fever" then raging among Moscow's merchants, which in her case manifested itself in a passion for old Russian portraits. Many a masterpiece of the genre now adorning the rooms in the Tretyakov Gallery came from their collection—works by Rokotov, Borovikovsky, Kiprensky, and the like. Contemporaries would recall her as an "energetic collector, the mistress of a fashionable salon that drew the most prominent artists and writers."

Nikolai often figured among the guests at Evfimia's glittering, worldly soirées. As for her brothers Mikhail and Stepan, they inspired Nossova to follow their example and consider leaving her collection to the city of Moscow. According to the painter Mstislav Dobuzhinsky, who decorated the interiors of the Nossov residence (ill.332), "Evfimia hopes to make a gift of her house to the city after her death, and her dream is that the most remarkable Russian painters, those she likes, will come there and create something. In addition to the house, she plans to bequeath to Moscow her collection of pictures and thereby create a gallery."

327

32

329. Dmitry Levitsky
*Portrait of Countess Ursula
Mniszek,* 1782
Oil on canvas, 72 x 57 cm
Tretyakov Gallery, Moscow

330. Vladimir
Borovikovsky
*Portrait of Princess Margarita
Dolgorukova*
Oil on canvas,
85.7 x 66.2 cm
Tretyakov Gallery, Moscow

331. Konstantin Somov
Portrait of Evfimia Nossova,
1911
Oil on canvas,
138.5 x 88 cm
Tretyakov Gallery, Moscow

332. Mstislav Dobuzhinsky
Ceiling fresco of the grand
staircase in the Nossov's
second residence, built by
architect I. Zholtovsky

It would be false to
imagine that Muscovite
collectors were exclusively
men. One of the
Ryabushinsky daughters,
Evfimia Nossova, displayed
almost as much panache as
her brother Nikolai,
collecting Russian portraits
of the eighteenth and
nineteenth centuries
(ill.329 and 330) and
giving commissions to
numerous contemporary
artists, notably for her own
likenesses (ill.331) or the
decoration of her house
(ill.332).

Nossova's taste in art owed much to the painter
Konstantin Somov, who noted in his diary: "Today
[Evfimia] confessed to me that I had played a major
role in her life." Writing to his sister, Somov said as
well: "Today, at five o'clock, we received a visit from my
model, Nossova, who struck me as exceptionally inter-
esting [as a subject]. Blond and very slender, with a
pale face, proud and decidedly elegant, and possessed
moreover of excellent taste." Elsewhere Somov
declared that his model was coiffed and dressed in an
amazing way. It seems Evfimia was something of a
muse to the painter.

Nossova, like her brothers, emigrated after the
Revolution of 1917. Before departing, she deposited
the best pictures in her collection at the Tretyakov
Gallery and the Bakhrushin Theatrical Museum, whose
founder—her nephew Yuri Bakhrushin—had described
her as "a typical representative of Muscovite capital-
ism, drawn to cultural patronage." All of her holdings
were nationalized by decree and made the property of
the state. Today the Tretyakov Gallery owns sixteen
portraits from the Nossov residence (ill.329 and 330),
which, following the October Revolution, housed a
museum dedicated to the proletariat. At the moment,
the old mansion is host to the Museum of Local
History for Moscow's Pervomaisky district.

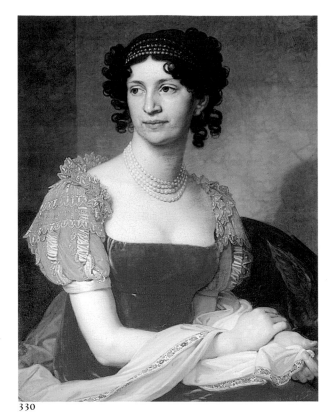
330

329

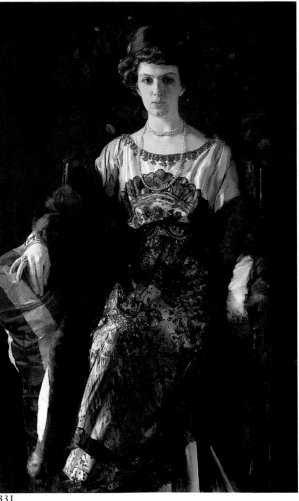
331

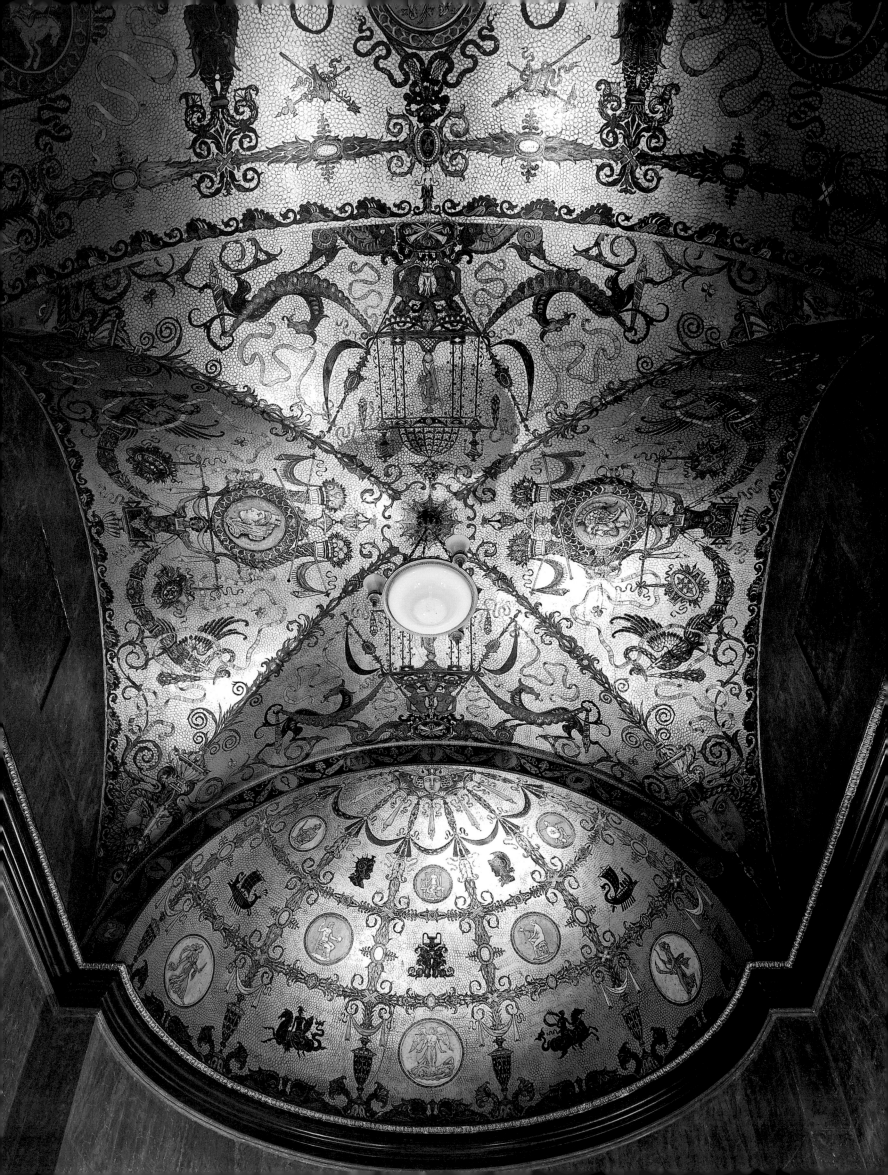

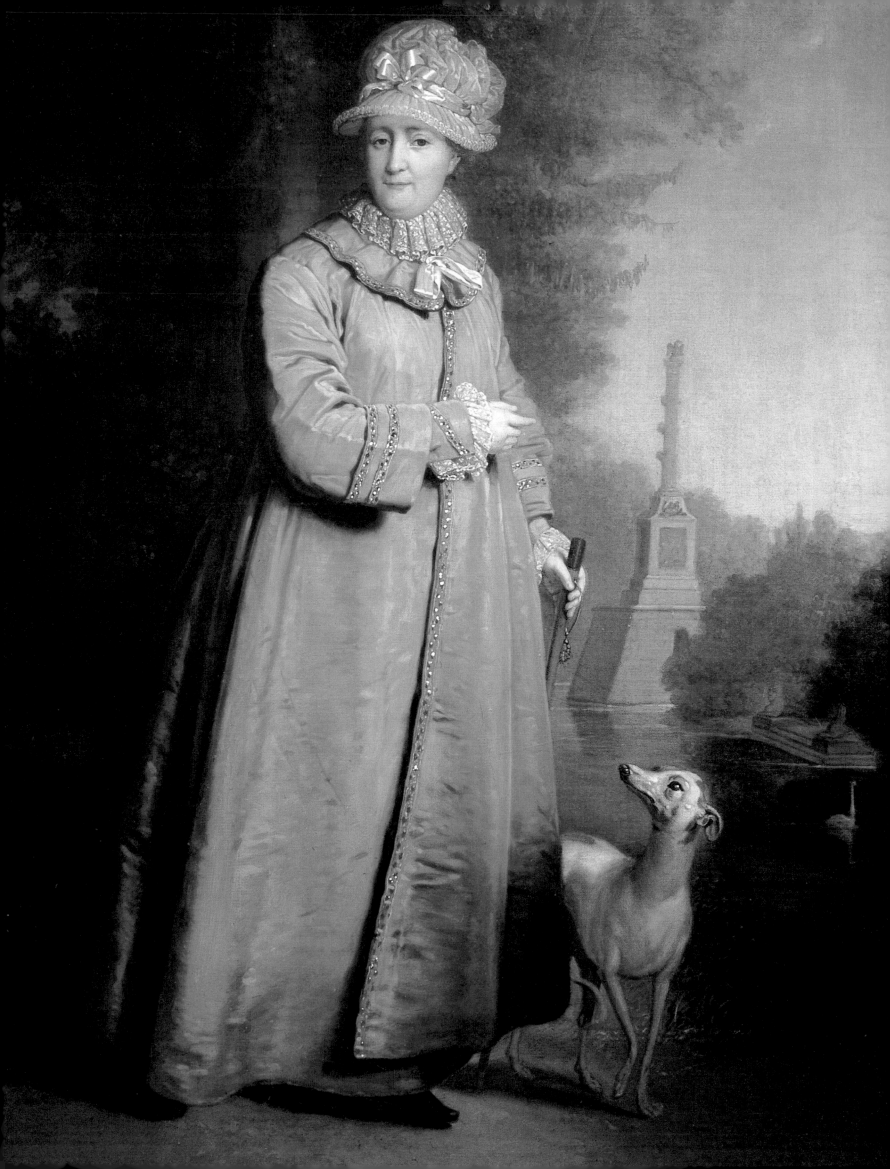

Pavel Kharitonenko
and Elena Olive

1880-1948

Pavel Kharitonenko (ill.334) grew up under a father, Ivan Kharitonenko, who had already discovered the pleasure of collecting pictures, thanks to his success as a sugar manufacturer in the city of Sumy. Among them were Alexei Bogolyubov's *Evening on the Banks of the Alassio* (1882) and Ilya Repin's *The Ukrainian Girl* (1892). Pavel, a powerful industrialist in his own right, became one of the richest men in Russia in the early years of the twentieth century, his fortune estimated at 60 million rubles. Known as the "sugar kings," the lucky Kharitonenkos also inspired a number of less flattering epithets, such as "thin mugs, fat pockets."

Like his father, Pavel conceived a life-long passion for art. He became a member of the Moscow Society of Art Lovers, as well as president of the Society of Friends of the Rumiantsev Museum and an honorary member of the Academy of Fine Arts, among other organizations.

Pavel collected icons and paintings, both Russian and European. Although fabulously rich, he liked to bargain with painters to get the best possible prices, a habit he shared with all the big Moscow industrialists. Mikhail Nesterov recalled an episode involving his cartoon entitled *Nativity*, prepared for frescoes in the Church of St. Vladimir of Kiev and then bought by Kharitonenko in 1901: "I made his acquaintance at my exhibition in Moscow, and it was later that, without haggling, he would pay me quite well, cash on the nail, for the canvases he had commissioned. Abroad, the Kharitonenkos bought from a Parisian antique dealer an old eighteenth-century Italian frame for my *Nativity*, which cost several times the ridiculous sum he had haggled me into accepting for my cartoon."

Pavel obtained some of his paintings from the Benckendorf collection in St. Petersburg as well as from Piotr Botkin's collection in Moscow. For the most part, however, he picked up things at the exhibitions and commissioned works directly from the painters in their studios, for example from Sergei Vinogradov.

From 1891 to 1893 Pavel Kharitonenko had a sumptuous mansion built directly opposite the Kremlin on St. Sophia Embankment on the River Moskva, a property subsequently occupied by the

334

335

333. Vladimir Borovikovsky
Catherine II Walking in the Gardens at Tsarskoie Selo, 1794
Oil on canvas, 95.5 x 66 cm
Tretyakov Gallery, Moscow

334. Valentin Serov
Portrait of Pavel Kharitonenko, 1901
Oil on canvas, 57 x 55 cm
Tretyakov Gallery, Moscow

335. François Flameng
Portrait of Vera Kharitonenko, 1893
Oil on panel, 45 x 36 cm
Hermitage, St. Petersburg

Any attempt to categorize Russian private collectors according to their favored school, period or country is not only doomed to failure, but also highlights one of the most intriguing features of the history of collecting in this country. In this respect, Pavel Kharitonenko (ill.334) and his wife Vera (ill.335) were no exceptions to the rule. Their collection was quite simply an expression of their personal tastes, unaffected by snobbery or fashion, by political implications or nationalistic sentiment, or by any prejudice toward either traditionalism or modernism.
Known as the "sugar kings," the couple used their immense fortune to acquire a range of works that was unusually broad in its scope, encompassing everything from icons to eighteenth- and nineteenth-century portraits and contemporary painting, both Russian and French, not forgetting a considerable collection of sculpture and the decorative arts.

336. Orest Kiprensky
Young Girl Wearing a Wreath of Poppies and Holding a Carnation, 1819
Oil on canvas,
42.5 x 40.9 cm
Tretyakov Gallery, Moscow

337. Ivan Aivazovsky
Wild Seas, 1868
Oil on canvas,
54.2 x 65 cm
Tretyakov Gallery, Moscow

The creation of the St. Petersburg Academy of Fine Arts by Count Shuvalov in 1757 laid the foundations for a genuinely Russian school of art. During the nineteenth century, Russian artists began to cast off the Western influence that had formerly been so strong, developing their own distinctive style and working on an imposing scale.

Ivan Aivazovsky, for example (ill.337), found considerable success with his impressive seascapes, redolent of the drama and high emotion that were prized by so many Russian collectors. Aivazovsky's success continued unabated throughout the second half of the nineteenth century and into the twentieth, with examples of his work being found in the collection of Nicholas I, in the private gallery of Vasily Kokorev (who possessed no fewer than twenty-three of them) and in the collection of Pavel Tretyakov, as well as in that of Kharitonenko and his wife just before the Revolution.

336

Ministry of Foreign Affairs and then by the British Embassy. The architect V. Zalessky drew up the plans, leaving the interiors to be designed by Feodor Shekhtel in the French Gothic style. The ballroom boasted a pair of landscapes by Hubert Robert and François Flameng decorated the ceiling over the painting gallery. In 1893 Flameng also painted a portrait of the owner's wife, Vera Kharitonenko, *née* Bakeieva (Hermitage; ill.335). In 1895 in Paris, the Kharitonenkos had their daughters Elena and Natalia portrayed by Charles Carolus-Duran. Pavel, in the course of his life, had also his portrait painted several times by Russian masters. One of them, Valentin Serov, turned his 1901 representation into a psychological study (ill.334). Later, in 1911, Malyavin portrayed Pavel with his son. Meanwhile, Pavel commissioned Nikolai Nevrev to make posthumous portraits of his parents (Tretyakov Gallery).

Pavel kept his collections in his mansion at least until 1913. when he had the architect Alexei Shchussiev build a church—St. Savior—on the Kharitonenkos's Natalievka estate in Kharkov province. Once the church had been completed, Pavel moved the religious and old works there, transforming St. Savior into a something of sanctuary for Russian art. The entire church, including the heating stove, was decorated with old faïence tiles.

The jewel of the Kharitonenko collection of Russian paintings was undoubtedly Ivan Kramskoi's *The Unknown Woman* (Tretyakov Gallery ; ill.342), a work viewed by contemporaries as a "scathing" critique of current reality. The female subject was seen as a "creature of the city" or even worse, "a courtesan in a carriage." Gradually, however, opinion evolved. Although Kramskoy refused to characterize the figure, others looked at her as the embodiment of Tolstoi's Anna Karenina. What one does sense is the artist's admiring involvement with his subject, her physical beauty tinted with a hint of arrogance.

337

338. Konstantin Somov
Portrait of Elena Olive, 1914
Oil on canvas,
106.5 x 89.6 cm
Tretyakov Gallery, Moscow

339. Konstantin Somov
Evening, 1900–1902
Oil on canvas,
142.3 x 205.3
Tretyakov Gallery, Moscow

When viewed in all its complexity, artistic life in Russia in the late nineteenth century and early twentieth century resists the obvious and all too easy temptation to reduce it to a twofold battle for influence: a geographical one between Moscow and St. Petersburg, and a stylistic one between modernism and classicism. In reality the debate is far more complex than this, as may be illustrated in part by the artists of the *Mir Iskusstva* (World of Art) group. With their passion for the traditional aesthetics, whether from the West or from their native Russian culture; for the theater, in which they took an active part; for books and publishing, to which they made an essential contribution; and above all for portraiture in all its forms, they represented an extraordinary variety of genres and styles. The work of an artist such as Konstantin Somov, with its restrained classicism expressed in a glowing palette (ill.338 and 339) and its nostalgic elegance referring back to the Age of Enlightenment, should not blind us to its roots in the medieval Russia of Bilibin, nor to its affinities with the seventeenth century of Alexander Benois, with the symbolism of Bakst and Roerich, and with the progressive stylistic tendencies of Golovin.

The Kharitonenko collection was strong in portraiture, dating from the eighteenth to the beginning of the twentieth century, with works by Stefano Torelli, Giovanni Battista Lampi, Joseph Grassy, Orest Kiprensky (ill.336), Domenico Scotti and Vasily Tropinin.

Pavel also bought the paintings of such contemporary artists as Vereshchagin (ill.340), Korovin, Malyavin, Repin, Surikov, Nesterov (ill.341), and Serov. Pavel owned Konstantin Somov's work in depth, including the remarkable canvas entitled *Evening* (Tretyakov Gallery; ill.339), and commissioned the artist to paint the portrait of his daughter Elena Olive (Tretyakov Gallery ; ill.338).

In all, the Kharitonenko collection held more than thirty works by Russian painters and more than sixty European canvases, including three by Hubert Robert (two of them still in his former house on St . Sophia embankment, the other one in the Pushkin Museum) and two by Camille Corot (*Hay Wagon* and *Belltower at Argenteuil,* Pushkin Museum). The greatest number of European works, however, came from the Barbizon School, including three paintings by Jules Dupré, two by Charles François Daubigny, and two by Narcisse Diaz de la Peña (Pushkin Museum). In 1903 Pavel had Albert Besnard paint another portrait of his two daughters (Pushkin Museum).

In 1899 Pavel Kharitonenko, the son of a sugar manufacturer from a Cossak village, was ennobled by the tsar: "We, Nicolas II, conscious of the outstand-

338

ingly useful activities of Pavel Kharitonenko for the good of the national industry, and in recognition of his merits, deign to elevate him to the rank of hereditary noble of the Russian Empire." At Sumy, the freshly dubbed noble had a bronze monument erected to his father, a project designed by the sculptor Alexander Opekushkin. Today, unfortunately, only the pedestal survives; in 1924 the statue of Ivan

339

340

340. Vasily Vereshchagin
The Taj Mahal in Agra,
1874-76
Oil on canvas,
40.5 x 55 cm
Tretyakov Gallery, Moscow

341. Mikhail Nesterov
In Russia (Spirit of the People),
1914–16
Oil on canvas,
306.4 x 483.5 cm
Tretyakov Gallery, Moscow

Works by Russian artists in the Kharitonenko collection represented every genre, from classical eighteenth-century portraits by Borovikovsky to nationalist compositions by Mikhail Nesterov (ill.341), a regular *Mir Iskusstva* (World of Art) exhibitor, by way of the works of Vasily Vereshchagin, a former pupil of Gérôme in Paris.

Kharitonenko was melted down and replaced by a figure representing Lenin.

Prince Sergei Shcherbatov, himself a onetime collector, left this description of the Kharitonenko gallery in his book *The Painter in Lost Russia*: "Although the Moscow patrons displayed a certain amount of ego-gratification in their picture-collecting, most of them evinced a sincere and intimate love of painting. . . . Kharitonenko adored French painting, but he scorned modern art." Pavel, moreover, had a taste for old Russian icons, which ran even deeper in his wife Vera. "Here there was a meeting of minds among all of us," wrote Prince Shcherbatov.

The Kharitonenko mansion became a regular meeting place for artists and the literati. From Mikhail Nesterov we have this recollection, written in 1912: "I remember a gala lunch at the Kharitonenkos. Gathered there were D.I. Tolstoi, director of the Hermitage, Count Olsufiev, my wife, and myself. We drank to my recent success and my health. And it was decided at this time that I should paint a holy image of the main iconostasis in the Sumy cathedral." The Church of St. Savior, on the Kharitonenko estate at Natalievka, had also been decorated by contemporary artists; Alexander Savinov painted the frescoes, while the sculptor Stepan Konenkov executed a *Crucifixion* on the south wall.

After the death of Pavel Kharitonenko in 1914, his collections passed to his widow Vera, who, as mentioned, was an ardent accumulator of icons. The entire family emigrated in 1918, leaving the deserted house to be occupied, for a while, by anarchists. Subsequently, the Tretyakov Gallery and the Rumiantsev Museum attempted to established branches there, but the People's Commissariat of Foreign Affairs claimed the property and turned it into apartments for VIPs. During the 1920s these would include the American dancer Isadora Duncan, the British writer H. G. Wells, and the minister of foreign affairs Maxim Litvinov, all of them served by the Kharitonenkos' former domestic staff. (Since 1930 the mansion has been the British Embassy.)

Now parts of the Kharitonenko collection can be found at the Tretyakov Gallery (more than one hundred canvases and icons), the Pushkin Museum of Fine Arts (some forty pictures), the Russian Museum and

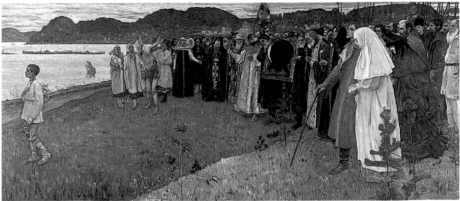

341

342. Ivan Kramskoi
The Unknown Woman, 1883
Oil on canvas,
75.5 x 99 cm
Tretyakov Gallery, Moscow

One of the best-known—and most admired—paintings in the Kharitonenko collection was Kramskoi's *The Unknown Woman* (ill.342). In fact she was far from unknown in St. Petersburg, where she was kept quite openly as the mistress of a member of the imperial family.

In her self-assurance, affluence and poise, this elegant young woman seems to encapsulate the wealth and confidence of the Russian merchant class of the late nineteenth century, without whose passion and extravagance the history of imperial Russia—and of its private collectors—would in every sense have been the poorer.

the Hermitage in St. Petersburg, as well as the art museums in Saratov and Kharkov.

Elena Olive (ill.338), Pavel's daughter, married twice, first Prince Urusov and then Baron Mikhail Olive, a lieutenant in the cavalry regiment of the Imperial Guard. The Olive residence, on Potemkin Street in St. Petersburg, was something of a museum, its elegant rooms filled with paintings, furniture, and *objets d'art* from the eighteenth century. Through Alexander Benois, the couple acquired two large Venetian *vedute* by Francesco Bataglioli (Hermitage), which hung in the dining room. According to a description of the Olive residence published in a 1916 issue of *Starye Gody* (Old Times), the study was paneled with carved *boiseries* dating back to the Régence period and the walls throughout the house, beginning with the staircase, had *papier peints* created by seventeenth-century Belgian manufacturers in Brussels. The article made special mention of the Red Salon with its *Bogdykhan* wallpaper from the Bovet factory. The study contained Auguste Pajou's terracotta portrait bust of the architect Pierre Rousseau (Hermitage). Paintings by French artists predominated in the Olive collection: François Boucher's *Landscape near Beauvais,* Carle Van Loo's *Portrait of Abbé Prévost,* and Philippe Mercier's *Couturière* (all in the Hermitage). Another portrait—this one of Hortensia Mancini and attributed to a painter in the circle of Pierre Mignard—most certainly came from the Benckendorf and Rostopshin collection (Hermitage). Next to portraits by Jean-Louis Voille or Madame Vigée-Lebrun, one would also see Jacob Voet's *Portrait of a Young Man* (Hermitage), as well as Russian portraits, by artists such as Ivan Nikitin and Dmitry Levitsky.

Valeri Chambers has provided a good account of the Olives's collection in an article devoted to the interior of the house on Potemkin Street: "This entire group of marbles, *papier peints,* tables, arm chairs, porcelains, etc., lives together in friendly communion. It's not a museum, nor a systematic collection, but rather a marvelous dwelling place."

In his memoirs Alexander Benois wrote: "I tried, in the first years of the revolution, to arrange things so that the sumptuous Olive residence could be converted into a museum of the old life." In 1921, the house did indeed become an "exhibition" of the past era, but this oddity survived only eighteen months. Closed in 1923, the residence was stripped of all its art works and objects, which were then divided between the Hermitage and the Russian Museum.

342

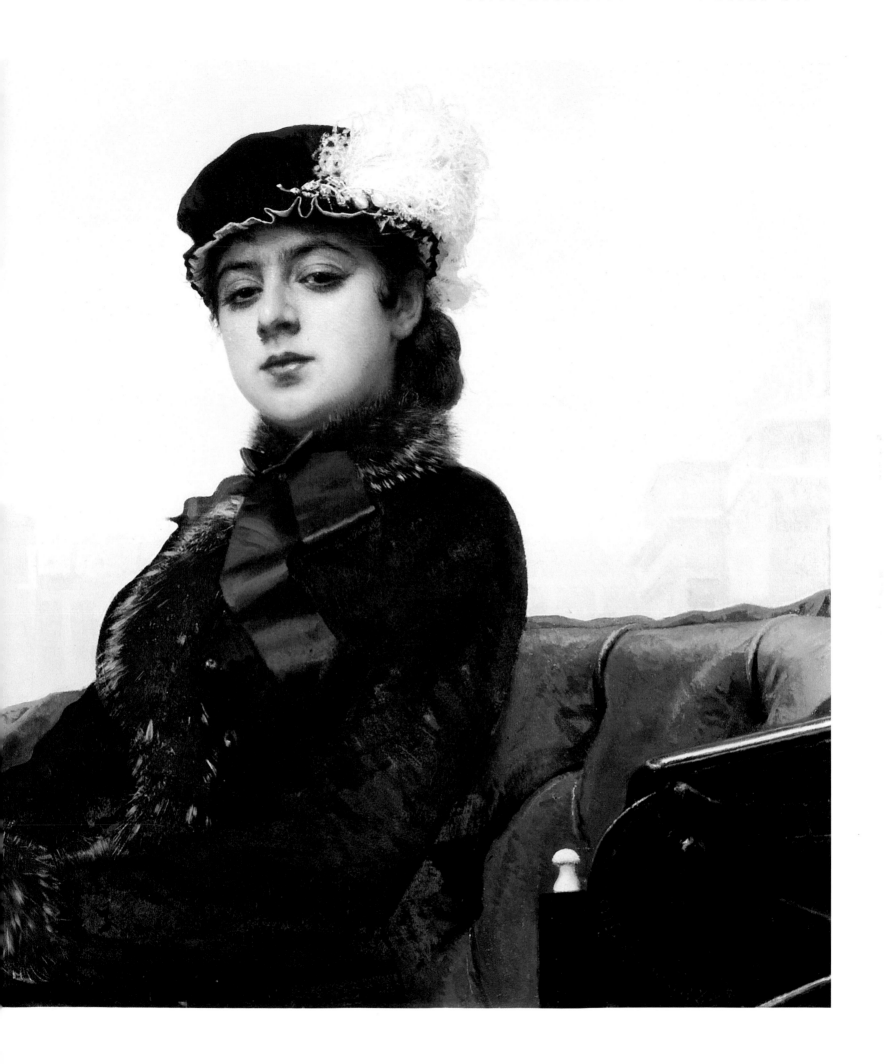

INDEX

Page numbers in bold refer to illustrations.
Patronymics are given in cases where they serve to distinguish
between different members of the same family.

BIBLIOGRAPHY

(the titles of Russian works are given in translation)

Asvarishch, B.I. *The Kushelev Gallery*. St. Petersburg, 1993.
——. *The Paintings of Alexander Gorchakov*. St. Petersburg, 1998.
Bakhrushin, A.P. *Pages from my Notebooks*. Moscow: Who Collects What, 1916.
Bannikov, A.P., and S.A. Sapojnikov, editor. *Dictionary of Russian Collectors (1700-1918)*, *Dvoriansky Vestnik (The Aristocratic Messenger)* (2004/to the letter K).
Belyakova, Zoia. *Grand Duchess Maria Nikolayevna and her Palace in St. Petersburg*. St. Petersburg: Ego Publishers, 1994.
Bokhanov, A.N. *Russian Collectors and Patrons*. Moscow, 1989.
Botkina, A.P. *Pavel Tretyakov in Life and Art*. Moscow, 1951 (5th edition 1995).
Buryshkin, P.A. *Merchants' Moscow*. Moscow, 1991.
Dodonova, A. A. *Dmitri Gennadievich Burylin*. Ivanovo, 1997.
Dumova, N. *Muscovite Patrons*. Moscow, 1992.
Gray, R.P. "The Golitsyn and Kushelev-Bezborodko Collections and their role in the Evolution of Public Art Galleries in Russia." *Oxford Slavonic Papers*, new series volume XXXI. Oxford: Clarendon Press, 1998.
——. "Muscovite Patrons of European painting – The Collections of Vasily Kokorev, Dmitry Botkin and Sergei Tretyakov." *Journal of the History of Collections* 10 no. 2 (1998). Oxford University Press.
Kean, Beverly Whitney. *French Painters, Russian Collectors*. London: Hodder & Stoughton, 1994.
Khudojestvennye Sokrovichtcha Rossii (Art Treasures of Russia)
Kuznetsov, S. *New Guide to the Stroganov Palace*. St. Petersburg, 1995.
Kryjanovskaia, M.Y. *The Applied Arts in Western Europe. The Middle Ages and the Renaissance*. Leningrad, 1986.
Levinson-Lessing, V.F. *History of the Hermitage Museum of Paintings (1764-1917)*. Leningrad, 1986.
Nenarokomova, I.S. *Pavel Tretyakov and his Gallery*. Moscow, 1988.
Neverov, O.Y., and M.B. Piotrovsky. *The Hermitage Museum. Collections and Collectors*. St. Petersburg, 1997.
"Patrons and Collectors." *Pamiatniki iskustva* (Monuments of Art). No. 29. Moscow, 1993.
Petrov, Y.A. *The Ryabushinsky Dynasty*. Moscow, 1997.
Polunina N., and A. Frolov. *The Collectors of Old Moscow*. Moscow, 1997.
——. "Russian collectors. Notes towards a biographical dictionary." *Pamiatniki Otechestva* (National Monuments). no. 29 (1993): 111-61.
Prokhorenko, G., and G. Vlasova. *Baron Stieglitz's Museum*. St. Petersburg: Cezar, 1994.
"The Pushkin National Art Museum at Seventy." *Muzeï-34*. Moscow, 1982.
Sebag Montefiore, Simon. *Prince of Princes: The Life of Potemkin*. London: Weidenfeld & Nicolson, 2000.

Starye Gody (Old Times)
Stehlin, J. *The Notebooks of Jacob Stehlin on the Arts in Russia*. Edited and translated from the German with a preface and notes by K.V. Malinovsky. Volumes I and II. Moscow, 1990.
The Yusupov Palace. Mansions of the Aristocracy. History of a Noble Line, an Estate and a Collection. St. Petersburg, 1999.

[Exhibition catalogues]
Anatole Demidoff, Prince of San Donato (1812-70). Contributions by Francis Haskell, Stephen Duffy, Robert Wenley and David Edge. London: Wallace Collection, 1994.
Destiny of a Collection: 500 intaglios from the Cabinet of the Duc d'Orléans. Contributions by O.Y. Neverov and Y.O. Kagan. St. Petersburg: Hermitage, 2001.
Hubert Robert et Saint-Pétersbourg – les commandes de la famille Impériale et des princes russes entre 1773 et 1802. Valence: Réunion des Musées Nationaux-Musée de Valence, 1999.
Hunter-Stiebel, Penelope, general editor. *Stroganoff. The Palace and Collections of a Russian Noble Family*. Portland and New York: Portland Art Museum with Harry N. Abrams, 2000.
Liselotte von der Pfalz. Madame am Hofe des Sonnenkönigs. Contributions by O.Y Neverov and Y.O. Kagan. Heidelberg, 1996.
Morozov and Shchukin, Russian Collectors. From Monet to Picasso. Essen: Volkwang Museum, 1993.
A Scholar's Whim: The Collection of Prince Nikolai Borisovich Yusupov. Moscow: Pushkin Museum of Fine Arts, 2001.
Splendeurs des collections de Catherine II de Russie. Le Cabinet de pierres gravées du Duc d'Orléans. Contributions by O.Y. Neverov and Y.O. Kagan. Paris: Mairie du Vᵉ arrondissement, 2000.

[Collections of Correspondence]
The Correspondence of I.E. Repin and P.M. Tretyakov (1873-1898). Moscow-Leningrad, 1946.
The Correspondence of I.N. Kramskoi, T.N. Kramskaia and P.M. Tretyakov (1869-1887). Moscow, 1953.
The Correspondence of P.M. Tretyakov and W.V. Stassov (1874-1897). Moscow-Leningrad, 1949.
The Correspondence of V.V. Vereshchagin and P.M. Tretyakov (1874-1898). Moscow, 1963.
Letters from Painters to Pavel Tretyakov (1856-1869). Moscow, 1960.
Letters from Painters to Pavel Tretyakov (1870-1879). Moscow, 1968.

PUBLISHER'S ACKNOWLEDGMENTS

The genesis of this publication was an exhibition that was suggested by Philippe de Montebello, director of the Metropolitan Museum of Art, to Dr. Mikhail Borisovich Piotrovsky, director of the State Hermitage, to mark the tercentenary of the founding of St. Petersburg. The subject was the private collections of imperial Russia, and the emphasis was to be on the decorative arts. Olga Raggio, chief curator of that department at the Met, and I had many discussions about the scope of such an exhibition, resulting in a most appreciated invitation by Mr. de Montebello to join him in St. Petersburg for the reopening of the splendidly refurbished Russian Museum, as well as to participate in his discussions with Mikhail Borisovich.

In post-*perestroika* Russia, the rehabilitation of the imperial family, culminating in the official burial of their remains in the fortress of St. Peter and St. Paul, developed concomitantly with the recognition that many members of Russia's pre-revolutionary ruling classes had made enormous contributions to their country. Few people are as conscious of this as Dr. Piotrovsky, who is the custodian at the Hermitage of so many of their treasures that came to this remarkable institution before and after 1917. He immediately welcomed Philippe de Montebello's suggestion, and the curators went to work on their wish lists. Reality soon dawned as everybody realized the vast scope of what they had undertaken to do. In fact, all the galleries of both museums would have been needed to do honor properly to imperial Russia's private collectors, so the Hermitage marked the tercentenary instead with an exhibition of works once in the collection of the Stroganov family (pp.26-39) and the Metropolitan Museum of Art with an exhibition of Russian treasures from their own collections.

As a result, I asked Mr. de Montebello and Dr. Piotrovsky whether they would allow Vendome Press to produce a book on this subject, and they both welcomed the suggestion. Dr. Piotrovsky proposed as author Oleg Neverov, curator in the Department of Antiquities at the Hermitage and undoubtedly the greatest living expert on what belonged to whom in imperial Russia. We agreed that the names of the Hermitage and Vendome Press should be linked together in this venture, a singular honor of which I am deeply appreciative.

I would like to thank deeply our co-publishers, Thames & Hudson in London, Slovo in Moscow, and Editions Flammarion in Paris, for joining us in this exciting adventure. Particular thanks go, of course, to Dr. Piotrovsky for his support and enthusiasm, to the staff of his highly efficient department of photographic rights and permissions, and to our splendid photo researcher in Moscow, Natalia Borissovskaia. Her unique knowledge of where all the visual secrets of Russia's past are hidden has brought together again in this book the collectors, their life's work, and their environment, something that would have been far more difficult to do in an exhibition. Special thanks go to everybody credited in the list of photo credits (below) for their cooperation, particularly to a delightful French colleague, Pierre Brochet, who left Paris to live in Moscow where he married a Russian aristocrat and founded his own publishing house.

My deep thanks go to my friend Emmanuel Ducamp, a distinguished author and lecturer on things Russian, who served as general editor of this book. In addition to all the usual drudgery involved in pulling everything together for both the French and English language editions, he wrote the commentaries that bring the book's illustrations to life, thus adding much historical and cultural information that is part of every educated Russian's knowledge, but far less known to foreigners. My appreciation also goes to Marc Walter, who has been designing Vendome books for many years, but never faced as formidable a task as this. He was assisted by Hervé Droin, Florence Cailly, and Sabine Arqué-Greenberg, as well as Isabel Venero and Sarah Davis. Antoine Garcia, Daniel Wheeler, and Barbara Mellor provided us with their professional help in the translation.

So staggering were the private collections of imperial Russia, in both their wealth and their scope, that an exhaustive work on the subject would run to many volumes. In this book we hope to open a window onto this world of untold riches, discerning patronage, and aesthetic enlightenment that has for many years been hidden from Western eyes.

Alexis Gregory
Chairman, The Vendome Press

PHOTO CREDITS

ACE-Studio Agency: ill. 2, 3, 14, 15, 27, 40, 51, 52, 55, 57, 60, 67, 95, 99, 101, 124, 126, 127, 132, 133, 135, 137, 156, 162, 202, 204, 207, 214, 230, 235, 237, 241, 244, 246, 271 273, 282, 283, 324, 325, 331, 334, 338, 342

All Photo Foundation: ill. 16, 117, 140, 194, 195, 206, 212, 227, 254, 262

Art Resource. © Scala/Art Resource, New York: ill.298

Avantgarde Publishers: p. 2; ill. 21, 22, 25, 26, 29, 30, 32, 37, 78, 83, 102, 105, 106, 110, 112, 114, 121, 128, 129, 130, 211, 213, 216, 219, 221, 248, 251, 266, 269, 274, 277, 280, 288, 291, 295, 297, 300, 305, 308, 309, 311, 313

Winnie Denker: ill. 4, 7, 20, 46, 65, 79

Iskousstvo Publishers: ill. 39, 47, 49, 50, 53, 61, 81, 82, 86, 90, 100, 119, 123, 125, 139, 142, 143, 145, 163, 164, 173, 183, 185, 208, 209, 210, 215, 222, 224, 226, 228, 229, 233, 242, 243, 247, 249, 250, 252, 260, 263, 264, 268, 296, 299, 318, 329, 330, 333, 336, 337

Louvre, Paris: ill. 167

Metropolitan Museum of Art, New York: ill. 155

National Gallery of Art, London: ill. 172

National Gallery of Art, Washington, D.C.: ill. 4, 161

Palazzo Pitti, Florence: ill. 171, 174

Igor Palmine: ill. 238, 239, 253, 265, 316, 317, 326, 328, 332

Poisk Publisher: ill. 7, 70, 79, 80, 88, 104, 191, 193

Private archive: ill. 107, 109, 189, 217, 218, 223, 231, 232, 234, 240, 256, 259, 261, 267, 270, 281, 284, 286, 287, 289, 290, 315, 321, 323, 327

Private collection: ill. 5, 9, 141, 200

Rijksmuseum, Amsterdam: ill. 19

Anatoly Sapronenkov: ill. 54, 68, 115, 118, 138

Sebastopol Art Museum: ill. 205

State Hermitage, St. Petersburg: pp. 6, 7; ill. 1, 3, 6, 8, 10, 13, 16 18, 23, 24, 31, 33 36, 38, 42, 46, 48, 58, 59, 62, 66, 69, 71, 76, 84, 85, 87, 89, 91 93, 96, 98, 103, 111, 120, 122, 131, 134, 136, 144, 146, 154, 157, 160, 165 166, 169, 170, 176, 182, 184, 186 188, 190, 196, 199, 201, 255, 275, 276, 285, 298, 306, 307, 310, 314, 319, 320, 335

The Wallace Collection, London: ill. 168, 175